Lennard J. Davis

How Those
with Money
Depict Those
without It

Poor
Things

DUKE UNIVERSITY PRESS DURHAM AND LONDON 2024

Printed and bound by CPI Group (UK) Ltd, Croydon, CR0 4YY
Project Editor: Bird Williams
Designed by Matt Tauch
Typeset in Garamond Premier Pro by
Westchester Publishing Services

Library of Congress Cataloging-in-Publication Data
Names: Davis, Lennard J., 1949- author.
Title: Poor things : how those with money depict those without it /
Lennard J. Davis.
Other titles: How those with money depict those without it
Description: Durham : Duke University Press, 2024. | Includes bibliographical
references and index.
Identifiers: LCCN 2024008011 (print)
LCCN 2024008012 (ebook)
ISBN 9781478031024 (paperback)
ISBN 9781478026747 (hardcover)
ISBN 9781478059974 (ebook)
Subjects: LCSH: Poverty in literature. | Poor in literature. | Authors. | Social
classes in literature. | Authorship. | BISAC: LITERARY CRITICISM /
American / General | ART / Art & Politics
Classification: LCC PN56. P56 D385 2024 (print)
LCC PN56. P56 (ebook)
DDC 809/.89206942—dc23/eng/20240705
LC record available at https://lccn.loc.gov/2024008011
LC ebook record available at https://lccn.loc.gov/2024008012

Cover art: Altered detail from Gustave Courbet oil painting,
The Charity of a Beggar at Ornans (1868). Burrell Collection.
Pollok Park, Glasgow, UK.

To my first-generation students and colleagues through whose eyes I have seen and through whose ears I have heard. To all writers, filmmakers, musicians, and other creative artists who grew up poor, I dedicate this book to you. I know it has been hard to tell your stories, and I am with you.

Contents

ix *Preface. What It's All About?*

1 Introduction. Scenes from a Life and from Lives

21 INTERCHAPTER 1. WHY ME?

25 Chapter One. How to Read This Book and How the Lives of the Poor Have Been Read, or, Why You?

42 Chapter Two. The Problem of Representing the Poor

70 Chapter Three. Transclass: Endo- and Exo-writers

110 Chapter Four. Biocultural Myths of the Poor Body

153 Chapter Five. Female Sex Workers

170 Chapter Six. The Encounter, or, the Object Talks Back

205 INTERCHAPTER 2. THEY GOT IT RIGHT NOW?

219 Conclusion. What Is to Be Done? Endings and Beginnings

231 *Notes*

253 *Bibliography*

279 *Index*

Preface

This book is about the genre of artistic creativity that takes as its subject poverty and poor people. While this is generally considered to be a paradoxically uplifting and depressing topic, it turns out that the best-known creators of narratives have most often come from the middle and upper classes. In fact, writers who come from poverty or who are poor make up only a minority of those who are known to the general public—and of those, few if any have been canonized. This state of affairs constitutes what I call *representational inequality*, which, like economic inequality, has had a profound effect. In addition, I suggest that those who write from outside the class they depict should be called *exo-writers*, and those who come from poverty *endo-writers*. A mediating concept would be *transclass writers*, those who have changed class positions. In the course of this work, I define these terms more precisely.

To rectify this representational inequality, which of course like other inequalities is part of a structure of social injustice based around the intersection of race, class, gender, and sexuality, I advocate that given the oppressive history of narratives about the poor (what I refer to as *poornography*), only endo-writers or transclass writers (those who have been poor) can and should create representations of poverty. I argue this because an analysis of these exo-works, focusing on the breeding ground of a poornographic approach in the nineteenth century, shows us a numbingly repetitive series of situations, descriptions, and tropes all focused on the revolting living conditions of the poor, violence, addiction, sexual license, crime, and lack. Meanwhile, a reading of endo-writers reveals a completely different set of issues revolving around friends, family, love, politics, and hunger sometimes but generally a plenitude of life, feelings, relationships, and aesthetic epiphanies. Such a stark contrast highlights the need for reform and backs up my call for representational equality.

There are some reasonable objections to my clarion call. First, one might argue against the notion that exo-writers can't be allies in the fight against poverty and the structural injustices that create impoverishment. To be clear, I am not saying that no exo-writer can write about the poor, but I am arguing, based on reading and viewing many instances of poornography, that exo-writers and artists tend to fall into harmful clichés that produce a demonstrably distorted vision of the lives of poor people, leading to larger political and social consequences. If I make that claim, then a second objection could be that I am hiding behind the specious and impossible-to-prove curtain of authenticity or accuracy. My response is to disclaim any assertion of those two *a*-words and instead substitute one of my own—*accountability*. By *accountability*, I mean that the group being described actually speaks back and approves or disapproves of the fictional or documentary depiction of itself. Thus, instead of appealing to some impossible-to-verify set of details or data, we look for the critical demographic response to such works. Of course, it should be clear that poor people at this point in history do not constitute a clear demographic who can respond forcefully in the cultural realm. Therefore, the response will need to be provided for the time being by transclass spokespeople.

By introducing the idea of exo- and endo-writers, as well as transclass writers, representational inequality, and accountability, I am trying to come up with a way of discussing class politics in the arts that has not yet been fully articulated. I recognize that there are preexisting discussions of this subject, and I am trying to reshape, not eliminate, these. The major counterexplanation to my take on poverty and therefore artistic works about the poor is what might be described as a structural one. From that perspective, poverty is a result of capitalism, which needs the poor for two reasons: first, poverty and poornography act as cautionary reminders to workers that they must accept the unfair labor offered by capital or face the horrors of poverty. Second, the poor are useful as a reserve labor force that can be called on during strikes and high employment to keep wages low. From this structuralist perspective, being poor is a feature of the general abuses of capitalism that needs to be corrected by progressive politics. While certainly true, that perspective shades or ignores the lived experience of poor people. Thus, according to this structural view, they can and should only be depicted as living in a disastrous world and needing remedy, lest we end up justifying the error of poverty.

In the works of many reformer artists, the daily life and lived experience of poor people is less important than their relatively simple, partial,

symbolic, and ideological function. But as I have said, endo-artists and transclass artists focus precisely on their experience of existing as a complete being in a complex world. In noting this disparity, I am not inventing an argument but rather describing a situation. In so doing, I could be, and have been, accused of replacing a genuine political critique of capitalism with a mere assertion of identity politics. In this view, poverty cannot and should not be an identity since who would be mad enough to define their identity solely through being oppressed? We come, this logic goes, not to praise poverty but to bury it. But of course, being poor is an identity that many of us have lived through. It has shaped us. It has given us insights from a subject position that the removed critic of capitalism cannot fathom. We are not symbols or algorithms but sentient beings with experience and history. To ignore that in favor of a purely structural argument is to perform a secondary cultural erasure of poor people over their primary erasure by the economy. Some have called this type of appropriation "elite capture," by which is meant that the elites capture social and political movements to reshape them in their own interests.[1]

What I am advocating, using Veena Das's idea of "dwelling with," is a nuanced and sustained attention to the lives of the poor as represented in art. As opposed to an anthropological observation, a literary reduction and stereotype, or an Olympian viewpoint, Das suggests a kind of habitation, a getting to know over time, an earned intimacy with poverty. It seems ironic that people who have never been poor should place themselves in a position to determine how poverty should be represented. The classic works of poornography written by the likes of Friedrich Engels, Elizabeth Gaskell, Nellie Bly, Charles Dickens, Émile Zola, Jack London, George Orwell, John Steinbeck, and others were based on relatively brief fieldwork and patchy research. The works are therefore incomplete at best and distorted at worst. There has been no dwelling with but rather a casual, glancing observation from a class-privileged position. In fact, these exo-accounts are made up of what I call *ideologemes*, which like Claude Lévi-Strauss's, concept of *mythemes*,[2] are basic units of knowledge or description that float through the sensorium of a culture. These ready-made units combine to form predictable descriptions and stereotypes, in this case, of poor people.

I would like to thank the many students in my courses on representing poverty who helped me think through the issues I have accumulated in this book. Also, thanks to the members of the Endo/Exo Writers Project, who collectively produced the website of the same name—these are the

professors Alex Dunst and Hannah Huber, as well as team members Carla Barger, Katie Brandt, Travis Mandell, and Justin Allen.

I owe a great debt of thanks to Ken Wissoker of Duke University Press, whose persistence allowed this book to see the light of day. Ken originally signed me on with a very different book, which, to his appropriate exasperation, I never produced. But after many lunches and a few awkward moments, I managed to find a topic agreeable to us both and, more amazingly, managed to write this book. Thanks to Gerald Graff, who read the entire manuscript and asked me repeatedly, "What's your argument?!" Also, thanks to Alex Dunst and Joseph Entin, who both gave me some important reactions to think about. Thanks to Justin Torres and Maggie Anderson for letting me interview them. I want to thank those people who heard me present some material from the book or vetted parts of the manuscript and provided feedback. These include Ato Quayson, Bruce Robbins, Sally Stein, Dierdre Lynch, Ewa Luczak, Dominika Ferens, Nicole Anderson, David Bolt, William Maxell, Walter Benn Michaels, and many more whose names I may have forgotten or never knew.

Introduction
Scenes from a Life and from Lives

I grew up poor, as did my father and his father.

My grandfather, Shlomo (Solomon) Melandovitz, immigrated to London around 1880 from Ariogola, a small town filled with two-room green wooden shacks near Kaunas, Lithuania (which the Jews called Kovno). It was said that he had heard about an upcoming attempt to recruit Jewish young men into the tsar's army, so he hid in a rain barrel overnight and took off in the morning. Arriving in England, he changed his family name to Davis, making a near homophone with the ending of his former name. He loved fish and fishing, and so it was logical that he sold fish from a cart in the Whitechapel slums as Jack the Ripper was plying his trade. He had no education to speak of. He could barely write. His wife, Bella Esther Moskovich, who also came from Lithuania, hawked fabrics door to door. In his spare time, Solomon fought in the boxing ring in the days before padded gloves. He killed a man in a match and fled to New York, never returning and never seeing his wife again. Or so the story goes. In New York he did sweated work in the garment industry. Eventually, he went to Los Angeles, where he finished his life as a barker at Sea World encouraging other people to love fish as much as he did.

My father, Moishe (aka Morris), was born in Whitechapel in 1898. He was discovered to be deaf before he began to speak. Living with his father, mother, and three siblings in a one-room tenement apartment, he numbered among the throngs of poor Jewish, Irish, and South Asian immigrants who made up the district. He was a kind of wild child without much language until he was sent to the London Asylum for the Jewish Deaf and Dumb, where he learned to read, write, and draw and unofficially picked up sign language, since the school was an oralist one. The asylum may have saved his life, as he received proper nutrition and vaccinations.

He could have been a talented artist, but because of his social class and deafness, he had only two trade choices—carpenter or tailor. He chose the former, tried it out, didn't like it, and then opted for the latter. He also took up sports. Initially, it was boxing, like his father, but he settled on race-walking and became a very accomplished athlete. He followed his father to New York, where he also worked in a sweatshop and did so for his entire life. No fish for him.

..............

The parents of my mother, Eva, immigrated to Liverpool from a small town in Poland called Nowogrud, not too far from Lomza. They were also poor. My grandfather, Eli Weintrobe (his family name had been Chmielewski, but his father also changed it), was a carpenter. His wife raised their five children and sold household goods. My mother became deaf at seven when she contracted spinal meningitis. Like my father, she also attended the London asylum, where she learned to be a seamstress; she spent her life altering women's clothing. Morris and Eva met in England but were married in New York City.[1] They spent their lives together in the Bronx in a one-bedroom apartment, and both were seasonally employed.

Although I was part of three generations (most probably many more) of poverty, I never heard anyone in my family lament this state of affairs. If anything, I got a positive message about working hard and valuing one's life and place in the world. In my own life, and in the memoirs I have written about it, you won't find the kind of descriptions that are rife in the history of writing about the poor by those who are not poor. Starting with Friedrich Engels and working up to the present, in literature, film, and art, the poor are too often depicted as living abject, violent lives in filthy, degrading conditions. They themselves are seen as unintelligent, unkempt beings who live in thriftlessness, intoxication, and sexual license. Stunted, underfed (or now obese), and feeble-minded, they are a blot on humanity's view of itself.

My father and mother were none of the above. They did not drink or smoke. Our 550-square-foot apartment was clean and tidy. My father's piecework salary in the 1950s when he was employed was $38 a week. When he was laid off, his unemployment insurance was much less. Yet, like many people who grew up poor, he was abstemious with his money. His favorite phrase was "Willful waste makes woeful want." He didn't waste, and we were not woefully wanting. We had food on the table, albeit of poor quality and limited variety, as well as being badly cooked. All vegetables came

out of a can, as did much of the fruit. Being thrifty for my father meant rarely doing anything or going anywhere. We didn't eat out. We didn't go on family trips. Having no car, we only took public transportation. Life was lived within a very small, simple compass, and we lived uncomplaining within those boundaries. Of course, not all poor people live tolerable lives, and we were among the fortunate poor, if you want to call us that.

Our lives contrasted vividly with the views of poor people that were and are written mainly by middle- and upper-class people. These canonical works by writers like Charles Dickens, Jack London, George Orwell, Émile Zola, and others are often the only remaining traces of those who for the most part, at least in the past, could rarely if ever represent themselves. As with all prejudicial views of people, the accepted and wanted perspectives (wanted by those who are not poor) are often a series of clichés that satisfy a public deprived of intimate direct knowledge. As with genres like the western, the viewers of the product know what to expect. In the western we expect to see one main unpaved street with the saloon that doubles as a bawdy house, the general store, the bank, the sheriff's office, the good guy, the bad guys, and the rest of the predictable characters. So it is with the poor. We expect violence, drugs, alcohol, prostitution, sexuality, crime, filth, and the rest of the limited possibilities envisioned by the creative nonobserver. Poor dwellings in movies always look a certain way—cracked, peeling walls with dirty windows and a soundtrack revealing crying babies and spatting couples. Apparently, richer people have neither fights nor babies that cry. I want to make clear that in general this kind of writing about the poor isn't about reproducing reality. Rather, it is genre writing first and foremost— what I am calling *poornography*.[2] Revising *poverty porn*, my term focuses more on writing rather than exclusively visual and audio media but shares a general definition of depicting poor people for various kinds of gain— financial, cultural, and otherwise. Just as you would not expect to learn about the actual West from the oater, it would be a deep mistake to think that you can learn very much about the lived experience of the poor from this kind of writing.

Of course, you could make the counterargument that poverty demands to be written about and that literature about the poor is an important part of the literary tradition. Further, it could be said that we can learn about the poor and ameliorate the conditions of poverty through awakening a knowledge and understanding of the plight of the poor. Gavin Jones writes, "Literature reveals how poverty is established, defined, and understood in discourse, as a psychological and cultural problem that

depends fundamentally on the language used to describe it. This is why creative writers have responded so productively to poverty."[3] While Jones is by no means ratifying the genre of poornography, he is allowing for a complex polemic between the emotional and psychological side of poverty, to which many writers are drawn, and the material realities of poverty, which may or may not be articulated in any given literary work. The argument for the benefits of middle-class writers laying out the dialectics of poverty for middle-class readers can indeed be made but is not without serious problems.

It matters how the poor are represented—not simply because of notions of accuracy and fairness, but because when we say *the poor*, we have, at various times, been talking about a large plurality of humans on earth. Until the 1950s about half the people in the world lived in "extreme poverty" (defined now as living on less than $2 a day). By the 1980s 44 percent of the world lived in that kind of destitution. Even today, half of the world's population lives on less than $5.50 per day.[4] And these statistics do not include the COVID pandemic's devastating effects. In 2021 the average incomes of people in the bottom 40 percent of the global income distribution were 6.7 percent lower than prepandemic.[5] Further, global poverty increased even more as a result of the war in Ukraine in 2022 than as a result of COVID.[6]

We can assume that when Dickens wrote of poverty or Zola described starvation and want, they were writing about the vast sweep of humanity for a very small slice of that humanity that was literate and lived in relative comfort.[7] That vast sweep of impoverished humanity in the century before Dickens wrote made up about 70 percent of the population of London if you include those who were on poor relief (about 10 percent) and those who experienced significant poverty at some point during their lives (60 percent).[8]

One of the striking consequences of how the poor are represented is the false dichotomy inaccurate representation creates between haves and have-nots. Like disability, poverty presents us in reality with a malleable and shifting category. Able-bodied people like to think that there is a firewall between being disabled and not being disabled. This mind-forged barrier seemingly reassures the "normal" that they will not become disabled. Likewise, if we think of the poor as a distinct, monolithic group, those with some financial security can hold on to a seemingly firm (but actually quite shaky) belief that there is a protective barrier between financial security and insecurity. We are reassured that in general the trend is moving away

from a world of mainly poor people to a largely middle-class one. But the reality is quite different. For example, according to one study of people "between the ages of 20 and 75, nearly 60 percent of Americans will experience at least one year below the official poverty line, while three quarters of Americans will encounter poverty or near poverty."[9] When novelists and filmmakers present us with the world of the poor, they contribute to this sense of the poor as separate and distinct from the majority of citizens. But when we look at the statistics, we see that the poorest people in the US economy are single recent mothers. This is not exactly a distinct socioeconomic group.[10] Rather, it is a portion of the population that any female may join.

............

Poornography according to my definition encompasses narratives about the poor by and for people who are not poor. This genre of storytelling is a kind of engine for generating conscious and unconscious bias against the poor. And the resonance with *pornography* is not accidental. This writing about and visual representation of the poor has historically had an almost salacious slant. As one historian wrote, such work "appealed to prurience behind a mask of respectability."[11] Linked to this desire is a kind of scopophilia that is focused on and obsessed with paintings, engravings, and photographic images of the poor. In art history, depictions of the poor start with painters like Pieter Bruegel the Elder, Jacques Callot, and, from the second half of the seventeenth century into the eighteenth century, northern Italian painters like Monsù Bernardo and Giacomo Ceruti, whose works were popular among wealthy patrons who collected this genre art.[12] The latter's work, while depicting the poor with compassion, dignity, and humanity, was nevertheless commissioned by the rich to "decorate their luxurious residences."[13] We recognize these impulses as parallel to an activity like slumming, which was considered in the nineteenth and twentieth centuries an appropriate entertainment for wealthy people, who organized trips to see how the more-than-other-half lived. Barring actually going to the slums, one could visit art exhibits that dramatized poverty. An 1884 Juvenile Fine Art Exhibition at Portland Hall in London's posh Regent Street featured toys, games, and a "Visit of 'Horrible London' to the West End. Illustrating 'How the Poor Live.'" What viewers could see were "children and other of the East-end of London engaged in their regular occupation" of sweated work.[14] Magic lantern shows entitled "How the Poor Live" were shown in many locations around the United Kingdom.

In addition to these activities, slumming had its literary correlate. Books were written about poor people and the slums for wealthier readers. For example, in 1903 George Sims edited and lavishly illustrated a book called *Living London: Its Work and Its Play, Its Humor and Its Pathos, Its Sights and Its Scenes*, which included articles about the slums. The book cost a pricey twelve shillings in cloth and sixteen shillings in half-leather—clearly not for any but middle-class and upper-class readers.[15] Gustave Doré and Blanchard Jerrold's *London: A Pilgrimage* had Doré's ornate illustrations of slums and doss-houses accompanied by Jerrold's text. Luxuriously bound with tissues protecting the engravings, the book was an expensive collector's item advertised as a "handsome Christmas present . . . and an elegant addition to the drawing-room table."[16] The notion of an expensive book for Christmas depicting the poor was not a one-off whim of a publisher. John Thomson and Adolphe Smith's *Street Life in London* was also sold as a Christmas book and reviewed in "gift and Christmas books sections of London newspapers."[17] And then of course there was the actual prurience of middle-class men engaging in sexual activity with lower-class women for pay. In the current moment, one still finds poverty tourism or "poorism," in which middle- and upper-class travelers visit the favelas of Rio de Janeiro or the slums of Delhi or Mumbai.[18] While the impulse now might be linked to some notion of helping the benighted denizens, the scopophilic pleasures linked to repulsion and disgust might equally be drivers of this lucrative activity.[19] Evangelical groups in California have gone so far as to construct an Epcot Center of poverty. Poverty Encounter is an immersive environment in which people can pay to experience what it is like to be poor, take a "ride" to a poor country, and then pack food and supplies for poor people while bringing the word of Jesus Christ to them at the same time.[20]

One of the main points of this book is that the depictions of the poor that we have are distorted at best and prurient, in the sense I am talking about, at worst. In other words, while many writers present a world they claim to be an objective description and copy of the squalor of the poor, it would be a mistake to think that no selection of details came into play. While we discuss the function of this genre throughout the book, it might make sense to provide at least one rationale for this type of depiction. Eric Schocket has noted of certain writings about the poor, "With remarkable unanimity, they tell an alternative tale of a middle-class 'lack' fulfilled through lower-class 'experience,' bourgeois ennui cured by way of proletarian pain."[21] Keith Gandal adds that writings about the slum "offer a tonic

for a tired middle-class society."[22] Erotic desire for the poor, whether expressed through prurience or disgust, drives the engine of poornography. And in many cases the poor provide comic relief. Author Mary Elizabeth Braddon mocks a theater writer whose play includes "fifteen murders and four low-comedy servants."[23]

In some sense, the whole concept behind writing about the poor was to give middle-class people a feel for "the real." Paula Rabinowitz, discussing documentary photography, adds tellingly that "images of poverty are a staple of liberal society's guilt."[24] And Lionel Trilling, who grew up in the Bronx near me, wrote that such works evoke "a pity which wonderfully served the needs of the pitier."[25] An entire genre of writing—realism—was characterized by its focus on poverty. While a motivational use of cultural objects and subjects may seem appealing, it is ultimately problematic. This notion of "real experience" is recorded by Howard Marshall, who, in writing about the East End slums, noted that when a poor person he knew went to the wealthy West End "to see what lay behind all the glitter and noise . . . he said, 'Once was enough—there's nothing in it—it isn't real.'" Marshall adds, "And that's the point: the people of the slum are real. They have to be real, and when you talk to them . . . you become conscious of your own artificiality."[26] Whether to make the middle class satisfied with their lives in comparison to the squalor of the poor or to make the middle class feel that their lives are superficial compared to the real of poverty, the goal of poornography is certainly not to provide an accurate view of the lives of the poor. Charles Booth, the nineteenth-century author of *Life and Labour of the People of London*, noted that in most writing about the East End of London, the actual place "lay hidden behind a curtain upon which were painted terrible pictures: Starving children, suffering women, overworked men, horrors of drunkenness and vice; monsters and demons of humanity; giants of disease and despair." He goes on to wonder, "Do these pictures truly represent what lay behind?"[27] While it may be ultimately impossible to determine the reality behind the curtain of poornography, it is possible to trace the fantasies of this genre of writing.

In a significant sense, this work is inspired by Edward Said's foundational book *Orientalism*, which presented us with the idea that the West had created a series of powerful and influential imaginings of the East and in so doing had influenced knowledge, policy, politics, and social and cultural life in relation to that imagined world. Benedict Anderson's notion of imagined communities fits in with such an analysis as well. In regard to the poor, then, we have a coordinated imagining of the poor by an imagined

community of those who are not poor. The imagined communities are both the poor, so overrepresented in literature, the arts, and culture in general, and the unpoor, equally imagined since this group is the binary opposite to the poor.

To illustrate how these two imagined worlds work, let me introduce you to Dorothy Tennant, who later in life married the famous explorer Henry Morton Stanley and became Lady Stanley. She was a Victorian painter whose book *London Street Arabs* became popular enough that its illustrations were used in advertisements for soap. The illustrations for her book are of lovely street children at play. One picture shows a poor boy giving a rich boy his hoop and stick for the game of hoop rolling (figure I.1). The rich boy is shown, uncharacteristically, holding out his hand as if begging.

One's initial reaction to her book is to think that Tennant is romanticizing the gritty world she simply does not want to see. Obviously, soap manufacturers liked the idea that dirty children could be cleaned up through art. Many critics prefer, if you like, the grim realities of Jacob Riis's photographs of the Lower East Side in New York City, which seem to stare poverty in its cruel and dirty face (figure I.2).

But let's consider what Tennant has to say: "Most of the pictures I had seen of ragged life appeared to me false and made up. They were all so deplorably piteous—pale, whining children with sunken eyes, holding up bunches of violets to heedless passers-by; dying match-girls, sorrowful watercress girls, emaciated mothers clasping weeping babies. How was it, I asked myself, that the other side is so seldom represented?"[28] We would be well within our rights to consider Tennant an abysmally deluded upper-class optimist who refused to consider the legitimate plight of the poor. Yet as she points out, she was born in London and was "fond of walking through its streets, parks, and squares."[29] She knows these locations and wonders, Where are "the merry, reckless, happy-go-lucky urchin; the tom-boy girl; the plump, untidy mother dancing and tossing her ragged baby [and] who had given this side of London life"?[30] Again, we might protest that she is longing for a romantic London that doesn't exist and in so doing is covering over the hidden and not-so-hidden injuries of class exploitation.

We might also say that she is not the only one who is covering up but also the writers, photographers, painters, and poets who deliberately choose the gritty side because it makes more sense to them and their vision—because these fit into the genre that they and their readers already know. When we add to this the detail that Jacob Riis's harder-seeming

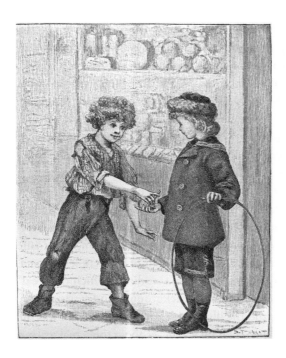

I.1
Untitled photo. Dorothy
Tennant [Mrs. H. M. Stanley]. *London Street Arabs*
(London: Cassell, 1890).

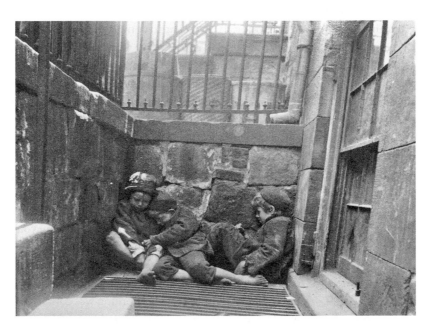

I.2 Photograph. *Street Arabs in Sleeping Quarters* [areaway, Mulberry Street]. Jacob
Riis, *How the Other Half Lives*. New York: Scribner's, 1890.

photographs were not impromptu street photography at all but were often prearranged tableaux staged for effect, we see that the illusion of presenting the gritty reality can often be just that.[31] Riis himself detailed his agenda, which was "showing . . . misery and vice."[32] He "knowingly manipulated his photographic images by exaggerating the effects of the flash, arranging the dirt and chaos of the domestic interiors, and using 'jagged-edge' framing to convey a sense of reporting."[33] Riis's own newspaper writing shows us that he was staging an event. Take, for example, the following description in one of his articles: "We stand upon the domain of the tenement. . . . Suppose we look into one. . . . Be a little careful, please! The hall is dark and you might stumble over the children pitching pennies there. . . . You can feel your way, if you cannot see it."[34] The illustrations for Henry Mayhew's *London Labour and the London Poor* were touted as being true to life because they were drawn from actual photographs of the people involved. However, those photographs were taken in a studio to which the "real" poor people were transported. Then the backgrounds and settings were invented by the artists who did the illustrations.[35] Realism, which was the larger genre of this kind of representation was never about the actual real but rather about the effect of the real. Realism is a technique that allows pigment (or words) to create the illusion of a three-dimensional world. Realism, according to its founding ideology, was meant to convey the sensorium of the seamy side of life. But accuracy and authenticity were never its aims.

As we think about Tennant's sunny view of the beauty of street children, we might consider the words of Norman Douglass, who grew up in the slums of London at the beginning of the twentieth century. While the poornographers often focus on the negative aspects of filth in slum streets, Douglass recalls one of his favorite childhood pleasures—mud. That mud is what many nineteenth-century writers never fail to mention when they talk about the degraded living conditions of the poor. But Douglass puts the muck in a more positive light. "Of mud you make pies, and bridges, and sticking brick (against a wall), and mud-carts (played with a tin can) and wells, and tunnels, and flowerpots, and castles—in fact Anything you please. There's nothing like mud, when all is said and done, and it's a perfect shame there isn't more mud about, nowadays; or sand, at least. You should see them go for it, when the streets are up."[36] These are the ludic pleasures of mud, which we might want to recall in London was composed of a mixture of what was found on the streets—horse manure and urine, gravel, coal, earth, and other organic materials. This filth might have been execrated by upper-class writers, but here it turns out to be a fundamental

building block of childhood fantasies. Douglass gives us the perfect taking-off point for seeing poverty writing as a genre very distantly related to the constitutive and lived experience of poor people.

Or we could look at Michael Gold's paean to a dirt lot on the Lower East Side of New York: "Shabby old ground, ripped like a battlefield by workers' picks and shovels, little garbage dump lying forgotten in the midst of tall tenements, O home of all the twisted junk, rusty baby carriages, lumber, bottles, boxes, moldy pants and dead cats of the neighborhood—everyone spat and held the nostrils when passing you. But in my mind you still blaze in a halo of childish romance. No place will ever seem as wonderful again."[37] That Gold, author of *Jews without Money*, should remember this abandoned lot with dead cats and moldy pants in terms reminiscent of Marcel Proust's madeleine or Walt Whitman's catalogs is telling. From within a certain sensibility the foul can seem fabulous, and yet the same sight would turn the stomach of a middle-class writer. Context is all.

Or we should pay attention to Gold's assessment of his Jewish immigrant mother: "How can I ever forget this dark little woman with bright eyes, who hobbled about all day in bare feet, cursing in Elizabethan Yiddish, using the forbidden words 'ladies' do not use, smacking us, beating us, fighting with her neighbors, helping her neighbors, busy from morn to midnight in the tenement struggle for life."[38] These are not the qualities one would expect a middle-class writer to praise in a maternal figure. An entirely different aesthetic is available to Gold than to Jane Austen or Virginia Woolf. Likewise, Justin Torres described his main character's working-class mother as "this confused goose of a woman, this stumbler, this gusher, with her backaches and headaches and her tired, tired ways, this uprooted Brooklyn creature, this tough talker, always with tears when she told us she loved us, her mixed up love, her needy love, her warmth."[39]

Another viewpoint is that of Agnes Smedley, who grew up poor in rural Missouri. Unlike the middle-class writer, she takes great pleasure in what others might see as the defects of her ramshackle home. "You could stand in the room and look straight up to the roof where there were holes that let the sky in. That I liked. Outside the house the earth was packed hard, as if baked, and no grass, trees or flowers grew there. That also I liked, for it was different."[40] A protective roof, clean plaster walls, a lawn, and decorative flowers would have been noted by middle-class writers as necessities that were painfully absent, but to the eyes of the small child, these are exciting details in an otherwise unremarkable environment.

Richard Wright in his memoir *Black Boy* has a similar joy in remembering a sewage ditch that ran in front of his grandmother's Natchez, Mississippi, home. "The greatest fun came from wading in the sewage ditch where we found old bottles, tin cans that held tiny crawfish, rusty spoons, bits of metal, old toothbrushes, dead cats and dogs, and occasional pennies." As also described by other writers, the effluvia of a wealthier society drift down into the lives of children who relish the panoply of detritus and use bricoleur skills to re-create them into playthings. "We made wooden boats out of cigar boxes, devised wooden paddles to which we twisted pieces of rubber and sent the cigar-box boats sailing down the ditch under their own power."[41] Saidiya Hartman cautions us to remember the "terrible beauty" of the African American slum. "The outsiders and uplifters fail to capture it, to get it right. All they see is a typical Negro alley. . . . They fail to discern the beauty and they see only the disorder, missing all the ways black folks create life and make bare need into an arena of elaboration."[42]

And when Israel Zangwill wrote one of the few books about Jews in London's East End (which was approximately 50 percent Jewish at the end of the nineteenth century), he noted, "This London Ghetto of ours is a region where, amid uncleanness and squalor, the rose of romance blows yet a little longer in the raw air of English reality; a world which hides beneath its stony and unlovely surface an inner world of dreams, fantastic and poetic as the mirage of the Orient."[43]

Add to the litany of praise for one's impoverished childhood poorscape Piri Thomas's description of the pleasures of Spanish Harlem gutters where he played with marbles: "We stretched to the limit skinny fingers with dirty gutter water caked between them, completely oblivious to the islands of dog filth, people filth, and street filth that lined the gutter."[44]

Even I could tell you about the abandoned lot across the street from my apartment house in the Bronx. It took up a quarter of the block and was a weedy, junk-strewn plot of land that rose up from the street like a sleeping giant. To us it was a mountain to sled down in the winter, and in the summer it was overgrown with plants we could not identify. We would dig in the soil to find ants and worms. The former I would collect and bring into my apartment, where I'd feed the Venus fly traps that I had gotten from a mail-order catalog. Often people in the neighborhood would dump their old linoleum flooring and other detritus there. We loved to make impromptu Frisbees from the broken linoleum and send them flying with the flick of a wrist. In the winter we would gather all the discarded Christmas trees and burn them in a triumphant bonfire. "The lot," as we

called it, served as many functions as there were children to imagine its uses. It never got old.

The true poornographer does not want to admit there are pleasures in the grittiness of poverty; rather, they need the ideological perspective of the middle-class readers to show either the degradation or the triumph of the human spirit. Poverty is purely a subject for reform, and therefore poor-nographers cannot report on ludic pleasures. For them and their readers, these pleasures, paradoxically, can only be obtained through reading about poverty. But if you have grown up poor, you know your life was not an unmitigated nightmare designed by a Marxist to illustrate the abuses of capitalism. Like any other subject position, it has its pleasures and pains. Often it is the sense memory, as with any other class existence, that remains for the writer. Peter Hitchcock notes that "sense perception [is] an aesthetic category of working-class representation."[45]

Another way of thinking about this litany of the pleasures of the poorscape is proposed to us by Veena Das, taking off from Elizabeth Povinelli who is interested in understanding suffering that is "ordinary, chronic and cruddy rather than catastrophic, crisis-laden and sublime." In paying attention to the mundane, Das wants us to "dwell" with these details. "I want my reader to enter that doorway [of the poor household] and not turn away after a first impression."[46] The problem with poornography, especially that written by those I am calling *exo-writers*, is that it proposes as a norm a quick look through the door, catastrophizes that vision, and then allows readers to turn the page and proceed. Exo-writers are writing about a world they live outside of, while *endo-writers* write from within. Exo-writers want us to observe and react; endo-writers want us to dwell.[47]

I am suggesting that instead of the poornographic view, which is exterior and draws preformed conclusions, we consider this idea of dwelling as a form of living with what Clifford Geertz has called "local knowledge." Geertz, as an anthropologist critiquing an earlier, more imperialistic view of the exo-ethnologist, suggests explaining social phenomena "by placing them in local frames of awareness . . . and then draw[ing] from those accounts . . . some conclusions about expression, power, identity, or justice."[48] The advantage of dwelling with local knowledges is that this action "welds the processes of self-knowledge, self-perception, self-understanding to those of other-knowledge, other-perception, other-understanding." Further, it sorts "out who we are and sort[s] out whom we are among. And as such it can free us from misleading representations of our own way of rendering matters."[49] While literature, art, and film are not exactly the same thing as a

study of culture and people, works about the poor have an anthropological aura about them as they introduce one group of people to another. And although we are talking about imaginative works rather than factual studies, the reality is that such works of the imagination are never passed off as simply dreams or reveries. When poor people appear in literary works, they very often are there to illustrate what poverty looks and feels like. So there is a validity to insisting that we dwell with mud, for example, or my garbage-strewn lot and accept it as something a local needs to explain to an exo-novelist rather than the other way around.

I initially decided in writing this book to focus on the East End of London around 1900. I did so because I wanted to better understand my father, who was born there in 1898, several years after the last Jack the Ripper murder. As I began to do my research, I found the usual descriptions of the desperation and degradation of the people living in the East End. Was that the abject world my father lived in? If so, was it strange that he had never described his life to me in those terms? He did say that they were very poor. He described the tiny flat he lived in and noted that he had to sleep on two chairs pushed together. He told me about how the children in his family didn't eat very well, and on Friday night, when his mother made the Sabbath meal, she gave them each a drop of schnapps from a thimble that she wore around her neck so they could keep this richer repast down in their starving stomachs. A poor person's aperitif or *digestivo*. He told me how they had to insert coins in a gas meter to make the gas flow so they could have light for a few minutes until the next coin was required. Yes, this isn't living comfortably, but the absence of self-pity or anger made me wonder how accurate the accounts of others were. And in the midst of all this, my father found the time and energy to be an artist when he was just a young teenager, using pen, ink, and watercolors to create a very different world.

It is so interesting to me that he chose to illustrate both the lives of ultrarich white people hunting (figure I.3) and the lives of poor, Black, enslaved people on the eve of emancipation (figure I.4). As a poor, Deaf kid, he must have recognized the vast gap between himself and these upper-class men, on the one hand, and possibly felt some imagined solidarity with the abused but hopeful enslaved people on the other. One can only imagine that a Victorian or Edwardian novelist would hesitate a long time before deciding to assign artistic status to a poor, Deaf Jewish child. More likely, the novelist would have had the disabled character draw meaningless circles, as Joseph Conrad did with Stevie in *The Secret Agent*.

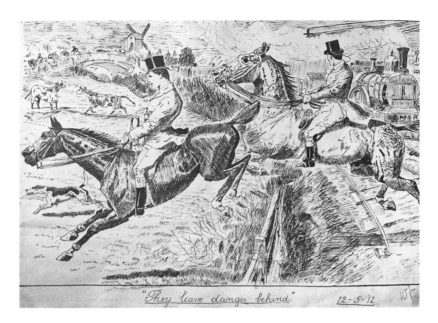

I.3 Morris Davis, *They Leave Danger Behind* (May 12, 1912). Pen and ink drawing from the author's family archive.

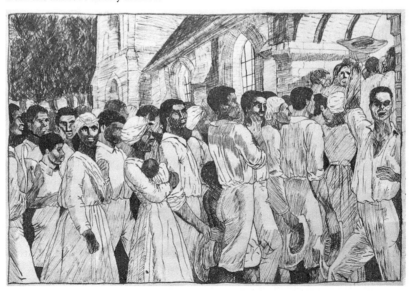

I.4 Pen and ink drawing *Slaves on the Eve of Freedom* (July, 14, 1912) by Morris Davis. Davis family archive.

Given that, as Pierre Bourdieu notes, the conditions of the poor and working class are such that they reproduce themselves, my parents were the successful reproduction of their parents' class as it echoed back down the ancestral line. My brother and I were the first in our family to leave our class, to nonreproduce, to be transclass.[50]

In trying to find out about the lives of the poor at the time, I immediately hit the archivist's problem that so many of the descriptions of the poor were written by the middle and upper classes. When one considers the works of novelists, clergymen, social reformers, police, early sociologists, and the like, what is apparent is the dearth of first-person accounts. Much harder to find were accounts by poor people of color, of non-Christian religions, and of various nondominant nationalities. In doing the research for this book, I have managed to find some first-person accounts that are not derived from criminal records or do-gooder interviewers—but these first-person works are few. I have come to think of this magic act of revealing the poor by hiding their real voices, artistic work, and narratives as what I call *representational inequality*. With economic inequality, the capital of society is concentrated in the hands of a few, and with representational inequality, the cultural capital required to become a writer whose work can use the technology of print and the distribution machinery of publishing to reach the consciousness of millions is limited to the economically privileged. The rank and file of poor people have been the victims, if you like, of this very representational inequality.[51]

............

Especially difficult to find were the voices of ordinary female sex workers; impossible to find were writings by sex workers of color, whose trade constituted a viable and varied portion of the lives of the poor. There is almost nothing published by a female sex worker about the trade until the 1960s. As one can imagine, inauthentic ventriloquizing of those voices was the work of middle- and upper-class white men. Likely this paradigm should be our model in talking about poornography. A class of poor people become interesting for a variety of reasons centered on the erotic or the disgusting and in a variety of times to novelists, artists, poets, librettists, filmmakers, and others involved in creating narratives and aesthetic objects. For hundreds of years the constitutive lives of female sex workers, then, were filtered through the eyes of the very people who either had caused women to be underpaid in the first place or actually paid them to have sex. As with so many other narrative creations, the bosses describe the workers,

the enslavers describe the enslaved, the men write the women, the nationals describe the immigrants, white people depict Black and brown people, the colonialist tells us about the indigenous, hetero writers describe LGBTQ+ people, or the victor triumphantly paints the portrait of the defeated.

And in the case of female sex workers, as with poor people in general, we see the kind of exploitative prurience I am describing that drives the creators and the consumers of the creation. *Pornography* derives etymologically from the Latin for "prostitute" combined with the word for "writing." Through writing and art, the prostitute was made into an aesthetic object on the one hand and a cautionary warning about female vulnerability, seductiveness, disease, and immorality on the other hand. The object of fascination is also the object reviled. This paradigm applies to the sex worker as well as the factory worker. Readers and writers are both inured to the oppressed beings in real life and at the same time curious about and even titillated by the representations of them in art and culture. Poornography is the guidebook for the faint of heart who want to know the territory but are afraid to ask the inhabitant.

This book takes a deeper dive into these issues. In chapter 1, I look at the complexities of writing about the poor in a world whose experts are largely not drawn from that group. In chapter 2, I examine the whole issue of representation as it applies to the poor. I argue that representational inequality is a manifestation of the unequal distribution of capital—cultural or otherwise. I also look into the historical circumstances surrounding the concept of representation in the eighteenth century with the rise of the novel and of representative democracy. I investigate how various authors' visions become popular and necessary and how these visions relate to the way they depict various experiences that readers have come to expect from genre writing. Authors become representors elected by readers to present visions of the poor that coincide with reader expectations, which were, of course, shaped by those authors and the developing genre requirements.

Chapter 3 explores the idea of being transclass, based on the theoretical work of Chantal Jaquet and Pierre Bourdieu. I contend that writers who come from poverty, those I am calling *endo-writers*, are essentially the only ones who have the platform and credentials to write about the poor. Such an assumption requires an understanding of what goes into the nature of being a transclass person who was born poor but moves (somewhat) out of the class into which they were born. In addition, the chapter examines the role of allies, many of whom fall into the category of undercover reporters like Nellie Bly, Jack London, Émile Zola, George Gissing, and George

Orwell, among others. Friedrich Engels lived with poor people in Manchester and had a lifelong relationship with a working-class woman and then with her sister. One of the questions posed is, Can a non-transclass ally bridge the gap between endo- and exo-writers? Another category of transclass writer comprises those who come from the middle class but lose their money and become poor. Foremost among these writers is George Gissing, whose novels deal with poverty—but with a waning transclass perspective of pessimism and revulsion.

Chapter 4 looks at the biocultural underpinnings of the way poor bodies are conceptualized, described, and inscribed into a narrative structure. Looking at the intersection of science, technology, medicine, and culture, I go through a series of false constructions of the poor body. Eugenics provided a playbook for assumptions about poor people and their inherited traits. In addition, the ascription of a tendency toward drunkenness was a part of the biocultural assumptions about the poor. Likewise, a biological prejudice against shortness, seen as an attribute of a degenerate and weakened inherited stock, is explored in the chapter. The constant refrain of filth and personal hygiene is one of the biggest myths projected onto the poor. I look at what living conditions were like and how public health standards were out of alignment with the way most people lived. Likewise, living with animals like pigs and chickens was seen as an aspect of filthy living, although such animals were common and even necessary for the life of the urban poor. Disease joins the assemblage of poor living, although the poor have no special claim to be ill, to be disease carriers, or the like. And of course crime, often seen as the purview of the poor, is no more likely to be a characteristic of poverty than it is a feature of middle-class life. The key in this, as in other areas, is the kind of crime and the mechanisms of incarceration and penalty. Likewise, the areas of disability, laziness, and sexuality are specially carved out as qualities of the poor body, when in fact they are well distributed over the various classes.

Chapter 5 deals with the complex problem of representing female sex workers. As one of the viable, and even preferable, ways of making a living for very poor women, sex work is also an area in which the protagonists rarely get to tell their story. The nineteenth century abounds with narratives about fallen women that moralize their fate but rarely pay attention to the economic conditions surrounding them. The sharp line between poor women in general and prostitutes in particular was largely illusionary. Rather, there was a shifting border between poor women who married for security, those who exchanged sex for security, those who ex-

changed money for goods and services, and those who exchanged sex for money. In eighteenth-century Philadelphia, sex commerce was "part of a continuum of illicit sex, and it was not always easy to distinguish which encounters crossed its fluid boundaries," notes Clare Lyons. She adds that "prostitution operated in many of the same social spaces as other forms of nonmarital sex."[52] Indeed, it is possible to argue that with the advent of factory work and wage labor, women who refused to do such work and saw prostitution as a better alternative were in fact taking a stand against the system. The chapter contrasts the novelistic accounts almost universally written by men with a narrative *Madeleine*, by an anonymous writer in 1919 who wrote what is probably the first modern novel/memoir by a female sex worker.

Chapter 6 examines the moment of encounter between the middle-class observer and the poor subject. This meeting carries a lot of social and cultural baggage, but often it is portrayed as a simple brush between two equals. That chapter focuses on the iconic photograph *Migrant Mother*, by Dorothea Lange. The dynamics in the relationship between the poor woman and the female photographer are examined as exemplary of the uneven encounter between exo-observer and endo-subject. But in addition to the moment of encounter, the chapter considers how the object can talk back. As it turns out, the woman photographed had an opportunity to respond later in life. In addition, the poet Maggie Anderson responds to Walker Evans's photographs of her Appalachian hometown. The power dynamic can transform when the object talks back. And this is true for the encounter between James Agee and the white southern sharecroppers he wrote about in *Let Us Now Praise Famous Men*.[53]

The final chapter asks whether it is possible to write about the poor and which strategies have worked. In it I bring forth what I call a "manifesto" that advocates some directions such writing might take and provokes some further discussion on the possibility and impossibility of this task.

Why Me?

I should account for myself and why I am writing this work. To do so involves a bit of personal biography. I was born in the Bronx in 1949 to two Deaf, Jewish immigrant parents who were among the working poor. My father, Morris, was a sewing-machine operator in the sweatshops that made up the garment district. His seasonal work left him unemployed for at least a quarter to a third of the year. My mother, Eva, did alterations on women's clothing at our apartment and later at Franklin Simon, a large department store in Midtown Manhattan. My brother, mother, father, and I lived in a one-bedroom apartment in a five-story walk-up in the Morrisania section of the borough. I went to the New York City public schools, including an all-boys high school with six thousand students. There were many organic intellectuals in my high school, some of whom might become transclass, and many more students destined to become part of the working class. Some distinguished alumni were James Baldwin, Romare Bearden, Charles Rangel, and more recently the rapper A Boogie wit da Hoodie.

My upbringing was abstemious and working class. We had no car, air-conditioner, or record player . . . I could go on but don't want to sound like Charles Dickens's famous humble braggart Josiah Bounderby.[1] Every necessary clothing item bought was accompanied with the phrase "Wear it in good health" or "Your father worked hard for the money to buy this."

When I lucked out and got into Columbia College in New York, I experienced a barrage of class-related insults. I was clearly not part of the prep-school crowd who wore blazers, rep-striped ties, and penny loafers. I didn't know enough to know about social class, but I soon learned through experiencing discrimination and reading Karl Marx. The latter was a revelation. I had never thought about social class because I grew up in a world where everyone was working class. As someone once concluded, whoever discovered water, it wasn't a fish. Yet the roots of poverty pull hard on your

identity, no matter how hard you try to deracinate yourself. In my junior year I went on scholarship to a summer study program at Trinity College in Oxford. The summer school was run by some enterprising professor at the University of Massachusetts who clearly wanted a way to get a free trip to England and an excuse to pub-crawl with students. At Oxford I could see more clearly the class issues—including the fact that each stairwell in the dormitory had a "scout" who could polish my shoes and procure women should I want that. And there was my maid, who would come into my rooms—yes, there were two—to draw the curtains and tidy up. But I also crashed against social class in a more personal way—I fell in love with a fellow student who was definitely from the upper classes. Despite my desperate attempts to woo her, we remained friends, much against my wishes, even during a weekend trip through Wales where we shared bed and bedroom. When we returned to the United States, I visited her at her parents' home in Massachusetts. Her father was the headmaster of a prestigious prep school. Her mother tended the gardens and fed the birds. She knew all the birds' Latin names, while I basically knew only two urban fowl—sparrows and pigeons. I was politely welcomed into the house—but never would be of it. Throughout all this, I really didn't have a class analysis and came away feeling somehow like a patronized pariah. And as someone who grew up in an Orthodox Jewish household, I felt the first stings of Christian privilege. To this family, I'd always be the Jew from New York who was nice enough but not really one of them.

University provided a way for me to become transclass, although, as that nomenclature suggests, one never really leaves one's class. I could provide endless stories of my misfit into a class to which I didn't belong. I'll choose just a few. When I was in graduate school, a fellow classmate who knew I was a budding foodie invited me to a special occasion—the Four Seasons, one of the top New York restaurants, had flown in a French chef to cook a special meal. This student had been able to secure reservations for four people, and she asked if I would like to come. It was an embarrassing moment, because I had never eaten in an upscale restaurant before and certainly wouldn't have the very large sum of money that would be needed. I had to confess that I couldn't afford to go. She very nicely told me not to worry and that she would pay for me. That in itself was embarrassing, but I felt pressured and agreed. When the time came, I arrived at the grand-looking space with its glass-enclosed dining area wrapped around a decorative pool of water. There were so many silverware utensils, I had no idea

which to use. I was, it seemed, the "date" of the woman who had invited me, and the other couple seemed well heeled and comfortable in the environment that, although lovely, made me want to run away. The meal included turbot flown in from France and some venison. When it came time to pay, my hostess simply said we should divide up the cost of the meal. This was in the days before credit cards were widely available. I had to stammer to her, in front of the others, Hadn't she said that she would pay for me? She looked annoyed and paid the bill. That was our last encounter. As I write this, the pain of the encounter still stings. I was the poor kid from the Bronx who was humiliated before all and sundry, including the waiter, who acted like a dandy but was probably from Queens. While not a career-rending moment, it somehow remains iconic for me as a lesson about being invited into but not being of the ruling class. Tellingly, I married a woman who was from the working classes.

More telling was my very long journey to tenure. I was an assistant professor for twenty years—which probably sets a record at that time in academia for injustice, pathos, and some kind of foolhardy and dogged determination. My first job was at Trinity College in Hartford, Connecticut, as a one-year visiting assistant professor. Trinity, at the time at least, was a home for prep-school kids who didn't get into the Ivy League. My colleagues were all from Harvard, Yale, Princeton, and Dartmouth; from the very beginning, I felt out of place. The students treated professors like hired tutors or governesses. I couldn't understand why I kept being invited to have lunch at fraternities. I didn't want to go for many reasons, but I was counseled to do so. Lunch was served to all-white boys by a Black woman who was insulted both behind her back and to her face. My host, somewhat embarrassed, leaned over to me and whispered by way of explanation, "Sorry, we're racist here." That explanation was provided with a shrug to expiate the offense—after all, white fraternity boys will be good old boys. I never went back. My colleagues kept saying how much I reminded them of the previous assistant professor I was replacing. I later learned that he was Jewish and from New York—so much resemblance there! Christian privilege again. One day when I was eating in the faculty club, which had communal tables, I happened to sit next to a person who turned out to be the president of the college. He asked me what my position was, and I replied that I was a visiting assistant professor. He followed up with a query: "Where was I visiting from?" Without missing a beat, and with absolutely a tin ear for the kind of niceties expected of me, I said, "From

the unemployment office." Bronx wisecracks didn't work particularly well in this venue. I wasn't fired, but I left the following year to take a job at Columbia University.

At Columbia, I was back in the contradictions I had found as a student—being in but not of the place. My academic story there and beyond is elucidated in the chapter on being transclass, but a brief summary is that I was denied tenure both at Columbia and then again at Brandeis. By Brandeis I had two books under my belt. Was my lack of tenure due to my own lack of mentored and natural skills? Was it my working-class background coming back to hurt me? It is a fact that working-class scholars have a harder time getting tenure-track positions and tenure than those from the middle and upper classes.[2]

Because many people only know me from my academic writing, there might be some surprise at or even suspicion of my talking about being working class. I don't generally present as someone who is of that class. My current position of distinguished professor at a Research 1 institution might belie or put into doubt any claim of that sort. I discuss this ambivalence further in the chapter on transclass, but I will say here that not a day goes by in which some aspect of my upbringing fails to either confront me or teach me something new. You don't leave roots behind; they trail you and anchor you to another reality.

Chapter One
How to Read This Book and How the Lives of Poor People Have Been Read, or, Why You?

In academic works, it is not usual to address the reader directly. Less important is the reader's reaction to the book, and more important is the subject of the book and how well it is presented. But in this case, since I'm arguing for authorship that subverts representational inequality, I am, to some degree, implicating or hailing my reader—perhaps both. The point is that it matters what social class you come from because your reaction to issues around poverty and poor people is highly conditioned by a number of factors. So, in effect, you are not a value-free reader but one who is steeped in a complex mix of attitudes toward poverty determined by your upbringing, current economic condition, relationship to money, capital, cultural capital, and the like.

Chances are that if you are reading this book, since it is published by a university press, you are probably an academic of some type—a student, a lecturer or adjunct, or a professor. As such, although you may not like to think about this, you are part of a cultural gatekeeping process. In this chapter I argue that since academics largely come from the middle and upper classes, they are structurally placed to not be particularly concerned about the poor. While they may be concerned about class and structural inequality, poor people tend to drop out of the equation. And since it is very difficult for poor people to get into academia and to succeed there, and even more difficult for them to get a job as a tenured professor, there is and has been a serious ambivalence in the academic professional managerial class concerning poverty.[1]

I'd like to describe this ambivalent emotional relationship to poverty as a kind of guilty involvement in the lives of the poor through moral and ethical concerns focusing on two antithetical positions. One is the stoic position, in which poverty is a given: there will always be poor people, and they are poor because of bad choices or laziness. The other is the compassionate position, in which poor people are good, industrious people but circumstances beyond their control have put them into a situation of extremity.

In either position, middle- and upper-class people can remove themselves from the equation. Deborah Nord has called this removal a form of quarantine by which writers depict the poor in a way that creates a separation between the reader and the poor person being described.[2] The notion of quarantine is all the more telling because the poor were often seen as the locus of disease transmission, and in pandemics they are reckoned as one of the most vulnerable groups. The stoic position allows for employers to hire the poor at low wages because they are giving an opportunity to those deserving poor who aren't overly lazy or injudicious. The compassionate position argues for social remedies that are beyond the reach of ordinary citizens to accomplish on their own. It also supports individual acts of charity on a limited basis, such as carrying a few dollars around to give to homeless people or subscribing to a select set of charities that support the poor. In all cases, the poor can be disposed of without too much extra thought or guilt. One of my goals in writing this book is to make readers feel uncomfortable with these choices and thus uncomfortable with the genre writing or filmmaking that in the end allows this double distancing. I would like to do what James Baldwin advised artists to do: "The artist cannot and must not take anything for granted but must drive to the heart of every answer and expose the question the answer hides."[3] While I might not be able to answer the problem of poverty, I would like to expose the complex questions that pat answers inscribed into novels and films hide.

To understand the strategy behind poornography, we might look to neurobiology. Susan Fiske has done work that shows that "social cognition," the concept of caring about the inner life of others, is vastly reduced in dealing with populations like the poor and homeless. We do not feel a connection to such people; instead, parts of the brain come into play, including the insula, that are linked to disgust over excrement and garbage, hence terms like *white trash*, *human garbage*, or *lumpenproletariat* (the last translates as pretty much the same as the others).[4] Another study notes that such mental activity in reaction to class happens within seconds.

Indeed, "social class is rapidly and accurately perceived in the early stages of social perception."[5] As such, this kind of class subconsciousness immediately creates the stoic distancing I am suggesting. This neurological activity then encourages "the sorting of individuals into social class groups, activating social class stereotypes, and enhancing conflict between the haves and have nots in society."[6] The groups typically triggering such neurological reactions, according to another study, are the poor (particularly images of the homeless), elderly, disabled, and Jews, among others.[7]

Amy Cuddy, in her work, proposes that there are two pairs of cognitive and affective evaluations that intermingle—cold or warm, competent or incompetent. Elderly people are seen as warm and incompetent, which elicits pity, sympathy, and condescension. The poor are seen as cold and incompetent, which elicits a shunning mechanism in the brain. Cold and incompetent maps nicely onto the "bad choices" and "laziness" model, while the "cold" label maps nicely onto the brutality, violence, addictive behavior, and lack of feeling stereotypically attributed to the poor.

We do not need the brain science (and there are major limitations to this kind of research) to arrive at the conclusion that middle-class people have shunned the poor while at the same time remaining fascinated with the simulations of poverty that are dispersed throughout the cultural sensorium.[8] And on the downside, neuroscience can feed directly into the bad choices/laziness paradigm.[9] But it is helpful to know that what we are talking about generally has been studied in detail in neurological research, and the findings are not vastly different from the general assumptions.

A complex process is involved in the way we think for ourselves about poverty. Cultural and national factors come into play. Americans tend to see the world as just, and so for them poverty is found among people who deserve to be poor.[10] Politics come into play when people estimate how difficult it is to escape from poverty. Liberals think it is very difficult, while conservatives feel it is easier to get out of poverty.[11]

Even progressive and enlightened people might routinely think that poor people tend to be drug or alcohol dependent, jobless, violent, criminal, single parents, and often people of color. But when we compare the United States to a country like Japan, which is very low on drug dependence, violence, and crime and is a very family-oriented country, we may be surprised to find that Japan has almost as much poverty as does the United States.[12] If we can remove the moral and judgmental element of the way we represent poverty, we may get a better sense of poverty in a step toward social and economic justice.

This book is part of my ongoing project to see how different others have been described and controlled by a general public through a biocultural system of oppression. I use the term *biocultural* to indicate how the interaction among science, medicine, technology, and culture works seamlessly to create various realities.[13] My work on disability has, one hopes, served this function, and my book on OCD aims to show how people with affective disorders have been treated over time under various care regimes.[14] Throughout this book I assess the weight of the biocultural as it affects poverty. One might object that being disabled is very different from being poor. One is an identity, and the other is the product of a social and economic system that needs an underclass to keep workers' wages low. Yet one of the insights of disability studies is that what seem like individual impairments are actually part of a larger social and economic process of disabling a variety of oppressed groups. Social justice works best when it sees those disabling actions as linked. In turn, we might ask, Why do some Marxists want to keep identity out of a structural analysis? And here I am asserting that the identity of poverty is not one that should simply be elided in favor of thinking of a future world in which the poor do not exist. As Peter Hitchcock puts this erasure, there is a problem in "the assumption that working-class communities only exist as that from which one must escape."[15]

But what brought me to this work was a specific incident and a larger observation. The specific incident happened while I was presenting a paper at the Society for Disability Studies. This was a somewhat academic and even philosophical presentation to a large audience at the conference. During the question-and-answer session at the end of the formal presentation, a woman complained loudly and with a peppering of obscenities that she had come to this conference at great personal expense since she was disabled and living on the meager allowance provided by Social Security Disability Insurance. She said that she didn't understand a word I was saying, that she was disgusted by the topic of my talk, and that it didn't help her one bit in negotiating the world her poverty presented. The audience, mainly academics, was very uncomfortable, but I found myself saying that I completely understood what she was saying, and agreeing that she was right. Most of us in disability studies had been ignoring the economic realities of people with disabilities, many of whom are unemployed and living in poverty.

I thought a lot about the incident and decided that I should work on poverty (and disability). I, of all people, had come from a poor background but had largely ignored the subject of poverty. I wasn't alone, as many of

my colleagues had as well. I began to realize that very few of them had come from the lower classes.[16] Although they intoned the "race, class, gender, sexuality, and disability" mantra, some might have given more weight to the identity group and less to class. And those who paid attention to class often downplayed poor people. Given the neurobiology I have briefly rehearsed here, it is no wonder. Middle-class people are programmed to move away from the poor—and the subject of poverty relates to that point.

At this point I would like to bring in the idea of the *implicated subject*. Michael Rothberg coined the term to describe the way we are implicated in various forms of social injustice without actually having done anything. The category of the implicated subject "can help us conceptualize and confront both the legacies of violent histories and the sociopolitical dynamics that create suffering and inequality in the present."[17] Linking this to other related ideas, like Lauren Berlant's "the ordinary of violence" and Rob Nixon's "slow violence," we can get a picture of a structural injustice in which we are implicated that does violence directly or indirectly to our fellow citizens, and those of other countries, but from which we can easily remove ourselves.[18]

In the United States, the vast majority of academics are from the middle and upper classes. There are surprisingly few to no data on the class background of professors because hiring committees and universities in general collect information relating to certain kinds of diversity but never socioeconomic class.[19] There is plenty of research to show that class background dramatically affects student admission and performance at university. Intelligence plays far less of a role in success than class.[20] In the United States, poorer students have great difficulty getting into elite institutions and are routinely tracked to community colleges. At Harvard University, for example, students from the most affluent 10 percent of the population outnumber those from the bottom 90 percent. Indeed, by income, about 50 percent of Harvard students come from the top 1 percent. Elite schools in general enroll more students from the 1 percent than from the bottom 50 percent.[21] Another way of putting this is that at selective institutions there are twenty-four high-income students for each low-income student.[22] Yet another way of saying this is that students from the top 1 percent are 77 percent more likely to attend an Ivy League school than those from families making $30,000 or less a year.[23] As a rule, upper-middle-class whites were three times more likely than low-income whites to be admitted to selective private colleges.[24] And in 2012, while 82 percent of eighteen-to-twenty-four-year-olds from the top economic quartile attended college,

only 45 percent from the lowest quartile did.[25] Of these, only 9 percent received college degrees, compared to 77 percent from the upper quartile.[26] Pell Grant recipients, who come from the poorest families, were most likely to attend two-year colleges.[27] Further, across the United States, universities are dramatically decreasing the number of Pell Grant recipients who are admitted rather than increasing them, according to a September 8, 2023, *New York Times* article by David Leonhardt. In short, economic diversity is not a priority for US universities, won't be, and probably never was.

Of course, race intersects with these statistics on poverty, and although there is some small percentage of African Americans and Latinx students at elite US colleges and universities, they are more underrepresented, despite affirmative action, than they were thirty-five years ago.[28] Yet it seems to still be true that when people of color attend the top twenty-eight elite colleges and universities, the majority come from middle- and upper-class families.[29] Over 50 percent of lower-income Black undergraduates and one-third of Latinx students who attend elite colleges come from elite private high schools.[30] A much smaller group come from public high schools.[31]

Further, although state universities may be more inclusive of poor students and students of color, they are hierarchized so that what Laura Hamilton and Kelly Nielsen call "the new university" operates on a segregated basis. Flagship schools and Research 1 institutions now routinely tout diversity and even sell their credentials as such to private-sector patrons and donors while maintaining a two-tier system for wealthier white students and poorer students of color.[32] While administrators, professors, and students at such universities may look approvingly on the success of diversity on their campus, they may well remain unaware of the racial and economic disparity the system creates.

Once admitted, poorer students do worse, have more attendance problems, and tend not to complete their degrees. In universities, poor students can easily become unhoused, especially if they are in nonelite colleges. According to experts, "about 10 to 15 percent of college students experience homelessness with an additional 20 to 30 percent having experienced housing insecurity while attending college."[33] Upward of 50 percent of college students experience food insecurity.[34] For example, at the City University of New York, 40 percent of students live with low or very low food security, according to James Barron in an August 14, 2023, *New York Times* article.[35]

It is therefore not a leap to suggest that poorer students are far less likely to become professors and that if they do become academics, their own careers may be deeply affected.[36] Most academics, at least in the United

States, do not come from poor backgrounds, and this is particularly true for the humanities.[37] Further, faculty hiring and promotion reproduces this two-tier system. As Lynn Arner writes about who gets teaching jobs and where, "Faculty offspring do the best of all: they are the most likely to be found in the most honored institutions. Trailing them are the middle-class progeny of big business and professional families. Conversely, academics from the working classes and from farm backgrounds are most commonly relegated to the lower-status colleges. Not surprisingly, the more years of schooling that faculty members' parents possess, the higher the status of the institutions where their offspring teach."[38] The two-tier system is ramped up when it comes to universities around the world, with poorer, less metropolitan universities falling into a second-, third-, or even fourth-class position.[39]

One study shows that poorer students tend to major in preprofessional programs while elite students major in the liberal arts. The result is that "nearly eight times as many liberal arts graduates enroll in PhD programs as do preprofessional graduates."[40]

Overall, the elite schools overwhelmingly produce the faculty that teach in the top universities. In fact, in the study of English literature, the same top schools place their PhDs in the vast majority of other schools—both elite and lower ranked.[41] In other words, class reproduces itself in academia as well as other strata of society. English professors at elite institutions, for example, are drawn from the same top ten or top twenty institutions and proliferate throughout the university system.[42] As Arner writes, "The implications of such tracking for first-generation university students who earn PhDs in English are profound: they are disproportionately disregarded for tenure-track jobs that include teaching in doctoral programs and are much more likely than their middle-class counterparts to be passed over in favor of better-heeled US academicians with prestigious pedigrees. Simultaneously, largely—although not entirely—because of their disproportionately poor institutional pedigree, first-generation university students are less likely than their competitors whose parents possess university degrees to secure tenure-track posts in any type of university English department."[43] In other words, for a poor graduate student to get a job at a major university, or any university or college, and then get tenure is as difficult as the proverbial camel going through the eye of the needle. These statistics seem to hold up globally as well.[44]

Given numbers like these, the emphasis on race, gender, sexuality, and postcoloniality, particularly in the humanities, makes complete sense in

light of the backgrounds of those who write about and teach such topics.[45] As Anthony Abraham Jack notes, "All too often, university communities do not have as robust conversations about social class as they do about gender and race."[46] Few colleges or universities think of class background as an element of diversity in hiring, promotion, and tenure despite ample research on the effectiveness of such considerations.[47] Therefore, a focus on the lived experience of the poor might seem less interesting to the largely elite class of professors.

What I am discussing as lack of care toward poor people is not about academics being ignorant about the bad effects of poverty. Rather, I am talking more about unconscious attitudes or lack of attention to many issues of accommodation that neuroscience and sociology have pointed to with great emphasis. It is well known that conscious prejudice or explicit bias is easier to ameliorate than unconscious prejudice or implicit bias.[48] The desire to write about one's own identity issues and to avoid or distance oneself from topics like poverty has no doubt been built into the academic agenda of teaching, research, and writing. Virginia Walcott Beauchamp, one of the first women to engage in the study of women's history and literature, who died at ninety-eight in 2019, noted many years ago that "the entire academic establishment is run by men, and they are interested in their experience. In their minds, the stories and lives of women are peripheral. That's why you've never heard of half of the books I teach."[49] It seems clear now that women's literature wasn't properly represented because women were not involved in researching and teaching about those works. That situation has changed dramatically for women and people of color (of course much more needs to be done) but less so for the poor. Universities themselves are stratified according to socioeconomic status, which in turn is produced by and produces racialized and class-based stratifications.

We might also add that middle-class academics at both elite and non-elite institutions are legacy beneficiaries of an unjust distribution of wealth and cultural capital. Michael Rothberg points to the power of inherited trauma using Marianne Hirsch's concept of "postmemory" while linking this to the "beneficiary" who "profits from the historical suffering of others as well as from contemporary inequality in the age of global, neoliberal capitalism."[50] In this sense, the middle-class academic is in the position of being an implicated subject while often being unaware of such. It has been much easier to understand that idea of privilege with race and gender than with issues around social class and poverty.

If many academics in the United States and globally come from the middle and upper classes and therefore don't have an accurate perception of poverty and their own privilege in this history of exploitation, it might also be the case that the motivation for downplaying the poor or, just as bad, focusing on poornography is that the ideology of the United States in general serves to deny class and avoid literary works that remind us of a class system. As Kevin Binfield and William Christmas note, "A dynamic inherent in higher education since the Second World War tends to exclude or marginalize laboring-class literature . . . [because] education is largely viewed as a way for students to transcend the limitations of class." Thus, students as well "view laboring-class literature as something of lower value—something to be left behind."[51] If middle-class professors and working-class students devalue focusing on poverty, there isn't much hope that others will find value in it.

Another aspect to this elitist discrimination against the poor has to do with the viewpoint held by those who are educated toward those who are less educated. Academics, by definition, have achieved the highest level of education. As such, they might value their own achievements and could have, at least in the past, tended to condescend to those with less education, who in most cases are the poor. Toon Kuppens and others have shown that "higher educated participants show education-based intergroup bias: They hold more negative attitudes towards less educated people than towards highly educated people." This may stem from a self-justifying position that academics hold: "The self-reported tolerance of the higher educated may reflect sophisticated ideological discourses that ultimately mask the self-interest of the higher educated."[52] As academics, we need to recognize that while we may fight against various oppressions, we are, nevertheless, part of the system that creates these inequalities. As Raewyn Connell reminds us, "We may not intend injustice, but the university collectively produces it, and we have to take our share of responsibility."[53]

Obviously, poverty intersects with race, gender, disability, old age, and deprivation—from the abject poor to the poor, the near poor, the precariat, the working class, and the lower middle class—all of whom may be either in poverty or a few paychecks away from homelessness and indigence.

Indeed, the connection among race, gender, and class is well documented. When we look at the statistic that the median wealth for Black households in the United States is $16,000 as compared to $163,000 for white ones, this connection is clear.[54] Black children are 7.6 times (and

Latinx children 5.3 times) more likely to live in very low-opportunity neighborhoods than white children.[55] And in the Mississippi, for example, African Americans have a poverty rate near 30 percent, which is almost triple the poverty rate of non-Hispanic whites.[56] Black families are more likely to have multigenerational poverty than whites. In fact, one study concludes, "Three generations of poverty is almost uniquely a Black experience."[57]

As populations age, particularly in the United States, they can easily fall into poverty. Gender intrudes because older women are more susceptible to poverty than older men. The staggering statistic is that the majority of elders in the United States cannot afford to meet their basic needs.[58] Close to 23 percent of citizens over sixty-five are living at or below the poverty line.[59]

From the perspective of this book, identity politics may have reflexively acknowledged class but sometimes directed its focus away from many of the issues I raise. Without the knowledge base that comes from either experiencing poverty personally or reading the works of writers who are or were poor, there can be only a very pro forma consideration of the form and content of such representations. Notable exceptions are books like Matt Brim's *Poor Queer Studies: Confronting Elitism in the University* and the *Routledge International Handbook of Working-Class Studies*.[60]

A further word on class. My contention is that a focus on class as an abstraction can erase attention to poverty as a reality. This might seem like a contradiction, so let me explain. Class is a structural concept, and the vast majority of my colleagues who talk about class do so from this structural perspective. They like statistics and dialectics. For them, class differences simply shouldn't exist. They imagine and strive for a future in which there is no poverty or major class distinctions. Therefore, they don't want or need to talk about the experience of being poor because poverty is an unwanted by-product of an unjust and unequal economic system. But as Julie Lindquist notes, class is "a complex affective experience" rather than exclusively "a set of social issues to be addressed through systematic analysis."[61] Many nonpoor and non-transclass people are content to understand class from this abstract economic perspective: there is a gap between the rich and the poor. The gap is too large, and therefore the rich should be a little less rich, and the poor should be a little less poor. These are not bad goals, but in sum they have the intended or unintended effect of erasing the actual poor by seeing poverty as a mistake of a larger system. Ironically, this view from the left is not entirely different from the capitalist perspective that the poor are those who failed to make it in the economic struggle for survival. For the leftist middle-class academic discussing poverty, being

poor is a mistake also—but this time it is the structurally inherent error of society at large in not providing a good-enough safety net. In the case from either the left or the right, the poor are a mistake and shouldn't exist. That doesn't leave much room for actual consideration of poor people. Hence, my point: if you talk about class in the abstract, then you don't have to discuss the poor in particular.

The other area in which a focus on class reifies the poor is the sense it gives of the fixity of class hierarchies. It is useful to a structural or schematic view of economic exploitation to see a ruling class, a middle class, a working class, and then an underclass. With those four characters, the passion play of good, bad, and in-between can be acted out with a predictable set of outcomes. But in reality, as with most rigid boundaries, the truth is harder to visualize and more about shifting borders.

Poverty is a seemingly easy subject for most people who discuss class. We don't need to know much about the poor, and we believe we know all that there is to know. Knowing about the poor doesn't seem to do much in terms of ameliorating society at large. Joan Scott wrote about how male academics initially responded to her work on women in French history; they said, "My understanding of the French Revolution is not changed by knowing that women participated in it." Scott had to respond that gender is "a constitutive element of social relationships [and] a primary way of signifying relationships of power."[62] Likewise, I would argue that simply acknowledging poverty does not come close to a constitutive analysis of poverty and its representations. As Gavin Jones points out, "Class analysis often fails to focus sharply on what poverty means as a social category. . . . Class analysis has, in this way, targeted the system of capitalist production and consumption, rather than considering the individuals and groups who have remained partly excluded from it."[63]

Another phrase that, I would argue, might well serve to downplay poverty is *income inequality*. This expression flourished during the Occupy protests, when it became common to talk about "the 99 percent and the 1 percent." Clearly the problem was the economic gap between the top and the bottom. The positive thing to come out of this realization was the "fight for fifteen" movement to raise the minimum wage among low-income earners as well as attempts to unionize fast-food restaurants and large low-cost stores like Walmart. But for those who don't or can't work, a minimum wage may seem irrelevant. One also doesn't have to point out that even with the minimum wage at fifteen dollars, workers will have a hard time meeting basic needs.

But more tellingly, income inequality applies to almost every person in a nation. Income inequality is defined not by what most people earn but by what they don't earn. Thus, the gap is structured by what CEOs, entrepreneurs, hedge-fund managers, and other highfliers earn in comparison to the rest of us. Income inequality also shields the professional-managerial class, who can say, along with everyone else, that they are victims of an unequal system. Just as the term *middle class* has been used to hide the emblems of wealth, so *income inequality* provides a big tent under which many who benefit from the current system can rest comfortably without guilt, shame, or action. But it is actually the upper-middle class, not just the superelite, that has experienced a much greater economic gain than the rest of the country.[64] Academics need to see themselves as part of this professional-managerial class who have benefited from a system not only of inherited wealth but of education that itself is part of that inherited wealth.[65] We the implicated subjects are not directly "perpetrators" of class and economic injustice, but, whether conscious or not, we benefit from the existing system. As Michael Rothberg notes, "The workings of contemporary capitalism at a global scale depend on relations of exploitation that systematically produce inequality as well as psychic and physical harm. Privileged consumers in the Global North are . . . participants and beneficiaries of a system that generates dispersed and unequal experiences of trauma and well-being. . . . [This implication] helps us conceptualize collective responsibility."[66]

When we talk about "the poor," what do we mean? It is possible to say that anyone who doesn't have enough money is poor. But that is a meaningless definition because it is distorted by lifestyle, location, and personality. A middle-class family that spends freely and lives in a major metropolitan area might not have enough money because they can't pay for their large house, college debts, and long-term care insurance. Conversely, a frugal working-class family with two income earners and no children, living in a small town, may have enough money for all their needs and then some.

A rigid concept of class conceals the true extent of poverty because it doesn't accurately reflect that individuals and families move back and forth through gradations of sufficiency and insufficiency over time. This precarious nature of economic life gives rise to the term *the precariat*. Like the proletariat, the precariat exists in the liminal space between security and scarcity. In the United States, more than 140 million people, 43 percent of the population, have difficulty covering basic living expenses.[67] In other

words, while the middle class has seen a very large jump in income, a large segment of people who are poor or working class have not.

A similar rigidity in conceptual thinking allows for the false belief that the majority of the poor live in impoverished third-world countries. Thus, the problem is "theirs," not "ours." The reality is that the extreme poor also live in middle-class countries. The United Nations and nongovernmental organizations (NGOs) tend to define extreme poverty as an individual living on $1.90 per day. Globally, about 40 percent of the world lived under such conditions in the 1980s, but because of the rapid industrialization of mainly China and India, where slightly more than a third of the world's population lives, that number has now fallen to about 10 percent. Extreme poverty is now concentrated in sub-Saharan Africa. However, middle-income countries have not seen a reduction in extreme poverty in the same period.[68] Now four out of ten extremely poor people live in low-income countries, while the majority of poor people live in middle-income nations, mainly India, Nigeria, Bangladesh, Indonesia, Kenya, Yemen, South Africa, China, Pakistan, and Zambia.[69] And we will want to remember that the United States has the highest rate of poverty in general and child poverty in particular compared to twenty-five other major countries in the world.[70]

In the midst of confusing definitions about who is poor and who is not, I propose a kind of Bechdel test of my own devising that will help you to identify if you grew up poor. This test asks three simple questions. Did your parents own their own home rather than rent? Did they go to college? Did they have retirement funds (aside from Social Security)? If you say yes to all three, then you are probably an implicated subject and were not poor. If you answer no to all the questions, you were poor. Obviously, this test is not scientific or particularly valid, but it provides a kind of dull Occam's razor with regard to the harder question of defining *poor*. It might also help you to understand what might be your reaction to the account I am providing. If you find yourself detached or even alienated from this discussion of poverty, you might want to ask yourself what complex emotional and unconscious reaction is being generated. Like all good defenses, a defense against being implicated in the poornographic enterprise will erect a forceful and effective shield against hearing information about such an involvement.

We can understand a general focus on creating rigid boundaries about the poor by looking at the problem historically. Poornography relies on

classist writing about the poor. We might say that this perspective began in the nineteenth century in England and the United States when large numbers of poor people began to congregate in urban areas. As some have pointed out, poverty had to be "discovered" in order to become the focus of those who were not poor.[71] In a world in which the vast majority of people were poor, being poor didn't deserve obsessive and repeated notice. But with the rise of a relatively small nonpoor segment of the population, along with an increasingly vociferous working-class movement, the vast impoverished majority became much noticed, written about, and studied with various aims of eradication and/or reform. In this sense, the poor became a problem because they didn't become middle class and didn't receive an advantage from industrialization and capitalism. They then became poster children for their failure to rise rather than reminders of the way most of the world lived. Poornography is the medium to convey this message.

It is worth noting that even when a writer's aim was charitable, a limited but well-used lexicon of disgust and exclusion was inevitably deployed to describe large numbers of poor people. Horace Greeley's reportage on the Lower East Side of New York City in 1864 contains in essence the general viewpoint:

> The hordes . . . live like swine only to poison the community. . . . Everyone . . . knows that these places are noisome, dirt-soaked, vile, debasing. . . . Simple cleanliness, to say nothing of ideas of decency, is impossible; of necessity, every element of pleasure in life, beyond the most sensual sort is utterly unknown. . . . In these places garbage steams its poison in the sun; there thieves and prostitutes congregate and are made; there are besotted creatures who roll up blind masses of votes for the rulers who are a curse to us; there are the deaths that swell our mortality reports, from there come our enormous taxes in good part; there disease lurks, and there is the daily food of pestilence awaiting its coming.[72]

Such poornographic works are legion in the nineteenth century, so Greeley's screed can stand in for any depiction of an impoverished group. Emphasizing the animal nature of poor people by calling them porcine is common, as well as failing to individualize members of the poor by describing the group as hordes. *Hordes*, according to the *Oxford English Dictionary*, can refer to "Asiatic" nomads or groups of animals.[73] The fear of immigrants and invasion is thus built into the term. Foreign immigrants, then as now, are seen as penetrating the pristine world of citizens with filth, disease, crime, and the like. Where poor people live might well be filthy

and foul-smelling, but here these characteristics are moralized as "vile" and "debasing." In the sense that cleanliness is next to godliness, there is no possibility for a poor family to be both clean and good if they live in a tenement. Consistent with the moralizing of economic conditions and therefore cleanliness is the implication that the poor cannot enjoy life except in "the most sensual" ways—which is an easy phrase to parse. Poor people can't enjoy life except through sexual activity, which is seen as a low form of enjoyment. The next sentence paints an image of garbage steaming in the sun—implying of course that rich people's garbage does not steam in the sun and is somehow qualitatively different. But Greeley's image captures the nineteenth century's concept of miasma, which, before germ theory, was conceptualized as the malodorous way that disease spread through the air. The interweaving of disease with uncleanliness then segues immediately into the sexual and transgressive again. The miasma "makes" prostitutes and thieves. Drunkenness is also a major feature of poornography, so it is "besotted creatures" who somehow are linked to corrupt politics. Greeley was a Republican, and so the besotted creatures might be Democratic operatives of a party that is "a curse to us." In addition, the poor are a problem because "we" have to pay taxes to support them. Their poverty costs "us" money. The final sentence links the food eaten by the poor with pestilence, which is somehow inherent in the tainted sustenance consumed.

A *New York Times* article from 1893 also reporting on the Lower East Side continues the theme of Greeley's piece: "This neighborhood peopled almost entirely by the people who claim to have been driven from Poland and Russia, is the eyesore of New York and perhaps the filthiest place on the western continent. It is impossible for a Christian to live there because he will be driven out, either by blows or the dirt and stench. Cleanliness is an unknown quantity to these people. They cannot be lifted up to a higher plane because they do not want to be. If the cholera should ever get among these people, they would scatter its germs as a sower does grain."[74] That this thinly veiled anti-Semitic rant would be allowed in the newspaper of record is itself worth noting. But the theme of filth, disease, and animality is clearly nothing new in this type of writing. It is passingly worth noting that my father and grandfather, who lived in this very neighborhood a few years later, never once used the word *filth* to describe their existence. Instead, I recall my father telling me about the many coffee shops that had a multitude of daily newspapers he could read for the price of a cup of coffee. He described the pleasures he and his friends had living in that area. Lived experiences and outsider observations are thus quite different.

With the "discovery" of poverty in this era came the desire to make a cordon sanitaire around the poor, both physically and mentally. They couldn't be like us, so they had to be another order of being most closely related to the animal. Robert Bremner's thesis is that periodic economic depressions in the United States in the nineteenth century left a vast majority of people likely to be unemployed. But changing views of work spurred by industrialization and capitalism molded the conception of work from a biblical curse to an individual chance at success. The poor, then, had to be failures since otherwise they would, in a Darwinian sense, have succeeded. Bremner describes "a strange brand of conservatism espoused by the dominant business classes. . . . The poor who remained poor must pay the price exacted by nature from all the unfit."[75] Studying these unfit people, as was done in eugenics, meant that their bodies were surveilled, their dwellings reported on, and their sex lives turned into the most sordid iteration of copulation and bestiality. The focus on prostitution, as we will see, was a way of justifying the activity of middle-class male users and abusers of women. Thievery must not, then, be seen as even vaguely related to possibly parallel forms of capitalist expropriation of labor, wages, and profits. And of course, garbage, filth, stench, and the like had to be intimately linked to poor bodies and dwellings.

Greeley was himself born into rural poverty, and much of his life was devoted to reform, particularly to the eradication of slavery and improvement in the life of working people. Is it a contradiction that he should write this kind of poornography? The answer is no precisely because the desire to reform is often intricately linked to the desire to demarcate, separate, and condemn. It should be recalled that the imperative to improve a part of the population was very much a part of middle- and upper-class life in the nineteenth century. Eliding the connection between poverty and their own way of life, privileged people tried to clean up the flotsam of capitalist abuse within their communities with gentler waves of charity and kindness.

Poverty also was good business for the media. In the nineteenth century, newspapers were the go-to publications to hype stories in which reporters, like Nellie Bly, Steven Crane, and Jack London, went "undercover" into tenements and rooming houses. Tales of depravity and crime sold tabloids. It could be argued that newspapers were in fact the prime way that the public came to associate the poor with criminality and violence. Lydia Jakobs points out that "newspapers and magazines were also key agents in the discussion of poverty throughout the Victorian period. The popularity

and cultural impact of stories and images of ragged children and miserable street urchins can hardly be overstated." She points to "the large number of novels, newspaper features, poems, pamphlets and works of social investigation dealing with the topic."[76] Even the classic poornographic tome, Henry Mayhew's *London Labour and the London Poor*, began as a series of eighty-two articles for the *Morning Chronicle*, published between 1849 and 1850, and then shifted to serial publication in two-penny pamphlets. Money was to be had by hawking the street hawkers and selling the street vendors to an eagerly consuming middle-class public.

But these economic and cultural advantages did not flow only to the press. Almost no segment of society failed to reap benefits from a focus on the poor. Charities and religious groups sought to involve themselves with the poor. Rich people, particularly the ladies of the house, found occupation and absolution in visiting the poor and bringing food and clothing. And of course, novelists and publishers made money off the representational backs of poor characters and settings.

Chapter Two
The Problem of Representing the Poor

The central paradox of representations of the poor is that in almost all instances (with a few notable exceptions), canonical authors and artists who portray the poor do not come from that class. While the poor aren't the only group that tends to be represented by the other, they have not advanced—as have other identity groups, like racialized people, women, and LGBTQ+ people—to both take back the right to represent themselves and critique inaccurate or malignant representations. Among the groups in the United States, the United Kingdom, as well as in major industrialized countries that haven't yet fully been able to do that, aside from the poor, are, for example, the disabled and the Deaf, but for the latter things are changing. For the former, not so much.

While it is the job of this book to examine the maladroit and often pernicious work done by authors, artists, filmmakers, and the like who blithely assume they are as credentialed to depict the poor as they are to write about the middle class, I need first to try and articulate the very complex problem that exists concerning this issue.

It would be right to point out that the issue of people writing about or portraying any oppressed or underrepresented group will always fall into this paradox. Even the most progressive writers with the best of intentions will often fail to re-create the conditions under which various groups live. We have a long history of women's lives being written by the very men who may well oppress them. The same is true of gay, lesbian, transgender, disabled, and Deaf people, as well as enslaved people, colonial subjects, people of color, and so on. Chimamanda Ngozi Adichie has called this the problem of having only "one story" available about a particular culture—in her

case being a Nigerian.[1] In addition, she asks what happens when within that story the implied reader is not of the culture being written about, and therefore an actual African cannot be imagined as an interlocutor to the characters within the story. That is, the implied reader is not African—or poor.

The argument around representation goes something like this: you have to have lived the constitutive life to understand and write about it knowledgably and accurately. This contention has swung back and forth over time. Race has been a prime example. Initially, many racialized characters were primarily written about by people who considered themselves white, although there are some notable exceptions.[2] Even "negro spirituals" sung in African American churches could be written by white composers.[3] After several waves of consciousness about the issue, the assumption then became that only people of color could best write about people of color. For example, in 1933 when George Gershwin's *Porgy and Bess* opened on Broadway, Hall Johnson, a Black composer, wrote that Gershwin was "as free to write about Negroes in his own way as any other composer to write about anything else. [But the work] was not a Negro opera by Gershwin, but Gershwin's idea of what a Negro opera should be."[4] Duke Ellington critiqued the opera for "inventing . . . Negro music," adding, "It was not the music of Catfish Row or any other kind of Negroes."[5] James Baldwin later added the now-obvious point that the opera was "a white man's vision of Negro life."[6] It's worth noting that while the racial issue dominates the critique of *Porgy and Bess*, there is an intertwined problem of depicting poor people. In 1959 Harry Belafonte refused to play Porgy for the film version of the play, saying, "All that crap-shooting and razors and lusts and cocaine is the old conception of the Negro."[7] As a successful Black actor, he derided the class-based racist view concerning African Americans. And Black critics in the 1960s like Harold Cruse derided the opera as "a product of American developments that were intended to shunt Negroes off into a tight box of subcultural, artistic dependence, stunted growth, caricature, aesthetic self-mimicry imposed by others, and creative insolvency." He advocated that "no Negro singer, actor, or performer should ever submit to a role in this vehicle again."[8] The point here is that a robust critical pushback from African Americans places the artistic work into a dialectic of critique and acceptance. No such pushback has happened with any continuous regularity and impact from poor people (African American, Latinx, Asian, or not).

There has been a swing back to the possibility that white people could create works about people of color but always including the idea that the

demographic being written about would have a strong critical role to play in discussing and delimiting the value of such work. We have seen Quentin Tarantino's film *Django Unchained* debated within African American circles for its accuracy, relevance, nuance, and tone.[9]

Transgender people have made a similar point. Fox Fisher writes:

> Anyone who belongs to an underrepresented group probably feels there is a lack of characters to relate to or that they can resonate with. As someone who has taken the leap to socially and medically transition and lived to tell the tale, I have the experience and understanding to be the one shaping stories and narratives with trans characters. Once I'd sorted myself out, I realised that I could be that creator of content to create stories and narratives that have a positive and realistic representation of trans characters. As a trans person myself I can do that with a deeper understanding of what it is to be trans.[10]

As much sense as this blog entry makes, it can always be disputed by formalists, modernists, or postmodernists who might consider that authenticity is a dodgy game made even murkier by the questionable assumption that "real" or even "accurate" representation can be achieved through signs, symbols, icons, and language games. Jacques Derrida, for one, attacks the notion of representation in discussing Antonin Artaud's idea of the theater of cruelty. Derrida derides Western civilization's belief that life can be represented in theater and art, saying, "Life is the nonrepresentable origin of representation."[11] How could a writer make characters "like me" when the "you" being written about is created out of language, pixels, or paint? Representation will always be several removes away from the original—a point that frustrated Plato a few thousand years ago. Stuart Hall points out that representation acts like a language because it substitutes a sign for a thing. Thus, all languages are "systems of representation" rather than direct presentations of reality.[12] E. H. Gombrich has written that "all artistic discoveries are not of likenesses but of equivalences which enable us to see reality in terms of an image and an image in terms of reality."[13] He does not advocate accurate representation of objects but instead he envisions substitutions taken to be alike. Georg Lukács wants a complex synthesis in fiction that presents the dynamics of historical materialism, so he sees simple reportage as failing those goals. For him, the psychological novel and the naturalistic novel are too simple to include the dialectical relationship between history and the individual.[14] In the same line of thinking, Louis Althusser and Étienne Balibar lessen the importance of facts per se and

want to implicate ideology as the grounds in which the dialectic struggle takes place. Knowledge then is seen as "an abstraction."[15] Fredric Jameson values realist representation but does not posit a one-for-one substitution between the historical world and the fictional world. Instead, Jameson sees the relation as "an analogy."[16] In synthesizing this line of Marxist thinking, June Howard concludes, "Literary texts like other texts are constructed not out of innocent 'facts' but on the basis of already complex structures of representation. And the operations performed on this raw material in order to produce a novel are specifically literary operations; they are distinct from the operations that would be performed to produce, say, a monograph on genetics or economics or history, and it is inappropriate to expect a narrative to provide knowledge in the same sense."[17] Indeed, even one's personal, original existence is composed of memories, experiences, and sensory information that are touched and enhanced by other sets of representations. As Richard Dyer notes, "There is no such thing as unmediated access to reality."[18] Is it then pointless to talk about the accuracy or authenticity of the depiction of the poor?

There are at least two approaches to the issue of representation. One is to see the produced narrative, including the characters and their way of speaking, being, and moving through the world, as the issue. The idea is that such a representation needs to resonate with those who are being depicted and strike them as an accurate or meaningful representation. But another way of seeing this is that the person who is doing the representing needs to be a good and accurate representer. In some ways the two are linked since an accurate or true representer will give us a better version of what is being represented. Dorothy Hale notes that writers like Henry James emphasize the "foundational characteristic of the individual identity" of the writer while theorists like Percy Lubbock see the representation as more important than the sensibility of the writer.[19] For Hale, "social formalism" mistakenly shifts from "that of the representer to that of the represented."[20] In this work I am reversing and making more complex that trend, in effect, by claiming that the representer needs to be considered more deeply and in a way that is somewhat different than has been considered thus far.

But there is a further complexity to this issue. If we, for the moment, set aside two major functionaries in representation—what or who is represented and also by whom this representation is represented—there are still a few more players in this script. There are the receivers of the representation and then the social, political, and cultural surround that provides a

context and meaning to representation. In effect, rather than a dialectic, there is a quadralectic with all four elements in constant play and interaction with each other. The representation as a product—a character, object, conversation, or narrative line—will be in dynamic tension with the person who created the representation as well as with the audience who will critique or praise it.[21] Add to this the milieu, which shifts and changes as it both creates an environment in which utterances and representations can be contextualized and at the same time alters itself to address the changing cavalcade of representations over time.

Unlike with regard to race and gender, the social-cultural-political milieu has not changed much regarding who should depict the poor. From the medieval period through the early twentieth century, the vast majority of depictions of the poor have been made by those who are not poor. The primary reason for this is that the poor did not have in the past access to the means of cultural production. Pierre Bourdieu would say that the cultural arbitrary always expresses and reproduces the interests of the dominant class. As such, it is virtually impossible that a poor person could get to the means of cultural production and then change the cultural arbitrary to express endogenous insights.[22]

Issues of authenticity have a particular historical resonance. Regina Bendix in her book *In Search of Authenticity: The Formation of Folklore Studies* points to a potentially pivotal moment when Johann Gottfried Herder emphasized the authenticity of "the folk" (*Volk*). As opposed to the stilted language and pretensions of high culture, folk culture and its songs and poetry would be more authentic to some true sense of a self uncontaminated by adulteration and pretense.[23] Herder, tellingly, excluded the urban poor. As he wrote, "*Volk* does not mean the rabble in the alleys; that group never sings or rhymes, it only screams and truncates."[24] German scholars were intent on getting to some authentic original through the process of collecting and preserving folk songs and poetry. To them, oral sources seemed more authentic than written ones—a feeling that evokes the kind of orality philosophers like Jacques Derrida in *Of Grammatology* saw as a mistaken belief that spoken language was truer to the essence of language than written language. In the United States, by contrast, there was little to no interest in the same era in plumbing the authentic poetry and song of Native Americans to find the essential truth of being. While some regarded the indigenous nations as being in touch with nature and containing within themselves a simplicity and innocence of being, their language was found to be both primal and yet wanting in complexity.[25] Instead, the

trend was toward the language of "the common," what Ralph Waldo Emerson calls the "vigorous Saxon" laborers.[26] In addition to that turn toward the white workers, there was a parallel movement to see African American songs and stories as containing an essential link to the authentic. Antonín Dvořák, noting his own credentials as "the son of poor parents," asserted of the United States, "I am now satisfied . . . that the future music of this country must be founded on what are called negro melodies. . . . These are the folk songs of America and your composers must turn to them. All of the great musicians have borrowed from the songs of the common people."[27] Field researchers like Zora Neale Hurston and Langston Hughes sought anthropological material among southern Black people and then incorporated their findings into novels and poetry.[28] And critics like Houston Baker and Henry Louis Gates placed emphasis on the Black vernacular, music, and forms of signifying as inherently more radical than standard English.

Likewise, literature that was written about the poor had a cultural resonance of being more authentic and realistic than that written about the rich. The move toward naturalism in nineteenth-century novels was an implicit statement about poverty being equated with the authentic. Poor and working-class people were living essential life while the rich were living a rarified and removed version of existence. Readers, writers, and publishers voted with their choices to focus on the former over the latter. But as was the case throughout, this "authentic" life was to be created largely by those who were not of that life. Research and undercover reporting were the methods that allowed better-off folks to record the lives of their worse-off fellow humans and then monetize the results.

This aspect of poornography changed in the United States during the 1920s and 1930s with the rise of proletarian literature. Working-class writers, Black, white and brown, got to be heard, seen, and published. But the vast majority of those books have failed to enter the canon. I discuss the few outliers later in this book. Now, it is occasionally possible for poor people to shift class through the process of accessing cultural production. The most dramatic cases of this are rappers who have come from poor neighborhoods and backgrounds and now have access to large audiences and paychecks. It is also true that the internet, for those with access to it, affords many poor people entrance to social networks in ways they did not have before. Still, it must seem clear that those poor people who have reached larger audiences now are still a tiny group within a vastly larger population. A publication like *POOR Magazine* and its related Poor News

Network has a Facebook and internet presence and is a significant activist organization but is thus far unknown to most people.[29] Likewise, the Class Work Project and its publication, *Lumpen*, are doing good work in the United Kingdom but, again, remain relatively unknown.[30] And very important, poor people do not have access to a collective mechanism by which works about them can be critiqued and evaluated. In other words, there is no regulatory mechanism by which poor people can publicly and influentially debate work about themselves in the way that other groups have done over time.

Given this somewhat persistent situation, I am arguing that only people who have grown up poor, those I am calling endo-writers and endo-artists, actually can and should make creative works about poverty at this juncture. This position no doubt seems reactionary given a set of assumptions about literature that we have inherited and adopted in academia and elsewhere. I recently gave a talk on this subject, and a friend who is a Marxist said to me afterward that he was sorry to see me endorse identity politics. That comment raises the question, Do the poor constitute an identity? Clearly not in the way that identities are formulated nowadays. The *Oxford English Dictionary* defines *identity politics* as the adherence of a group of people of a "particular religion, race, social background, etc., to political beliefs or goals specific to the group concerned."[31] The poor are too heterodox a group to adhere to a goal specific to themselves, and they are not defined by any clearly delimited set of physical, ethnic, or social qualities. It seems a bit of a stretch, in that case, to say that the poor represent an identity group at this point in our history. I would say that rather than endorsing identity politics (which, as a disability studies scholar, I don't oppose in principle), I am opposing a demeaning set of stereotypes that nonpoor people have assembled to describe, contain, and control a group they would like to continue being subservient, docile, and largely silent. I should add that my recommendations concerning who should represent the poor do not necessarily apply across the board, as in the notion that only in-group people can represent those within such groups. With the poor, a group that generally does not have access to publishers, distributors, agents, and such, there is a specific need to have in-group representatives, most likely transclass writers and artists, represent them.

Instead of authenticity, it would make more sense to talk about accountability. Rather than looking to the content of the work to see if it is an accurate reproduction of the lived experience of poor people, we might want to question the author who assumes that they have the proper back-

ground to write about a specific oppressed group. We have no problem nowadays insisting that members of various identity groups should be the prime describers of that group, but we have not reached that point with those who represent the poor. If we make the analogy with transgender issues, as we have by adopting the term *transclass*, we might want to also add the notion of cis to the mix. Can we speak of a cis-class person as one who remains in the social class into which they were born? If so, then the question becomes, How accountable is a cis-middle-class person when they depict the life of a poor person? The cis-class writer might even be able to reproduce some aspects of the lived experience of the poor person, just as male writers have sometimes done with female characters, but how accountable are they for doing so? And in factoring an algorithm of accountability, questions about harm done by a particular kind of narration need to be considered. In other words, this is not a simple equation, where only a person of a certain identity can write about that identity, but a more complex set of givens that need consideration in figuring who might be the best interlocutor and what might be the optimal narration.

The idea of accountability might seem to echo Mikhail Bakhtin's notion of answerability; however, it is quite different. Bakhtin suggests that what links life and art is that the individual, whether author or reader, needs to be answerable to the political implications of both life and art. "The poet must remember that it is his poetry which bears the guilt for the vulgar prose of life, whereas the man of everyday life ought to know that the fruitlessness of art is due to his willingness to be unexacting and to the unseriousness of the concerns in his life."[32] Bakhtin did not fully develop this idea in his early writings. He is speaking about some kind of guilt for not being political, but the idea of accountability I am proposing is less about guilt or apathy (or a linguistic sense of uttering and answering) and more actively about being responsive and responsible to the group being depicted in a work of art, particularly if that group is oppressed and lacks access to a mechanism for mounting a response to the work or the author. In Bakhtin's idea an author can answer in a variety of ways; there is no notion of responsibility to the groups depicted in a work.

In a way, I am allying myself with Plato, who doubted that artists were the best people to represent reality. In *The Republic*, Socrates argued that because artists were not specialists in a particular craft or activity, the results of their mimesis would be flawed since they were imprecise knowers of what they sought to depict. A shoemaker, as the argument goes, would know much more about shoes than an artist who paints shoes. Following

that logic, am I saying that people who have experienced poverty would be the experts on poverty as opposed to middle-class writers or filmmakers who had not?

There are several modern refutations to what I am proposing. One line begins most forcefully with New Criticism. W. K. Wimsatt and Monroe Beardley in 1954 put forward a clarion call against the idea that the intention of the author matters—what they called "the intentional fallacy."[33] For them the structure and function of the literary text were paramount, and therefore the history, biography, social milieu, and so on were so much less important as to be almost negligible. That position was taken up by structuralists, formalists, semiologists, and various kinds of postmodernists. I am not going to enter into the long history of this position except to say that the argument against the intentional fallacy has revolved around issues of authenticity on the one hand and the justification of authorial intention on the other.

The problem is that arguing for or against a notion of authenticity or intentionality, while very interesting in and of itself, distracts from the larger political point I am making. You can assert that the author's intention matters or not, but you aren't going to solve the bigger problem of poor people's lack of access to cultural production, or the larger political issues that surround the misrepresentation of the lives of the poor because of this lack of access. In other words, as Dyer says, "representations . . . have real consequences for real people . . . in terms of the way representations delimit and enable what people can be in any given society."[34]

What I would like to propose is that these formalist questions are coming from a position that is necessarily askew. In my book *Resisting Novels: Fiction and Ideology*, I made the point that you don't have to look at the content of novels to find them ideological. Rather, the very structural and formal elements of character, plot, dialogue, and location themselves are imbued with bourgeois values—novels are ideological from the get-go regardless of the author's intention. I'd like to clarify that point a bit more in this book. Rather than find this determinism, if you will, primarily in the structure of novels, I'd break this down further into what have been called *ideologemes*, which might be analogous to Roland Barthes's idea of mythemes.[35]

If almost all works about the poor are written by people who are not poor (I talk more later about the special case of transclass authors who were poor originally and changed their class), then the building blocks that such authors use to create narrative structures will necessarily be deter-

mined by what is available to them and understandable to their audiences. As Dyer writes, "Representations are presentations, always and necessarily entailing the use of codes and conventions of the available cultural forms of presentation. Such forms restrict and shape what else can be said by and/or about any aspect of a reality in a given place in a given society at a given time."[36] Those preformed bits of language or predetermined visual images float in the culture like nonmaterial Lego pieces and are used by individual speakers, writers, and artists to build their constructions. These are rather like the available automobile parts that are used to construct a car. You don't start with stones, dirt, and minerals to build a car—you use the ready-made components, like computer chips, batteries, and camshafts. Likewise, if you build a novel or a film, you use those small bits of language or imagery that exist in the culture to establish what a poor person looks like, thinks like, acts like, and talks like, along with the locations that a poor person is likely to inhabit. You also are chained, as it were, to the narrative features that define something that will be recognizable and even familiar to audiences (and to authors) as a plot.

Let's say you wanted to write a novel about a poor person, and you made that person happy, intelligent, and inquisitive and had them living in a comfortable but simple dwelling, with diligent parents who weren't violent, criminal, lustful, or addicted to drugs or alcohol. Let's say they worshipped religiously, tried to be ethical, didn't swear, and spoke with an unaccented speech pattern. Let's posit that the main character fell in love with another poor person with a similar background. The first thing you'd have to say was that there was no plot, and then you'd have to ask, How does this narrative of poverty differ from a middle-class narrative?

In fact, a limited set of descriptors and visual cues are used to indicate poverty. Characteristic of poornography in general, these ideologemes of poverty have a kind of attraction for us. In the same way that Halloween costumes are always easily recognizable because they retread common perceptions—hoboes are people with dirt on their faces who carry a stick with a dangling handkerchief filled with possessions; princesses wear crowns or tiaras and are dressed in satiny clothing; witches dress in black and have pointed hats and brooms and often a hooked nose with a wart on it—so too are the trappings and environments of the poor easily recognizable.

It is actually difficult to avoid these visual cues. A look at art history shows that there really are only a few ways to visually represent poverty. The classic gesture that indicates someone is poor is an extended hand

2.1 Jacques Callot, *Male Beggar Dressed in Rags* (ca. 1622). Engraving from the series *Les Gueux*.

2.2 Detail of Gustave Courbet, *The Charity of a Beggar at Ornans* (1868). Oil painting. Burrell Collection. Pollok Park, Glasgow, UK.

with an open palm facing upward—a visual representation of begging. The other features are ragged clothing, absence of shoes or the presence of dilapidated footwear, and emaciation, as we see in a 1662 drawing by Jacques Callot (figure 2.1). That is about it. All the complexity of a constitutive life is completely boiled down to these few attributes. Only Gustave Courbet, in his painting *The Charity of a Beggar at Ornans* (1868) (figure 2.2), introduces the element of body odor as the Roma child holds his nose as he accepts a coin from an elderly impoverished man who is represented as, of course, tattered, emaciated, and with an outstretched hand and shoddy footwear.

Poverty is difficult to represent because to the middle classes it stands for a lack.[37] As Gavin Jones writes, "Poverty loses its urgency if it is not at least . . . defined by the lack . . . of the resources necessary for subsistence, for life itself, or for health and well-being."[38] How does a painting or a

photograph show something that is not there? A telling feature of exo-writers and representers is their rigid focus on the lack—in most cases lack of money, comfort, and the like. In the wake of this difficulty, middle-class authors and painters have sought ways to depict and aestheticize poverty. In the eighteenth and early nineteenth centuries, rural poverty was included in the list of perquisites for the picturesque. In an influential book, *Essays on the Picturesque*, published in 1810, Uvedale Price included in his list of possible subjects ruins, old mills, and barns but also "wandering tribes of gypsies and beggars."[39] Nancy Armstrong makes a similar point: "From its inception, the picturesque aesthetic had been uniquely geared to the task of turning poverty into art."[40] It is easier to aestheticize poverty in rural areas than in urban settings. And it has been harder for exo-writers to develop a way of talking about the plenitude of lived experience in such settings rather than the lack of resources and amenities. Meanwhile, endo-writers seem to have no trouble doing this. Just as with disability, in which the nondisabled observer often sees only a lack or an inability, so too with poverty there isn't much room in the dominant cultural sensorium to imagine a plenum of life among the poor.

Walter Benn Michaels has discussed the work of photographer Viktoria Binschtok, whose series *Die Abwesenheit der Antragsteller* (*The Absence of Applicants*) (2006) (figure 2.3) is made up of seemingly abstract images that are in reality the marks left on a wall in an unemployment office by those leaning against that wall while waiting to find jobs. Visually, Binschtok is representing poor people (or at least those without jobs) by depicting their absence and thus the trace of their absence. For Michaels, this is a more formal and less content-driven way of "showing" issues around class and class difference.[41]

Or we might look at the work of photographer Dawoud Bey. *Night Coming Tenderly, Black* (figure 2.4) shows us an almost lightless rural landscape to put into context what the experience of poor enslaved people on the Underground Railroad might have been.

But generally such refined and anaclitic visions of poverty do not abound. The genre requires an indexical and iconic representation pointing to or embodying known and recognizable figures that can invoke the presence of an absence. Take, for example, the 2018 film *Roma*, by director Alfonso Cuarón. The movie is set in 1960s Mexico and focuses on a young maid named Cleo. Cuarón, who grew up in an upper-middle-class family, wanted to make a nostalgic film depicting the family's life and crisis when the father leaves the mother. But rather than have himself as a

2.3 Viktoria Binschtok, *Die Abwesenheit der Antragsteller* (2006). Photograph courtesy of the artist. https://brooklynrail.org/2011/10/art/the-beauty-of-a-social -problem.

2.4 Dawoud Bey, *Night Coming Tenderly, Black* (2017). Photograph from Rennie Collection, Vancouver, Canada.

small child be the central character whose point of view was the cynosure of the film, he chose instead to have the poor maid Cleo be the central character. In this sense the film would be about her life in and among this well-off family. By definition, this should make the film political and exemplary in showing how a class division affects the way people live. The maid comes from a poor family outside of the big city. Cuarón, however, gives us a very exterior view of Cleo that amounts to an absence. We know almost nothing about her, her childhood, or her family. We see her from the outside—as a faithful servant who repeatedly is made to clean up dog excrement, an act metaphorically serving as an explanation of her subsidiary role in the family. While Cuarón's focus on the dirty work may seem to place him on the side of the poor indigenous servant, is it enough to carry through a just representation of the young woman? How can he depict the absence of money, status, agency? If he gave her a fuller inner life, would the clichés of her poverty and dependency disappear? It is telling that the last lines of the film are those of Cleo, who on returning from a trip to the beach in which she has saved the life of one of the wealthy family's children, says to the other maid, Adela, in the house, "I'll tell you about it later" ("Luego te cuenta"). Cleo may tell Adela later, but the audience never gets that interiority.

Roma won the Best Director and Best Foreign Film Awards at the Oscars in 2019. The following year another film about poverty won the Best Director, Best Picture, Best Original Screenplay, Best International Feature Awards. That film, *Parasite* directed by Bong Joon Ho is also about lack. The Kim family is poor and living in a dank, insect-infested, semibasement dwelling in Seoul, where the top 20 percent have sixty-four times the wealth of the bottom 20 percent, according to Min Joo Kim, in the July 7, 2023, *Washington Post*.[42] As viewers of *Parasite*, we experience the lack of money and the lack of the comforts it brings. The first part of the film is a sort of comic home-invasion film in which through a series of clever, if not devious, subterfuges the Kim family moves into the wealthy and privileged Park family home. A theme throughout the film is that the poor Kims, while managing to impersonate richer people, still carry the smell of poverty—a theme consonant with many depictions of the poor, including that in Courbet's painting. While Cleo in *Roma* reflects the stereotype of the deserving poor, the Kims are the dangerous poor who will stop at nothing to get money. In the second act of the film, we see, secreted in the basement of the wealthy house, the husband of the former housekeeper, who has been surviving on scraps of food pilfered at night from the re-

frigerator of the rich homeowners. Thus, two groups of poor people live subterranean existences off of the trickle-down spoils of the rich. Indeed, in a dramatic scene, embodying a form of pathetic fallacy, a rainstorm creates a literal trickle-down that flows from the wealthy Park house down through the streets to the impoverished Kim basement, which is wrecked by this flood. In a symbolic move, the film shows us excremental brown effluvia from the flooding erupting from the Kims' toilet. (This echoes the constant attempts of a poor drunkard to urinate at the window of the semibasement. This is a family that is pissed and shit on.) The conflicts in the film build up to an inevitable bloodbath in which the poor kill the rich, with accompanying damage to themselves. The film ends with a kind of moral coda—a fantasy in which the poor Kim son dreams he will take over the rich house, now abandoned by the Parks and bought by Germans, and free his father from its basement, where he now hides from the police. But the final shot of the film reveals that the son is still in the semibasement where the film began, and he will never overcome his impoverished position. Clearly the Kims are the undeserving poor, motivated only by their own greed and class resentment, who get their moment to erase their lack, only to be put forcibly back into their place by the mechanisms of the plot. Message: violence and trickery won't get you out of your underground life.

Cuarón may be doing the only thing an upper-class person writing about a poor person can do—leaving things out. Bong Joon Ho, also from a privileged background, presents a more filled-in set of characters, but they are filled in mainly by their longing for the money and privilege of the well-off. It is as if the middle-class or upper-class writer cannot imagine poverty without seeing the characters as continually reflecting on their own lack. In *Parasite* a false equivalence ends up being drawn between the greed of the poor and the slack complacency of the rich. Neither deserves their money—and each needs to be punished for wanting it.

Representing poverty by absence is quite difficult, whereas representing wealth by presence is rather easy. Images and narratives abound with the cumulative possessions of the wealthy. Wealth is about superfluity, overabundance, and excess. We might think of Mother Hubbard versus Old King Cole—one has a bare cupboard, and the other has "fiddlers three." Possibly the most dramatic presentation of superfluity is the unforgettable scene in Émile Zola's *Ladies Paradise* in which pages are devoted to a minute description of a department's white sale of dry goods.[43] This amounts to what Karl Marx notes as a signature of capitalism—"an immense accumulation of commodities."[44] But when it comes to describing poverty, how

can one present the absence of money and possessions? Most poornog-raphers fall back on describing the tangible living conditions. Therefore, crumbling buildings, hanging laundry, and mounds of excrement stand in for the absence of money.

Georg Lukács notes that such reportorial writing tends to focus on the "evils of capitalist society . . . [and its] most crying abuses and grievances," written in a reportage mode by those with "petty-bourgeois radicalism, sometimes bordering on socialism."[45] Lukács's point is that while it may seem liberatory to describe the abuses of capitalism, often the exo-writers who do this kind of description are seeking more to instill a sense of simple outrage in the reader than to promote any complex plan for systematic political change.

While a presence with an absence is difficult to create narratively, it is important to understand what is missing in this absence: obviously, money and means but also personality and lived experience. The exo-writers can report only what they sense through vision, hearing, and scent and only present what they learn by research. They obviously cannot present life with any complexity or psychological interiority. On the other hand, as Lukács and others have pointed out, the hallmark of classic bourgeois nov-els is the creation of a psychological interiority that gives readers the im-pression of being inside a character's mind and thoughts. Lukács laments that reportage-type novels are in effect simply doing what the bourgeois novel does in regard to psychology. They are reproducing some aspect of the mind or the objects without providing an overall study of the mecha-nism of capitalism. Simply detailing abuses or absences is not enough and almost in effect makes exo-writers agents for the overarching structures of control and dominance.

The problem is that presenting a presence with an absence allows for description without representation. That last phrase may chime with the famous political clarion call of the American Revolution—"no taxation without representation."[46] I draw that parallel because there is often more than a casual relationship between the political idea of representative democracy and the notion of authorial representation. W. J. T. Mitchell tightens this ligature when he writes, "We now think of 'representative government' and the accountability of representatives to their constituents as fundamental postulates of modern government. One obvious question that comes up in contemporary theories of representation, consequently, is the relationship between aesthetic or semiotic representation (things that 'stand for' other things) and political representation (persons who 'act for'

other persons)."[47] In some sense, Mitchell is rephrasing Gayatri Spivak's use of Immanuel Kant's term to make a distinction between *Vertretung* and *Darstellung* as two types of representation—the former being political representation and the latter aesthetic representation.[48]

While Mitchell and Spivak do not elaborate on the possible historical connection between these two types of representations, Nancy Ruttenburg does in her *Democratic Personality: Popular Voice and the Trial of American Authorship*. Her overall argument is that a democratic impulse, which she calls *democratic personality*, preceded both the founding of representational democracy and aesthetic representation in novels and poetry. That earlier impulse was transgressive, chaotic, and contradictory and had to be contained, in a way, within the strictures and structures of the state and of bourgeois literature. Her approach is mostly literary with a specific focus on religion in the United States. Here I would want to expand her quest to include more genres and historical modalities by asking, "Is there a connection between the beginning of the novel in the eighteenth century and the consolidation of representative democracy in the same period?" In both, a person is given or takes the power to represent another person or group of people. In a direct democracy, each citizen would be part of a deliberative process that sets the rules, laws, conventions, and the like for the group. In writing, this would amount to each person being the author of their own story. A direct democracy of writing would be a vast collection of memoirs or something like the NPR radio project StoryCorps, which has kiosks and locations in which ordinary people can record their personal stories.[49] In another sense, family gatherings or attendance at a pub, bar, or other communal location allows for a free exchange of stories and anecdotes in which individuals can shape a narrative about themselves.

However, with the rise of the novel and the development of the publishing industry, a direct writing public is displaced to a representative authorship in which certain individuals gain cultural capital in representing the lives of others. If we think of the early emphasis on epistolary fiction, we might understand that early fiction writers like Samuel Richardson or Frances Burney might have been trying to hijack direct writing to create this new and unique form of fiction. In so doing, the author re-presents the activity of ordinary direct letter writers and in the process makes themselves a re-presenter of that activity. To think this through, we could revise one motto of the American Revolution by converting "No taxation without representation" to "No novelization without representation." While a

bit awkward, the revised credo has some relevance. As mentioned, at the same time as Western bourgeois society was concerning itself with the issue of political representation, the novel as a form was developing. Indeed, the word *representation* was first used by Edmund Burke in 1769 in the political sense we know, according to the *Oxford English Dictionary*, which defines the term as "the action, fact, or right of being represented or representing others in a legislative or deliberative assembly; the principles or system associated with this." At the same time, the novel was concerned with the problem of representing the individual in a parallel process—rendering the life of an individual and re-presenting it in language. Plays were interested in reproducing social situations and the life of a person at a crucial or stressful moment. Epics depicted an idealized individual in battle, in which the fate of their society depended on their heroic acts. But the novel sought to represent an individual life over a period of time.

An Ngram chart shows us that the words *representative, representation, author*, and *reader* all spike between 1790 and 1810 (figure 2.5). Although Google Ngram is not the most reliable source, it does give us an idea that the confluence of the notion of representation and narrative held a distinct interest among those who were writing and reading books at the time.

To solve the problem of representation (and the accuracy of that representation), writers had to engage in a dialectic between factuality and fictionality. I have discussed this at much greater length in my book *Factual Fictions: Origins of the English Novel*. If there were a productive ambivalence between the factuality of the work and the credence of the reader, novelists could claim that because a work was "true," its content could be instructive and useful. Claiming that a novel was true was a way of asserting that its representation was accurate. When the "editor" of *Robinson Crusoe* claims the work is a real document, he bypasses the dodgy issue of representation.[50] Something is not a representation if it is in fact simply a presentation. To re-present a person or situation, an author must claim a certain privilege or right, which in turn is granted to the writer by groups of readers.

While novelists were working out these problems, political thinkers like James Madison, Alexander Hamilton, and John Jay were hashing out in *The Federalist Papers* the details of how political representation might work. In this sense they were working out similar problems to those faced by novelists. If there were individuals who were to be both governed how should their being and wishes be represented in a government? A similar

2.5 Author created N-gram chart measuring frequency of use of the words *author,* *reader, representation,* and *representative* between 1600 and 2000.

problem of accuracy and veracity is found with novels, in the way that citizen readers choose individuals/characters to represent their wishes, desires, and opinions.

Madison was worried that there might be a misalignment in representation because the type of person chosen by an election might not correctly represent the interests of those who had cast their votes. As he wrote, "Those who administer it [government] may forget their obligations to their constituents and prove unfaithful to their important trust" (No. 62; 304).[51] Likewise, there might not be a sufficient number of representatives to proportionately stand for the interests of the voting public majority and minority. These concerns might equally relate to the reading public. Authors might not accurately represent the expectations and ideology of readers, and there might not be enough authors in the mix to do so in proportion to the types of readers.

I'm not saying that the reading public and the voting public were identical in the eighteenth century. Nor am I claiming that the processes of political representation and literary representation facilely map onto each other in that era. But this framework allows us to understand something about the process of representation and the issue of accuracy. In some sense, we might be able to reframe the argument about accuracy and authenticity if we think of the problem from the point of view of those who are represented in narrative. If they concur with the author's representation,

then they will buy the book and, as a demographic, approve of the depiction of themselves presented in narrative form. This is less, in fact, about accuracy than about recognizing oneself and one's lived experience, as complex and ideological as that may be, in the textual representation. As Bruce Robbins writes, "Once literary representations are no longer judged by the criterion of an impossible immediacy . . . then their 'literariness' . . . becomes a medium or arena of political skirmishing, alive with the turbulent significance of moves and countermoves."[52] Those "moves and countermoves" amount to a quadralectic among author, audience, the represented, and milieu.

Representational inequality can be seen as a constantly fluctuating problem tied to the demographic representation of readers. The point is that readers will drive attitudes toward various marginalized and dominant identities. White middle-class readers in the nineteenth century, for example, supported writers who would convey to them their own experience of the world, including their view or imagined view of the poor, women, people of color, and colonized and enslaved people.

In this regard, we might take the example of Henry Mayhew's *London Labour and the London Poor*, which is often cited, along with Charles Dickens's novels, as a resource for understanding the poor and working classes in Victorian England. It is important also to note that when such works enter the canon, any doubt as to their accuracy or standing is erased. They simply become the go-to books on the subject. One art historian notes that dubious representations, illustrations, and paintings in the nineteenth century "are increasingly regarded not as works of art but as evidence; and their 'realism' has been taken for granted. They are accepted as accurate and objective records of the age."[53] This seems to be the case with "authorities" like Mayhew. He himself was raised by a wealthy solicitor father in comfortable digs near Regents Park. Mayhew had financial troubles and often lived hand to mouth. His series of articles on the London poor for the *Chronicle*, later assembled into a book, became his best-known work and eventually the canonical book on the subject.

But while middle-class and wealthy readers liked the depictions they saw in Mayhew's work, he was roundly criticized by the very demographic he sought to portray. In one of the unusual instances of poor people's voices being noticed (although subsequently lost over time), a group of street vendors in London met on two occasions, covered by the press, to denounce Mayhew's work. They had invited the author to appear in person, but Mayhew refused. The chairperson of the meeting attacked

the author, saying that his behavior was "ungentlemanly and unjust." We should note how the lower-class spokesperson turns the class tables on Mayhew using his gentleman status as a foil for his behavior, which the critic characterized as an attempt to "wage war against one of the poorest, the lowest, and the most illiterate classes of the community . . . to injure a class of society that never injured him." He elaborated that Mayhew "had got up his book to suit the tastes and views of the upper and middle classes, and he had selected a helpless class to be the victim of slanders—the butt and target to be fired at by public scorn and ridicule."[54] Indeed, Mayhew set up a meeting of "street people" in a large hall in Holborn by distributing free tickets widely to anyone who earned their living selling objects or produce on the streets. But as soon as the meeting opened, Mayhew was criticized for using the meeting as a pretext to profit personally by publishing what people said. He then canceled the meeting. George Martin, an official of the Street Trader's Protection Association, wrote about this fiasco, saying that his organization came into being as a protest against Mayhew's writings. "Mayhew has charged us with vices he cannot prove. . . . [H]e or his agents have used petty and disgraceful tricks to elicit statements from poor men addicted to intoxication . . . exaggerated the information received . . . and . . . caricatured, and sneered, and vilified, and exposed the worst and hidden the best of our nature."[55] If this group of poor people had any representational equality, they might have influenced the reception of Mayhew's "classic" work. Instead, the canonical work displaces the actual subjects of the work and becomes the preferred narrative. The voices of the street vendors are drowned out by the official and dominant narrative of poornography.

One might add that the canonical status we have granted Mayhew's work could be very far off from what Mayhew intended. Far from seeing his work reverentially, Mayhew himself may have regarded his work as somewhere between sensational and comic. Indeed, Mayhew was one of the founders (if not *the* founder) of the satirical magazine *Punch*. He did not think it was inappropriate to stage at St. Martin's Hall in 1857 a combined lecture and comic recitation "which exploited" his own book. In this public event, Mayhew "spoke about his work and imitated various London street-sellers. James Hatton accompanied him on the piano and sang comic songs."[56] He then took this show on the road for three months around the provinces. One can imagine, given this almost vaudevillian approach, that the organization of street sellers may well have had valid objections when they protested Mayhew's portrayal of them.

As the demographics changed, in the 1920s, for example, and more working-class people and people of color became involved in reading and writing, the nature of the representation changed. As with a voting public, the sheer number of readers of a certain perspective will drive the election of various novelists who share that perspective through the simple act of buying their books. I'm not suggesting that a free market exists with books any more than with any other commodity since the publishing industry is far from being a level playing field. But the circulation of ideas (and ideas about how the world looks and feels) could be said to have a quasi-order to it.

If I am postulating a kind of shadow democracy based in literary models, is what I am discussing already conceptualized in Jürgen Habermas's idea of the public sphere?[57] One could argue that the public sphere, with its coffeehouses, magazines, pamphlets, and the like, amounts to a kind of humanistic government outside of the government. While that may be true, the public sphere isn't based so much on the concept of a single writer representing the wishes of a group of people who buy that writer's work and therefore choose that writer as a representative spokesperson. The public sphere is made up of a vast variety of dialogic voices. These may or may not include fictional characters whose lives represent the world the readers live in. If there is representation at all, it is through the personae of the writers, who might assume names like Publius or Isaac Bickerstaff. But re-creating a world within a book isn't the job of the public sphere, although some novels, for example, might well come to represent or stand for some positions espoused in the public sphere.

To go back to the issue of modernism and postmodernism in regard to realism and authenticity, the model I am proposing in some sense bypasses or short-circuits the philosophical argument about intention. It should be clear as well that what I'm describing is not exactly reader-response theory either.

While most identity groups have now been incorporated into the reading franchise, as it were, one of the few groups that still remains outside of this paradigm is the poor. In that sense, both as voters and as consumers of art and culture, they can't publicly opine on their representation, by consumption or at the polls, nor can they engage in the public sphere, which would allow their issues and lived experience to be accurately represented in the representational sensorium. In fact, only about 20 percent of poor people vote in political elections.[58] How many fewer "vote" for cultural representation?

It is also important to note that this state of affairs can change through the withdrawal of consent or the ratification of new representatives, and when (and if) that withdrawal happens, then the issues being raised here would become moot. In other words, this isn't a permanent situation but depends on a complex political, social, and personal mix of interactions and concatenations.

It might be fair to complain about what I've presented. What if middle-class writers get it wrong but their efforts achieve some kind of social or economic change that helps poor people? Paul Lauter stresses that many writers who are not from poverty are writing to effect change. Rather than focus on class origin, he argues, isn't it more important to say how well the writer accomplishes this task?[59] Didn't Dickens help reform some of the worst abuses of the Poor Laws? Didn't Dorothea Lange's photograph *Migrant Mother* call attention to starving pea pickers and their plight in California? Isn't this simply one argument in the long line of leftist theorists decrying the bourgeois function of literature and art under capitalism or neoliberalism? To buttress this objection, one might want to cite Lynn Hunt's book *Inventing Human Rights: A History*, which argues, in part, that novels in the eighteenth century helped create human rights by fostering empathy. Hunt notes that the wild popularity of the big-three epistolary novels—Samuel Richardson's *Pamela* and *Clarissa* and Jean-Jacques Rousseau's *Julie, Or the New Heloise* created a reading public who became acutely attuned to the suffering of characters. For Hunt the fact that novels and human rights came about in the same period suggests that the former encouraged the latter. "Learning to empathize opened the path to human rights."[60]

Likewise, one might want to cite Steven Pinker, who himself approves of Hunt when he says that "whether or not novels in general, or epistolary novels in particular, were the critical genre in expanding empathy, the explosion of reading may have contributed to the Humanitarian Revolution by getting people into the habit of straying from their parochial vantage points."[61]

While there is some truth to this point, its flaws are manifest. How would we measure the effectiveness of art in achieving change? Is this the change that the poor want? Is the relief structured by them or thrown at them? And how much do the fame and effectiveness of the middle-class "spokespeople" for the poor actually crowd out and prevent organic intellectuals among the poor from coming to occupy the public and prominent place held by their unelected doppelgängers? It is here that the idea

of accountability, instead of authenticity, comes into play. Would not the authors and the readers have to grapple with a level of accountability in which authors would have to discuss their ability to depict the group they are representing? Instead of dwelling with the poor, they are selling the poor.

Another argument against my general point might be that the middle-class writers are simply better writers. Their writing abilities have gotten them prominence, not their ideological positions. Writers from the working class may be inferior writers given their lack of education and most likely autodidactic training. The popularity of exo-writers may just be based on a meritocratic surge of interest in the better writer. This point has the problem of being hard to actually prove since aesthetics is a relative subject, and prominent writers will shape the aesthetic response of readers, who have become used to, and therefore expect, a particular type of writing. But it would be wrong to see endo-writers like Richard Wright, Henry Roth, James Baldwin, and Tillie Olsen as poor writers in comparison with the exo-writers who have become very well known.

It might make sense here to focus on a moment in a "classic" novel about poverty—*Mary Barton* (1848), by Elizabeth Gaskell. Gaskell, herself a writer from the well-to-do classes, is one of the first British authors, along with Frances Trollope, to write about the poor. In a telling moment in *Mary Barton*, a group of workingmen come to negotiate with the factory owners. Gaskell sets the scene by describing the men approaching the room:

> Tramp, tramp, came the heavy clogged feet up the stairs; and in a minute five wild, earnest-looking men stood in the room. . . . Had they been larger boned men, you would have called them gaunt; as it was they were little of stature, and their fustian clothes hung loosely upon their shrunk limbs. . . . [They wore] dilapidated coats and trousers. . . . It was long since many of them had known the luxury of a new article of dress; and air-gaps were to be seen in their garments. Some of the masters were rather affronted at such a ragged detachment.[62]

Here of course we see the required ideologemes or classemes in the sartorial description of the workingmen. Their physical appearance, unlike our contemporary view of hulking workmen, was more in line with a eugenic vision of a stunted, degenerated, and enervated race of humans. Gaskell, however, does not condemn their minds, as she adds, "The operatives had more regard to their brains, and power of speech, than to their wardrobes."[63]

Pertinently, the narrator does not describe how the "masters" are dressed since they are the degree zero of identity and most likely are in the same or a similar class as the projected reader of the novel. Gaskell occupies a particularly difficult role as a narrator mediating between labor and capital. She admits to being agnostic as to the benefits or demerits of the factory system when she says in her preface, "It is not for me to judge. . . . I know nothing about political economy, or the theories of trade."[64] Her goal as a novelist is to create "sympathy" between masters and men. To occupy this middle ground, she employs the classemes of ragged clothing while annealing that observation with a positive sense of the workingmen's minds and eloquence. This strategy may derive from Gaskell's religious sense of the equality of souls.

While the men are meeting, the ne'er-do-well son of one of the masters takes out his silver pencil and draws "an admirable caricature of them—lank, ragged, dispirited, and famine stricken." In drawing this picture, Harry Carson is essentially putting into visual relief the verbal description already provided by Gaskell. In this sense, he is a secret sharer of the narrator's art. Less willing to admit to the quality of their minds, Carson scribbles "a hasty quotation from the fat knight's well-known speech in [Shakespeare's] Henry IV."[65] In the speech referred to, Falstaff demeans his soldiers, calling them "scarecrows," "most of them out of prison. There's not a shirt and a half in all my company." Hal calls them "pitiful rascals," and Westmoreland replies, "They are exceeding poor and bare—too beggarly." Falstaff responds that they are "good enough to toss; food for powder, food for powder. They'll fill a pit as well as better." And he adds, "For their poverty, I know not where they had that, and for their bareness, I am sure they never learned that of me."[66] Falstaff's callousness about his impoverished soldiers is thus inscribed on and into Carson's drawing, a reflection of his equal callousness toward the workingmen standing before him. Carson then passed the caricature around to the other masters in the room, who "all smiled, and nodded their heads."[67] The assumed superiority of the masters, who have the shared cultural capital to recognize the quote from William Shakespeare as describing the worthlessness of the men before them, who are excluded from that circle of knowledge and power, is sobering.

When Carson tears the drawing in two and throws the two twisted pieces into the fireplace, "careless as to whether they reached their aim or not," we note his louche insouciance as to even the value of such ephemera.[68] However, one of the men notes what has transpired and retrieves the drawing. When he brings it before the original models for the caricatures,

those men react. One recognizes a friend "by his big nose" but also notes, "That's me, by G-d, it's the very way I'm obligated to pin my waistcoat up, to hide that I've gotten no shirt." While Carson has the details right, his decision to include embarrassing details of the men's poverty causes pain in those men.[69] "That is a shame, and I'll not stand it," says the person whose absence of a shirt has been rendered.[70]

John Slater, the man with the large nose, admits, "I could laugh at a jest as well as e'er the best on 'em, though it did tell again myself, if I were not clemming." Gaskell has her characters speak in the Lancashire dialect, in which *clemming* means "starving."[71] Here is a pivotal point—Gaskell herself has an unflinching eye and ear when it comes to depicting these men. While she recognizes the difficulty and even embarrassment of portraying what she sees, including a kind of guilty reference to her own actions in this scene, she nevertheless is doing her job as narrator. Slater's "eyes filled with tears; he was a poor, pinched, sharp-featured man, with a gentle and melancholy expression of countenance."[72] Is Gaskell trying to ameliorate her Carson-like description by her tribute to Slater's gentle countenance?

Slater continues, saying that the cries of his starving family haunt him, and will even if he were dead, so he "cannot laugh at aught." Reaching for the moral, Gaskell has Slater lament, "It seems to make me sad that there is any as can make game on what they've never knowed; as can make such laughable pictures on men, whose very hearts within 'em are so raw and sore as ours were and are, God help us."[73]

John Barton, Mary's father, who has become embittered by the treatment of the workingmen, then speaks. He begins by noting the improved economic conditions and the influx of orders, so that it made sense for the workingmen to approach the masters and ask for a raise in wages. Of those masters' refusal to raise wages, he adds, "One would think that it would be enough of hard-heartedness, but it isn't. They go and make jesting pictures on us! I could laugh at myself, as well as poor John Slater there; but then I must be easy in my mind to laugh. Now I only know that I would give the last drop o' my blood to avenge us on yon chap, who had so little feeling in him as to make game on earnest, suffering men." This bitter declaration is echoed by the assembled workers: "a low angry murmur" goes around, "but it did not yet take form or words."[74]

It is important to note here that the men are reacting to the caricature, not the words scribbled beneath it with Falstaff's condemnation of the poor. We know from the novel that John Barton, Mary Barton, and Wilson all can read. Thus, their lack of reaction to the words of Shakespeare

cannot be due to illiteracy. One can speculate that though they can read the Bible, poetry by the likes of the working-class poet Samuel Bamford, and the radical newspaper the *Northern Star*, there might be an issue around their cultural literacy. Shakespeare may well be considered impenetrable to the workingmen, although clearly understood by some of the masters. But the point I'd like to draw from this scene is that Gaskell herself might have some guilt around her own portrayal of the men in words. Therefore, she displaces, from language to visuality, her awkward position of chronicler to Harry Carson and his caricature.

We might want to remember that one of the complaints listed by Chartist journalists was the depiction of working-class people by the likes of Gaskell. A writer from the *English Charter Circular*, another radical newspaper, pointed out this problem: "Whenever sketches of the poor are given in any literary periodical, it is generally the composition of some clever, irresistible humorist, seeking to raise, it may be, a good natured smile, or even a broad grin at provincialisms; the peculiar habits and usage of trade, the eccentricities of individuals remarkable in some other mode than their poverty, but how rarely do we hear of the benevolence, the active sympathy, or charities of the poor."[75] One notes that the working-class writer here objects to the very kind of humor that Carson uses and sympathizes with the reaction of the working-class characters to that humor. More interesting is that the author here also complains about "sketches," which can apply to either words or drawings.

In either case, the workmen in *Mary Barton* may remain ignorant of the words of Shakespeare while taking the meaning of the verbal and visual ridicule to heart. In fact, in the plot they are driven to kill Harry Carson and draw lots to do so. John Barton draws the fatal lot and ends up murdering the son and heir of his own boss. As Gaskell points out, the image in question provokes an emotional reaction but no words.

The words that end up killing Carson are actually and literally those of Samuel Bamford, the working-class poet whose verse is included in *Mary Barton*. The paper on which one of Bamford's poems was transcribed is used as wadding in the gun that kills Carson. Perhaps this is a heavy-handed symbol of the power of words used in the wrong hands. And fittingly, the poem itself decries the lot of the poor. When John Barton hears this poem, he asks his daughter to copy it for him on a piece of paper. Mary writes the poem on the verso of a valentine given to her by Jem Wilson, a working-class man who loves her but is scorned, at least initially, by Mary in favor of the rake Harry Carson, who only intends to take

her virginity without offering marriage. (Bad guys in this kind of novel are often really bad in a variety of ways.) The logic of the novel's imagery is that the lack of attention to the poor, described by Bamford, is then the remedy to Carson's crude caricature of the workingmen. Gaskell, in effect, is killing the part of her that dares to write about the poor but doing so with the very means she herself is guilty of using—literary language.

This extended example from Gaskell's novel illustrates in detail the complexities around the idea of representing the poor. The representer is both exhibiter of the abuses against the poor and at the same time perpetrator of the same. Writing is not a neutral act, and any attempt to take no position automatically takes a position. Gaskell would like to condemn callous depictions of the poor, but she, unconsciously at least, supports that same act of harsh description in her authorial command. In effect, it is hard to get out of the car while you are driving it.

My point in this chapter is that representation is a complex process by which authors are chosen by reading demographics (and publishers who intuit the needs of that demographic) and then often present back to those publics their own set of expectations. These expectations can change over time and under various kinds of political and social pressures. Rather than thinking of representation as an act of authenticity, it might be more apt to think of it as a combination of responsiveness to a demographic (or demographics) and accountability to such. In addition, the presence in the authorial sensorium of ideologemes will precraft certain kinds of narratives by providing only a limited set of tools to build representations. In this case, stories about the poor will seem real or accurate only if they are filled with ideologemes that match readers' genre expectations. This "filling" is a sublimination of the inability of writers and visual artists to depict lack. Therefore, authors may not be in full control of the representations they present and therefore might be unrepresentative representers. Representative equality will then depend on the extent to the which the author or artist depicting poverty is dwelling with and justly representing not the expectations of middle-class and upper-class readers but the poor people to whom they are accountable.

Chapter Three
Transclass: Endo- and Exo- writers

I had a telling dream the other night that followed a visit with a couple who were comfortably wealthy. These friends own three homes and have refurbished each with the most up-to-date amenities. In my dream my male friend was a businessman who worked in some kind of high-finance arena, and the woman was a stay-at-home mom who was an artist. I was their domestic servant: my job was to assist them in routine household chores and repairs. I was happy to be of assistance and gladly ran and fetched things while doing minor household repairs.

In real life I am a college professor, not a domestic servant. But given my working-class background, this dream reflects that I unconsciously had felt unequal to my friends. This sense of being out of place is a hallmark of many excluded groups. In this case, I am a transclass émigré. I grew up in the working classes and now live in the middle classes. I mix with people of all classes, and I thought I had made the transition from one class to another. Isn't this the American dream? But in reality, as I've done the work for this book, I have come to see that one doesn't leave one's class behind. In fact, there is a rich seam to be mined about the experience of being transclass.

In researching and teaching about poverty, I came to notice that there were very few terms that didn't have a negative sense for someone who "rose up" from poverty to the middle or upper classes or "sank" from those classes. Think of words like *parvenu, social climber, class traitor, nouveau riche, déclassé,* and the like. This linguistic usage makes sense given that the ability to "rise" in class is a touted hallmark of success in capitalism. This ideology praises ambition and perseverance as qualities fueled by

competition and financial reward but also condemns the nouveau riche as being without manners or savoir faire. And that same ideology condemns those who "fall" in class for having failed in the economic struggle. When I mentioned this issue in a class, saying that we didn't have a term that wasn't negative for someone who had moved out of the working classes, one of my students said her French friend used the term *transclass*. When I looked the term up, I came across Chantal Jaquet, professor of philosophy at the Sorbonne, who wrote the book *Transclasses: A Theory of Social Non-reproduction*. As I will elaborate, the book gave me a way to rethink the complex process of moving across classes in the chronotope of one's life.

A pivotal moment in my coming to understand my transclass status happened in San Francisco in 1998. I was part of a Modern Language Association (MLA) panel that fled the usual Hilton-like venue and met, in an activist spirit, at a community center in the Mission District. The panel was about an edited book called *Liberating Memory: Our Work and Our Working-Class Consciousness*.[1] As the title of the book suggests, the goal of the editor, Janet Zandy, was to get a group of writers, artists, and academics to speak about how their working-class upbringing was still informing their lives. I read from my chapter, which was called ambivalently "A Voyage Out (or Is It Back?)." In the essay I was grasping for ways of proclaiming that I was still working class, but I clearly didn't feel I actually was. I noted my parents' survival skills but ended up recalling a childhood that was "spare, depleted, and grey," in which my parents, "exhausted by their work, had little time to enrich my life."[2] Getting into Columbia University and obtaining a PhD was the way "I abandoned my class and fled. . . . This was my voyage out."[3] And I ended on a cagey dodge about my class status: "I think it would be disingenuous to claim that I am still working class. There is a dialectic between the past and the present. The past is never effaced by the present. And like the unconscious, my class experience is perhaps the background radiation that informs daily action. But I do feel that I can never fully return to those origins. . . . The voyage out may contain a return, but it is never entirely a voyage back. And the desire to connect is often more about desire than connection, despite the will for desire and the will to connect."[4]

Now, as I read this, I can hear myself searching for a category that isn't part of the simple binary of working class/ruling class. A hand reached across the space between the folding chairs behind the table at which the speakers were seated and grabbed mine. It was the novelist Tillie Olsen, who had been sitting quietly next to me. Feelingly, she said to me, still

holding my hand, "Don't ever let them take that away from you. You're still working class." I'm not sure I accepted that, but I remembered the moment. She continued holding my hand throughout the rest of the session. There was something unsettling as well as comforting in her reassurance and her support. And something lovely and strange about the handholding with a famous author who was born the year after my mother. If I think about the moment now, I see that I was waiting for the term *transclass* to be invented, for my uncertainty and hesitancy to have a name. And I also could see that Olsen's very un-MLA gesture of comforting me physically was probably a trace of our working-class upbringing coming to be felt in the most visceral way. This uncertain position in the social structure—neither lower-class fish nor middle-class fowl—takes its toll and needs articulation, understanding, and desire.

...........

In my unconscious search for the term *transclass*, which did not yet exist, I can now hear that others were searching for that term as well. The editors of a 1993 book on working-class female academics wrote emphatically that "people do not pass out of one class into another, although their tastes, expectations, and habits may change as class identity shifts. Moreover, people raised in working-class families that have been subtly and consistently demeaned through America's class structure retain the scars of that experience."[5] Barbara Jensen describes being in both worlds: "I am a working class to professional middle class 'crossover'; or 'straddler.' . . . I have developed a dual vision in which I can't help but see things from the points of view of both of my classes."[6] Lillian Breslow Rubin, who wrote about being of working-class origins, noted, "But no matter how far we travel, we can never leave our roots behind. I found they claimed me at unexpected times, in unexpected places."[7] These writers are describing in reality the situation that Jaquet theorizes. The transclass reader or writer often does not feel empowered to tell or validate their own story. They often have trouble getting published and carry with them the feeling that they do not have the right to be published. As Darren McGarvey writes in his introduction to *Poverty Safari: Understanding the Anger of Britain's Underclass*, "People like me don't write books—or so my head keeps telling me. 'Write a book?' it sneers over my shoulder, 'you haven't read enough of them to even attempt such a thing.'"[8] This insecurity is echoed by other transclass writers like Valerie Miner, who complains, "I get cranky about what does get published and heralded, and angry about what doesn't. For writers from working-

class families, the making of art can be a cultural disenfranchisement, for we do not belong in literary circles and our writing rarely makes it back home. Those of us who write about our class heritage experience a variety of censorship and self-censorship."[9]

If, as I argue, only those from the poor and working classes, what I'm calling *endo-writers* and *endo-artists*, should create works about the poor, especially until negative stereotypes are solidly removed from the culture, the question is, How might this happen? It is extremely unlikely that poor people, even in the age of the internet and social media, could widely and effectively write works or make films and videos that would enter the mass market. While there are notable exceptions, often people who were able to get into university writing programs or film schools, the general rule applies. Indeed, one area in which some select few have had an effect is hip-hop and rap. Or we have the rare exception of a filmmaker like Barry Jenkins, who in *Moonlight* depicted his working-class, African American upbringing in Liberty City housing projects. Writers like Justin Torres, who wrote *We the Animals*, and Joseph Earl Thomas, author of *Sink: A Memoir*, are the exception rather than the rule (and both of them were admitted to prestigious writing programs). And exceptions actually don't prove the rule (they test the rule—as was the original sense of the word *prove*), and that rule is that the ruling class basically sets the agenda for art and uses its offspring to that end. One would think that the number of artists from working-class backgrounds would have slowly grown over the years, as opportunities and collective wealth increase. But in fact the number of working-class artists, writers, filmmakers, and the like has shrunk by half since the 1970s (at least in the United Kingdom).[10]

To try to remedy the poor's lack of access to a wider audience, middle-class and upper-class allies have tried to write about the poor. They have done this using several stratagems. One has been going undercover, which involves putting on the clothing of poor people, adopting their speaking style and general manner, going to live in their neighborhoods, and then writing about the experience "firsthand."[11] Another approach might be to simply live among the poor without the subterfuge, as did the African American writer Ann Petry, who grew up in wealthy, old-money Old Saybrook, Connecticut, but came to live in Harlem, where she observed the life she wrote about in *The Street*. I will discuss some prime examples of this kind of novel writing, reportage, and memoir, along with the positives and negatives of varying approaches.

But, first, I would like to approach the idea of transclass. Transclass by definition is an identity that has intersectionality built into it.[12] It might be better described by the term *trans-sectionality*. The transclass person is a Venn diagram of at least two intersecting circles, but one might want to add a diachronic element to the diagram as well. Jaquet says the transclass person is a Janus-like figure with one visage facing the class of origin and the other facing the current class. "Transclasses thus call into question the static principles of the division of individuals into clearly defined social categories and the postulate of a fixed identity, because it is very hard to assign them properties or qualities that lead to their being recognized as belonging to this or that class."[13]

The second part of Jaquet's book title contains the word *nonreproduction*, deploying Pierre Bourdieu's ideas about the inevitability of the reproduction of class. In Bourdieu's view one of the functions of class is to reproduce itself. Poor people raise children who will be poor. Rich people raise children who will be rich. Exceptions are always there, but the general rule applies more consistently than the specific exception. And yet transclass people do not reproduce the conditions under which they were born. This nonreproduction is tricky in terms of political theory because to the capitalist nonreproduction confirms that people can break away from their class of origin—in the well-used example of the "self-made man"—and indicates that those who remain poor either are lazy or have made bad decisions. To the Marxist, a transclass person is an irrelevant, anecdotal instance that in no way dissolves the rigidity of class structure. Jaquet doesn't want to weaponize or deplore the transclass but to study it and see what it is. Surprisingly few if any have done this type of analysis.

It might make sense to consider one other view of the transclass person—that of someone who has survived or overcome the injuries of class through resilience. Kenneth Oldfield and Richard Greggory Johnson III have compiled a collection of essays called *Resilience: Queer Professors from the Working Class*. This book, along with the one I appear in with Tillie Olsen, and three other books—*Strangers in Paradise: Academics from the Working Class*, *This Fine Place So Far from Home: Voices of Academics from the Working Classes*, and *Working-Class Women in the Academy: Laborers in the Knowledge Factory*—may constitute the complete collective opus of monographs or personal essays about being transclass academics and artists.[14] These works tend to emphasize how individual authors' gumption and stick-to-it-ness led them to make it through the hurdles of academic life despite their upbringing. As Oldfield and Johnson say,

"When the going got especially difficult, they used these support systems [books, school, work, family, or friends] to gain the sustenance necessary to continue. All these scholars triumphed over incredible odds to become academics. They survived because of their *resilience*. . . . We knew this word had to be in the book's title."[15] While I have no objection to giving credit to individuals' personal energies, I think the word *resilience* only gives fuel to the mythical "bootstraps" engine of capitalism. It seems to continue the old saw that the poor generally are lazy and therefore cannot make it out of their slough of poverty. But look at those few exceptions with resilience! These are a bit equivalent to the "overcoming" narratives we see so often with disabled people, who become mascots for persistence and fortitude that "normal" people like to read about.

In contrast to the individual-with-resilience argument, Jaquet notes that no one changes class by themselves. The pull-yourself-up-by-your-own-bootstraps theory of the capitalist is in fact false. It takes a village—including the involvement of parents, friends (both are mentioned by Oldfield and Johnson), sympathetic educators, unions, state sponsorship, programs like the GI Bill and Pell Grants, and the like—to accomplish a transclass move. Some poor writers have had the support of wealthy patrons who make possible a transition to visibility through writing and publishing. The Norwegian writer Knut Hamsum, who eventually won the Nobel Prize, was beholden to Erasmus Zahl, who provided funds that allowed Hamsun to leave the manual labor and itinerant jobs he had held to devote himself to writing. James Baldwin also was able to leave the crushing laborer jobs he had because of the mentorship of Beauford Delaney.

In my own case, a series of older teachers, mainly male, contributed to my transclass transition. These teachers formed a kind of bucket brigade bringing me from my Bronx apartment to the university. My own home was poor in literature and the arts with just a few paperback books (mostly salacious) bought by my older brother, which included not a single canonical work of literature aside from *Lady Chatterley's Lover*. The first older male to help me was Nathan Zuckerman, a podiatrist, who lived in our tenement and had an office a few blocks away in which, behind all the gouging and cutting tools of his trade, he had crammed rooms of electronic equipment from oscilloscopes to condensers and resistors. He was an organic intellectual of the first order and gave me free rein to tinker with radio parts and soldering irons. I made my first science project there. Then there was a nerdy neighbor named Sydney, who taught mathematics in the high school I was destined to attend and took me aside one day, as

I played on the garbage-strewn abandoned lot across from my apartment building, to tell me two things he thought important. One was that the whole was greater than the sum of its parts, and the second was to question everything, including what my teachers said. I didn't quite understand the part/whole paradox, but I did take to heart his notion of radical critique. The next person to take an interest in me was my primary-school principal, Sydney Nathan Levy. He headed the inner-city school I attended, which tried its best to educate us. I'm not sure why Levy paid attention to me; it might have been because he knew my parents were Deaf and probably was because he had decided I had promise but needed help. He knew I was interested in science and would arrange for me to come to his office, where he gave me books with experiments I could do at home. He introduced me to a friend of his who sent me lenses and instructions on how to make a telescope from cardboard tubes harvested from paper towel and toilet paper rolls. Levy and I had a secret signal we'd use when we passed in the hallway so the other children wouldn't be jealous. We would hold our pinkies aloft and give a subtle wiggle. This special treatment made me feel I was valued in the educational system. In my junior high school (our most illustrious alumnus was Lee Harvey Oswald), the first of my English teachers—Peter Poulakis—introduced us to poems like "Richard Corey" and "Sir Patrick Spens" as well as novels like *1984* and *Brave New World*. We were required to get a letter of permission from our parents to read these works, considered risqué at the time. Poulakis had grown up in the Bronx, the son of Greek immigrants; had a rich Bronx accent; and like me had attended public high school and then got an MA from Columbia. In high school another English teacher, Ronald Greenhouse, inspired me with his herringbone sports jacket and insouciant style. We read the typical New York State canon of books, including *A Tale of Two Cities* and *Ethan Frome* (the two novels most calculated to make you never want to be an English major). Another teacher who did not inspire me but advised me on college applications was "Doc" Bernhard. He ran his own shyster operation in the basement of the high school, where he directed the "college office" as well as promoted his private "Bernhard Tours" for rich Jewish girls from Long Island who wanted to see Europe. It was he who suggested I apply to Columbia, Princeton, Oberlin, and Harper College (which became Binghamton University SUNY). He also gave us elocution lessons where we learned to abandon our Bronx accents and say "choc-o-late" instead of "chawk-lit" and "van-i-lla" instead of "van-ella." He was trying to give us some cultural capital, as Bourdieu called it. Most of us

squandered that capital, but I worked hard to get rid of my accent, which caused problems with my friends, who saw me as affecting airs. When the diphthongs in *dog* and *water* disappeared, I sounded like a pretentious kid in my neighborhood. Changing the way one speaks is a serious issue for transclass speakers and writers. Part of the feeling of being disenfranchised comes from knowing that one's language could be a tell in one's attempt to erase class markers. Agnes Smedley in *Daughter of Earth* has the character Marie Rogers, a stand-in for the author, write that her working-class sister "resented my more cultivated speech as an attempt to 'show off,' for I had tried to correct my accent and dialect. Her resentment expressed itself in a scornful silence."[16] The class accent can work in the other direction when middle-class people transition to working class. The pseudonymous prostitute Madeleine Blair recalls that her "correct" English led her to become a "marked woman" among those working-class people with whom she associated, who thought her "stuck up."[17]

Although I have written a number of books, I can recall with shame and embarrassment every faux pas, grammatical mistake, and malapropism that survived editing and appeared in my works. (Look for some in this one!) For some writers of a different class, these errors would simply be errors. But for the transclass writer they are mortal wounds, the palpable signs and reminders of bad etiquette, bad education, and bad training. The class police will quickly call these out as disqualifiers for any of the content one has written. I recall painfully a colleague at one university I taught at, who took it on himself late one evening, as I was working in my office, to bring in the entire manuscript of my second book, which he had read as part of a tenure review, and painfully go through instance after instance of my solecisms. I'm sure (am I?) that he was trying to be helpful, but the effect on me was to crush me into the ground. He was telling me, in so many corrections, that I didn't belong in academia.

Shame seems to be inherently part of the transclass experience. Novels and memoirs about being poor abound with scenes in which the main character is shamed or made to feel shame by middle-class and rich people. The mother of the narrator of *The House on Mango Street* says, "Shame is a bad thing, you know. It keeps you down."[18] That shame, as I have admitted, goes deep and stays seared into one's consciousness and memory—even with the somewhat ineffective antidote of resilience and class consciousness. When Tillie Olsen describes her character Mazie Holbrook, a nine-year-old, venturing out of her poor neighborhood near the meat-processing plants with her mother and siblings, we get to see and feel

that shame. She describes how "a vague shame, a weedy sense of not belonging, of something being wrong about them, stirred uneasy through Mazie." The situation is compounded because Mazie's little brother, Ben, has to pee and is "clutching himself." Two middle-class girls who walk by "stared and snickered," which causes Mazie to snap at her brother, "Ben, get your hand away from yourself," while Ben himself bemoans his inability to ever get a tricycle like those he sees on the well-appointed front lawns. The shame worsens as Ben pulls on his mother Anna's skirt, and "[as she keeps] walking obliviously, her thighs came bared." A woman "putting on white gloves" smiles at them, and Mazie "quickly . . . moved between her and Anna, as if to protect her mother against something." Mazie's reaction of protecting her mother against a nameless but felt "something" fits into the category of being shamed for a class difference, which in this case is linked to her brother's and her mother's nakedness before the eyes of the exo-world. Mazie mutters, "Just you keep your face to yourself lady. . . . Old crummy Nicey Nice."[19] The white gloves, smile, and bourgeois respectability provide the protection for the overly nice but regulating control of the middle-class woman's gaze, which in turn dramatizes the family's nakedness. The world that condemns or is patronizing to her family creates this fog of shame to keep the ideological turfing from being seen clearly for what it is.

Agnes Smedley invokes an iconic scene of class embarrassment when Marie, the poor protagonist of *Daughter of Earth*, goes to a party of a schoolmate who lives across the tracks on the better side of town. Having no knowledge of how the richer half lives, Marie brings bananas to the event as a gift. Arriving, "I saw that other children had brought presents of books, silver pieces, handkerchiefs and lovely things such as I had never seen in my life. . . . I had to walk up before them all and place my three bananas there." The invidious comparison with the other children's clothing and lifestyles makes her feel "shamefully shabby," and her embarrassment increases when the children discover that she lives "beyond the tracks."[20] And scholar and psychotherapist Barbara Jensen recounts of her coming of age in the 1960s, "I was still ashamed of all the more intangible aspects of my upbringing—my speech, spelling, energetic and emotional personal style."[21] For these endo-writers, debilitating shame permeates the revelation of the class structure, in which the poor person is placed on the lowest floor of a very tall edifice.

I was well aware of this relational comparison in one sense and yet oblivious in another. I probably would have gone to City College like most

of my friends and my brother, were it not for Doc Bernhard's advice. My group of helpers at high school was significant because my parents were set against me applying to these colleges. My mother didn't want me to "go away." In fact, I ran away from home in protest and went to stay at my then-married brother's apartment until my parents relented. I paid for all my college applications myself from my bar mitzvah money and the cash I'd accumulated from working in the local watchmaker's shop because I didn't have their support.

Without their advice or coaching, I was at a bit of a loss and "failed" my Princeton interview. Actually, I more than failed the interview . . . I passed out. I had gone across the Hudson to visit the campus, which struck me as so alien to my life in the Bronx that it seemed both unreal and undesirable. I remember learning about the "eating clubs" and the mandatory "chapel requirement"—both of which repelled me. I remember noting and being amused that the squirrels on campus were black (unlike the gray squirrels of the Bronx) while the students were almost all white. My meager accumulation of cultural capital was sorely taxed by my interview with a Princeton alum who was a businessman in the 666 Building on New York's Fifth Avenue. I don't think I had ever been in an office of that type before. My idea of a workplace was the sweatshop where my father was employed. I was ushered in by the alum's secretary after a long (probably deliberately so) wait. The Princetonian was dressed in a dark suit and looked like he had stepped out of central casting for *Madmen*. I wore my herringbone tweed jacket (my style copied from my high school English teacher Ronald Greenhouse). We began chatting, but the discussion became political immediately. This was the 1960s, and rebellion was in the air—favored by the likes of me and opposed by men like my interviewer. He mentioned a recent news story about a young man who was a Catholic Worker and had set himself on fire in front of the United Nations to protest the Vietnam War. The alum asked what I thought. I said I thought the protester had a right to do that, and then my interviewer got very heated as he defended the war and pointed out that suicide was against the law. I muttered something about the protester not being able to be punished since he was dead, but my body reacted to this aggressive form of questioning by deciding to turn off the light switch and go to bed. I turned pale, the room began spinning, and I started to lose consciousness. Now the alum became concerned and asked if I was okay. I barely responded, and the interview ended. Was this the equivalent of a mouse going into shock when being batted about by a cat? I intuitively saw the interviewer as a custodian of

his class position, and I recognized that I would never be let through the ivory gate he was guarding. Like the protester, I was immolated there in his Danish modern office and reduced to a pile of ashes—and then unceremoniously swept out. Anthony Abraham Jack talks about the difference between poor kids who had gone through agencies like Prep for Prep and ended up in elite high schools and those who didn't. The former were able to handle situations like my Fifth Avenue interview, but those he calls "the doubly disadvantaged" lacked the familiarity and social skills that would allow a successful transition to an elite college.[22] That would have been me.

Eventually, I received acceptance letters from three of the four schools to which I applied. Princeton demurred to having a fainting freshman. I decided to go to Columbia. I don't think I really understood the cultural clout of Ivy League colleges, but Columbia was the closest to my parents, and since it was in my city, it was familiar. There I met two more teachers who would help me complete my transclass transition—Edward Said and Steven Marcus. It did take a village, of sorts, to bring me from a working-class kid of sweatshop, immigrant parents to the professor I am today.

The concept of intersectionality, as capacious as it seeks to be, has not yet fully comprehended the set of social complexities involved in the transclass experience. The fact is that we aren't looking at the intersection of categories like gender and race. The transclass is less of an intersection in a synchronic sense than a diachronic one. It might best be understood as a form of diachrony imposed on synchrony because transclass is the embodied legacy of history and culture as these are manifested in the current moment of a person.

There is an analogy between transclass and exile that is illuminating. As with a political exile, the transclass can never really go back to the locus of origin. As Edward Said noted in an interview about exile, "The state of exile is a pretty serious and unpleasant experience. I mean someone who has been sent away, banished from his or her native place. It was traditionally considered to be one of the worst fates. You could never return to your patria, your place of origin, your country, your native soil. And I think it's right to concentrate therefore on the dispossessions, the diminutions, the unhappiness of all that, the impermanence, the loss and so on." But in the case of the transclass, as with that of the exile, there is what Said called "an advantage." He saw that the "essential privilege of exile is to have not just one set of eyes but half a dozen, each of them corresponding to the places you've been. And, therefore, instead of looking at an experience as a single, unitary thing, it always has at least two aspects." Said calls this consciousness a type

of "doubleness" that allows a unique vision different from that of someone who lives and works in the place they were born. That doubleness allows for a vision that is necessarily "multiple and complex and composite."[23] Was Said citing or remembering or misremembering W. E. B. Du Bois's notion of double consciousness? Du Bois wrote, "It is a peculiar sensation, this double-consciousness, this sense of always looking at one's self through the eyes of others, of measuring one's soul by the tape of a world that looks on in amused contempt and pity. One ever feels his two-ness,—an American, a Negro; two souls, two thoughts, two unreconciled strivings; two warring ideals in one dark body, whose dogged strength alone keeps it from being torn asunder."[24] The confluence of racially and economically cleft existences creates this doubleness, which Du Bois might have seen as social alienation but which also can be seen as "an endowment."[25] Janet Zandy puts the issue this way: "The working-class writer has a heightened consciousness of the multiple 'we' inside the writer's 'I.'"[26]

The accurate representation of the experience of poverty needs the doubleness Said discussed to achieve a complex rendering of the dynamics inherent in being poor. Bourdieu, in his self-analysis, notes that he, coming from a lower-class background, could not do the kind of sociology that involves "loftiness, a social distance, in which I could never feel at home and to which the relationship to the social world associated with certain social origins no doubt predisposes."[27] The transclass writer "never feels at home," is always an immigrant, a go-between, and so is quite suited to be an interpreter of one world to another. Jack notes that in universities the transclass student lacks "a feeling of belonging in that place, a feeling that shapes your sense of who you are."[28] Said's doubleness, noted in the title of his autobiography, *Out of Place*, speaks to his sense of being between two worlds. That position gave him an advantage, and so he was able to critique the facile representation of "the Orient" to the Western world, which had created and promulgated those stereotypes. As Jaquet says, "Non-reproduction is not an individual phenomenon, but trans-individual."[29] That transindividuality allows for the in-betweenness of the writer, who must be dialectically in both worlds. The exo-writer has to search through the clichés and stereotypes and remember to bring the preformed mythemes of poverty to the already predisposed middle-class reader. The endo-writer has the simpler but, in a sense, more complex task of just remembering. By that I mean that the task of remembering is just that but also needs to be a kind of just remembrance in the sense of giving justice to those remembered. These conceptions are best embodied by

Mollie Orshansky, who created the poverty index still employed by the US federal government today. She grew up poor in the Bronx and once said, "If I write about the poor, I don't need a good imagination—I have a good memory."[30]

Is there a question of style in transclass writing and being? Jaquet notes that the transclass person never fits into social norms easily. Bourdieu recalls how his working-class origins show up in his writing and interventions. "Only slowly did I understand that if some of my most banal reactions were often misinterpreted, it was often because the manner—tone, voice, gestures, facial expressions, etc. . . . a mixture of aggressive shyness and a growling, even furious, bluntness, might be taken at face value, in other words, in a sense too seriously, and that contrasted so much with the distant assurance of well-born Parisians."[31] Bourdieu calls this a "cleft habitus" coming from a "dual experience" that highlights "a very strong discrepancy between high academic consecration and low social origin."[32]

Christina Sharpe, in her book *In the Wake: On Blackness and Being*, targets a similar sense of being in but not of the academic world. "It is a big leap from working class, to Ivy League schools, to being a tenured professor. And *a part of* that leap and *apart from* its specificities are the sense and awareness of precarity."[33] The precarity Sharpe refers to is that of living in the afterlife of enslavement, which includes "skewed life chances, limited access to health and education, premature death, incarceration, and impoverishment."[34] These diminishments are the result of racial discrimination and its resulting economic impacts. As such, she writes, "They texture my reading practices, my ways of being in the world, my relations with and to others."[35] For Sharpe as an African American transclass writer, her vision of the world is always based on a sense of precarity and the skewed life. She sees the world through this perspective, which specifically brings her a significant kind of insight as a result.

This sense of being in but not part of the academic world holds true for white working-class writers as well. Transclass writer Barbara Jensen recounts her college experiences, including being part of 1960s radicalism, as follows: "I was painfully aware that I was switching back and forth between two very different worlds . . . [as] I began to realize that the invisibility of working-class culture is part of the larger injustice of class in America."[36]

Given the specialized vision of endo-writers, what explains the widespread acceptance of exo-writers over endo-writers? The answer may be that most middle-class readers like to see confirmed what they already "know." Exo-writers give us the familiar collection of ideologemes and my-

thologies. But endo-writers who write "from within working-class experience can highlight gaps and oversimplifications."[37] Because of middle-class readers' expectations, the tone of the exo-writer feels right to the middle-class reader, and that of the endo-writer feels wrong, the emphasis jarring, the intimacy between writer and subject matter too great. To return to a transclass writer like Knut Hamsun, his novel *Hunger* is confrontational in its portrayal of a young writer who is starving throughout most of the novel. While an exo-writer might talk passingly of hunger, Hamsun's novel is obsessed with starvation. You feel the hunger pangs along with each turn of phrase. While starving, the nameless main character is trying to compose essays and a play. It makes sense that in his desperation he has a different vision from an exo-writer; he wants to write a literary work with "no wedding, no balls, no picnics."[38] His account is one of alienation and isolation in the midst of a thriving society. This transclass perspective, edged with the metaphor and yet reality of starvation—deprivation of the goods of society, place, class, and the like—is a likely one for a transclass writer observing the exclusionary mechanism of society from its periphery. This is why standard novels about poverty often ring false to the true denizens of that world. Lillian Breslow Rubin recalls a "classroom lecture about life in the working class that angered and puzzled me because it didn't sound like the world I knew of or the life I'd lived."[39]

The transclass person has not so much an identity as a (concealed) history that is constantly being reorganized and displaced like a crucial packet of index cards that can never be truly put in order. As Jaquet notes, the transclass is involved in the kind of passing (or not) performed by an ambiguously racialized person. While the identitarian passing is a kind of betrayal, as we see in novels like Nell Larsen's *Passing*, the transclass version of passing is less a betrayal than a modality to effect change. Or perhaps it is a necessary disguise since there are no alternative masks for the transclass writer.

Thus far we have been thinking of transclass as defining someone who had poor origins but was able to achieve a social status that allowed publication and dissemination of ideas, visions, art, literature, and the like. The trajectory we are describing is stereotyped as a moving "up" in class. The richer classes have enshrined metaphors into our language that give the sense that they are the upper classes, that one rises in class status. A preferable way to think of this spatially is to see that people move *through* classes, as Lillian Breslow Rubin has suggested.[40] Rather than go with the ideology that classes are rigid structures that give a sort of permanent iden-

tity to people, it might be better to think of classes the way transgender theorists have thought about gender. There can be many genders, and a person can move through them. Instead of thinking of the individuals who are born into the middle class or wealthier classes and then lose their money and status as falling, we might think of them as transitioning. Using the available language, we might see this kind of transitioning as a waxing and waning. Like the moon or the tides, which wax and wane, there is no optimal stage. Rather than valorizing wealth and denigrating poverty, as the rising/falling metaphor does, the waxing/waning one allows us to think of class in a more fluid way.

There are various kinds of exo-writers we might want to consider before thinking about waxing and waning transclass writers. There are the writers like Charles Dickens, Émile Zola, Stephen Crane, or Frank Norris who dissolve their own middle-class backgrounds into the voice of an omniscient narrator. If one takes that rhetorical strategy, there is no need to provide one's credentials, explain one's biases, or even do research. Zola, however, was very detailed in the type of research dossiers he compiled before writing a work like *Germinal*, his novel about impoverished miners. Often, he visited locations and talked to people, but as meticulous as he was, the entire time he took to gather his information amounted to barely a few weeks or a month, if that. Clearly, one can't have an intimate and inside knowledge of the coal miner in rural France with a seemingly touristic act of delving for facts and feelings. Ann Petry, whose grandfather had been enslaved, grew up in relative economic stability in a wealthy Connecticut town. Her father, her aunt, and she were pharmacists; her mother was a chiropodist and businesswoman. Her life in Harlem was a new experience for her, and this led her to observe and write about poor, urban Black people as an exo-writer. Her book *The Street*, while illuminating individual identities, gives us a familiar detail of an apartment that her protagonist Lutie is considering renting, advertised as having "parquet floors," which was meant to signal elegant living. However, "parquet floors here meant that the wood was so old and so discolored no amount of varnish or shellac would conceal the scars and the old, scraped places, the years of dragging furniture across the floors, the hammer blows of time and children and drunks and dirty, slovenly women."[41] The description continues to pinpoint a detail: "Steam heat meant a rattling, clanging noise in radiators early in the morning and then a hissing that went on all day." Such a detail of the sound sensorium would clearly bother an interloper into this world who came from a private house rather than a tenement, but for those of us

who grew up in such buildings, or at least for me, that sound was a great comfort and harmonic susurration of security. The main character, Lutie Johnson, "swallowed a laugh" at the poor, uneducated superintendent, who already at the beginning of the novel stands as a symbol for male sexual violence, and then realizes "she shouldn't be making fun of him, very likely he had taught himself to read and write."[42] The novel ends up turning Lutie into a murderer and sending her eight-year-old son to reform school. Petry's vision is that "the street" will inevitably corrupt even the best of souls. That view of the urban poor is definitely written from a lofty perspective.

Other kinds of exo-writers take their credentials from the act of going underground. Writers like Nellie Bly, Jack London, and George Orwell (the pen name for Eric Blair) donned a costume of poverty. All lived for limited periods in poor neighborhoods—Bly on the Lower East Side of New York; London in what he called "the Abyss" of turn-of-the-century Whitechapel, London; and Orwell in Paris and in various locations in the United Kingdom. Eric Schocket calls these "class-transvestite narratives," which he describes as "attempts to close epistemological gaps through cross-class impersonation."[43] Writers like Dickens and Zola "produce knowledge through the distancing rhetoric of the social spectacle." But class-transvestite narratives reverse this process, "producing authentic knowledge and performing authenticity itself, through the act of embodiment. . . . [They] construct cultural authority differently; control through strategic distance is replaced by control through strategic engagement."[44]

With these undercover exo-writers, there is a magical moment in which they feel transformed by the clothing they wear and almost believe that it turns them into working-class and poor people. Jack London, for example, decides he should wear a "costume" to fit in with the poor people of London on whom he will be reporting. He dons "rags," into which he sews a gold sovereign (an interesting metaphor for going undercover with the knowledge of financial safety and quick relief under the covers of the clothing). London continues, "No sooner was I out on the streets than I was impressed by the difference in status effected by my clothes. All servility vanished from the demeanor of the common people with whom I came in contact. Presto! In the twinkling of an eye, so to say, I had become one of them."[45] Magic indeed! Does London actually believe in his quick change? He writes, "My frayed and out-at-elbows jacket was the badge and advertisement of my class, which was their class. It made me of like kind, and in place of the fawning and too-respectful attention I had hitherto received, I now shared with them a comradeship. . . . In my rags and tatters . . .

[I] encountered men on a basis of equality. . . . For the first time I met the English lower classes face to face."[46] Here part of the problem with this class transvestitism is London's naive faith in how he is being received by the lower classes. Peter Hitchcock problematizes this feeling of instant knowing of the poor, saying that it "highlights the colonizing moment of a ruling class, because the identification at issue occurs as if proletarian subjectivity . . . is transparent."[47] If one looks at a photograph of London together with a lower-class interviewee (figure 3.1), the extent of London's disguise becomes a bit doubtful. Would clothing such as this completely transform him? Clearly, he is not dressed like a gentleman, but would other obvious signs of class come through to canny Cockneys? It is also worth noting that London looks with authoritarian confidence into the camera with a slight smile, while his poor companion eschews the prying gaze of the lens. Orwell, according to his friend, the humorist Malcom Muggeridge, deliberately imitated Jack London by "put[ing] on his proletarian fancy dress"— although, according to Muggeridge, the disguise did not fool anyone.[48]

Similarly, French artist Gustave Doré and English journalist Blanchard Jerrold went undercover to draw and report on the London slums. However, they were accompanied by two private detectives to protect them from the rabble. Doré is described as "dressed in some ragamuffin style or other, hurrying in and out of the streets and alleys, rapidly taking notes with the rarest precision—notes which served him for the composition" of his engravings.[49] His disguise could hardly have convinced locals that he was the real thing—what with his accompanying police escort and his furtive note-taking. The pictures in their book *London: A Pilgrimage* (see figure 3.2) give credence to the charge of contemporaries that the artist was "inventing rather than copying" and that he "never actually drew from life on the spot."[50]

Nellie Bly took a somewhat different approach in dressing down for an undercover assignment. Rather than disguising herself in rags, she decided to be part of the "deserving poor." As she wrote in her newspaper article, "My first intention was to dress poorly, so as to look as much as possible like those with whom I was to live, but on second consideration, I decided that I had never found any excuse for the dirty poor, and that if I was to be poor it was not necessary to be also ragged and dirty."[51] Clean or dirty, she had faith that her disguise would permit her entrance to the world of the poor without being noticed.

When George Gissing, another exo-writer who was downwardly mobile, what I am calling a *waning transclass* writer, attended workingmen's

3.1 Jack London (right) and unidentified man, London (1902). Alamy.

3.2 *Scripture Reader in a Night Refuge* (1872). Engraving from Gustave Doré and Blanchard Jerrold, *London: A Pilgrimage*. London: Grant and Company, 1872.

gatherings, he wore what he referred to as "my workman's clothing." He stated that he was wearing it "so much, I shall soon forget whether that or my more respectable suit is my proper attire."[52] Waning transclass writers' social position is so dubious it is not clear where they should be classified since they fall between the upper-class rearing they experienced and the current working-class existence they unwillingly entered. It is no coincidence that Gissing's second novel is actually called *The Unclassed*. In sum, the attempt of exo-writers or waning transclass writers to research the poor can often be, as Jack Conroy put it, full of "artificialities and falsities" inserted by "so-called proletarian writers, some of whom gathered their material from a short fling at factory or millwork during a college vacation."[53]

Given the magical thinking around the omniscient narrators' claim to give us an accurate view of the poor, there are not a lot of positive transclass characters in literature. Rather, we are more familiar with the parvenu, social climber, or self-made person Exo-writers are naturally suspicious of the transclass character because that person threatens to undo the recognizable features of class depictions. Often, transclass characters tend to be ridiculed by exo-writers in the stereotype of the obnoxious nouveau riche. The most iconic of these is Josiah Bounderby in Dickens's *Hard Times*. Dickens is widely regarded as an author who writes feelingly about poverty. Yet Dickens creates a monster in the seemingly transclass character Bounderby, who is mockingly sketched as a rich hypocrite constantly touting his impoverished upbringing. His Dickensian refrain is the repeated assertion that he was "brought up in the gutter." As Dickens describes him, he was "a man who was always proclaiming, through that brassy speaking-trumpet of a voice of his, his old ignorance and his old poverty."[54] If Bounderby is one of the few adult transclass characters available, we can tell that this subject was of limited interest to readers of the time. Later, with Horatio Alger and his young adult novels, we can see the transclass figure as a kind of modern picaro who uses his wiles to go from rags to riches.

It might help to look at the work of a few actual transclass writers. One eighteenth-century writer of letters was Ignatius Sancho, an African born on a slave ship bound for London. He grew up in poverty until he was brought into the household of the Duke of Montagu. As an adult, he wrote letters to many people, including Lawrence Sterne, and these were collected and published in a two-volume edition.[55] Tellingly, Sancho adopts the language and form of the eighteenth-century epistolary writer and discusses universal subjects, rarely if ever referring to his former poverty and upbringing. Olaudah Equiano is another African writer of the

period, whose book *The Interesting Narrative of the Life of Olaudah Equiano* recounts the difficult life the author led as an enslaved person. But the politics of poverty were not the subject of these writers.

For discussions of poverty, we might want to begin with Thomas Cooper. An autodidact, Cooper started out his career as a shoemaker and became a Chartist leader. His working-class origin and story inspired Charles Kingsley to base his novel *Alton Locke* on Cooper's life. Arrested in 1843 for his role in the Plug Plot, he spent two years in prison, in the course of which he wrote an epic poem and a collection of short stories.

In one such short story, "'Merrie England'—No More!" (1845), Cooper describes a disagreement between two workingmen. One declares, "I hope my lad will never steal and have to be sentenced to transportation. I've often heard him cry for bread, since he was born, and had none to give him; but I would sooner see him perish with hunger than live to hear him transported, for I think it would break my heart."[56] While one man opines that transportation would be a viable alternative, the other would rather die than be shipped off to Australia. The ensuing conversation takes these ideas seriously. Unlike many narratives by exo-writers, Cooper doesn't give the men working-class or regional accents. He allows them to speak standard English with a few substitutions, like *o'* for *of*. While he briefly mentions that the men are pale, ragged, and dejected, he does not harp on their physical condition. It is their thinking that interests the writer. The conversation quickly shifts to the men considering their subject position in society. Reacting to a mention of God, the men are skeptical that there is a God, recognizing the church-state structure that wants them to believe in providence, sin, and predestination as explaining their lot in life.[57] "'Well, I'm come seriously to the same conclusion,' said one who had not spoken before. . . . 'What purpose could a Being have, who, they say, is as infinitely good as He is infinitely powerful, in placing me where I must undergo insult and starvation, while he places that man,—the oppressor and grinder, who is riding past now, in his gig,—in plenty and abundance?'"[58]

The men discuss Jonathan Edwards, John Calvin, Armenian sects, and socialism with facility. These are clearly what Antonio Gramsci would later call *organic intellectuals*, by which he meant intelligent and learned people found in the working classes and among the poor who were autodidacts or products of communities of thinking people.[59] As Cooper notes, "But let it be understood that the heralds must be furnished with brains, as well as tongues; for whoever enters Leicester, or any other of the populous starving hives of England, must expect to find the deepest subjects of theology,

and government, and political economy, taken up with a subtlety that would often puzzle a graduate of Oxford or Cambridge. Whoever supposes the starving 'manufacturing masses' know no more, and can use no better language, than the peasantry in the agricultural counties, will find himself egregiously mistaken."[60] Worth noting is the drumbeat of "starving." As an endo-writer, Cooper is aware of hunger in a way that the exo-writer, obsessed with odors, cramped quarters, and violence, cannot be. Rather than the details of the impoverished, the transclass writer is more interested in ideas and sensations.

One might think that these men, especially when compared to the depictions of the poor by exo-writers of the period, were exceptional or particularly gifted. But Cooper wants us to know this isn't the case. "These, and similar observations, were uttered aloud, in the open street, at broad day, by hundreds of starved, oppressed, and insulted frame-work knitters, who thus gave vent to their despair."[61] And the cause for the oppression is clearer than those provided by Dickens in *Hard Times*, for example, who sees poverty as a universal and enduring state when he transforms Matthew 26:11—"The poor you will always have with you, but you will not always have me"—into a caution to his middle-class readers that if they deprive the poor of imagination and creativity, then "in the day of your triumph, when romance is utterly driven out of their souls, and they and a bare existence stand face to face, Reality will take a wolfish turn, and make an end of you."[62] For Dickens, the poor are "always with you," and the answer is to forget about their material conditions or their intellectual life and give them entertainment that will contain their animal nature and prevent them from revolting. For Dickens, the "good" poor are simple and morally virtuous despite their grimy and desperate surroundings.

Cooper, clearly, sees things differently. The poor don't need art, although that might be nice to have; they need politics. To a "piety monger" distributing tracts, one of workers talks about economics; the religious man "looked very sourly at me, and said the poor did not use to trouble themselves about politics in his father's time, and everybody was more comfortable then than they are now. 'The more fools were they,' said I: 'if the poor had begun to think of their rights sooner, instead of listening to religious cant, we should not have been so badly off now': and away he went, and never said another word."[63]

.............

Cooper is well aware of his transclass position. He knows that readers may not like to see the poor portrayed as intellectuals or as well-spoken in-

dividuals. Where are the familiar conventions of exaggerated and amusing language usage? Where are the mud in the streets, violence, alcohol, sexual license, and begrimed filth? All are missing, ruining the poornographic experience. In direct violation of narrative convention, Cooper notes that there is no tidy ending to his story: "There is no 'tale' to finish about John or his lad, or Jim and his wife. They went on starving,—begging,—receiving threats of imprisonment,—tried the 'Bastille' for a few weeks,—came out and had a little work,—starved again; and they are still going the same miserable round, like thousands in 'merrie England.'"[64] In a postscript written about thirty years later, Cooper is aware that "the foregoing sketch may be read with unpleasant feelings, by some who open these pages." He offers no solace but says "that Truth demands its insertion. History—when it is duly written—will have to tell of these miseries of working-men in the past, and of the dread unbelief to which misery and despair drove them."[65] As an endo-writer, he cannot produce the tale required by middle-class readers. Instead, he offers the particularities of economic improvement as a resolution that transpired in those thirty years.

Cooper, as an endo-writer and transclass writer, has a very different point of view from his contemporary exo-writers like Elizabeth Gaskell. Her two canonical works about the lives of the poor are *Mary Barton* and *North and South*. In the latter, the working classes are placed in the novel to frame the story of Margaret Hale—a middle-class woman whose father renounces his comfortable position as parish minister in a rural area because of a crisis of faith. He moves his family to Milton (read Manchester), where he tutors a factory owner named Thornton who wants to improve himself through education. While some poor families play ancillary roles as objects of charity and then examples of how the working class suffers during strikes, the story is really framed between the utilitarian role of the male factory owner and the moral role of the woman. A climactic scene occurs when the strike turns dangerous and a rock is thrown at the factory owner, who is saved when Margaret places her body between his and the missile. Tellingly, as many have noted, the mob is described as a force of nature rather than individualized people. The resolution of the novel is that Margaret marries Thornton and creates a new type of factory that is kinder and more caring. Capitalism with a smiley face is the needed resolution for this exo-writer—a very different perspective from that of Cooper.

At the same time as the endo-writer Cooper was jailed, a twenty-two-year-old upper-class German arrived in Manchester to take up a job as a bureaucrat in his father's cotton-thread factory. Friedrich Engels over the

next two years wrote his now-famous *The Condition of the Working Class in England.* Clearly someone from the wealthier classes, Engels was the first of the undercover writers considered here. While working in his father's factory, he prowled the streets of Manchester, took notes, and engaged with the proletarians there. In addition, within a short time he began a relationship with Mary Burns, a mostly illiterate Irish woman. She appears to have been his lover and probably his facilitator in meeting and living with the working classes in Manchester.

Much has been speculated about Engels's relationship with Mary Burns and her sister, Lizzie. Engels continued what was certainly a sexual relationship of twenty years with Mary until she died, then subsequently lived with her sister, whom he married within hours of her own death. Although Engels lived with the sisters, he always maintained his own lodgings in a more respectable part of town.[66] But it seems clear that his understanding of Manchester working-class life was conditioned by the Burns sisters. After Lizzie died, Engels wrote to a friend, "My wife [as he called her in this letter] was also of genuine Irish proletarian blood and her passionate feeling for her class, a feeling that was inborn, was of far greater value to me and has been a greater standby to me at all critical junctures than anything of which the priggishness and sophistry of the 'heddicated' [educated] and 'sensitive' daughters of the bourgeois might have been capable."

Although many have written about Engels and Mary Burns, for the purposes of this discussion of allies, I want to elaborate a few points about this connection. Although we have almost no information about Mary Burns, it seems possible that she was, as were so many laboring women, a woman who exchanged sex for security and who essentially became a kept woman under Engels's protection.[67] We can imagine that a young German haute bourgeois like Engels with a noticeable accent and imperfect English syntax would have some difficulty entering a British working-class culture without help. He acknowledges such, saying, "My English may not be pure, yet I hope you will find it *plain*."[68] Yet Engels writes boldly in the dedication of his book to "the working classes of Great Britain":

> Working Men! To you I dedicate a work, in which I have tried to lay before my German Countrymen a faithful picture of your condition, of your sufferings and struggles, of your hopes and prospects. I have lived long enough amidst you to know something about your circumstances. . . . I wanted more than an mere *abstract* knowledge of my subject. I wanted to see you in your own homes, to observe you in your everyday life, to chat

with you on your conditions and grievances, to witness your struggles. . . . I have done so. I forsook the company and the dinner-parties, the port wine and champagne of the middle classes, and devoted my leisure hours almost exclusively to the intercourse with plain Working Men.[69]

We may think of Engels as writing this book undercover. Engels, Nellie Bly, Jack London, Stephen Crane, George Orwell, and others are all convinced that there is no problem in their forays into the "abyss" of the poor. For them, simply being there, and in some cases dressing like a poor person, is enough to gain them access to the reality of life among the poor and enough to give them the credentials to write about the experience unproblematically. If we look carefully at what Engels writes, we have to wonder about his rather broad claims. Engels qualifies his observation by saying he knows "something" about the circumstances. He doesn't say he fully blended into the world he is observing. Rather, he says he saw people in their own homes and then notes that he observed, chatted, and witnessed. He adds a kind of rueful praising of his own abstinence in giving up the enjoyable pleasures of middle-class life—dinner parties, especially focusing on wine and champagne. We do know that the younger Engels once wrote that if he could live his life as he wanted, he would give himself over to sex and prostitution.[70] Indeed, one of his first disheartened observations upon arrival in Manchester concerned the female factory workers in his father's mill. "I do not remember to have seen one tall, well-built girl. They were all short, dumpy, and badly formed, decidedly ugly in the whole development of the figure."[71] We can imagine this might have been, to him, a rather big penance to pay. And in a very middle-class way he notes that his "leisure hours" were given over to "intercourse" with working people. The idea of his having leisure time, as a member of the leisure classes, signals a point of view probably not held by those he observes.

Yet is Engels an ally? He clearly devoted himself to Burns, although he was not married to her nor faithful. But he felt comfortable living with her in the way he had designed. He wrote to Karl Marx, "I live nearly all the time with Mary so as to save money. Unfortunately I cannot manage without lodgings; if I could I would live with her all the time."[72] Engels's regret was that the powers who controlled his life, "the philistines," as he called them, found out that he was living with Mary, and so he had to take lodgings and maintain a double life.[73]

He had spent twenty-one months in England before he wrote his magnum opus. This certainly is much more time than the average undercover

writer spends, but given the ambitious aim, was it enough? In his dedication he clearly places himself as a class traitor, reviling the middle classes. He writes that he is "a foreigner to *them* [the middle classes], not to *you* [the working classes], I hope." His almost wistful "I hope" asks the English working class to accept him as one with themselves and situates at least his stated desire to be an ally. A question is whether this kind of cohabitation combined with political will and ideological commitment can create an ally whose writing might be in some sense compared to that of a transclass writer.

While we can appreciate Engels's lived experience with the poor, we must also understand his larger project. His work is meant to be a detailed, statistic-laden study of the working classes very much in line with the kind of discourses of knowledge described by Michel Foucault in *The Order of Things* as the beginning of the human sciences.[74] In the end, Engels is observing the poor, collecting materials and data, so that the middle-class German activists can be informed and take action. As he writes, "The real conditions of the life of the proletariat are so little known among us that even the well-meaning 'societies for the uplift of the working classes,' in which our bourgeoisie is now mistreating the social question, constantly start out from the most ridiculous and preposterous judgements concerning the condition of the workers."[75] In doing so, he focuses on his compatriots. "We Germans more than anybody else stand in need of a knowledge of the facts."[76] The book, then, is not meant for those it is written about. And not a single informant or even individual is named. Even if they were, they couldn't have read the book, if they could read, because it was not translated into English until 1885, some forty years after its German publication.

Why study the working class in England rather than in Germany? For Engels and Marx, England was the perfect laboratory to observe the beginning of a new class of workers—the proletariat. Engels uses the word *classical* to talk about these perfect conditions: "A description of the classical form which the conditions of existence of the proletariat have assumed in Britain is very important . . . [because] German Socialism and Communism have proceeded . . . from theoretical premises."[77]

If the exo-writer has certain obsessions and foci for their writing, Engels does seem to agglutinate those types of observations. As the first person to write a very long treatise on poverty, Engels is either setting a pattern that others will follow or shares with other exo-writers the themes of the genre we are describing as poornography. First and foremost are the

adjectives that litter the work and that show up regularly in poornography. In no particular order we see these words in Engels's work:

filthy
horrible
hideous
repulsive
shocking
stench
verminous
grimy
misery
foul-smelling
refuse
offal
hateful
ragged
vile
smoke-begrimed
old
ruinous
degrading
disorderly
narrow
crooked

In the section called "The Great Towns," Engels particularly dwells on the living conditions of the poor. As we read, we can acknowledge the degraded life imposed on poor people, but we also have to wonder a bit about the impact of such modalities of living on the middle-class and upper-class writers and readers. When Engels gives us the following description, we have alternate ways of parsing it.

True, poverty often dwells in hidden alleys close to the palaces of the rich; but in general a separate territory has been assigned to it, where, removed from the sight of the happier classes, it may struggle along as it can. These slums are pretty equally arranged in all the great towns of England, the worst houses in the worst quarters of the towns. . . . The streets are generally unpaved, rough, dirty, filled with vegetable and animal refuse, without

sewers or gutters, but supplied with foul, stagnant pools instead. . . . Further, the streets serve as drying grounds in fine weather; lines are stretched across from house to house, and hung with wet clothing.[78]

While this description is daunting, it is framed as a revelation to the "happier classes" who may not have encountered the degradation Engels points to. On the other hand, his abhorrence of the lack of sewers or gutters may be a foreigner's perspective since England at this point had not developed municipal sewer systems. We tend to forget that even the rich had to dispose of their excretions by fairly crude methods. Engels's pointing to the hanging out of wet laundry seems more an aesthetic issue than a practical one and will become a hallmark of poornographic writing about lower-class dwellings.

By contrast, to take an endo-writer's perspective about a hundred years later and in another country, Piri Thomas defends the hanging of wet laundry in his Spanish Harlem neighborhood, speaking against people "who complain that clothes on the front-side fire escape make the block look cheap. . . . I liked it; I thought it gave class to the front fire escapes to be dressed up with underwear panties, and scrubbed work clothes."[79] It is ironic that the very symbol of cleanliness, "scrubbed work clothes," becomes, in the eyes of the exo-writer, a symbol of poverty with its association of uncleanliness. Will Eisner, in his graphic novel of tenement life in the Bronx in the 1940s, liberally depicts hanging laundry, but as one illustration shows, the clothesline was less an iconic symbol of poverty and more an actual line of communication. Two women are talking to each other over interconnecting clotheslines as Eisner writes about "what community spirit there was."[80] This is more than a matter of taste. It is a defense of habitus and a critique of the bourgeois assessment of the poorscape.

Engels goes on to describe a neighborhood called the Rookery, located in St. Giles in London. "It is a disorderly collection of tall, three or four-storeyed houses, with narrow, crooked, filthy streets, in which there is quite as much life as in the great thoroughfares of the town, except that, here, people of the working class only are seen."[81] The word *disorderly* along with *crooked* crops up a lot in Engels's observations. What seems objectionable to him is that there are no straight lines nor any sense of urban planning. Again, this jagged and narrow structuring of architecture is a feature of many older cities. Engels, a young reformer, might have had visions of Paris or Berlin as they were being rebuilt at the moment, with grand avenues and boulevards engineered with a unity of vision that was characteristic of a new kind of urban planning, best known by the work of Baron Georges-

Eugène Haussmann in Paris. Yet the "quaint" particularity of London's and Manchester's older city streets had been lovingly described by many writers. Are we dealing with a cultural clash in the view of a "modern," progressive foreign visitor?

Engels shows us a vegetable market with a clutter of baskets that make movement difficult and fish stalls from which arise "a horrible smell." Indeed, one can imagine that fish stalls would smell bad in a world without refrigeration and sanitation. But is this so unusual? He builds up to the narrow courts that run off the bigger streets,

> in which the filth and tottering ruin surpass all description. Scarcely a whole window-pane can be found, the walls are crumbling, door-posts and window frames loose and broken, doors of old boards nailed together, or altogether wanting in this thieves' quarter, where no doors are needed, there being nothing to steal. Heaps of garbage and ashes lie in all directions, and the foul liquids emptied before the doors gather in stinking pools. Here live the poorest of the poor, the worst paid workers with thieves and the victims of prostitution indiscriminately huddled together, the majority Irish, or of Irish extraction, and those who have not yet sunk in the whirlpool of moral ruin which surrounds them, sinking daily deeper, losing daily more and more of their power to resist the demoralizing influence of want, filth, and evil surroundings.[82]

While of course one wants to acknowledge the difficult living conditions of the poor, it is also important to note a virtual obsession with these conditions, which make up a consistent theme of middle-class writers who come into these neighborhoods. What strikes them are the structural aspects of life—the buildings, the disrepair, differences in methods of disposal of refuse, odors. There are no people here, only a litany of horrifying things. The rhetorical tone is one of shock and moral outrage, if not superiority. Engels, although possibly living with a prostitute, in his public writing has little or no sympathy for prostitution, seeing it as simply allied to thievery. The implication that the Irish are somehow connected to all this brings in issues of racism. All this culminates in "moral ruin," which is simply and causally associated with living in this inferno.

The main point here is that the middle-class writer is drawn to the superficial aspects of the poor neighborhood that can be seen quickly, sniffed uncomfortably, and then written about quickly. What is needed is the insight of the endo-writer, and since that writer, being poor, has little access to publishing, the responsibility falls on the waxing transclass writer.

In addition to the quick look and the quick sniff, the exo-writer often unconsciously relies on the work of other poornographers. For example, Engels, operating under very different standards of proof than we might have now, says in a footnote that after he had written his account, he came across an article called "The Dwellings of the Poor, from the Notebook of an M.D.," in the *Illuminated Magazine* of October 1844. The article, asserts Engels, "in many places almost literally and everywhere in general tenor—[agreed] with what I had said." He uses the article as proof of his own accuracy, if one might doubt him. But the article, it is worth noting, itself refers to another authority—Charles Dickens—as a source. *Oliver Twist* had been published in 1838, and the author of the article, M.D., opens, "We shall not readily forget a stroll, we had in company with a friend one Sunday morning in July last. We had left the country to visit some of the scenes made classic by the writings of Dickens."[83] Interestingly, the writer uses a principle of selection, envisioning London through Dickens's eyes, in confronting the confusion that makes up the environment of the poor. One could say he was engaging in a form of slumming or sightseeing. M.D. and his friend, both living in the comfort of the countryside, retrace locations from Dickens's novel, particularly Saffron Hill, where Fagin and his crew were depicted as living. The easy transition from the imaginary of Dickens to the streets of Holborn and environs creates the need to describe in genre terms. Obligingly, M.D. then gives us what we (and Engels) expect:

> Houses had no back yards to them; all the debris of the apartments, or nearly so, was thrown from the windows into the streets, to ascend again as a pestilential vapour; scarce a window-frame had a whole piece of glass in it; the doorways were low and dirty; the sides of the walls were formed simply of lath and plaster, parts of which had fallen away in many places, and through these dilapidations men and women could be seen huddling together, some in a state of nudity, others smoking and drinking, and all regardless of the common decencies of life.[84]

As he continues, he pinpoints "an old woman, clad in a thread-bare vest, which had faded away to the most delectable of all colours, a yellowish green, was sitting alone on the muddy ground in the centre of the court." She is clearly mentally distressed but is described in a sarcastic way as "a maniac only capable of uttering . . . broken sentences."[85] She becomes, in the writer's narrative, a kind of fantastic literary character reminiscent of other mad people in Dickens's novels. "Laying hold of my waistcoat, [she] said 'Pretty—Very pretty—Too pretty for Poll.'"[86]

As the country visitors go on, "two policemen told us that if we went a few paces we 'should see a sight'": a courtyard with horses, one of which had died. "The stench there was insufferable; it crept like poison through every sense. My companion felt sick, giddy, and incapable of proceeding."[87] Without belaboring the point, the description tells us that visitors to this neighborhood were not uncommon, since the police relate to the two observers by giving them more instructions to find the outré sights and sounds that are characteristic of poornography.

Indeed, a whole industry relies on the exo-writers influenced by each other. Guidebooks to "Dickens' Land" include visits, like those of the above writer and his friend, to locations like Saffron Hill, where Oliver Twist was held in captivity by Fagin. These guidebooks repeat the descriptions written by Dickens, creating nothing less than an ideological Möbius strip that seamlessly moves from literary description to nonfiction accounts and back again. Robert Allbut in his 1899 guidebook *Rambles in Dickens' Land* includes a description that neatly maps onto *Oliver Twist,* Engels's descriptions, and that of the account by M. D. from the *Illuminated Magazine.* "Returning to Great Saffron Hill, we may recall its description as given in the days of 'Oliver Twist': 'The street was very narrow and muddy, and the air was impregnated with filthy odours. The sole places that seemed to prosper amid the general blight of the place were the public-houses, and in them the lowest orders of the Irish were wrangling with might and main. Covered ways and yards, which here and there diverged from the main street, disclosed little knots of houses where drunken men and women were positively wallowing in filth.'"[88]

While I don't want to downplay the difficult living conditions of the poor, we can't treat these writings of middle-class visitors as objective or ones that people living in poverty would feel resonated with their world-view. These exo-observers come to such areas with a point of view, a notion of what to notice and what not to notice. And they are influenced by past writers who have defined and honed the genre. It is telling, for example, that Henry Mayhew began the research for his book *London Labour and the London Poor* by going to the location Jacob's Island, which Dickens had described as Fagin's playground in *Oliver Twist.*[89] Exo-writers tend to focus on the physicality of the area, which often hits them in an unaccustomed way. Endo-writers, who have grown up in these conditions, see them very differently. To put it concisely, a fishmonger isn't going to be disturbed by the smell of fish while a visitor to a street market might be.

There is no interiority given to the poor by the casual observer—all is based on the superficial observation of surroundings. Who are the people living in the neighborhood? Do they have individuality? Do they have individual histories that matter? Do they have love, aspirations, and trivial concerns of daily life? These are not the concerns of poornography written by exo-writers.

Even writers of color who come from wealthier circumstances can fall prey to the poornographic impulse. African American writer Amelia Etta Hall Johnson opens her novel *Clarence and Corinne; or, God's Way*, originally published in 1890 by the American Baptist Publication Society, with such a poorscape: "On the outskirts of the pretty town of N___, among the neat vine-covered houses, like a blot upon a beautiful picture, there stood a weather-beaten, tumble-down cottage. Its windows possessed but few unbroken panes, and rags took the place of glass. . . . Dismal as was the outside of this wretched abode, still more so was the inside."[90] This is followed by paragraphs of more detailed description of the interior with accumulating adjectives: "rickety," "broken," "rough," "begrimed," and the like, along with the drunken, violent father and the depressed slattern mother—all of which carry the moral opprobrium that will ultimately be removed by hard work and religious devotion.

Interestingly, one area exo-writers rarely if ever touch on is who owns the rookeries and slums that such writers are drawn to. The poor seem held responsible for their own living conditions, but we know that the owners of the poor's housing were middle class and often rich. Indeed, the poorest dwellings could actually generate a serious income when you factor in the multiple rents coming from the numbers of people who lived in such crowded dwellings. Exo-readers and exo-writers were less interested in their own culpability and more fascinated by the details of poverty and deprivation.

The poor neighborhood takes on an aura of mystery and fascination by the mid-nineteenth century. As one historian of slums notes, "The slum was a sensation. What had existed for centuries and what had been a reality of the Industrial Revolution and the early urbanization of Great Britain was now to be seen as something spectacular." Such locations possess an air of "unreality and a sense of danger for those outside them and who only read of them."[91]

We can feel a change in point of view if we look at the writings of Ben Brierly, an endo-writer born in Manchester who worked as a weaver, among other trades. Unlike the barely outlined poor in these exo-writers'

accounts, Brierly developed literary interests at an early age. He and his friends organized a self-help group to buy used books and read them, all the while trying to write verse.[92] We don't find such characters as Brierly in exo-writers' novels or descriptions. Brierly, aware of this state of affairs, contradicts the genre requirements of poornography, stating, "Those writers who have represented Lancashire as nothing but a vast cinder-heap . . . have gathered . . . impressions . . . where, in busy times, the clank of hammers, and the grinding of wheels, is heard through the thick smoke which hangs like a perpetual cloud over them. But Lancashire hath brighter places than these." Brierly then imagines one of these exo-writers disagreeing, "I have visited the metropolis . . . and nowhere for miles, east, west, north, or south of that black hive have I found anything but the dust and grease of mechanical labor, with collateral hardness of human exterior, as if your manhood was a combination of wheels and pulleys and straps, and human thought generated by steam." Brierly responds to this imaginary exo-writer, "If literary men have sought out these places, wherefrom to glean a knowledge of Lancashire character, they have made a mistake." He further implicates these literary types in creating a kind of poornography. "They might as well have gone to 'Wessex' or Tipperary, or to those dark haunts where Dickens found his Cockney low life."[93] His criticism of exo-writers is that their principle of selection has become predicable and that the roots of this predictability might be found in that factual-fictional world of the novel. By saying that these writers may have gone to "Wessex," he is pointing to the nonexistent world created by Thomas Hardy. And he drives his point home with the reference to Dickens.

Charles Dickens tends to give us working-class people who either are in "a muddle" about the economic and trade-related conditions that govern their lives or are portrayed as violent, angry, or childlike. On the other hand, endo-writers like Cooper and Brierly show us greater intelligence and subtlety than the demands of poornography require. We might recall Engels's comments on learning of working-class intelligence: "At first one cannot get over one's surprise on hearing in the Hall of Science [in Manchester] the most ordinary workers speaking with a clear understanding on political, religious, and social affairs; but when one comes across the remarkable popular pamphlets and hears the lectures of the Socialists, for example Watts in Manchester, one ceases to be surprised."[94] And Joseph Jekyll's introduction to the letters of Ignatius Sancho reminds his eighteenth-century readers that art, philosophy, intelligence, and the like are not confined to rich, white Britons but are shared by Africans because

"the perfection of the reasoning faculties does not depend on a peculiar conformation of the skull or the colour of a common integument."[95]

Given the prevalence of books and writings by allies and the established norms for writing about the poor, transclass writers, then, have a difficult position from which to work. Either they fit the stereotype assigned to them and their class, and thus render a preformed, knowable world that is familiar to the exo-reader. Or they present an alternative world in which thinkers, artists, politicians, and activists exist with all the complexity those endeavors contain. That dilemma is presented in George Gissing's 1880 novel *Workers in the Dawn*, in which his main character, Arthur Golding, is faced with an internal choice between being an artist and being a political activist. For Gissing, you cannot be both. This choice is presented to Arthur in the context of the "stirrings of a double life."[96] That notion of a doubleness of vision and purpose, which we noted earlier, is very much connected to the dilemma of the transclass position. Gissing observes that the "two distinct impulses seemed to grow within Arthur Golding's mind with equal force and rigidity," yet "their co-existence was incompatible with the perfection of either."[97]

Gissing was a waning transclass writer. He grew up in a middle-class environment and through a combination of personality and happenstance spent most of his life barely surviving by his literary efforts and tutoring. As with Engels, Dickens, London, Bly, and Orwell, he is known as one of the go-to writers if you want to know about the urban poor in England. Thus, he is another exo-writer who has achieved expert status on poverty. His vision of the poor is right in line with that of the other writers of the era. His descriptions are filled with the words we have come to know— *hideous, horrible, disgusting, dirty, filthy, brutal, drunken*. These dregs of the poverty lexicon ooze through his work consistently. But unlike some of the exo-writers we have seen, Gissing actually lived in lodging houses in poor neighborhoods for much of his life. Thus, he had the daily lived experience of the poor, but unlike endo-writers, he had mainly contempt and revulsion for the lives of those around him.

Given that experience, Gissing is torturously torn in his writing between the exo-, endo-, and transclass worlds. In Gissing's fiction we often see a male protagonist muddled between an impulse toward the aesthetic and (what he sees as) a contradictory impulse toward social and economic justice. In the novel *Demos: A Story of English Socialism*, Gissing builds a narrative and architectural structure to illustrate this dilemma. Richard Muttimer and Hubert Eldon stand respectively for the working classes

and the upper classes. Through the machinations of a lost-will narrative, the working-class Muttimer inherits a manor house and a factory that goes with it, while the gentry-connected Eldon is disinherited from the same. As Muttimer institutes his socialist plans to make the factory a fair-wage and housing location, he develops the arrogance and complacency of the upper classes. Gissing wants his reader to relish and cringe at the excesses of the nouveau riche transclass capitalist. At the same time, Eldon as a waning transclass character devotes himself to the arts and to the natural world. Meanwhile, Muttimer destroys and wastes nature by expanding his factory in a formerly Edenic British countryside. These two protagonists, of course, vie for the affections of the same woman.

A waning transclass US writer was Fanny Fern, born as Sarah Payson Willis Parton into a wealthy family; the death of her husband and her family's unwillingness to support her and her children led her into poverty for several years. Ultimately she became a journalist and was the first woman to have a regular column in a newspaper, eventually becoming the most highly paid such writer in the country. Her poverty experience, therefore, represents a low point in her life and career. As such, her signal novel *Ruth Hall* takes a waning transclass writer's viewpoint on being poor. The protagonist, Ruth, follows the same trajectory as the author and ends up living on the wrong side of the tracks.

A classic poornographic description frames her new dwelling: "In a dark, narrow street, in one of those heterogeneous boarding-houses abounding in the city, where clerks, market-boys, apprentices, and sewing-girls, bolt their meals with railroad velocity; where the maid-of-all-work, with red arms, frowzy head, and leathern lungs, screams in the entry for any boarder who happens to be inquired for at the door; where one plate suffices for fish, flesh, fowl, and dessert; where soiled table-cloths, sticky crockery, oily cookery, and bad grammar, predominate; where greasy cards are shuffled, bad cigars are smoked of an evening you might have found Ruth and her children."[98] While unappetizing, this description implies that there is a better way to live, with specialized domestic servants and better cigars. This is clearly a fall from grace for the heroine and her children. Her former friends are appalled: "Ruth couldn't live in such a place as this. Just look at that red-faced Irish girl leaning out of the front window on her elbows. . . . [I]f Ruth Hall has got down hill so far as this, *I* can't keep up her acquaintance; . . . faugh! Just smell that odor of cabbage issuing from the first entry. Come, come, Mary, take your hand off the knocker; I wouldn't be seen in that vulgar house for a kingdom."[99] Across the street, a tenement

is "full of pale, anxious, care-worn faces—never a laugh, never a song—instead, ribald curses, and the cries of neglected, half-fed children." Many of these hapless denizens are doing piecework at home for a "Jewish owner [who] reaped all the profits."[100] Clearly, we have an exo-view of poverty from a writer who dipped into that world, hated what she saw from her upper-class Christian perspective, and was relieved to part ways with the working classes.

Like Fern and Gissing, Theodore Dreiser carried with him the waning transclass mentality. He was born in Terre Haute, Indiana, in 1871. His father was a German immigrant whose ancestors had been mayors in his European town. When Dreiser's father came to the United States, he was able to work his way into being the owner of a wool mill. Dreiser's family lived in "one of the best residential sections in town" until a series of disasters led the father to become a laborer looking for work.[101] Dreiser grew up with his family subsequently strapped for cash, and his novels reflect this transclass identity. As Richard Lingeman puts it, "The memory of belonging to that elevated sphere caused Theodore [and his family] . . . always to consider themselves better than their fallen state." But it also "made him identify with the heroes in so many melodramas and dime novels of the nineteenth century: the young man or woman of good birth who is plunged into poverty as a child but who rises by hard work or virtue. . . . The Horatio Alger dreams of recovering his rightful place mingled with the fear that failure—disaster—would be his lot."[102] The plots of Dreiser's novels reflect exactly this combination of the desire to rise in social class and amass financial wealth together with ambivalence about those goals and often disastrous failures, to remind the reader of the precariousness of wealth as well as the aura of glitter surrounding it.

Another waning transclass writer is the anonymous author of *Madeleine* (1919), who wrote a memoir about being a prostitute and a madame.[103] Madeleine Blair (a pseudonym) grew up in a cultured and well-to-do family whose father became an alcoholic and left the family in financial ruin. Abandoned by the father, Madeleine's mother moved to an impoverished neighborhood, where Madeleine realized that the women who were living relatively well were sex workers on the side while plying other low-paying jobs. Having become pregnant at an early age, Madeleine leaves her small town in Missouri for Kansas City, St. Louis, and eventually Chicago, where she learns the trade while she tries to maintain an intellectual and aesthetic life. The book is remarkable for the quality of the writing.

And language plays a central role in this waning transclass narrative. While accent and roughness often betray the endo-writer, this linguistic cultural imprimatur brands Madeleine as unique among her sister sex workers and indeed becomes a cause for concern as she is often seen as being stuck up or putting on airs.

The cultural capital of the waning transclass writer allows entrance into the literary world and therefore publication. It is not clear how Madeleine came to publish her story with Harper and Brothers, but the introduction by Judge Ben Lindsey, the founder of juvenile court, gives us a clue about her connections with the cultural and political elite. It is possible that her cultural capital expressed through her waning transclass status became apparent to a member of the power elite like Judge Lindsey. We can see that Madeleine was reared to be among the upper-middle classes: "We heard much of the beauties of literature and had access to many good books."[104] She herself stated that she had learned to read "at an unusually early age and possessed rather a remarkable faculty for the English language. Sonorous words appealed to me and soon found a place in my memory."[105] Then, when her father deserted the family, they had to move to "the worst neighborhood in the town."[106] She uses the classic language of poornography to describe how "dirt, squalor, ignorance, vitiated standards, sin, all the horrible concomitants of poverty engulphed me."[107] Yet because she was a waning transclass child, the environment stands in contrast to her inner life, which retains its cultural capital. "But I still retained many traces of the earlier condition to which I had been born. The most notable example was my retention of the English spoken in my home which was not only different from that used by our present neighbors, but notably better than that spoken by the 'first families.'" Madeleine Blair then uses that language to promote herself in a world that would be much more set against a single female sex worker and ultimately to write and publish her memoir with a prestigious press.

Richard Wright presents us with a view of the waxing transclass writer. Coming from small-town American poverty, he recounts his experience in *Black Boy*, published in 1945. One would expect Wright, as an endo-writer, to avoid the castigating descriptors of the exo-writer, but in depicting the horrors of racism, he does not have the familiar love of his own world that writers like Agnes Smedley and Michael Gold do. He must of course excoriate race hatred and its effects on African Americans. Yet he can pause to remember the kind of nuanced delights of the poorscape. He recounts that

"our greatest fun came from wading in the sewage ditch where we found old bottles, tin cans that held tiny crawfish, rusty spoons, bits of metal, old toothbrushes, dead cats and dogs, and occasional pennies."[108] He tells how groups of children would spy on adults relieving themselves in "a long row of ramshackle wooden outdoor privies," and "for hours we would laugh, point, whisper, joke" scatologically about the scene.[109]

Yet, with Wright, there is an interesting ambivalence in his transclass consciousness. As an aspiring writer, Wright finds himself both inside and outside of his environment. He is quite open about his disdain for poor, rural Black folk. He states that he saw "a bare, bleak pool of black life and I hated it; the people were alike, their homes were alike, and their farms were alike." He describes the Black sharecroppers as "walleyed yokels."[110] And his view of the urban African Americans was that they lived in "dingy flats filled with rickety furniture and ill clad children . . . most of [whom] were illiterate."[111] But being a transclass writer, he has no specific reverence for middle-class African Americans either. He sees "prim, brown, puritanical girls who taught in the public schools, black college students who tried to conceal their plantation origin." In this group he sees "snobbery, clannishness, gossip, intrigue, petty class rivalry, and conspicuous displays of cheap clothing." He adds, "When with them I looked at them as if they were a million miles away. I had been kept out of their world too long ever to be able to become a real part of it."[112] He sums up his position saying, "Well-to-do Negroes lived in a world that was almost as alien to me as the world inhabited by whites."[113] This critique was typical of the Black social realist writers of the 1930s who saw themselves as "*of* as well as *for* the poor and working-class masses of African Americans, often construing themselves as 'cultural workers.'"[114] Wallace Thurman also echoes this class prejudice in his 1929 novel *The Blacker the Berry*, in which his main character's grandparents dislike being lumped together with poor Black people although black themselves. "You were . . . classed with those hordes of hungry, ragged, ignorant black folk arriving from the South in such great numbers, packed like so many stampeding cattle in dirty, manure-littered box cars . . . this raucous and smelly rabble of recently freed cotton pickers and plantation hands." Instead, they make choices "for a future select Negro group."[115] The main character's stepfather, Aloysius, had an Irish father and an African American mother but despised his blackness, seeing it as a class marker as well as a racial one. "He couldn't be made to realize that being a Negro did not necessarily indicate that one must also be a ne'er-do-well. Had he been white, or so he said, he would have been a successful criminal lawyer, but

being considered black it was impossible for him ever to be anything more advanced than a Pullman car porter or a dining car waiter."[116]

.

Another less-known transclass African American writer is Willard Motley, who, like Wright, lived and worked in Chicago. Unlike Wright, Motley came of age in the early twentieth century in the largely Irish and German middle-class Englewood neighborhood and went to the local high school.[117] His family was the only African American one in the neighborhood, where restrictive covenants specified that houses could not be sold, according to his grandfather, to "Negroes or Jews."[118] Motley's class background combined with his race and his gender identity (queer) makes him an interesting variety of transclass writer. In addition to these features, his best-known book, also made into a movie starring Humphrey Bogart, was about working-class Italian American life. A complex family disappointment yielded a scandal in which Motley discovered that his mother was actually his grandmother, and his sister was really his mother, who was impregnated by a boarder who may have also been his grandmother's lover. It also appears that his grandfather was a womanizer who contracted syphilis and was hospitalized during the time that the boarder was in residence.[119] Given the shocking revelations hiding behind Black middle-class respectability, Motley, according to Alan Wald, developed "an undying hatred of the pretensions of the African American middle class" and "turned his back on the past . . . moving in 1939 to the very slums from which middle-class people aspired to escape."[120] He chose Maxwell Street on the West Side of Chicago near Hull House, which he called "the humpty-dumpty neighborhood."[121] This multicultural neighborhood is described in great detail in his novel *Knock on Any Door*:

> There were Italian stores crowded together with spaghetti, olives, tomato paste for sale. . . . The streets were crowded with people. All kinds of people. Negroes in flashy clothes—high-waisted pants wide-brimmed hats loud shirts. . . . Young Mexican fellows with black hair and blue sports shirts worn outside their pants and open at the neck. . . . Two gypsy women passed. . . . There were beggars with sad eyes. . . . A blind man's cane tapped the side-walk. Dress shops, hat shops, men's clothing stores were crowded together along Halsted, hiding the slum streets behind them. Hiding the synagogues, the Greek church, the Negro storefront churches, the taverns, the maternity center, the public bath. . . . [M]en and women shouting their

wares in hoarse, rasping voices, Jewish words, Italian words, Polish and
Russian words, Spanish, mixed-up English. And once in a while you heard
a chicken cackling or a baby crying. The smells were hot dog, garlic, fish,
steam table, cheese, pickle, garbage can, mould and urine smells.[122]

Here the catalog of the poorscape abounds, described dutifully and with a
certain admiration and fascination. But it is the exotic that the transclass
writer is depicting. In this case, Motley was a waning transclass writer who
had experienced a better life and was living in a poorer neighborhood than
the one he was reared in.

Motley wrote for local newspapers when he was as young as thirteen.
These youthful works show us how a middle-class child was in effect reared
on poornographic works. One early story he wrote tells of a poor brother
and sister who are invited to live in a rich family. Another piece describes
a painting by Hans Larwin on exhibit at the Chicago Art Institute that
depicts, in Motley's words, "a line of poor and hungry people waiting in the
breadline for food." His attention is grabbed by two images in the paint-
ing: "A little girl about three years old is pictured with a cup in her hand
and her mouth open. It seems to form these words, 'Mother, I am hungry.'"
And "one poor, old, crippled man with a pair of glasses on is dressed in rags
from head to foot, and the artist has even pictured hunger in his eyes."[123]
That even at thirteen Motley focused on the major themes of writing about
the poor is a telling example of how inculcated the genre is in the primer
of childhood reading.

Like Gissing, the adult Motley is, in his own words, both fascinated
and repulsed by the "down-to-earth world, the bread and beans world, the
tenement-bleak world of poverty and hunger . . . the miserable little houses
that Jane Addams knew."[124] His views are highlighted in an inner mono-
logue by a character who stands in for the author in *Let Noon Be Fair*:
"The writer is involved in life. The artist, the realistic writer, is involved
with life as it is, and in his involvement tries to alleviate the causes, tries
to change, or at least to point out. He explores the ugly, the miserable,
the humble, to show the beauty and humanity of it."[125] But the exotic and
erotic win out over the political in the litany of reasons one writes about
the poor. Taking place in a poor Mexican town, *Let Noon Be Fair* follows
this monologue with a scene in which the writer has sex with a cognitively
disabled domestic who masturbates on his floor, imploring him to enter
her. The lure of sex, violence, and drugs outweighs other issues for the wan-
ing transclass writer.

In *Let No Man Write My Epitaph*, his sequel to *Knock on Any Door*, Motley places the son of his former antihero, Nick Romano, back in the same Maxwell Street neighborhood but raises the volume on the poornographic landscape: "Hoboes stumbled along the sidewalk. Drunks staggered into them. Bums sat on curbings. Men stood against store fronts and in doorways letting their water as unconcerned as horses. . . . Bar smells hung over the sidewalk, damp-sweet and sickening. Juke boxes smacked their high pitched falsely hilarious songs out across the sidewalk and halfway across the street in shrill blasts."[126] Although Motley chose to live in this neighborhood, his attraction to and repulsion for the seedy side of life lay out a complex relationship between the writerly impulse to portray and the waning transclass sense of repugnance. Indeed, at one point Motley tellingly describes his note-taking and daily observation of his Maxwell Street poorscape for his writing as "walking my beat."[127] The transclass writer living in poverty is never fully of that environment and possibly, as Motley implies, is more like a cop than a reporter. In fact, when Motley knew his book *Knock on Any Door* was going to be made into an MGM film directed by Nicholas Ray and starring Humphrey Bogart, Motley invited the actor who was to play Nick Romano and director Ray to come to his neighborhood. "There's nothing like it on Main Street I assure you. . . . We could wear old clothes and tramp West Madison day and night until both of you got the feel and tempo of the street, the people down there."[128] Adopting another persona, the undercover reporter, Motley illustrates the limited roles available to the waning transclass writer. As he had previously done when he took several road trips across the United States while living at his parents' house, Motley was searching for material to write about and adopting the clothing, speech, and ways of poor people to get at that material.[129]

In the end, the transclass writer, particularly the waxing one, is the most likely to offer us a description of poverty that can resonate, if not stand in for, experience. This claim is bordered by the complexity of the issue of representation, the pitfalls of an appeal to authenticity, and the problematics of realism. If the argument that cannot be disputed is that actually no one's version of reality is actual, then it is ultimately impossible to claim anything about the verisimilitude of art. If we take a more pragmatic approach than that reductio, we then have to rely on transclass writers to at least take us to the house, even if they cannot unlock it.

Chapter Four
Biocultural Myths of the Poor Body

A limited palette of descriptive ideologemes about the poor is available to writers and visual artists. These include adjectives like *short*, *stupid*, *drunk*, *addicted*, *diseased*, *dark-skinned*, *dirty*, *sexual*, *criminal*, *lazy*, *violent*, *child-like*, and *mentally troubled*. These are the stock-in-trade hues used to paint or tar the poor. Take, for example, the opening declaration of George Foster's 1850 *New York by Gas-Light and Other Urban Sketches*: "What a task we have undertaken! To penetrate beneath the veil of night and lay bare the fearful mysteries of darkness in the metropolis—the festivities of prostitution, the orgies of pauperism, the haunts of theft and murder, the scenes of drunkenness and beastly debauch, and all the same realities that go to make up the lower stratum—the underground story—of life in New York."[1] This litany of licentiousness makes the tacit assumption that readers of poornography, that is, the nonpoor, are by contrast all tall, smart, white, adult, sober, clean, normally sexual, sane, peaceful, and good. And the further assumption is that these qualities ascribed to the poor are inherently bad, if not flatly repulsive and disgusting. I am not the first to notice the existence of these ideologemes. The late Barbara Ehrenreich, who wrote extensively on poverty, pointed out that to sociologists like Oscar Lewis and Michael Harrington, who developed the notion that there was a culture of poverty, the poor person lived in an enclosed world utterly unlike that of the nonpoor. Ehrenreich says that such thinkers conceived of the poor person as "half child, half psychopath."[2] This retrograde position was most illustratively put on the editorial pages of the *New Republic*, which on February 16, 1964, opined that the poor are "a sealed-off community with its own crippled values, liable to erupt into crime and psychopathic violence."[3] The

use of ableist language combines with an unfounded prediction of criminality and mental illness.

It is important to point out that these descriptors are part of a worldview that blames the poor for their conditions rather than capitalism and neoliberalism. Having these traits may be the result of environment, but resilience and inner fortitude, as the conventional wisdom goes, should be enough to withstand those social forces that drive the poor into the ground.

As opposed to the "science" around the culture of poverty, we might want to take a biocultural look at the reality of poverty. I am using the term *biocultural* as developed by David Morris and myself in "Biocultures Manifesto."[4] In that work we emphasize that in order to understand the contemporary world and its cultural productions, we need to have a foundation not only in the humanities but in the areas of science, technology, engineering, and medicine (STEM), which increasingly are used to describe and regulate our world. I refine the use of the term *biocultural* in this book to indicate two aspects—one that falsely uses "science" to oppress groups, as in eugenics, and one that thinks of the total person by including a liberatory aspect to the application of STEM to human life and culture. While it may be somewhat difficult to thread that needle since the outcomes of various STEM applications are not clear and most likely will not be clear except retrospectively, it is nevertheless important to try and do so.

If we look to our own times, we can see that something as random as temperature and exposure to heat, which seems evenly distributed across the globe and not subject to social class, is in fact significantly related to class. Poorer citizens' neighborhoods worldwide are more exposed to higher temperatures than are middle-class or wealthy environs.[5] Race and poverty conspire destructively in this scenario since formerly redlined neighborhoods now have higher temperatures and therefore greater exposure to smog, which in turn has demonstrable health consequences.[6] In addition, poorer neighborhoods have smaller parks with less access for the inhabitants than do middle-class or richer surroundings. There are also health side effects as well since access to nature yields lower stress levels and mortality rates. And racial implications apply since poor people in New York City have 21 percent less park space than their richer counterparts, but people of color have an even scantier 33 percent less.[7] Also richer neighborhoods have dramatically more trees lining their streets than poor neighborhoods.[8]

Not only heat but also inferior air quality impacts poor communities, which leads to more respiratory problems and increased mortality.[9] This is not just true for the present but holds for the past as well. In Victorian London, the very gasworks that provided light and warmth to the rich and middle class were always placed in poor neighborhoods, creating, according to a contemporary writer, a "centre whence radiates a whole neighborhood of squalor, poverty, and disease."[10] And something as ubiquitous as noise disproportionately impacts poorer communities and communities of color as well, increasing mortality dramatically.[11] We cannot and should not assume that bad behaviors among the poor are the major contributors to their living conditions, working conditions, health and safety issues, and matters of personality or temperament.[12]

Even sleep affects the health and well-being of poor people. Because poor neighborhoods have higher noise levels, more pollution, and less greenspace, poor people sleep less than middle-class or wealthy people.[13] Also, the demands of stressful work, night shifts, and obesity can cut into the quality and length of sleep. And sleep affects health outcomes. Black people regardless of income level get less sleep than whites.[14] And low-income neighborhoods in Washington, DC (which were also Black), had higher rates of traffic accidents and overall deaths than higher-income areas.[15]

These biocultural and biopolitical impacts create the negative healthscape that ultimately shapes the life and death of the poor. In fact, at least one study showed that wealth or the lack of it affects something as universal as people's faces. Participants in the study were asked to look at headshots and identify whether the person in the photograph was rich or poor. The socioeconomic status of the person could be ascertained with a high degree of accuracy simply by looking at their face.[16] And this finding carried over to assessing that person's ability to land a job based on face-to-face interviews. Not having a job or money obviously will affect health. Indeed, simply giving money to poor mothers positively affected the brain function of their children.[17] Not having money seems to directly affect the regions in the brain that control language skills and impulse control. In poor children these are smaller, even by the age of two, than those of children who grow up in wealthier families.[18]

This dramatic accumulation of biocultural data adds up to significant differences in health outcomes based on poverty and race. The most dramatic example might be that people living on the South Side of Chicago in the historically poor, Black neighborhood experience a gap of thirty years

in life expectancy compared to those who live on the historically white and richer North Side. This is the most egregious gap among five hundred cities in the United States.[19] Equally relevant is that Black men in Harlem were less likely to live to sixty-five than their impoverished counterparts in Bangladesh.[20] And given all this, it makes sense that during a pandemic like COVID, Black people had a higher incidence of hospitalization.[21] So, the biological impacts directly and indirectly the lives, health, and prospects of poor people and Black and brown people—but often not in ways that are generally considered.

Given the importance of the biocultural, it might make sense to go through some of these stereotypes in more detail so we can better understand the nature of such descriptors. I consider what I am calling *biocultural myths* because these use "science" to arrive at oppressive cultural and political outcomes. As I have just shown, there is plenty of good science around poverty to drive social justice, but there is even more bad science that has driven oppression and injustice.

There is a literal blackout of poor Black people in England in the eighteenth and nineteenth centuries. One estimate is that in the eighteenth century there were 1,144 poor Black people in London by mid-1786.[22] Another estimate notes that in the eighteenth century Black people made up 0.02 percent of the British population but as much as 2 percent of the London demographic. And another cites ten thousand as the number of Black people living in Britain in the early part of the nineteenth century.[23] Their great numbers, and the growing discontent with their presence, led to numerous attempts to ship free Black people off to places like Nova Scotia, Sierra Leone, and the Bahamas. By the early nineteenth century, when a compendium *Vagabondiana* depicting street sellers and mendicants in England was published, there were at least four hundred Black beggars in London, yet only one, named Joseph Johnson, appears in the book.[24] Black beggars were so integrated into the world of white beggars that a mobility-impaired Black violinist named Billy Waters was elected to be "King of the Beggars," and his funeral in 1823 was widely attended by many of the beggars in London.[25] Given these statistics, we can see a narrative forming that presents to the middle-class reader the accounts they want rather than the situation as it was. Henry Mayhew is one of the few writers to mention "negro beggars." He says that most were from America and used the nineteenth-century British opposition to slavery by claiming to be a "fugitive slave" to encourage almsgiving. But Mayhew notes that some white beggars "fortunate enough to have flattish or turned-up noses

dyed themselves black and "stood pad" as real Africans.[26] Apparently, this is a rare instance when racial difference could bring a certain kind of attention and profit.

Accounts of rural, industrial, and urban poverty in the United States in the nineteenth century tend to focus more on white people than people of color. Two of the exceptions are descriptions of the Five Points neighborhood in New York. The reporter George Foster says, rather blandly, "Of course the negroes form a large and rather controlling portion of the population of the Points." He goes on to note that they can live in this degraded setting because "they bear brutalization better than the whites, (probably from having been so long used to it!)." The racist viewpoint continues with his noting miscegenation in the area and then summarizing that "they are savage, sullen, reckless dogs, and are continually promoting some 'muss' or other, which not unfrequently leads to absolute riot."[27] A British visitor to New York in 1843 also describes the African American character of Five Points. Like other writers, he sees the neighborhood as "Hades" and writes in purple prose carrying the metaphor forward with references to Satan and fiends. Predictably, he focuses on the fact that the buildings are "crowded with human beings, black and white, male and female, indiscriminately mixed together." He describes a dance hall "of mostly blacks . . . the music made by two old negroes . . . some of the females danced without either shoes or stockings and they accompanied the music with the most extravagant and vulgar gestures."[28]

Charles Dickens described Five Points in his *American Notes* and included many references to its African American inhabitants. "Open the door of one of these cramped hutches full of sleeping negroes. Pah! They have a charcoal fire within; there is a smell of singeing clothes, or flesh, so close they gather round the brazier; and vapours issue forth that blind and suffocate."[29] Dickens's olfactory disgust figures into a general racism on the issue, but as with Black beggars in London, one has to consider whether inclusion or exclusion from literary references adds up to the greater discrimination. Excluding images of and references to people of a particular race amounts to a kind of erasure, while negative images serve to compound the moralizing around the racial discourse. The two can work in synchrony as an accelerant to racist discourse.

A telling point is that the East End in London was at least 50 percent Jewish in the era of Jack the Ripper. Yet films and television series that depict the East End create a visual landscape of threatening figures huddled over fires—thieves, prostitutes, drunkards, and the like—but almost

never show us Jewish inhabitants. Instead, we hear cockney curses and see light-skinned Brits. Not a single Jewish face, Yiddish exclamation, or shop sign written in Hebrew or Yiddish is depicted, essentially bleaching out the presence of Jews in their very own neighborhoods. As with Black people the Jewish exclusion from representation is in essence a form of racism that can be compounded by the rare inclusion. Fagin, in Dickens's *Oliver Twist*, can hardly be said to be an accurate or beneficial presence. The poornographer sits on the horns of a dilemma. To omit is problematic; to include is also problematic.

In general, given the eugenic concerns of the nineteenth and early twentieth centuries, poor people were themselves often seen as a separate race. Jack London easily describes the poor as a degenerate "new and different race." In *People of the Abyss*, the author sees the poor as a degraded form of humanity. "A new race has sprung up, a street people. . . . A short and stunted people is created—a breed strikingly differentiated from their masters' breed, a pavement folk, as it were, lacking stamina and strength . . . a deteriorated stock left to undergo still further deterioration." He adds that for this reason it is criminal for them to marry.[30] Like Alexander Graham Bell, who advocated that the Deaf should not marry because it would create a "race" of Deaf people, London fears the same perpetuation of a devolved and weakened species of human.[31] As Ewa Barbara Luczak observes, "It is here that the voice of Jack London the eugenicist is heard."[32] George Gissing has a character in his novel *Demos* say that "the rich and the poor are two different races, as much apart as if there was an ocean between them."[33] Émile Zola, in his *Germinal*, writes that a mining community is composed of "a race of worn-out beasts, destroyed from father to son by a hundred years of toil and starvation."[34] And both Karl Marx and Friedrich Engels used the language of disability to describe how poor people are a "crippled race" through the effects of exploitation.[35]

H. G. Wells more fully develops the idea that class becomes race when he imagines in *The Time Machine* that rich and poor evolve into separate races—the proletarians become the beast-like Morlocks, and the upper class the enervated Eloi. The Time Traveler, now in the future, wonders, "What if in this interval the race had lost its manliness, and had developed into something inhuman, unsympathetic, and overwhelmingly powerful?"[36] That Wells links the underground Morlocks to the poor and the aboveground Eloi to the rich is made clear when the Time Traveler notes with great certainty, "It seemed clear as daylight to me that the gradual widening of . . . the social difference between the Capitalist and the Labourer,

was the key to the whole position."[37] And he traces this new race of subterranean Morlocks to a tendency for laborers to work underground and even travel through the Metropolitan Railway beneath the ground. Tightening the eugenic argument, Wells says, "Even now, does not an East-end worker live in such artificial conditions as practically to be cut off from the natural surface of the earth? . . . So, in the end, above ground you have the Haves, pursuing pleasure and comfort and beauty, and below ground the Havenots, the Workers, getting continually adapted to the conditions of their labour."[38]

Tellingly, for Wells, the two races of the future are both white—but they have different kinds of white skins. The Eloi's are like porcelain, which could also flush red like "the more beautiful kind of consumptive."[39] The Morlocks are a "dull white" with "flaxen hair."[40] Their bodies are "pallid" and "the half-bleached color of the worms and things one sees preserved in spirit in a zoological museum."[41] In terms of racialized qualities, the Morlocks share the paleness often attributed to poor people, especially those who work in factories or coal mines. Zola describes one of these miners in *Germinal* as having "pale skin, as white as that of an anaemic girl."[42] And the members of his family have "straw-colored hair and anaemic complexion[s]."[43] Elizabeth Gaskell describes the working poor as having "sallow complexions . . . which has often been noticed in a manufacturing population."[44] One of the main characters in *Mary Barton* is said to have "a wan, colorless face."[45] An article in *McClure's Magazine* from 1909 identifies poor southern whites as easily identifiable by their "peculiar pallor—'the Florida complexion'—their skin is like tallow, and you seem to be looking through a semi-transparent layer into an ashy or saffron layer beneath."[46] That the Morlocks, like these poor people, have a kind of sickly whiteness and flaxen hair presents us with a kind of white-racial profiling. And the yellow hair, rather than being a sign of being a Nordic type, is rather associated with childhood malnutrition often found among the poor.[47]

Poor people were racialized in other ways. For example, linking poor whites with Africans and African Americans was a way of saying that all poor people shared similar racialized characteristics. For example, the Irish were seen as a race that was degenerate, ranking lower than the prejudiced status given to African Americans. John Beddoe in his 1862 "Index of Negrescence" created a ladder of degeneracy by measuring the relative "blackness" of white Europeans, which placed the Irish on the lowest rung.[48] Jews were also racialized in this way, as Arthur Abernathy's book *The Jew a Negro* suggests. Abernathy writes in 1919, "Thousands of years of effort to throw

off their nigrescence have failed to eradicate those race characteristics, and the Jew of today is essentially Negro in habits, physical peculiarities and tendencies."[49] And there had been a guilt by metaphorical association when, for example, George Sims sees the poor inhabitants of London as "the wild races who inhabit . . . [the] dark continent that is within easy walking distance of the General Post Office."[50] Indeed, London saw himself, as did his reviewers, as "an explorer" going into this deepest, darkest continent of poverty.[51]

Henry Mayhew characterizes the wandering poor, including vagrants, prostitutes, street vendors, and beggars, as being eugenically separate from the true-born English citizen. Of these "classes" he notes, "There is a greater development of the animal than of the intellectual or moral nature of man, and they are more or less distinguished for their high cheekbones and protruding jaws."[52] Interestingly, the street sellers themselves responded with a refutation of this eugenic characterization of themselves. George Martin, the head of the street vendors association, found Mayhew's racialization a "highly amusing assertion." He then adds, "Were this a fact, the street people would be a distinct tribe . . . but . . . this is not the fact." Martin then points out that Mayhew himself has a "vast amount of cheekbone. . . . [and] protuberance of jaw."[53] In addition, Mayhew lists a set of moral failings associated with degeneration, including use of slang, disregard for property rights, improvidence, laziness, lack of respect for female honor, cruelty, and lack of religion.[54] These are characteristics often attributed to "degenerate races." The middle-class writer was seen as an explorer like those who had gone into "darkest Africa." Take, for example, the title of Peter Keating's more contemporary collection of accounts of poor people in London, which characterizes the nature of these writings as *Into Unknown England, 1866–1913: Selections from the Social Explorers.*

In the United States, southern whites, also known as *poor white trash*, were seen by those in the North as a degenerate race. Harriet Beecher Stowe notes that the southern states were home to "a poor white population as degraded and brutal as ever existed in any of the most crowded districts of Europe."[55] Racial degeneration could be linked to not only black and brown people but the inhabitants of crowded districts like Whitechapel and parts of eastern Europe, notably thronged with Jewish populations. But the poor whites of the South were also seen as having "united all the vices of the negro with those of their own race" so that they formed a kind of degenerate hybridity.[56] And some saw this race of poor whites as existing not only in the South but in the North as well, explaining their racial

existence as linked to their "blood" by virtue of their being descendants of those from the "poor-houses and prison-cells of Great Britain."[57]

The racial issue could be flipped around so that "savages" and "cannibals" would seem less degenerate than poor slum dwellers in "civilized" countries. Jack London describes the crowding in the London slums that allowed for the genders to mix indiscriminately and adds, "No headman of an African village would allow such a promiscuous mixing of young men and women, boys and girls."[58] At another point, London compares the British urban poor unfavorably with the Inuit. "The men of Civilisation live worse than the beasts, and have less to eat and wear and protect them from the elements than the savage Innuit in a frigid climate who lives to-day as he lived in the stone age ten thousand years ago."[59] A reviewer of Mayhew's writings on the poor notes "the existence of a large class, in our metropolis, more degraded than the savages of New Zealand, than the blacks of the Great Karroo, or the insular communities of the Pacific."[60] A church official says that "the people of the West End knew as little of it [the East End] as of the savages of Australia or the South Sea Isles."[61] And Ralph Barnes Grindrod, author of *Slaves of the Needle*, says that garment workers, according to a physician, suffer from "unavoidable consequence of a perseverance in this worse than negro servitude."[62]

If the poor are not seen as a race per se in some works, then they are seen as a kind of race or nationality apart. In Charlotte Bronte's *Jane Eyre*, Jane, as a young girl, is asked if she has relatives. She has been told that they are "poor, low relations." When queried if she would go to them, Jane associates poverty with "ragged clothes, scanty food, fireless grates, rude manners, and debasing vices . . . synonymous with degradation." From her perspective the poor are a people apart, and she cannot understand how she could "learn to speak like them, to adopt their manners, to be uneducated, to grow up like one of the poor women I saw sometimes nursing their children or washing their clothes at the cottage doors of the village."[63] It is as if the poor are another nation with their own dress, language, and uncivilized customs such as public breastfeeding.

The poor in the past were often described as short. In eighteenth-century England, writers complained of a "pigmy generation . . . a parcel of poor diminutive creatures" born to gin-soaked parents.[64] But with the nineteenth century and the rise of eugenics, shortness was linked to being of weak stock and seen as the result of degeneration. In *Mary Barton* we recall the delegation of short workingmen who have come to make a demand on the factory owners. Elizabeth Gaskell describes them: "Had

they been larger boned men, you would have called them gaunt; as it was, they were little of stature, and their fustian clothes hung loosely upon their shrunk limbs."[65] And one of the main characters, John Barton, is described as "below the middle size and slightly made; there was almost a stunted look about him."[66] This kind of description is at odds with our more contemporary envisioning of the working class in which the men are seen as large and often powerful brutes of the Stanley Kowalski mode.

Charles Davenport, who directed the Eugenics Record Office in the United States, worried about immigration, concerned that the influx of southern Europeans would make the country "darker in pigmentation, shorter in stature . . . more given to crimes of larceny, assault, murder, rape, and sex-immorality."[67] Immigrants on Ellis Island were turned back for being short.[68] Indeed, the author William Faulkner was rejected by the United States Army for being short (at five feet five) and underweight.[69] Dr. Van Evrie advised against educating African Americans since such activities would result in "dwarfed or destroyed" bodies.[70] As may be recalled, Jack London in writing about "people of the abyss" in the East End of London in the early 1900s called them "a new and different race of people, short of stature, and of wretched or beer-sodden appearance."[71] Later he remarks as he waits for a place at a doss-house, "One thing particularly conspicuous in this crowd was the shortness of stature. I, who am but of medium height, looks over the heads of nine out of ten. The natives were all short, as were the foreign sailors."[72]

The emphasis on shortness as a negative was of course simply observational and probably had to do with the fact that different ethnic and nationality groups have different average heights. In general, northern Europeans are taller than people from southern Europe. Jews, who made up a plurality of the people in London's East End, were shorter than their British counterparts.[73] Seeing this height difference as a type of stunting rather than genetic diversity, eugenicists could argue that shortness, combined with other undesirable traits like darker skin color, as noted above, was a characteristic of inferior races. It is also possible to argue that early childhood malnutrition could lead to shorter heights in adults. Poverty would seem to groom its children to be these lower (in all senses of the word) sorts.

In George Moore's 1894 novel *Esther Waters*, the protagonist is a working-class woman who falls on hard times and seeks a job as a domestic servant. She is turned away at one point for being short. "If you were only an inch or two taller I could get you a dozen places as a housemaid," says

the secretary of the registry office, adding, "Tall servants are all the fashion."[74] Later this requirement is reinforced by another "lady [who] told Esther that she liked tall servants."[75] Moore is highlighting the effects of eugenic thinking on the market for household labor, which combines with an element of scarcity to make tall domestics a rare and desired commodity.

Eugenicists might well believe that shortness is an undesirable trait. If their aim is to breed "fitter" humans, then it would make sense that traits one would consider desirable in breeding animal stock—bigger, stronger, healthier—would transfer logically to humans. In reality, tallness has very little practical use except arguably in battle, basketball, and perhaps the harvesting of fruit. It does seem to be true that in Western cultures heterosexual women base mate selection at least partly on a preference for taller men while heterosexual men prefer average-height women. Regarding homosexual men, taller men prefer shorter men and vice versa. A general interest in dimorphism seems to be more important, in that sense, than any particular preference for height. Since men tend to be taller than women, that pattern holds sway. But this preference is not universal, and in some non-Western cultures, one does not find this preference or prejudice.[76] Obviously a lot more factors than height come into play in mate selection, and different factors influence the choice of a sexual partner versus a romantic one.[77] But it makes sense that a preference for taller male partners would reflect the general eugenic preferences unconsciously and consciously added to the culture since the mid-nineteenth century. A totally unscientific use of Google Ngram Viewer suggests that the words *tall men* have a major uptick post-1800, which might well correspond with the rise of eugenics. While William Shakespeare uses *tall* infrequently, more often than not he uses it when talking about the height of women like Hermia and Rosalind, who, we may remember, were played by boys. It is a long-shot speculation that tallness and maleness were not necessarily connected as a desired combination until the eugenics period. Authors did not specify the heights of protagonists like Achilles, Orestes, Hamlet, Tom Jones, D'Arcy, and the like. Why would we assume that they were tall? These authors arguably did not believe that height was a descriptor of fitness, strength, or male dominance.

If height were important before eugenics, why wouldn't we know the names of short authors and statesmen? The fact that John Keats was five feet tall doesn't seem to have entered our consciousness or that of his contemporaries—and likewise for William Blake (five feet one), Sir Isaac Newton (five feet six), James Madison (five feet four), Wolfgang Amadeus

Mozart (five feet four), Ludwig van Beethoven (five feet four), and Franz Schubert (five feet one). We seem barely aware that Thomas Hardy was five feet one. In other words, emphasizing shortness as degeneracy might seem uniquely linked to eugenics.

If we didn't have a eugenics gradient scale about height, what would tallness or shortness indicate? From a biological perspective, shortness seems to be an evolutionary advantage. According to recent DNA work, shortness seems to have been linked to the rise of agriculture in southern Europe with these genes probably brought in by groups migrating from the Middle East.[78] From an evolutionary perspective, shortness developed alongside other advantages, most notably longevity and resistance to some diseases like cancer and dementia, as well as overall mortality. These factors could be related to the development of certain genes that aid in extracting more nutrition from grains.

Given this possible rosier prognosis for genetic shortness over tallness, how did shortness become denigrated and associated with poverty? One cannot discount the ideological dimension that northern Europeans, who are taller, perceived the shorter, darker immigrants as inferior. Because tallness was a biological characteristic of northern Europeans, it might not be an exaggeration to say that tallness was a stand-in for white privilege. Further, poor nutrition can lead to childhood stunting, particularly in the first two years of life. It would be logical, then, that stunting was a side effect of poverty. However, many studies have found a relationship in animals, insects, and bacteria between early starvation and longevity.[79] There are also, to counter this, other studies that show increased cognitive impairment, motor function problems, infant mortality, birthing mortality, and the like with poor nutrition.

Overall, we'd have to say that there is not a simple correlation between shortness and poverty from a purely factual perspective. Yet, during the eugenic period and afterward, shortness had become a proxy for being poor. But the seeming defects of shortness could relatively easily, given another point of view, be seen as a positive in terms of health and longevity. As with the other ideologemes related to poornography, we are in a realm of signification and symbol rather than in accurate description and fact.

Another trope associated with poverty is drunkenness. Many novels, news stories, films, and books about the poor emphasize and portray the element of alcoholism and drug use. But do the poor drink more or use drugs more than other classes? It seems fairly clear that the rich drink as much as, if not more than, the poor—if only because they have the means

to procure alcohol.[80] In fact, there is an algorithmic association between the amount of money one earns and the amount of alcohol consumed, with higher-income earners reporting drinking more than low-income earners.[81] In addition, richer neighborhoods, those with inhabitants that benefit the most from income inequality, consumed the most alcohol and marijuana—exactly the opposite of what is usually depicted in literature and film.[82]

.............

The question then arises, Why are the poor routinely and notionally associated with drunkenness? Could there be some historical reason that middle-class writers looked at the poor and saw drunks? Let's begin with the assumption that over time there were various panics about alcohol that created a class of violators—often the poor—who were seen as abusers of alcohol.[83] The fact is that alcohol consumption seems to be fairly consistent over time, varying by availability, income, country, and custom. Further, the larger picture is that in the past, until drinking water became potable in the late nineteenth and early twentieth century, most people drank either some form of alcoholic beverage or, in the eighteenth century, a brewed product like tea or coffee. The consumption of alcohol in general was quite staggering. In the colonial period in the United States, 6.6 gallons of hard liquor were consumed per person per year, which is the equivalent of about six shot glasses of eighty-proof liquor per day. In addition, fermented cider consumption was at fifteen gallons per person per year.[84] Philadelphia during the Revolutionary War had at least one tavern for each one hundred residents (compare this with 2007 when there was one alcohol-serving establishment per one thousand residents of Philadelphia). New York City had an even denser population of liquor establishments in the 1770s with enough locations that the entire population could hypothetically drink at all the public houses at the same time.[85] In 1829 the secretary of war estimated that each American citizen drank four ounces of distilled liquor per day.[86]

James Nicholls has argued convincingly that in England an aspect of class warfare often centered on the alehouse, which was the communal gathering place for working-class and poor people. Brewing was, before mass production, a poor person's activity.[87] Alehouses served as places where the poor and the underemployed could gather, find work, and buy a cheap and pleasurable commodity. The first licensing act, passed in 1552, "reaffirmed the power of local elites by locking them into a national system

of control over an institution which formed the hub of lower-class social activity."[88] These types of laws continued the right of ruling elites to control lower-class behavior by defining what drinking and brewing activities were criminal and what were not.

Indeed, class was defined by what you drank. In England poor people drank ale; rich people drank wine. Obviously, beer and ale were local products of England, where grain and hops could be grown. Wine grapes do not grow in England, and so vinous substances had to be imported from France and elsewhere in Europe. Beer and ale were easily made in local inns and households, and therefore could be subject to upper-class regulation, whereas wine was a luxury that, since not locally made, could not be regulated in the same manner. In short, lower-class production of intoxicants was criminalized if these were not registered according to the licensing act; upper-class intoxicants had no such criminality or registration attached to them.

Politics then came into play in this class struggle over intoxicants. As Royalist poet John Phillips (1631–1706) put it during the Interregnum:

From hops and grains let us purge our brains;
They do smell of anarchy.[89]

Nicholls follows up on this, saying, "As the traditional drink of the court, wine represented both stability and sophistication; ale and beer, by contrast, seemed to stand for a provincial dullness which had erupted into a horrifying Puritan enthusiasm."[90]

In eighteenth-century England, politics could be distilled down to what beverage you drank—"Tories stood for claret; Whigs stood for beer."[91] With the advent of cheap distilled liquor, gin became a popular drink of the lower classes. But again, we have come to accept the influencers' view of gin and tend to look at William Hogarth's famous engraving of *Gin Lane* (figure 4.1) as a telling depiction of the dangers of that alcoholic beverage. The picture shows us a world of chaos caused by the consumption of gin. With robbery, murder, accidental death, and a host of other calamities rolling out before the viewer's eyes, this engraving has been used as a telling indictment of the poor. On the other hand, Hogarth's companion engraving, *Beer Street* (figure 4.2), shows the positive side of alcohol consumption with a parallel scene in which harmony and contentment reign. But were beer drinkers more peaceful and harmonious than gin drinkers? We don't have strong evidence to prove that thesis, and

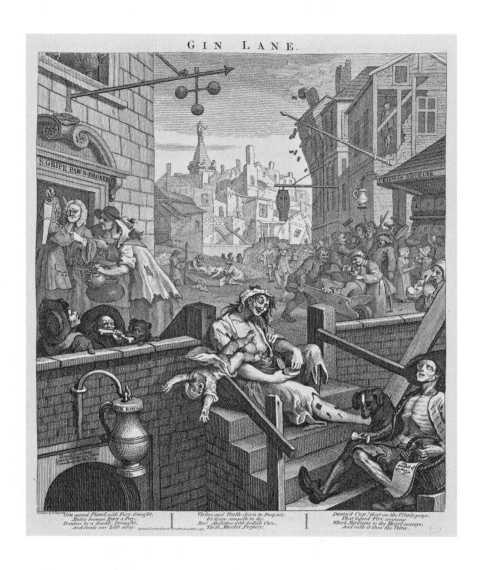

4.1 and 4.2 William Hogarth, *Gin Lane* and *Beer Street* (1751) Engraving. Metropolitan Museum of Art. New York.

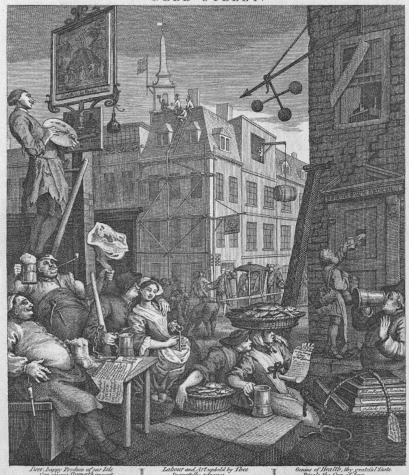

Designed by W. Hogarth. Published according to Act of Parliament Feb.1. 1751.

Beer, happy Produce of our Isle
Can sinewy Strength impart,
And wearied with Fatigue and Toil
Can cheer each manly Heart.

Labour and Art upheld by Thee
Successfully advance,
We quaff Thy balmy Juice with Glee
And Water leave to France.

Genius of Health, thy grateful Taste
Rivals the Cup of Jove,
And warms each English generous Breast
With Liberty and Love.

Price 1s.

any hot summer's day in our own times makes requisite a gin and tonic or a negroni—neither of which seems to produce undue violence or disruption. In fact, in our current ideological modality, it seems that beers rather than gin and tonics are associated with violence and bad behavior. You don't see a movie in which a threatening character is quaffing a gin and tonic, whereas scenes abound in which beer-drinking louts create havoc.

Thaddeus Russell suggests that before the American Revolution, drinking alcohol was broadly spread across the colonies, but after the revolution upper-class colonists shifted to coffee, and the sobering effects of the coffeehouse came to replace the bawdy uproar at taverns. Indeed, people like Benjamin Rush and Alexander Hamilton made many attempts to curb the drinking of spirits.[92]

Of course, there were those who did not blame alcohol or its abuse for the problems of poverty. While sensational writers continued to stress that the poor were drunks, Charles Booth, who studied the poor extensively in nineteenth-century London, wrote that "intemperance was an unimportant cause of poverty as compared to illness and unemployment."[93] Drinking was also associated with gambling. In England, public houses might often serve as betting locations, even though it was against the law for publicans to serve as betting agents. Few novels have contained as much about horses and betting as *Esther Waters*, where it is more than a leitmotif. The fortunes of major characters rise and fall on the horseracing odds, leading to plot-promoting wins and life-ending losses. In the novel an upper-class judge condemns gambling, saying, "The vice [of gambling] among the poorer classes is largely on the increase, and it seems to me that it is the duty of all in every effort to stamp it out."[94] The narrator ironically lets the reader know that the same "Lordship" is also an inveterate gambler who had lost three hundred pounds on the very same horse that ruined the defendant. Yet the judge has no hesitation in indicting gambling as a way "to obtain wealth without work. . . . [A]nd any wealth that is obtained without work is in a measure a fraud committed upon the community." Gambling is no less than the cause of "poverty, despair, idleness and every other vice. . . . Drink, too, is gambling's firmest ally."[95] But of course, the judge is a drinker as well and consumes a magnum of champagne when his horse loses.

.

Moore is laying the irony on heavily, but the point is that gambling, like drinking, is hardly confined to the poor. The difficulties brought about by these activities are strongly projected from the middle and upper classes

onto the poor because they are the designated surveilled group. In novels those who are hard workers are seen as the only acceptable incarnation of the poor. If the rich obtain money "without work," that seems to be the normal course of inherited and invested wealth. If the poor attempt to earn money by other means—whether sex work, black market sales, or gambling—they find themselves the object of criminal prosecution.

In fact, there is a historical connection between gambling and using financial instruments related to stocks and bonds. In the United Kingdom, the government under Queen Elizabeth I began the first national lottery. For those who could not afford to buy the full ticket, shares of a ticket were sold by brokers designated by the Crown. When joint-stock companies came into existence, these brokers became stock (as opposed to lottery) brokers, which is what we still call them. Gambling didn't start out as something that the poor were seen as inappropriately doing. Initially it was considered an aristocratic folly. Horseracing was a prime interest of royalty with races being held on the land of wealthy gentry.

The actual public scandal around betting involved not so much the poor as the wealthy. Exclusive men's clubs in London were notorious for gambling. Debts were often accumulated at staggering rates, and lawsuits, physical attacks, murders, suicides, and collection of debts were well known and publicized. By 1841 London had become the most populous city on earth, surpassing Beijing. This crowding resulted in a pileup of poor humans within certain neighborhoods of the city.[96] There is no doubt that areas in which poor people lived in crowded conditions had a great deal of refuse, garbage, food scraps, dead animals, and the like. But filth was not unique to the poor. Rich people still had to dispose of their excretions and ordure. Grander houses had multiple cesspools. When filled, these were bricked over, and another began. "Some of the best homes in the West End were 'literally honeycombed' in their foundations with chambers full of ancient ordure."[97] Even, or especially, royalty could be filthy. In London a street called Dunghill Mews (now part of Trafalgar Square) was located next to Royal Mews. Obviously, the proliferation of royal horses created the inevitable proliferation of horse excrement next door. Versailles was infamous for the stench that hung over it, and the frequent leakage of excrement from commodes as well as untrained dogs and guests urinating and defecating in the stairwells. When the court of Charles II spent the summer of 1665 in Oxford, the local diarist Anthony Wood observed they were "nasty and beastly, leaving at their departure their excrements in every corner, in chimneys, studies, coalhouses, [and] cellars."[98]

Before we can understand why exo-writers so frequently wrote about filth and stench in poor neighborhoods, we have to ask a question. Was this stench of humanity and animal life so unusual that it required writing about, or was it fairly common? If common, why focus a particular animus against the poor for living in such conditions?

Without public toilets, for example, until the mid-1880s, Londoners of all classes, particularly men, had to urinate in the street unless they found some dedicated indoor location. Especially useful were alleys and courtyards, which would of course smell of urine. One instance mentioned was the example of workingmen attending the Mechanic's Institute near Chancery Lane. Men leaving the institute would "satisfy any call of nature against the low wall as immediately below the rails of the Inn [of Chancery]."[99] This was such a widespread issue that some buildings installed sloped shelves that would direct the urine stream, should it be directed against the wall, onto the shoes of the person relieving himself. One such shelf is still visible in Clifford's Inn Passage off Fleet Street.[100] The point is that it took rather extraordinary, and by all accounts unsuccessful, measures to try and deodorize middle-class London.

There was no coordinated sewer system in greater London until well into the twentieth century. Indeed, the first cities with a coordinated sewage system were Chicago and Brooklyn (then a separate city from Manhattan) in the late 1850s. New York City as a whole did not have a complete working sewer system until 1902. It was estimated that by 1857, 250 tons of fecal matter was flowing into the Thames every day. In the summer of 1858, this produced a stench from the river so great that Parliament could not remain in session until measures had been taken to block the windows that fronted on the river.[101]

It was not that refuse and collected excrement were unknown in the past, but in the nineteenth century, it was seemingly weaponized as an indictment against the poor in particular. As Pamela Gilbert put it, "Accumulated waste that earlier had been perceived as an unpleasant but unavoidable reality of life in the city now seemed evidence of a vicious, even murderous, disregard for life. Bodily wastes were seen no longer simply as byproducts of the life process, but as animated and hostile filth that would, given the chance, attack the body itself."[102] And those responsible for this attack on life were determined to be solely the poor. Dickens makes this quick transition from filth to moral corruption. In *Dombey and Son* he describes the "noxious particles that rise from the vitiated air," that is,

miasma, and then quickly mentions "the moral pestilence that rises with them."[103] Filth and bad morals go together; a minister testifying before a royal commission noted, "A clean, fresh, and well-ordered house exercises over its inmates a moral, no less than physical, influence . . . whereas, a filthy, squalid, unwholesome dwelling . . . tends directly to make every dweller in such a hovel . . . selfish and sensual."[104]

When these filthy living conditions appear in novels, we can see how poornography operates. There is a memorable moment in *Mary Barton* that illustrates some of the points I am making. In this scene two working-class men go to see a dying fellow worker who is living in the center of an industrial city. We get a clear description of the streets being filled with excrement. "It was [an] unpaved [street]; and down the middle a gutter forced its way, every now and then forming pools in the holes with which the street abounded. Never was the old Edinburgh cry of 'Gardez l'eau!' more necessary than in this street. As they passed, women from their doors tossed household slops of every description into the gutter; they ran into the next pool, which over-flowed and stagnated. Heaps of ashes were the stepping-stones on which the passer-by, who cared the least for cleanliness, took care not to put his foot."[105] The genre requirements in this case are sensational details linked to disgust. The reference to the Scottish exclamation (in French) reminds us that the Scots were reputed to be dirty because they call out from the upper stories when they dump the contents of their chamber pots into the street. Of course, there was little recourse, as we have seen, for dealing with excrement short of sending it into the open sewers or piling it up elsewhere. The word *ashes* was a common euphemism for excrement. Even the working-class men who were "not dainty . . . picked their way" through the ordure.[106]

As the two visitors enter the basement dwelling of their dying colleague, they find "the smell was so fetid as almost to knock the men down." They feel "the damp, nay wet, brick floor, through which the stagnant, filthy moisture of the street oozed up."[107] The man is lying "on straw, so damp and mouldy no dog would have chosen it."[108]

The normally staid Victorian critic Steven Marcus responded in a less than "academic" way to this paragraph when he wrote, "Englishmen, women, and children were virtually living in shit."[109] Gaskell has included these details to shock middle-class readers, reenacting, no doubt, her own discomfort when entering poor neighborhoods. But the presence of odors, waste, and mud would not have surprised the people who lived there. A

newly found standard of cleanliness in middle- and upper-class households is here posited as the only way to live. And the literature furthers this ideology in carving out the reading public from the vast majority of the world.

Part of the animus against the poor for "filth" was based on the conception during the Victorian period that disease was transmitted by miasma, the odors arising from filth, rather than by contagion, or what we would now call the *germ theory*. The former implies that accumulation of waste itself spontaneously generated disease, which then spread through the air in noxious smells. This theory, which took firmer hold among certain doctors and public health officials in the first part of the nineteenth century, was particularly tenacious. It is possible that this conception heightened a fear of odors and created a new attitude toward smells. Edwin Chadwick, famous for his efforts to create public sanitation in London, had the most succinct and memorable adage: "All smell is disease." He elaborated, saying to a parliamentary commission, "All smell is, if it be intense, immediate acute disease; and eventually we may say that, by depressing the system and rendering it susceptible to the action of other causes, all smell is disease."[110]

.............

It might be fair to say that strong odors were common in the history of humanity. If we look at Jonathan Swift's satirical 1710 poem "A Description of a City Shower," we can note an almost comfortable attitude toward sewer smells.

> Returning home at night, you'll find the sink
> Strike your offended sense with double stink.[111]

The *sink* is a cesspool in eighteenth-century usage. Swift takes for granted that the cesspool smells. That is a given in his life. He is noting that when it rains, the normal smell doubles in intensity. Alexander Pope, in his 1709 poem "The Alley," quite matter-of-factly notes that among the fisherwomen of various towns, their infants engage in activities:

> Some play, some eat, some cack against the wall,
> And as they crouchen low, for bread and butter call.[112]

The fact that the children defecate against the wall of the house seems to simply fit in with playing and eating.

Even the sanctity of the bedroom might have normally been tinged with strong smells. Bedding—mattresses and linens—were passed down from generation to generation and were included in wills. Shakespeare famously left his "second-best" mattress to his wife. Wills routinely included mattresses—and one might want to remember that birth, sex, vomiting, incontinence, menstruation, and death were all infused into the sensescape of bedding.[113]

We might contrast this eighteenth-century blasé attitude toward smells with the more exaggerated reaction of the mid-nineteenth-century horror regarding odors, now seen as the conveyers of disease. The exo-narrator often comes from a class that by now is well separated from cesspools and animal production and expects a scentless environment.[114] Indeed, a moral equivalence was starting to be made between people who live in areas where there is garbage and garbage itself. A nineteenth-century exo-writer describes: "the dregs of life which exist at the depths of civilization . . . the living nastiness and offensive living matter which we have been content to allow to accumulate in our streets. . . . [T]here are moral miasmas as well as physical."[115]

Terms like *knocked over* or *fainting from* intensify these types of descriptions. Take, for example, this 1844 account of two gentlemen from the country coming to visit the slums of London they had read about in *Oliver Twist*: "The stench there was insufferable; it crept like poison through every sense. My companion felt sick, giddy, and incapable of proceeding."[116] And the two previously mentioned working-class men in *Mary Barton* visit an ailing friend in a cellar where "the smell was so fetid as to almost knock the men down."[117] We need to remember when we read such accounts that, according to Chadwick's dictum, victims of olfactory attack actually felt themselves in mortal danger. Chadwick in his famous Poor Laws report to Parliament specifically cites "atmospheric impurity" as the "main cause" of epidemic and pandemic diseases and thus mortality.[118]

The major sanitary reformers like Chadwick and Florence Nightingale, dedicated anticontagionists, firmly believed in the miasma theory over the germ theory. Their focus, then, was on cleaning up and deodorizing the dwellings of the poor so that disease would not spread to the rest of the population through this spontaneous generation of miasma. Their aim was in keeping with the Poor Laws in general—to reduce the economic burden on the middle and upper classes for providing support

to the poor, disabled, diseased, and elderly. However, their efforts could have unforeseen consequences: in 1848, when cholera seemed to return to London, the Board of Health caused the London sewers to be flushed and the contents directed to the Thames, where most of the city's drinking water came from. Instead of confining cholera to the locality (where the feared miasmas would arise), the board succeeded in spreading the actual germs to the larger community that drew its drinking water from the Thames.[119] From June to September, the dead mounted from 246 to 6,644 as a result.[120]

Exo-writers seem to imply that the poor were naturally filthy. However, that point of view need not be true. As with the use of animals for protein and manure (see the next section), the collection and use of human excrement had economic benefits. A Dr. Arnot wrote of the slums in in Glasgow in 1842, "There were no privies or drains there, and the dung heaps received all the filth which the swarm of wretched inhabitants could give; and we learnt that a considerable part of the rent of houses was paid by the produce of dung heaps. Thus, worse off than wild animals, many of which withdraw to a distance and conceal their ordure, the dwellers in these courts have converted their shame into a kind of money by which their lodging was to be paid."[121] Again, an exo-writer is appalled by a traditional method of disposing of human waste that made not only environmental but economic sense.

An 1845 letter to the *Times* sent by a group of poor residents of London's St. Giles slum area, known as the Rookery, expresses dismay about their lack of access to privies, garbage cans, drains, or other forms of sanitation. These residents also complain that the people they thought were "commissioners" from the sewer company coming to aid them turned out instead to be developers complaining about the stench that would affect their investments on the nearby posher New Oxford Street. The tenants wrote in desperation to the *Times* because it was an "influential paper"; they hoped that the landlords and commissioners would "make our houses decent for Christians to live in."[122] This rare complaint written by poor people themselves lets us know that their desire to improve conditions created by unscrupulous owners and regulators was not unknown.[123]

Another sign that the poor were not "naturally" filthy can be gleaned from observing the activities of Charles Cochrane, who in the 1840s built public privies and wash stations. He fitted these with washing basins, soap, towels, razors, and other hygienic accouterments. Cochrane calculated that in one year there were 135,916 visits from men, 27,508 from women,

and 2,796 from children, which amounts to more than 450 people per day. Cochrane publicized not only the usage but the fact that no items had been stolen. His point was that it isn't true that the poor "loved dirt."[124]

A more structural argument can be made that laws and regulations conceived of different solutions to the disposal of human waste and the washing of the body. While some middle-class people by the middle of the nineteenth century in England could afford indoor plumbing and running water, working-class people could not. Public baths were instituted by the state to create a way for the poor to bathe. It wasn't until 1918 that baths with hot and cold running water in working-class residences were mandated by legislation.[125]

Considering the class-based nature of representation, one would have to observe that few if any novels depicting upper-class life recount anything that might relate to odor or excretion. While it is clear that the characters in Jane Austen's novels must have used commodes or simply relieved themselves outside, none of this is ever mentioned. Novels and art in general essentially deodorized and repressed the olfactory side of middle-class life. This sanitized view of high society, as opposed to the olfactory-rich world of the poor, did not correspond to the actuality of the odorants that no doubt made up the sensorium of polite life. We know, for example, that it was common for wealthy families to have a commode installed in a sideboard in comfortable dining rooms. When the females of the company withdrew after dinner, the males would use the chamber pot concealed within this piece of furniture to relieve themselves. This British custom was widely accepted within England but was strange to a French visitor, who described how "the sideboard is garnished also with chamber pots, in line with the common practice of going over to the sideboard to pee, while the others are drinking. Nothing is hidden. I find that very indecent."[126] How did Jane Austen miss this extremely common habit of British upper-class men? One can only imagine how different *Pride and Prejudice* would have been had such a scene been included.

Indeed, the smell of the poor might simply be a remnant of the way humanity lived before the amenities of easily available running water, hot water, shower baths, and the like proliferated. A telling scene in John Steinbeck's *The Grapes of Wrath* reminds us of this contrast. The Joad family has been able to live in Weedpatch, a government-run facility where there are sanitary stations including soap and showers. "Pa" says to the manager of the camp, "Never was so clean in my life. Funny thing—use t'a be I on'y got a bath ever' week an' I never seemed to stink. But now if I don't get one

ever' day I stink. Wonder if takin' a bath so often makes that?" The manager replied, "Maybe you couldn't smell yourself before."[127]

While we tend to think that sewers solved the problem of disposal of human waste, and therefore made cities less contagious and safer, particularly insulating middle-class people from the supposed filth of the poor, the reality is that sewers were not the pristinely clean and sanitary solutions they were touted as being. In the nineteenth century, sewers often backed up, returning undifferentiated waste to the residents of houses. Worse, instead of the unique cesspools that might contain one's own ordure, sewers combined the fecal matter of large numbers of people, thus creating a way that disease might spread through a city. Contemporary critics of public "sanitation" inveighed against "monster sewers," warning that "the seeds of disease . . . should not be carried from house to house." This was most tellingly the case when such disease might be spread, through sewers, "from unhealthy parts to salubrious districts" such as the suburbs.[128] Michelle Allen duly notes that this objection was "ostensibly concerned with diseased sewage, but this rhetoric also implies a concern with boundaries and the difficulty of separating oneself from the urban poor (that other filthy mass)."[129]

After the discovery of germ theory and a more nuanced understanding of how diseases were transmitted, filth took another prominent role. With the discovery, for example, that hookworm was transmitted through the vector of human fecal matter, US health officials turned their attention to poor people's privies. In 1914 one such official pointed to the connection between the housefly and hookworm. "Flies breed and feed at the privies, soil their feet and bodies with filth, carry the filth to the food . . . with which it is swallowed." The urgency of the hookworm infestation was accelerated by demonstrating a kind of racial miscegenation of the fecal matter. "Our test does not show us whether the contamination in a given person comes from the privy of a white person or a negro neighbor, but as the two races are living in such proximity [in the South], it is clear that each race is eating not only its own excrement, but also that of the other race." The writer goes on to call on the "Mothers of the South" to observe their "moral duty to protect their children."[130] One can detect a moral outrage that white people are inadvertently eating the excrement of Black people and becoming ill and diminished as a result.

Social workers in the United States focused on household cleanliness as a means for bringing poor immigrants into American life. Cleanliness was the emphasis of these social workers since ethnic groups in New York were

routinely described as filthy. Take Charles Loring Brace's description of Italians living in the Lower East Side, which depicts women at home who "roll their dirty macaroni. . . . They were, without exception, the dirtiest population I had met with." He adds the eugenic explanation that "so degraded was their type, and probably so mingled in North Italy with ancient Celtic blood, that their faces could hardly be distinguished from those of Irish poor children—an occasional liquid dark eye only betraying their nationality."[131] Brace doubly condemns the Italians by associating them fancifully with the reviled Irish. Of course, the "filthy" Jews were not far behind in the list of denizens living in dirt and depravity.

One specific area was a concern about cleanliness on the Lower East Side revolving around contaminated milk being fed to children. A 1908 article focused on this subject, noting that "one-third of all babies die before five years old of diseases chiefly connected with digestive tract and a considerable percent of diseases are definitely known to be caused by milk."[132] The reason for this lack of cleanliness among Lower East Side mothers was that milk was sold in various grades, with the most sanitary milk being bottled and sold at high prices for the elites. Poor women bought "loose milk" scooped from open containers in grocery stores and brought the liquid home in their own pails or glasses. Like so many other health conditions, infant mortality resulting from contaminated milk was in essence a structural problem of class and the unequal distribution of goods and services.

Accounts of poor urban neighborhoods often convey a repulsion that humans are living intimately with animals, notably pigs, cows, chickens, and the like. In eighteenth-century London, animals were so common that Alexander Pope could write in his 1708 poem "In Imitation of Spenser: The Alley":

A brandy and tobacco shop is neare.
And hens, and dogs, and hogs are feeding by. . . . [133]

Pope's matter-of-fact reference to hogs in his poem is rather unremarkable given the necessity of urban pork production. The reality is that in eighteenth- and early nineteenth-century London, pigs were regularly kept in courtyards and enclosed areas within the city. While beef and lamb were driven in from the countryside, pork was a city-bred product. In 1822, 20,000 pigs were sold in the Smithfield Market, but the city was consuming over 210,000 hogs and 60,000 suckling pigs, and the majority of these were raised by poor people in the city.[134] Hogs were often the way

poor urban farmers could provide a living and sustenance for themselves. In New York City, at this time, the argument by hog owners against attempts to regulate public spaces was that roaming pigs on the commons allowed owners to "pay their rents and supply their families with animal food during the winter" and to avoid becoming a "public burden."[135]

But by the mid-nineteenth century, we find a rise in objections to the fact that swine were kept in London and other cities. The equation became simple in the later period—people who live with animals are themselves animals, and people who live with swine are swinish. The much-reviled Irish in Manchester, London, and elsewhere were particularly associated with the keeping of pigs in cities and were routinely denigrated and condescended to as a result. As noted, the pig was intimately part of Irish rural culture, and when Irish peasants moved into urban areas, they used pigs as economic leverage against poverty and hunger. But this economic necessity was turned into moral opprobrium. A *New York Times* article describes "shanties in which the pigs and the Patricks lie down together while little ones of Celtic and swinish origin lie miscellaneously, with billy-goats here and there interspersed."[136] Charles Dickens in his *American Notes* described the domestic pigs that daily roamed the streets of Manhattan.[137] And an English visitor to New York City wrote in 1819 that the place was "miserably dirty" with "innumerable hungry pigs of all sizes and complexions, great and small beasts prowling in grunting ferocity, and in themselves so great a nuisance."[138] An 1820 estimate placed twenty thousand hogs in the settled parts of New York City.[139] That would amount to one hog per five people. Even in 1843 Robert Collyer could note that hogs "are allowed by the corporation, the same privileges of citizens, to walk the streets wallowed in at their pleasure. These domestic animals are seen at every turn, they not only hold their dominion in the street but upon the sidewalks, frequently stopping the pedestrian in his course, and not unfrequently tripping people of meditation upon their noses."[140] There was surely a class issue between poor people who had domestic pigs for food and their richer counterparts.

There is also a cultural shift we could place in the mid-nineteenth century, when there begins to be a disconnect between food production and urban living. According to one writer, in Georgian London, "many Londoners were prepared to accept the smell of pigsties providing that their noses and stomachs were not overwhelmed."[141] But by the mid-nineteenth century, the miasma theory had linked all strong smells to

the possibility of disease. The goal, then, was to eliminate the animals and the smell they produced. One way of rethinking this issue is to see a clash of not only aesthetics but also economic interests. Middle-class and upper-class people were gradually separated from the animal ecosystem and economic system that provided high-quality protein to their kitchens. When nations were largely rural, there was an intimate connection between livestock and people. But as the population shifted to the cities, that connection changed. Those who could afford to go to the butcher and buy meat might be able to ignore the necessity of raising animals, but the poor in urban areas found there was great economic advantage to living with domestic animals.

In reality, pigs are some of the most efficient animals for converting feed into meat.[142] In addition, they symbiotically fit into urban recycling of wasted food. Spoiled vegetables and the like made perfect fuel for pigs, and spent grains from brewing were consumed widely by urban pigs, reducing the necessity for removal and disposal. Knowing this, distilleries routinely kept pigs on-site.[143]

Before refrigeration, it was necessary to have sources of animal products in or very near urban areas. "In the nineteenth century no English city had severed itself from its rural connection. The largest of them all still conducted extensive back-yard agriculture, not merely half-a-dozen hens in a coop of soap boxes, but cow-stalls, sheep-folds, pig-sties above and below ground, in and out of dwellings, on and off streets, whenever this rudimentary factory farming could be made to work."[144] The association of pigs and other animals with poverty was in fact a result of practicality rather than slovenly disregard. But from the poornographic perspective, moral outrage and sensory disgust overrode economic concerns and turned a necessity into a disgrace.

Of course, to the poornographer, the poor bring disease. Aaron Clark, the mayor of New York in 1838, said of the poor immigrants, "They will bring disease among us; and if they have it not with them on arrival, they may generate a plague by collecting in crowds within small tenements and foul hovels."[145] While it clearly isn't true that a socioeconomic class can "bring" disease, Clark isn't wrong that crowding in areas with bad-quality drinking water, for example, can cause illness. The great cholera plagues of nineteenth-century London were associated with people living in crowded conditions in areas with poor drainage, environmental pollution, and the like. The residents of the neighborhoods of Southwark, Lambeth, Wandsworth, and Camberwell,

among others along the polluted Thames, were more likely to contract cholera than inhabitants of other areas.[146] These neighborhoods at the time comprised shoddy housing for the poor built on marshland with little or no sanitation.

It is part of the ideology of poornographers to blame the poor for their diseases, seeing them as living disreputable and unsanitary lives and making bad decisions on nutrition. The reality is of course more complex.

If we break up disease into several types, we can get a better biopolitical understanding of the relation between poverty and disease. There are infectious diseases and chronic ones. Infectious diseases can spread through the population through many vectors—insects, animals, bacteria, and viruses. Those diseases that are airborne or spread by close personal contact, for example, will spread quickly where there is the greatest population density. Influenza, measles, tuberculosis, and smallpox are thus more likely to spread through a crowded tenement than a bucolic suburb. Diseases spread by an animal or insect vectors, like bubonic plague or West Nile, will also do better in crowded conditions. Waterborne diseases like cholera, typhoid, and dysentery will thrive in unsanitary conditions where water is easily contaminated. Often fecal contact can transmit some of these diseases, including hepatitis, so in poorer areas where people share towels, have limited access to hot water, or eat food prepared by a diseased person, such diseases can spread.

The take-home message is that crowding and poor sanitation can cause epidemics. Obviously, poor people are not responsible for the state of their water quality or the density of their dwellings, but blaming the victim is the norm in middle- and upper-class concerns about disease. Those concerns tend to focus not on economic factors but on the lifestyle of poor people. One 1845 report from the United Kingdom asserted that economic causes were less relevant than the way the poor lived. "It is proved, that the greater liability of the working classes to the most afflictive and painful disorders does not arise from deficiency of food and clothing, but from their living . . . in narrow streets, confined courts, damp dwelling, and close chambers, undrained, unventilated, and uncleansed."[147] There were a few opponents to this idea that disease arose from the uncleanliness of the poor. One alternative view was provided by William Pulteney Alison, who insisted that there was a better way of "preventing the introduction . . . of a disease . . . by a more liberal and better-managed provision against the destitution of the unemployed."[148]

It is true that being poor is associated with greater risk for chronic conditions. These conditions are also often directly tied to income. Indeed, a

well-off person who develops a chronic condition can go down the road to living in poverty, according to the World Health Organization. Chronic conditions can send financially stable people "into a downward spiral of worsening disease and poverty."[149] Chronic conditions like asthma, cardiac diseases, COPD, and the like can be exacerbated by excessive heat, which, as already mentioned, poor people living in urban areas are subjected to more than their wealthy counterparts.[150]

Criminality is almost always associated with poverty. But were the poor more criminal than other classes? The Old Bailey court records of eighteenth-century London show that only 2.7 percent of defendants were from the elite classes, and those crimes were more often murder than theft.[151] But then again, what was the percentage of the general population who were considered gentlemen? By the mid-nineteenth century, the aristocracy and gentry probably numbered around twenty thousand, compared to a total population of twenty million. That would put the elite at less than 0.001 percent of the population, so having 2.7 percent of defendants be elites is actually a startling high number. And this depends entirely on how one defines crime. If criminality involves the theft of property, then the social construction of this crime depends entirely on the type of theft that a society makes laws about. Crime statistics are notoriously dodgy accumulations of data with shifting definitions of what a crime might be, various public panics, and the willingness to prosecute certain activities.

If we look at crime statistics in eighteenth-century London, the vast majority of offenses were against property. Obviously poor people don't have much property and need material things to survive. If the poor behave themselves, they generally will remain poor. Middle-class citizens are defined by the ownership of property and wealth. Is property a well-deserved and earned reward for hard work and the investment of capital, or is it, as Pierre-Joseph Proudhon succinctly put it, theft?[152] The dialectic between property and theft is made more acute when we consider that there can be no theft without property, and probably no property without some form of theft.

A novel like Victor Hugo's *Les Misérables* asks hard questions about the criminality of appropriating property for survival. If Jean Valjean steals a loaf of bread to feed his family, is that actually equal to any other form of theft? In eighteenth-century London there were serious and often lethal punishments for what might seem like minor forms of larceny. In addition, most ordinary trials in London were held in summary courts that had judges who were alderman without legal training and who were chosen

from among the wealthiest citizens—most were bankers, financiers, and merchants.[153] Clearly, they had cause to apply the most restrictive sense of property, as well as a strong bias toward severe punishment for theft. Crime statistics in London would therefore reflect those prejudices. Also, a factor worth taking into consideration is that there was no official police force until 1828. Therefore, arrests and imprisonment were in effect accomplished through a loose system of watchmen, marshals, and community action, including constables. Watchmen were notoriously ineffective—ridiculed in the press as lazy, ancient, and decrepit. Constables were frequently artisans practicing their trade within the community, and they could easily offend their current and potential customers by accusing them. Constables were paid a low wage but supplemented with payments per successful prosecution. Since their salary depended on how many people they arrested, their tendency would be to avoid arresting fellow tradesmen and clients, choosing instead from a less prosperous demographic. Vagrancy acts only furthered this situation, allowing constables to arrest anyone "sleeping rough, begging, soliciting or hawking."[154] Comparing crime statistics before and after the institution of an official police force would then be difficult.[155] It is the conclusion of one set of researchers that poverty and crime do not so easily go together and that only "a fraction of those in economic need actually resorted to theft to support themselves, and that poverty was only one of many possible motivations for committing a crime."[156]

Murder is more clearly defined as a crime that would not necessarily be economically constructed. We have seen that the elites were disproportionately represented in the commission of homicides. But is murder more frequent among the lower classes? Statistically, the poor do commit more murders than the middle classes or wealthy, but one study notes that murder in the upper classes is more premeditated and therefore possibly harder to detect and prove.[157] The reality is that murder in the United Kingdom at the end of the nineteenth century was extremely rare, despite sensationalized news stories to the contrary. The murder rate in England and Wales was approximately one in fifty thousand, according to one source.[158] This statistic might be compared to the current murder rate for the United Kingdom in 2018, which is one in ninety thousand. The current US murder rate is one in twenty thousand—far greater than either of the previous two. The stereotype is that the poor living in crowded conditions in London lived lives that were violent, brutal, and short. But if the murder rate in the United Kingdom now is barely half the rate in the

nineteenth century, how violent was life among the poor? When one looks at the conditions for murder, the most common situation, as we all know, involves people who know each other—frequently spouses or cohabiters. Murder during robbery makes up a much smaller percentage of homicides. And random Jack the Ripper murders are extremely rare.

Obviously, the social panic and drama around murder far exceeds its occurrence, and it is entirely possible that the wave of fascination about lower-class murders is due almost entirely to the attention generated by a sensational press. As Barry Godfrey writes, "The growing power and entertainment focus of the press towards the end of the [nineteenth] century" contributed to a public panic about murders among the poor, "as well as being related to contemporary anxieties about immigration, poverty and homelessness, prostitution, and the general sociopolitical climate in East London."[159]

But surely the poor had a great number of assaults. Weren't they always brawling and fighting? Statistics show that in England and Wales in 1871 there were thirty-three offenses annually per ten thousand people. By the turn of the century, that number had been cut in half, to 16.1 per ten thousand.[160] This state of affairs simply doesn't add up to a melee of drunken poor people duking it out on the streets.

We might associate disability with charity in the past. Certainly, it was one of the functions of the church and of the parish to provide for the deserving poor—made up mainly of the elderly, widows and children, and the disabled, or some combination of the previous categories. One estimate is that a fifth of the residents of workhouses were there because of a disability.[161] But we also have to recall that crimes might be committed by those in the working classes who were or became disabled. Parish houses and workhouses didn't hold all the indigent, and one might have to engage in petty crime to stay alive if one had a disability. Take, for example, John Martin, an Englishman and a sailor who lost the use of one side of his body. In 1784 he stole a two-penny pewter pot from a tavern and was sentenced to six months in jail and a whipping. In 1785 he again ran afoul of the law for taking some iron bars. He was described as having "a stroke of palsy" and "could only hobble about." He resorted to theft, according to his testimony, to "preserve his life." His life should have been preserved by back wages owed him for years of going to sea. Martin sailed on the *Endeavor*, Captain James Cook's vessel, as well as other major ships. Without those wages, and unable to work because of his disability, he turned to petty

4.3 Robert Koehler, *The Strike* (1886). Oil painting. Deutsches Histroisches Museum. Berlin, Germany.

4.4 Robert Koehler, *The Socialist* (1885). Oil painting. Deutsches Histroisches Museum. Berlin, Germany.

thievery to live. As Drew Gray notes, Martin "was poor and his treatment there [in prison] reflected this."[162]

The poor were often seen as an angry rabble willing to turn any political event violent. Novels of the nineteenth century often show us how a work boycott can get out of hand and turn violent. In Elizabeth Gaskell's *North and South*, such a strike becomes a melee after an anonymous worker throws a stone at the heroine of the novel, who is trying to calm the crowd. An 1886 painting, *The Strike* (figure 4.3), by German American painter Robert Koehler, reproduced in *Harper's Weekly*, parallels this poornographic meme. An angry man wearing red, symbolic of socialism and communism, confronts the wealthy factory owner while pointing in the direction of the abused workers, his other hand clenched into a fist. A detail shows us a woman trying to discourage one man as another bends over to pick up a stone he will presumably throw at the wealthy proprietor, while another person collects stones in the distance. Potential violence from the workers looms over the gloomy industrial landscape. The catalog for the original showing of the painting in 1886 noted that "the dissatisfaction in the faces of the men is intense. Some appear ready to use violence. . . . Only a little thing will turn the crowd into a mob."[163]

The same painter had done an earlier picture, *The Socialist* (figure 4.4), which echoes the threat of violence coming from the angered working class and their allies. The upraised fist, clenched other hand, well-thumbed socialist newspapers, and frenzied look brought terror to the readers of the many publications that reproduced the image. The *New York Times* reviewer described the painting as that of "an orator expounding dynamite doctrines to some willing audience."[164]

In Gaskell's other factory novel, *Mary Barton*, a distraught and class-conscious father who fears his daughter will lose her virginity to the son of the mine owner ends up killing the young man. In *Germinal*, by Émile Zola, a striking mob turns violent, almost raping the coal mine manager's daughter, and a group of frenzied women cause the death of a complicit store owner who himself has raped them and their daughters as an extortion for food. Said store owner is then castrated by the women, and his genitals paraded around on the end of a stick. Meanwhile, more violence abounds as an anarchist plants a bomb that collapses a mine shaft and kills some more protagonists. In Charles Dickens's *Hard Times*, a group of strikers ends up, through a violent ostracism, killing a nonstriking factory worker. The novels and story go on with the same notion that striking workers represent a dangerous hazard to middle-class comfort. The same could be

4.5 William Balfour Ker, *From the Depths* (1906). Print in John Ames Mitchell, *The Silent War*. New York: Life Publishing, 1906. Illustrated by Ker.

said for stories about enslaved people's rebellions. Arna Bontemps's *Black Thunder*, which depicts such a failed rebellion, is filled with the possibility of violence that the Black rebels intend for the white people. William Attaway's *Blood on the Forge* contains a scene of its African American protagonists living in fear of the wrath of unionizing whites. William Balfour Ker's 1906 painting *From the Depths* (figure 4.5) sums up the imagery of violence with a scene in which the wealthy cavort amid luxury while the

working classes labor beneath them. A fist breaks through the floor of the festivities, an unwanted reminder of class struggle and violence.

And Jacob Riis echoes this lurking threat in the final words of *How the Other Half Lives*: "The sea of a mighty population, held in galling fetters, heaves uneasily in the tenements. Once already our city . . . has felt the swell of its resistless flood. If it rise once more, no human power may avail to check it. The gap between the classes, in which it surges, unseen, unsuspected by the thoughtless, is widening day by day."[165] Riis ends with two lines from a poem by James Russell Lowell:

Think ye that building shall endure
Which shelters the noble and crushes the poor?[166]

In other words, a staple of poornography is the depiction of seething anger and resentment on the part of workers and the dispossessed, leading to an outbreak of violence and revenge. It doesn't take much analysis to see this as a projection of the fear of the middle classes and rich toward the poor and a further refraction of the state's own institutionalized violence, now turned against those citizens who have historically benefited from that violence.

But is this violence on the part of the poor a myth or a reality? Certainly, there has been violence on the part of striking workers, but the historical record shows us disproportionate violence against strikers by businesses in combination with local, state, and federal forces. One has only to recall the Peterloo Massacre in England in the nineteenth century, the Lattimer and Columbine Mine Massacres in the United States in the early twentieth century, and the Chicago railroad strike of 1877, as well as federal involvement and murder in the Pullman strike. There are further iterations of such violence throughout labor history.

We tend to forget the very tangible and peaceful rebellions that do not hold historical memory or lingering attention. A series of strikes on the Lower East Side of New York City by Jewish women, mostly housewives, were effective and occurred with a lot of emotion but without major violence. In 1902, in response to the rising cost of kosher meat, women rallied and gathered twenty thousand attendees in protest. The boycott spread through all the city and was successful in lowering the cost of meat.[167] In 1907 six hundred women organized a rent strike there that ultimately led to two thousand signatories. Within weeks the strike had spread to the east and west sides of Manhattan and to Williamsburg, Brooklyn.[168] In 1917 the

price of kosher meat again triggered another boycott by Jewish women, and that strike spread throughout the United States, including Boston, Philadelphia, Baltimore, Chicago, St. Louis, and Cleveland.[169] Rent strikes were also initiated and enforced by women on the Lower East Side. In addition, union organizing and picketing were often largely carried out by women. A strike that started in 1909 at the Leiserson and Triangle Shirtwaist shops became a general strike at a meeting of two thousand women held at the Cooper Union. Fifteen thousand shirtwaist makers went on the picket lines, mainly women.[170] These types of political actions remained below the radar and were largely forms of nonviolent passive resistance.

So, what accounts for this usual association of the poor worker with political violence? Could it be that collective action threatened the foundations of the economic system and therefore felt like violence to the middle classes and owners of businesses? One hallmark in the United States may have been the first general strike, held in 1877. The length and determination of this spontaneous uprising of workers across the United States, recalling the Paris Commune a few years earlier, brought fear to the hearts of owners. A contemporary journalist sympathetic to the status quo wrote, "The whole country seemed stricken by a profound dread of impending ruin. In the large cities the cause of the strikers was espoused by a nondescript class of the idle, the vicious, the visionary and the whole rabble of Pariahs of society. No standing army was available, and these classes absolutely controlled the country. . . . [I]t seemed as if the whole social and political structure was on the very brink of ruin. From the Atlantic to the Pacific the laws were momentarily subverted."[171] It seems clear that the desire of workers to oppose lower wages and bad working conditions was seen as violence, whether or not there was actual physical violence during these events. And as noted earlier, the major violence came with the calling in of the National Guard and federal troops to suppress the general strike. Over a hundred thousand workers participated. Of those, over a thousand were jailed, and over a hundred were killed. Worker "violence" tended to be to property, while owner violence tended to be to life and limb.

You don't have to look hard to find descriptions of the poor as lazy. Take, for example, William Byrd II, a wealthy landowner in Virginia, who in 1728 wrote of the poor whites in the South, "I am sorry to say it but Idleness is the general character of the men of the Southern parts of this Colony. . . . To speak the truth, 'tis a thorough aversion to labor that makes people file off to N[orth] Carolina, where plenty and warm sun confirm

them in their disposition to laziness for their whole lives."[172] The implication, of course, is that if only the poor weren't so lazy, they wouldn't be so poor. By most accounts in poornography, the poor are either ambitious to rise out of their class, as we see in rags-to-riches stories, or lazy and more than content to remain poor. Horatio Alger's young heroes all use gumption and drive to escape poverty. Likewise, the poor are often depicted as enjoying life on the dole without the desire to work.

In seeking a cause for this supposed laziness, researchers in the United States at the end of the nineteenth century sought a medical explanation. Poor white people were seen as routinely infected by hookworm parasites, and that caused the debilitation that led to laziness. Indeed, hookworm was called "the lazy man's disease" because it supposedly created indolence and low energy through the endemic infection of families and communities.[173] Because hookworm was transmitted through bare skin by exposure to dirt and human feces, the reformers naturally linked laziness, disease, and uncleanliness in an unholy trinity that would characterize the rural poor. As the *New York Times* wrote at the time, "The uncinaria [hookworm] is picked up in its embryo stage by barefooted children . . . [who] grow into sickly, bloodless, indolent, stupid adults."[174] Of course, the dire warnings about hookworm infection were inflated through a poornographic fascination and disgust. However, current research indicates that hookworms in the gut do little to alter the microbiome.[175] Further, hookworm infection seems to be an effective cure for difficult-to-treat allergies.[176]

But according to some historians of the poor, there was a kind of impossible activity of the poor to both survive within the constrictions of laws, institutions, and economic conditions and have an active agency in changing the laws under which they had to live. For example, according to Peter Mandler, "for the poor" knowledge of the complexities of the social, cultural, and legal world is "essential to survival."[177] Tim Hitchcock and Robert Shoemaker are even more emphatic in saying that "basic human need and fear, whether in the form of hunger, disease or the prospect of death on the scaffold, motivate the poor and the accused criminal to explore, within their cultural context, the structures of society as thoroughly as possible (more thoroughly than any other group)."[178]

Social Darwinians like Charles Murray have claimed that the poor are lazy. If only they would work more hours, they could escape poverty. Murray writes, "Anyone who is willing to work hard can make a decent living."[179] Yet his work is contradicted by Marlene Kim, who argues that

even if poor people worked a full forty hours a week, most of them would remain poor.[180] The poorest neighborhoods are in fact where one might find the most industriousness. The Lower East Side of Manhattan at the beginning of the twentieth century was one of the most densely populated poor areas in the world, and it was also the most industrialized location in the city.[181] Indeed, studies show that in recent years the poor have experienced a greater increase in the number of hours they work than have the middle class or the rich. This trend is actually more so among women.[182]

It may be that poverty creates an inability to function at one's best. Clearly, malnutrition slows down one's ability to work, resulting in lower energy levels, reduced activity, and poor cognitive functioning. Indeed, one study shows that poverty does affect one's ability to think and act. Subsistence farmers who have just cashed in on their harvest have better cognitive function than before the harvest, when they are poorer. The same study showed that poor people had diminished cognitive function when asked to think about finances than did people who were not poor.[183] Another study of poor Ugandan farmers showed that when they were asked to think about their financial condition, they were less likely to work and more likely to seek relief with entertainment of various sorts.[184] The stress of living with poverty has biocultural effects on adults and children. As one study put it, "Ongoing stress associated with poverty, or the stress of living with less than one needs, creates constant wear and tear on the body, dysregulating and damaging the body's physiological stress response system and reducing cognitive and psychological resources for battling adversity and stress."[185] Not only stress but actual brain development in children is inhibited in direct proportion to the poverty they experience in early childhood. Measurable decreased gray matter in the brain leads to a decrease in executive function, a crucial ability that is directly linked to the ability to plan, execute plans, and act.[186] In other words, what we call *drive* or *ambition* is related to our ability to master executive functioning, and therefore *laziness* is the pejorative assessment of a lack of executive function.

But couldn't this potential for poor functioning be corrected by increased exposure to education? There is some evidence for this, but at least according to one study, the combined risks of being a poor child will permanently influence their later development. These risks are "substandard environmental conditions including toxins, hazardous waste, ambient air and water pollution, noise, crowding, poor housing, poorly maintained school buildings, residential turnover, traffic congestion, poor neighborhood sanitation and maintenance, and crime." The psychosocial harm is

also well documented; poor children experience significantly higher levels of family turmoil, family separation, and violence and significantly lower levels of structure and routine in their daily lives. As the study puts it, there is "evidence for a new, complementary pathway that links early childhood poverty to high levels of exposure to multiple risks, which in turn elevates chronic toxic stress."[187]

As we can see, *laziness* is a reductive term to describe the vastly complex web of harms, both emotional and physiological, that impress themselves on the mind and body of poor people. The obvious point is that routinely hurling the epithet of *lazy* at the poor is yet another form of this harm and disregards the social, political, and biocultural surround that creates and sustains poverty.

Poornography would have it both ways. On the one hand, the poor are lazy and therefore live unproductive and valueless lives. On the other hand, the poor are carefree and happy and therefore can enjoy life more than the rich can. That is the beauty of a genre that can denigrate in prismatically refracted ways. A few examples from classic Broadway musicals might help here. The first is *Porgy and Bess*, mentioned previously, which has made the song "I Got Plenty of Nuttin'" famous. In it, Porgy celebrates, in a dialect that separates him from the white, middle-class audience, the value of being poor.

> Oh, I got plenty o' nuttin'
> An' nuttin's plenty fo' me
> I got no car, got no mule, I got no misery
> De folks wid plenty o' plenty
> Got a lock an dey door
> 'Fraid somebody's a-goin' to rob 'em
> While dey's out a-makin' more
> What for?[188]

Obviously, being a rich person in a capitalist economy is difficult and time-consuming while being poor is relaxing and allows one to fully enjoy life. As Porgy sings:

> 'Cause de things dat I prize
> Like de stars in de skies
> All are free
> Oh, I got plenty o' nuttin'

An' nuttin's plenty fo' me
I got my gal, got my song
Got Hebben de whole day long!
No use complainin'!
Got my gal, got my Lawd, got my song.[189]

Having the "gal" shows us that poor people have good sexual lives and can enjoy them in ways that rich people can't. This point is specifically picked up and amplified in the play version of *The Sound of Music*, in which two rich people sing about how the rich can't really fall in love while the poor can. Called "How Can Love Survive?" it is sung by Max, the witty upper-class friend of wealthy Georg von Trapp, and the wealthy Elsa, who wants to marry Georg. (He, of course, eventually marries the poor Maria.) Directly referencing *Porgy and Bess*, Max sings:

You're fond of bonds and you own a lot.
I have a plane and a diesel yacht,
Plenty of nothing you haven't got
How can love survive?[190]

Taking the line from the George Gershwin play that opened some twenty years earlier, Richard Rodgers and Oscar Hammerstein tell us that being in love seems linked to being poor. They mention that the rich don't have a "little shack" or a "cold water flat . . . warmed by the glow of insolvency."

You millionaires with financial affairs
Are too busy for simple pleasure.
When you are poor it is toujours l'amour,
For l'amour all the poor have leisure!
Caught in our gold-plated chains are we,
Lost in our wealthy domains are we,
Trapped by our capital gains are we.[191]

Being poor means having the leisure to be "toujours" in love. Of course, the French usage only highlights the difference between the wealthy singers and the poor they are imagining. And this theme is parsed somewhat differently in Yip Harburg's song "When the Idle Poor Become the Idle Rich," which replays clichés about the poor while at the same time imagining a quasi-socialist future in which the rich and the poor are the same—equally rich.

When a rich man doesn't want to work,
He's a bon vivant, yes, he's a bon vivant,
But when a poor man doesn't want to work,
He's a loafer, he's a lounger, he's a lazy good for nothing, he's a jerk.[192]

And linking this paradox to the sexual view of the lazy and indulgent poor, the lyrics elaborate:

When a rich man chases after dames,
He's a man about town, oh, he's a man about town,
But when a poor man chases after dames,
He's a bounder, he's a rounder, he's a rotter and a lotta dirty names.

Yarburg imagines this utopia in which financial equality erases ethnic prejudice:

When the idle poor become the idle rich,
You'll never know just who is who or who is which,
No one will see the Irish or the Slav in you,
For when you're on Park Avenue, Cornelius and Mike look alike.[193]

Here ethnicity dissolves through the solvent of money. While these lyrics are meant to take a satiric view of the laziness of the poor when compared to the rich, this works as something that is funny only if you sort of believe in the idleness of the poor—as so many do.

The usual view of the poor, also expressed in the previous lyrics, is that they are more sexual than the middle or upper classes. They are seen as lacking morality and self-control. Often the attribution of sexual license starts with the living conditions of the poor. Sleeping arrangements in slums come under immediate scrutiny. Engels, in his account of the working classes, notes that "men, women, and children are thrown together without distinction of age or sex."[194] This mixing is noted by Edinburgh clergyman Dr. John Lee in testifying before the Commission of Religious Instruction in 1836, where he reviled the fact of "two married couples often sharing one room."[195] An article in the *Artisan* noted that "men, women, young and old, sleep in revolting confusion."[196] The article continues, describing the areas housing the "proletarians" as "nearly all disgustingly filthy and ill-smelling, the refuge of beggars, thieves, tramps, and prostitutes, who eat, drink, smoke, and sleep here without the slightest regard to comfort or decency

in an atmosphere endurable to these degraded beings only."[197] Again, a book by J. C. Symons notes, "We found a complete layer of human beings stretched upon the floor, often fifteen to twenty, some clad, others naked, men and women indiscriminately."[198] The word *indiscriminately* is often used in talking about poor people's sleeping circumstances. It serves double duty, showing that people might sleep together without discriminating based on gender. But it easily slides over to ideas about indiscriminate sex, as if that is the logical outcome of mixed-gender sleeping situations within families.

The rich and the middle classes, by contrast, were seen as better able to control their sexual urges. In a discussion about the dangers of obscenity and pornography in the House of Lords in 1857, the Lord Chief Justice John Campbell pointed out that the previous high price of salacious printed material in effect protected the poor from being corrupted. "It was not alone indecent books of a high price which was a sort of check, that were sold, but periodical papers of the most licentious and disgusting description were coming out week by week, and sold to any person who asked for them, and in any numbers."[199] Obviously, the issue of poor women becoming sex workers led to a sense that the poor were naturally more sexual. I discuss this at greater length in chapter 5.

All told, there is a culturally collective view of the poor based on bad science and stereotypes that is taken as fact. This biocultural miasma clouds the horizon and leads to a kind of diseased thinking. To be poor is to be ill, violent, drunken, stupid, lazy, and so on. It is hoped that this chapter at least puts some of those misconceptions to rest. Yet one would like to ask, What cultural, social, and political function do these cumulative stereotypes serve? It seems obvious that since capitalism transforms the very nature of the life and work of the poor and working classes, a rationale for the exploitation of labor and the creation of a reserve army of potential workers was needed. These bits of misinformation—ideologemes of a larger structure—serve to inoculate a reading public with preformed bits of bad information that will then eviscerate any remaining available alternate viewpoints. By segregating the poor and relying on representational inequality to prevent the spread of contending voices and visions, capitalism writ large can use these biocultural mythemes to account for its own abusive practices by blaming the poor for their own lot. Bringing in "science" buttresses claims that the shockingly bad living and working conditions of the poor were brought on by their own vices, bad habits, and bad blood.

Chapter Five
Female Sex Workers

Writing about any aspect of poverty is fraught with problems. Indeed, isn't the whole point of this book that you really can't write about poverty without inadvertently engaging in poornography? Making that point throughout the book doesn't erase my own complicity. Writing about prostitution (the literal meaning of *pornography*) opens the author and the reader to charges of pandering, scopophilia, prurience, false or ideological concern, and more—the list is long.

Yet simply to retread the worn arguments for and against prostitution will be of no use to anyone. And to not write about sex work in a book on poverty would be equally impossible. Add to the prohibitions and imprecations the fact that I am a cisgender male. I could add "white," but then I'd have to qualify that by saying Jewish. The list of identity-related dis/qualifications might point, equally, to ditching this attempt.

But female sex work calls out for attention, particularly in the context of representational inequality and biocultural myths. It has been virtually impossible to find any first-person written accounts by working-class female sex workers from before the 1970s, when the sexual revolution allowed books like *The Happy Hooker* to be published.[1] Deborah Nord describes this problem of representation from a feminist perspective: "If the rambler [through city streets] was a man, and if one of the primary tropes of urban description was the woman of the streets, could there have been a female spectator or a vision . . . crafted by a female imagination?"[2] The answer seems to be largely no. Early narratives of female lower-class sex work, whether they used the first or the third person, were for the most part written by middle-class men. Included were novels such as Daniel Defoe's *Moll Flanders* and *Roxana* as well as John Cleland's *Fanny Hill: Memoirs of a Woman of Pleasure*. There are a few exceptions in England, and there were

a handful of memoirs purportedly written by French and English transclass courtesans who became wealthy and well known, including Harriet Wilson, Peg Plunkett, and Julia Johnstone. *Memoirs of a Courtesan*, by Celeste Mogador, is one example of such a work. It differs markedly from *Fanny Hill* by creating what its author calls a "chaste" narrative. Mogador rose from poverty to fame and notoriety as a working woman, novelist, playwright, and celebrity. But narratives by working women of the lower classes were largely absent, and those that did appear did not really talk about the real working conditions of sex workers. The ones printed tended to be defenses by well-known prostitutes designed to promote their public personas or to raise money for themselves when they had fallen into debt (an authorial problem not limited to prostitutes). What therefore remains is the wealth of pornographic and poornographic narratives written by exowriters about female sex workers. To understand the distortions caused by that kind of writing, it is first necessary to get a clearer picture of what life was like for working women.

It is clear that if thousands of poor women, many of them with children, were homeless or destitute in the eighteenth and nineteenth centuries, their choices for employment would have been limited—working in a factory, engaging in domestic labor, and being a seamstress or a laundress were the obvious choices. All of these provided minimal income under grueling conditions, and the first two were dangerous as well. Sex work, or the use of sex for securing lodging, food, or other kinds of security, would have been a logical use of labor power.[3] As mentioned, we have almost no first-person accounts of this widespread and common occupation. The first major published narrative by a transclass working woman was an anonymous US work, *Madeleine*, in 1919. It is a well-written and compelling narrative tracing a life in a downwardly mobile family that had social status, books, and education until the father abandoned the family, largely because of his alcoholism. The pseudonymous author, Madeleine Blair, learned to read and enjoy literature, which accounts for her ability to gain enough cultural capital to succeed in publishing a memoir. Like other transclass narratives, the author doesn't focus on the sordid side of things in her early childhood but rather tells us about her relationship with her family, her siblings, and then her eventual sexual abuse and pregnancy. She ends up as a sex worker in Chicago brothels and over time becomes the owner of a brothel in Canada.[4] One of her main points is that white slavery is a myth, that most women who work in the sex industry do so to make a living, by their own choice.

White slavery was the key term in a sex panic that happened in the United Kingdom and the United States at the turn of the twentieth century. This panic sold newspapers as journalists' breathless reportage "provided virtually pornographic entertainment to the reading audience."[5] The fear was that white women were being captured and forced into prostitution by foreign criminals—mainly Asians and Jews.[6] This panic fits in with a series of previous beliefs about prostitution—that crude animal sexuality prevailed among the poor, that promiscuous crowding in tenements and hovels weakened an already weak morality, that poor women were both sexualized and likely to become prostitutes, and that once "fallen," a woman would never rise to respectability again. It also reflects a guilty conscience about the virtual lack of discussion of "black slavery," which would have involved not only chattel labor but also chattel sex.

Given those beliefs, some of which prevail even today, how are we to think through sex for money or for security? To begin to answer that question, we must deal with very strong beliefs inculcated from childhood not simply by the obvious moralists but also by well-meaning parents and socially progressive writers and thinkers. As a thought experiment, could we stop thinking of prostitution as a separate category of work and include it in the many exploitative and low-paying jobs available to women in various eras? To do that, and therefore place sex work outside the realm of sexual morality and moral panic, requires a series of observations.

.

Terminology first: If we think the problem through chronologically, the earliest terms in English that were widely employed to describe women of loose morals were *whore, bawd,* and *common woman*.[7] But those words in medieval England or the colonial United States didn't mean someone who exchanged sex for money or goods but rather any female who had sex outside of marriage.[8] These words could be used as well to designate a woman who had relations with more than one man. Given the nature of human relations, particularly among the poor, this designation probably applied to a good many women and girls. There was no specific word for women who exchanged sex for money in this period. As Ruth Mazo Karras puts it, "If late medieval English culture had no conceptual category reserved for women who engaged in sex for money, what does this reveal about that culture's understanding of sexuality? One possibility is that in

this precapitalist economy it really did not matter whether or not money was involved."[9]

Does it really matter if money is involved? And when did it begin to matter? One might want to make the point that sex and money have been intertwined historically. For a woman under patriarchy, there were almost no ways to be economically and socially secure on one's own. Marriage was the main way that women could find some kind of stability, and when we look at the ranks of the poor in the past, a single woman or one who had lost her husband was often listed in parish and civil records as impoverished and in need of assistance or housing. Romantic love was not a cultural given, and therefore arranged marriages were in essence contracts that offered the wife's body in exchange for her being financially supported. Certainly, among the upper classes, particularly the royalty, marriages were often arranged with little input from the bride-to-be. Indeed, this was a wrong that Mary Wollstonecraft in *A Vindication of the Rights of Women* decried, seeing marriage in England at the end of the eighteenth century as a form of "legal prostitution" for those women who have to marry for "support."[10] Women had virtually no legal recourse against unwanted sexual advances—even on the part of their husbands. In the United States, rape within marriage was only made illegal in the 1990s. For many poor women, entering into a sexual relationship with a man, particularly a workingman, allowed for a modicum of security and provisions in exchange for sexual and domestic labor.

Before birth control, such relations inevitably led to pregnancy. Parish records show us that the usual pattern among the rural poor was the chronological sequence: penetration, pregnancy, marriage. Whether a woman was married or not, if a man left her during or after her pregnancy, and if her family didn't support her, she would be thrown into economic hardship. Until the Married Women's Property Act of 1882 in the United Kingdom, any property owned by a woman automatically became the sole possession of the husband when she married. Thus, abandonment could often mean complete financial ruin. The ranks of female sex workers in the eighteenth through the twentieth centuries were often made up of such women who had been married with children and then were abandoned by death or design.

While we tend to romanticize the nuclear or extended family in the past, the reality is that given disease and death during childbirth, pandemics, and a generally poor state of health and hygiene, marriages often did not last a lifetime. Without extensive family support, and with the age of

first sexual encounter being rather low for the rural and urban poor, the odds were not in favor of a pregnant woman being supported. Without familial or spousal financial support and with a child or children, the only recourse for a woman was to turn to the parish or to low-paid work. But the parish might not be an easy option. Parish records in England in the Renaissance period, for example, show that those who were supported or who lived in parish housing were mainly older men and women—many of whom were disabled or otherwise unable to work. There were not many young women with children.

The lowest-paid jobs in England in the eighteenth and nineteenth centuries were mill girl, factory worker, seamstress, household servant, milliner, and laundress, among others. Begging, selling flowers, and engaging in sex work were the more public ways to make money. All of those employments were onerous, dangerous, and insecure. Factory workers were exploited and labored under perilous and debilitating conditions for uncertain periods with fluctuating wages. As many nineteenth-century novels show us, starvation was a way of life, especially during strikes or economic downturns. Becoming a dressmaker involved apprenticeship, often for years without pay, and then being subject to low wages and fluctuating demand. George Foster, a New York reporter, describes the lot of apprentice dressmakers in the nineteenth-century city and indicates that they were likely to end up as sex workers:

> It is necessary to state that the dressmakers . . . get absolutely nothing for their work. The way it is managed is this: the proprietors of the large dress-making establishments receive a great number of apprentices, who remain six months for nothing, boarding themselves in the meantime, for the privilege of learning the trade. They can already sew swiftly and well, or they are not accepted. To them are given out the dresses, and they are kept constantly at work sewing (not learning anything new) until the very day before their apprenticeship expires. Then a few hours are spent in giving them some general directing about cutting a dress, and they are discharged—there being no room for *journeywomen on wages* in an establishment where all work is done by *apprentices for nothing*. As fast as their "education" is completed they are replaced by other apprentices. And so it goes on . . . and the poor girls turning out upon the world to die of starvation and despair, or sell themselves to infamy.[11]

Domestic labor in the houses of middle- and upper-class people was considered the least desirable work for a woman. And there were many

women in service since servants made up 20 percent of the population of London by the mid-nineteenth century.[12] Many families would have far preferred factory work for their daughters. Our fantasy of a PBS *Masterpiece*, upstairs-downstairs life in a *Downton Abbey*–type setting is just that. The reality was long hours, paltry wages, almost no free time, and a prohibition on having any sexual relationship or getting married. Physical and mental abuse added to sexual abuse by the males in the family made it one of the most stressful and dangerous jobs for a woman. If the servant became the object of a master's sexual interest, she risked rape, unwanted pregnancy, and the ire of the mistress of the house. In the anonymous Victorian memoir *My Secret Life*, we read many hard-to-stomach examples of such sexual exploitation. If a servant became pregnant, she was most likely to be fired without a letter of recommendation, which in essence put her on a blacklist for further work. Being single and having a child out of wedlock meant being pushed into the lowest economic levels. Many female sex workers came from the ranks of those who had been domestic servants.

Since domestic labor was one of the routes to prostitution via the scenario of having sex with or being assaulted by males within the household and then being dismissed without a recommendation, it is surprising that there are so few novels that detail this reality. It is likely that the readers of poornography did not want this egregious but all-too-common practice thrown into too-strong relief. In Samuel Richardson's novel *Pamela*, we do see the predicament established, but the fairy-tale resolution of marriage to the upper-class male in the novel prevents the tale from being told too explicitly.[13] Charlotte Brontë's *Jane Eyre*, while it dangles the possibility of such an occurrence, also prevents it by having a strong female protagonist who rejects her employer's wishes to consummate their relationship outside of marriage. Jane is aided by various plot devices that end up ultimately offering her the sanction of marriage. In a novel like *Mary Barton*, the secondary character Esther is a more typical nineteenth-century fallen woman, the cast-off lover of a middle-class man (although not a servant in his household).[14] In the novel Esther's becoming a prostitute is cast as more a consequence of moral failure than an economic decision, while the latter was the reality for many prostitutes. Poornography places the moral onus on women and does not consider any real sense of the financial advantages in sex work over other degrading forms of labor offered to women by capitalism. In creating the "fallen woman," middle-class poornographers were in effect providing another ideologeme in the lexicon of poornography.

Lurid reportorial accounts of prostitution focus instead on the threat presented by the female sex worker to the hapless middle-class male, rather than the other way around. George Foster describes prostitution as the "mother and nurse of every vice that afflicts and degrades humanity."[15] He provides an account of a New York encounter in the 1850s: two women described as "magnificently attired" with "voluptuous bosoms half naked," who are "on the look-out for victims." A young man is attracted, and "from that moment his doom is sealed. Need we follow him to the filthy street, the squalid chamber where Prostitution performs her horrid rites and ends by robbing her devotees?—Where drunkenness is brought in to aid the harlot in her infamous work—and where, if all else fails, the sleeping potion mingled in the foaming goblet does its inevitable work, and delivers the victim helpless into the hands of the despoiler."[16] The journalistic account inverts through hyperbole and personification the class and power relations so that in the end it is the middle-class youth who is the one despoiled by the encounter, and his payment for services is transformed into theft by the sex worker.

Rather than seeing prostitution as the nineteenth-century moralists would have it—a fate worse than death and an inherently criminal activity—might we not see it as a viable form of physical labor that could be a personal revolt against wage labor? Most women who became sex workers did so for a short time and moved in and out of that line of work as their situation changed. The average length of time doing such work was two or three years, mostly when they were between the ages of eighteen and twenty-three. Going outside the wage-labor system, female sex workers were their own bosses; most were not in brothels, and the pimp system did not begin to be largely employed until the 1960s. Yet the inventiveness and drive of such women cannot, and never is, compared to the ambition of males trying to advance in the economic system by whatever means.

The sharp line between poor women in general and prostitutes in particular was largely illusionary. Rather, there was a shifting border between poor women who married for security, those who exchanged sex for security, those who exchanged sex for goods and services, and those who exchanged sex for money. In postrevolutionary Philadelphia, prostitution was, according to Clare Lyons, "part of a continuum of illicit sex . . . and it was not always easy to distinguish which encounters crossed its fluid boundaries." A woman might have, Lyons continues, "supplemented her income by periodically strolling the streets" and "had much in common with the woman who frequented taverns accepting food and drink from a

gentleman with whom she later had sexual relations." Gifts of goods, food, or alcohol were commonly given to sex workers as well as to nonmarital sexual partners.[17] The anonymous author of *Madeleine* describes her poor neighborhood, in which there are women selling sex in "boarding-houses, dressmaking shops, hand-laundries, and the homes of working men whose wives added to the family finances by occasional prostitution."[18]

In stating this case, I don't want to claim that sex work is great work. The point is that for a poor woman in the past, and even now, there are a wide range of dangerous, physically and mentally harmful jobs that barely provide subsistence living.[19] The choice between one and the other is a luxury that middle-class people speculating and writing about the poor can enjoy. Previous puritanical beliefs that sex is a separate and suspicious activity that can only be justified by reproduction and enjoyed mildly only in the context of marriage have contributed to the singling out of sex work as particularly reprehensible. Lynda Nead points out the intertwined connection among sexuality, morality, and economic status: "The middle class was composed of a diverse range of occupational groups and levels of income; what was important, therefore, was the creation of a coherent and distinct class identity which would set the middle class apart from the social and economic classes above and below it. In many ways, this class coherence was established through the formation of shared notions of morality and respectability—domestic ideology and the production of clearly demarcated gender roles were central features in this process of class definition."[20] Indeed, it is possible to argue that with the advent of factory work and wage labor, women who refused to do such labor and saw sex work as a better alternative were in fact taking a stand against the oppressive and sexist economic system. Between the Scylla of factory work and the Charybdis of domestic labor, a poor woman had little choice. Both paid poorly, and domestic labor was often abusive beyond simply the bad wages—including seduction, rape, and unwanted pregnancies. Up to half the women selling sex in Britain in the late nineteenth century were former domestic workers.[21] In York, 68.5 percent of the female sex workers had been domestic servants, while only 11.9 percent had been in the needle trades.[22] In France in the nineteenth century, female sex workers came mostly from artisanal trades, not factories. Work as a milliner was the most common underpaid job that led to prostitution.[23] In the United States in 1916, a Department of Labor study found that for women working in department stores and doing light manufacturing, the average wage per week was $6.67, which was a subsistence wage. At the same time, the

average wage earned by a female sex worker was between $30 and $50 per night, which compares very favorably to the $20 per week earned by skilled male trade union members.[24] In other words, sex work made economic sense for a segment of poor women, yet it is rarely written about as such in novels and other pornographic forms.

Sex workers blurred the line, as Nead writes, among commodity, worker, and owner by selling and reselling something that cannot be entirely bought or owned and by doing this transaction outside of the expected forms of exploited labor. Judith Walkowitz notes that when contemporary nineteenth-century moralists critiqued "the types of employment, the social gatherings, and the living conditions that could lead to a woman's downfall, they effectively encompassed the whole of working-class life."[25] Clare Lyons asserts that in nineteenth-century Philadelphia, "prostitutes were the most obvious manifestation of economically independent women."[26] In other words, the focus on prostitution in the nineteenth century was in some sense a focus by the middle class on alternative forms of living—namely, the institutions and manner of the poor. Social rebel Charles Baudelaire put it the most succinctly: the prostitute is a "woman in revolt against society," although he quickly adds of prostitutes that "in truth, they exist very much more for the pleasure of the observer than for their own."[27]

Indeed, it may well be that the fear of prostitution and the panic around syphilis were really part of a middle-class concern that their men would become infected and bring home venereal disease to their wives. Prostitution was a well-established profession in Britain and the British Isles and in some sense underpinned the putative morality and decency of the middle classes. To create the virtuous middle-class woman, the angel in the house, you had to have in the culture her opposite—the immoral fallen woman. The reality is that with later marriages in the middle classes, as the man accumulated enough wealth to sustain a middle-class couple, and with a prohibition on sex with middle-class women until marriage as well as a general opprobrium of masturbation, prostitution essentially sustained masculinity under bourgeois capitalism.[28] Because this was a routine practice of middle- and upper-class men, the opprobrium had to be shifted to the sex workers, focusing on their moral failings and the venereal diseases they were seen to harbor.

In Glasgow, for example, the largest city in Scotland and the second largest in the United Kingdom, there were 450 brothels—60 for the upper classes; 180 for businessmen, clerks, shopmen, and students; and 210 for the

lower orders.[29] In Philadelphia in the 1760s and 1770s, sex with prostitutes constituted the "most common non-marital sexual behavior."[30] It makes sense that concern about prostitution was often really a concern about the health of the men who used this service. Dr. Toussaint Barthelemy wrote in nineteenth-century France, "Experience proves that venereal disease, wherever it appears, always comes from the street. . . . Clean up below (streets, sidewalks, bars, dance halls, wine shops, etc.) and you will clean up the rest."[31] In this directional-driven explanation, disease comes from the netherworlds of the poor and infects the upper worlds of the better-off, never the other way around. Alain Corbin quotes a contemporary who wrote, "Of all the diseases that can affect mankind through contagion, and which have the most serious repercussions on society, there is none more serious, more dangerous, and more to be feared than syphilis."[32] Like Jo's illness in *Bleak House*, while nonsexual in nature, disease spreads from the miasmatic slum of Tom-All-Alone to the rarified air of Lord and Lady Deadlock's mansion.[33] Readers of novels like *Bleak House* were acutely alert to tropes that depicted the poor as dangerously diseased, and stories about women who did sex work would naturally inherit that trope.

Contemporary sex workers Juno Mac and Molly Smith write that sex work is the "'the safety net' onto which almost any destitute person can fall. This explains the indomitable resilience of sex work."[34] They go on to elaborate, "To say that prostitution is work is not to say that it is *good* work, or that we should be uncritical of it. To be better than poverty or a lower paid job is an abysmally low bar, especially for anyone who claims to be part of any movement towards liberation. People who sell or trade sex are among the world's least powerful people, the people often forced to do the worst jobs."[35]

I don't want to downplay the effect of male violence and privilege in the creation of the women who became prostitutes. Even today, being a woman, being poor, especially an immigrant and a person of color, raises dramatically the chance of having one's first sexual experience be forced or coerced.[36] And those encounters frequently lead to unwanted pregnancies, now in the context of increasing impediments to abortion, which could often be the triggering event for a woman to enter into prostitution.

Some reasonable objections to prostitution, as detailed by Mac and Smith, could be enumerated. There is most obviously a feminist critique of mainly female prostitutes providing sex to mainly male clients for money. Then there is a health problem of STDs being transmitted in these transactions. The issue of trafficking is currently a focus of concern, although this

issue did not come to the fore until the end of the nineteenth century with the white-slavery panic.

Mac and Smith advocate decriminalization. Interestingly, organizations like Amnesty International and Human Rights Watch also support the decriminalization of prostitution. In addition, the World Health Organization and the United Nations Population Fund believe that decriminalization would "contribute to major global health gains."[37] Some would like to decriminalize prostitution but support criminalizing the use of prostitutes. While this action might satisfy some who fear the trafficking and denigration of women, it also seems somewhat paradoxical since without clients sex work would surely suffer.

Indeed, health, disease, and deterioration were some of the major issues raised by the middle classes concerning poor women as prostitutes in the nineteenth century. We have only to return to Esther in *Mary Barton*. Having had a baby out of wedlock, she ends up becoming a prostitute and an alcoholic. She is described as pale, weak, and enervated, eventually dying of consumption. This standard description is echoed by William Logan in his book *The Great Social Evil*; Logan looks at the prostitute and sees "for the soft and beauteous eyes that once looked love . . . hollow orbs where hunger has come and where death is fast following; for the rosy cheek with the blush of innocence not yet faded from it—the pallor of decay; for the sweet ringing laugh—the wild shriek of mirth or the breast-shattering cough of consumption; for the simple dress the tawdry rags of what was once a fashionable dishabille, won by the wages and torn to tatters in the service of sin."[38] George Foster, writing about prostitution in New York in the 1850s, describes "the descending ladder of infamy, up which they can never again ascend. . . . [All] will be drunkards in the kennels . . . full of loathsome diseases, tramping the streets at all hours and weather, in search of sailors, loafers, green-horns, negroes, anything or anybody to decoy into their filthy dens."[39] The permanent descending spiral is echoed by Ralph Wardlaw, writing about being a "fallen woman": "The tendency is all downwards . . . rising is a thing unknown. It cannot be. It is all descent. . . . It is all down-down down rapidly down; down from stage to stage, till it terminates in some . . . scene of squalid wretchedness."[40] This downward spiral became an obsession in the nineteenth century with the irrevocable status of the fallen woman. Yet most female sex workers were occasional in their work. As noted, many turned to sex work when their primary occupation did not pay enough or went through cyclical economic downturns.[41] Contemporary observers observed that there were more prostitutes on the

streets during such economic downturns.[42] And prostitution was often a trade adopted in youth and given up within a few years.[43] One working woman explains that the idea of a permanent fall is not accurate: "We often do marry, and well too; why shouldn't we, we are pretty, we dress well, we can talk and insinuate ourselves into the hearts of men by appealing to their passions and their senses."[44]

The inevitability of disease and destruction was continually outlined by nineteenth-century moralists in novels and elsewhere, and even in those whose works don't fit easily into a moral structure. Émile Zola in his novel *Nana* can hardly be considered a moralist, yet his central character, who makes it to the top of the social ladder, ends up dying of a horrendous disease. In Zola's worldview the disease could relate more to his eugenic views concerning hereditary weakness. And the same diseased finale is true for Emma in Gustave Flaubert's *Madame Bovary* despite the fact that she was not a prostitute in the traditional sense of the term. Charles Dickens, much more of a moralist, paints the direst picture of prostitutes, addressing his "appeal to fallen women" who have just been arrested:

> Think, for a moment, what your present situation is. Think how impossible it is that it ever can be better if you continue to live as you have lived, and how certain it is that it must be worse. You know what the streets are; you know how cruel the companions that you find there are; you know the vices practiced there, and to what wretched consequences they bring you, even while you are young. Shunned by decent people, marked out from all other kinds of women as you walk along, avoided by the very children, hunted by the police, imprisoned over and over again . . . you have, already, dismal experience of the truth. But, to grow old in such a way of life, and among such company—to escape an early death from terrible disease, or your own maddened hand, and arrive at old age in such a course—will be an aggravation of every misery that you know now, which words cannot describe. Imagine for yourself the bed on which you, then an object terrible to look at, will lie down to die. Imagine all the long, long years of shame, want, crime, and ruin, that will rise before you. And by that dreadful day, and by the judgement that will follow it, and by the recollection you are certain to have then, when it is too late, of the offer that is made to you now, when it is NOT too late.[45]

But given the hyperbolic imaginary of poornography, what might the reality of prostitution tell us? William Acton, who spent a good deal of his life in the nineteenth century as a reformer of social ills—particularly

prostitution—presents a rather different picture of women's health in regard to sex work. "If we compare the prostitute at thirty-five with her sister, who perhaps is the married mother of a family, or has been a toiling slave for years in the over-heated laboratories of fashion, we shall seldom find that the constitutional ravages often thought to be necessary consequences of prostitution exceed those attributed to the cares of a family and the heart-wearing struggles of virtuous labour."[46] In France, Alexandre Parent-Duchâtelet did similar work to Acton and noted that "despite so much excess and so many causes of diseases, their health is more resistant than that of most women who have children and do housework."[47] In other words, the biocultural notion that prostitution equals disease and death is, according to Acton and others, greatly exaggerated. Some saw prostitution as actually protective to public health since it kept unmarried men away from the virtuous women they might one day marry. As Keith Nield put it, "Considered simply as a matter of public health, prostitution and the 'diseases associate' with it posed lesser threat to life and vigour than cholera, consumption or bad drains. And as a question of public morality, prostitution could be considered on good authority as protective of virtue and preservative of the social *status quo.*"[48]

Aside from the canonical literary works concerning prostitution, there is very little left for analysis. Since male use of female sex workers was so common and imbricated into early capitalism, we can of course see it where it cannot be seen, as contemporary readers might have been well aware of. Take, for instance, the rather innocuous trip that Frank Churchill takes to London for a "haircut" in the novel *Emma*, by Jane Austen. Austen, not exactly a racy author (although she does have the teenager Lydia run off with the roué Wickham), must have understood that men taking trips to London from the countryside would often do so for sexual reasons. In fact, *haircut* was Regency slang for having an illicit sexual relationship.[49] Frank and all the Darcys and Wickhams and Bingleys had sexual lives that craved more than celibacy and would therefore have routinely gone off to London or Bath or Southampton to have their "hair cut." This would have been the innuendo that dared not say its name in novels of the period.

One exception is *The Unclassed*, by George Gissing, which is a novelistic study of class and sex work. Gissing is exploring women who are "unclassed" in the sense that they are sex workers who are clever, witty, and ethical—at least by Gissing's standard. Gissing was no academic or medical authority on prostitution, but he lived his life in lodging houses in London, and his first lasting relationship was with a woman who was most

likely a sex worker in some form or other. What is notable about the novel is that it was praised minimally and condemned roundly when it was first published in 1884 as a defense of prostitution since the main characters are amiable and mostly educated working women. The novel was also banned by Mudie's Lending Library, an essential means of distributing novels during the period and a bellwether for acquisitions by other libraries.[50] As Gissing's career took off later, he was embarrassed by what he had written, and when he had a chance to republish the book in 1895, he condensed the novel and left out the objectionable parts.

One significant section he removed was a telling conversation between two of the main characters—Osmond Waymark, an unemployed man of letters very much like Gissing at the time, and Ida Starr, an eighteen-year-old who makes her living as a sex worker. The chapter is entitled "Thinking Makes It So," taking its inspiration from the lines in *Hamlet* in which the Danish prince says, "There is nothing either good or bad but thinking makes it so."[51]

After reading *The Vicar of Wakefield*, which Waymark has given her, Ida muses, "Doesn't it seem strange,—I mean when you think about it,—that so much trouble and misery and shame should be caused just by a girl being led astray, as they call it."[52] Waymark agrees with her and notes, "People don't think so. They believe in what they call contamination of the soul." Starr remarks, "It seems so queer. Suppose a girl is found out to have a lover who visits her so as to make people suspicious. Her character is lost; her soul is contaminated. Then suppose it is discovered all at once that the two have been married. Character instantly comes back, and the soul is made pure again. Surely there's something very absurd in all this."[53]

At this point Starr makes a larger statement: "I am as pure as any woman who lives. I can be so at any moment whenever I choose. But there are times when I am indeed vile. I know it perfectly well. I hate myself when I feel it. I get my living by a vile trade. But what I will declare is this: that my trade does not render me hopelessly degraded. Give me a fortune to-morrow I will be as chaste as if I still sat on my mother's knee."[54] The economic motif is clear—working women might easily decide to work in the sex trade if it is better than the other exploitative but approved possibilities. To make this point clearer, Gissing creates a conversation between Waymark and Starr's roommate, Sally, who works during the day as a seamstress and by night as a sex worker.[55] Less educated than Starr, Grace nonetheless is fully capable of explaining the economic reasons that sex work makes sense. She details that she makes seven shillings a week by sewing coats, but that alone

cannot sustain her. She is tired when she comes home and then has to go out again nocturnally to do her second job on the street. As a result, she declares she will only work at night where she, and others like her, can make a better living without having to hold two jobs.

Gissing's goal was to write a novel about prostitution that would be more accurate than the conventional treatment of such women, as we have seen. He has Waymark declare, "The fact is, the novel of everyday life is getting worn out. We must dig deeper, get to untouched social strata. Dickens felt this, but he had not the courage to face his subjects; his monthly numbers had to lie on the family tea-table, which is emphatically not where you will find anything out of the common. Not *virginibus puerisque* will be my book, I assure you, but for men and women who look beneath the surface."[56] In writing a book that would not be for "girls and boys," as the Latin translates, Gissing's goal is to surpass Dickens's weak attempt to include prostitutes in the form of Nancy in *Oliver Twist* or fallen women like Little Emily and Martha Endell in *David Copperfield*. These characters are mere moral signposts along the road to bad reputation. But Gissing's Ida Starr is quite different from them. She has chosen her way of life with a clear head, although propelled by economic necessity, and is both intelligent and witty. The novel's machinery will reward her with economic security and marriage rather than project her as a symbol of moral failure crowned by early death. Ida debunks this idea in response to Waymark's reminder that "we have to admit the teaching of experience, that what is called a vicious life does often end in real degradation. . . . Many a girl has sunk to fearful depths, who, if circumstances had averted the first step, might have never known evil." Ida shoots back, "Then she was not worth preserving." Her point is that "every-day life will offer a thousand occasions for degradation." And she adds, "I am strong. I shall not allow myself to sink."[57]

The initial lack of success of this book is tied to the way Gissing broke with poornographic genre requirements. The fallen-woman story was required at this time, and publishers were in no rush to break that mold. One of Gissing's first rejections was from publisher George Bentley, who wrote, "It does not appear to me wholesome, to hold up the idea that a life of vice can be lived without loss of purity and womanly nature."[58] A contemporary reviewer scoffs at Gissing's notion that a sensitive and intelligent woman could be a sex worker: "The notion that the mind of a prostitute can remain pure and unsullied in the midst of her profession is simply contrary to fact."[59] Another reviewer complains that "a long-continued

platonic attachment between a normal young man—even of aesthetic tastes—and a London prostitute is an incident hardly within the range of probability, to say the least."[60] All of these responses are indicative of the cordon sanitaire established between being an intelligent, sensitive woman and being a sex worker. Gissing commits the reprehensible act of breaching that line. He acts out of his personal connection with a sex worker and in so doing reveals the class prejudice involved in demeaning women who choose this work. Ida Starr is a prostitute for a short period of time, but Victorian middle-class men demand that such women remain fallen forever. In so doing they appeal to the "normal," "nature," "probability," "fact," and other ideologically upheld buttresses. Gissing's transclass position allowed him to do otherwise.

Aside from the anonymously written *Madeleine*, we had to wait until 1972 for Xaviera Hollander's *The Happy Hooker*, which was probably the first book written by a prostitute for a general public; it was published by the popular publishing house Dell in 1972. The book was cowritten with Robin Moore and Yvonne Dunleavy, so it likely isn't actually the sole production of the putative author. An artifact of the sexual revolution, the book could be read and reviewed widely. The book is actually a kind of soft-core work that is meant to be both biography and pornography as well. Typically, as with *Madeleine*, it was written by someone who did not grow up poor, although Madeleine's family started off middle class and then plummeted because of her father's alcoholism. Hollander's experience is linked to youthful sexual adventures but also a strong sense of business know-how. Having worked for a company called Manpower that provided temps, she learned how to be the middle person in providing workers for specific uses. She also notes what she learned: "My best skills were administrative, in an intermediary capacity. I also learned another valuable lesson from that job. That if you have real initiative it is best to work as independent if you can, because others tend to sit back and reap the profits of your hard efforts."[61] The book combines an upbeat view of prostitution with a respect for the business side of these transactions. After several arrests and a kind of fame from the investigations of Mayor John Lindsay of New York and the Knapp Commission into corruption, she became, as she says, "one of New York's most celebrated madams," who was then invited by "several universities" to give lectures on "The Myth and Reality of Prostitution."[62] Far from the tales of downward mobility and death of the nineteenth century, Hollander's narrative is more of a success story.

It is clear that the depiction of prostitution by writers who often might have been the clients of working women, or who were the wives of men who visited prostitutes, is skewed by morality and eugenics. However, Mac and Smith perceptively see that "prostitution is a richly symbolic terrain. It is where our society's anxieties about power, womanhood, and the nation coalesce."[63] If we can include and yet move beyond the symbolic, recognizing our limitations in arriving at "the truth," it might nevertheless be possible to assemble a collection of observations that point more directly to the lived, rather than imagined, experience of poor women who were sex workers. As with any aspect of writing about the poor, it is the poor who must speak their truth, whether or not that truth is acceptable to the middle-class reader.

Chapter Six
The Encounter, or, The Object Talks Back

The usual encounter between the middle-class observer, writer, or photographer and the poor person who is being observed takes place in a classic asymmetrical power dynamic. The person with the means to publish or exhibit the encounter controls the information that is produced. As we saw with the undercover experience, the middle-class observer feels completely adequate to the job and rarely expresses any difficulty with framing the encounter or recording it. What of course is usually missing is the response of the person being described or scrutinized. If there is a response, it is always filtered through the sensorium of the observer. Here the asymmetry involved in representational inequality is at its height. This is particularly true when the poor person is living a precarious life in a perilous moment.

In this sense, the observed becomes an object. And often the result of this objectification is the creation of an object of value. The value might be monetary in the sense that the photograph or narrative becomes a monetized thing capable of sale for the profit of the observer. The value might constitute a type of cultural capital that adds to the observer's cultural hedge fund. The value might be purely aesthetic in the capturing of an aspect of poverty for the delectation of future observers. However, it is possible that under certain conditions value could be the remediation of the difficult conditions under which the observed lives.

But under the usual conditions, the person, as object, then is rendered silent. A voice-over, in effect, is added by the observer, who ventriloquizes a voice for the observed. By definition, that voice or stance then stands in for the suppressed voice of the now-objectified person.

Finding moments in which the object talks back is difficult.[1] Such moments only occur in the background noise that can be caught by a discerning transclass analyst. I'd like to present a few such talk-back moments and see if any significance can be drawn from them.

One famous and much-written-about photograph might help open this discussion. The picture *Migrant Mother* (figure 6.1), taken by Dorothea Lange of a poor woman during the Depression era, has become iconic. Most US viewers have seen the picture in one form or another. It has been widely anthologized, was used in posters, and even became a US postage stamp. Dubbed the *Mona Lisa* of Depression photography, it is one of two or three photographs that represent that era.

We can look at the photograph as this iconic representation of true American grit in the face of difficulty. Yet a photograph like this one has performed an act of transformation; it has taken a moment in time and fixed it into a timeless image. But what if we think of the picture as in fact an encounter between two people—the photographer Dorothea Lange

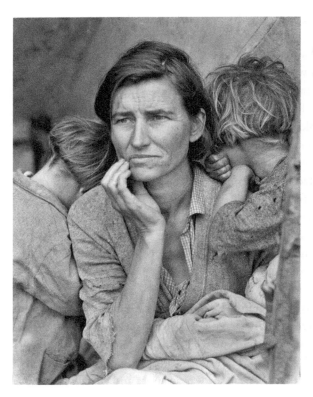

6.1 Dorothea Lange, *Migrant Mother* (1936). Photograph. LOC Prints & Photographs Division, FSA OWI Collection.

and the subject of the photograph? In so doing, the photograph turned the woman (who only much later was identified as Florence Owens Thompson) into an object—whether of admiration, pity, or fascination—for the consumption of a nonpoor public.

The picture has much of the iconography we have come to expect in representations of the poor—ragged and worn clothing, a stressed and sorrowful look on the woman's face. The untidiness of her hair and that of her children adds to the "look" of poverty. The two older children's faces are turned away from our view, protected by their mother's body, while the infant is securely held in its mother's arms, asleep and unaware of the surrounding grinding poverty.

But for our purposes, it is important to place the picture in the context in which it was taken. In 1936 Dorothea Lange had been taking photographs for the Farm Security Administration (FSA) when she had the encounter we are observing. Up to that point Lange was a photographer living in San Francisco who had a commercial studio on Sutter Street near Union Square in a high-rent building that housed a "distinguished art gallery" and an Elizabeth Arden beauty salon. The *San Francisco Chronicle* referred to her as "a photographic artist of great talent, whose work has exceptional quality and feeling, and has secured a large clientele."[2] She moved in cultured and wealthy circles, having come from an elite family in which her father was a lawyer, a member of the local board of trade, and an elected representative to the state legislature. Lange was a friend to Imogene Cunningham, Frida Kahlo, and Diego Rivera and had photographed the likes of Ernst Bloch. The Depression made it difficult to make money. She had to close her studio and took to street photography of the poor and homeless, as many of her colleagues were doing in accord with left-wing politics, which aided in the development of what Michael Denning has called "the cultural front."[3] She then fell into a job working for a professor named Paul Taylor, who was interviewing itinerant farmworkers for a federal government agency that eventually became the FSA. Taylor and Lange married, and he helped her get a job working for Roy Stryker at the FSA taking photographs of the rural poor.

Although Lange usually took meticulous notes on her subjects, she did not have any for this photograph. Twenty-four years after the photograph was taken, Lange wrote an article in *Popular Photography* of her recollection, which she says was "so vivid and well-remembered that I will attempt to pass it on to you."[4] It is important to parse this whole account carefully. Lange had no doubt that her account was accurate and correct because it

6.2 Dorothea Lange, "The Assignment I'll Never Forget," *Popular Photography* 46, no. 2 (June 1960). Author photograph of the article.

was so "vivid and well-remembered." But is it? We examine that premise further along.

There are really two distinct encounters regarding this picture, and we may want to recall Paula Rabinowitz's caution: "Who looks at whom? This question is at the heart of image, word, and sound within documentary rhetoric."[5] There is the encounter between Lange and Florence Owens Thompson, and later the encounter between Lange and the reader of her short memoir in *Popular Photography* (figure 6.2). The magazine, first published in 1937, was the most widely read journal devoted to photography. It was designed for photography enthusiasts—and its covers through the years alternated between two subjects—either a woman or a camera. In fact, the first issue of the magazine sported a cover with a naked woman taking a shower. There is a metaphor being sold to the audience for the magazine—there are women to take pictures of and cameras to do that with.

It is this demographic, then, that Lange comfortably addresses as "you." It is evidently clear that this "you" is not poor, is probably male, and therefore is quite far from the lived experience of the migrant mother. The camera

and the subject are the main objects of concern. By this point, the picture Lange is discussing has made her career, so the magazine banner over the article touts her as "a famed photographer," noting that she "tells of the picture that symbolized an era." A photo of Lange, now older, looks almost nostalgically and lovingly across the centerfold at the migrant mother (figure 6.2). She continues to address the reader: "As you look at the photograph of the migrant mother, you may well say to yourself 'How many times have I seen this one?'" Lange qualifies that she isn't a "one-picture photographer." Clearly, she is at pains to let the photography enthusiast know that she doesn't want to be defined solely by this picture. Lange notes that she had often "complained" about the fame of the photograph but had been told that "time is the greatest of editors . . . and the most reliable." We will want to remember that Lange resents having herself summed up in the photograph but seems to have no notion that the subject of the photograph might have had similar misgivings.

She tells the reader that after all these years, never having captioned the picture, she will present the photograph, "this time with the story." Here now is the classic moment we have been studying throughout this book—the middle-class person representing, narrativizing, and speaking for the poor person. And for Lange, hers is *the* story, not an account or a version of the story. The authoritative voice is, well, authoritative.

Lange tells us that she had been working for the FSA as a photographer and had been "traveling in the field alone for a month, photographing the migratory farm labor of California" during a "cold, miserable winter" in 1936. She emphasizes her own migratory nature and her exhaustion. "My work was done, time was up, and I was worked out" after "my long trip." Unlike for the migrants, her own labor was over, and "it was a time of relief," so Lange could return to her own nonnomadic and presumably comfortable home. "Sixty-five miles an hour for seven hours would get me home to my family that night. . . . I felt freed, for I could lift my mind off my job and think of home." I don't want to minimize the difficulty of her labor as a woman working as a photographer under difficult conditions, but her narrative lets us know that she was from a different class than her subjects. It is *her* labor rather than theirs that she emphasizes. A photograph of Lange and her car with a 1936 license plate (figure 6.3) gives a sense of this difference. She is dressed in a more sophisticated way than the people she is photographing—down to her shoes, which are PF Flyers, a stylish canvas-and-rubber shoe created by Goodrich that came on the market only a year or two before the photograph (figure 6.4).

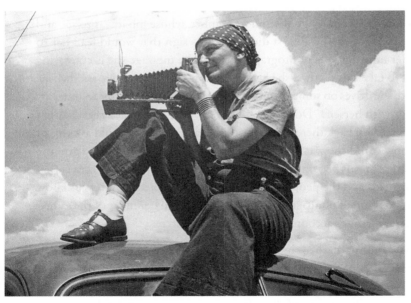

6.3 *Dorothea Lange on the Job* (February 1936). Photographed by Paul Schuster. Rondal Partridge Archive.

6.4 Ad for Goodrich Sport Shoes.

6.5 Dorothea Lange (c. 1934). Photograph. LOC Prints & Photographs Division, FSA OWI Collection.

Another photograph presents her with more working-class clothing (figure 6.5), but the image of a confident photographer is embedded in its visual language. Both photos show her atop a car that is in good shape and more than adequate to her general task. And in both she holds a camera, which is the machine that gives her the power to record the reality she wants. Both of these pictures are clearly posed; her elevated position on top of a car with a camera enshrines her role as an objective observer with the power to record the moment with accuracy.

We may want to recall the words of Francis Bacon that were tacked up on her studio wall: "The contemplation of things as they are, without substitution or imposture, without error or confusion, is in itself a nobler thing than a whole harvest of invention."[6] Indeed, she takes a moment in her *Popular Photography* narrative to state that the work that she and others did for the government has "proved of real value" and that now (in the 1950s) there should be a revival of "perceptive cameramen" photography in the United States.

As her account continues, she says she saw in passing, actually "barely saw . . . out of the corner of my eye," a "crude sign" that scrawled "Pea Pickers Camp." The sign and presumably the people in the camp are characterized by the word *crude*. The photographer, whose job it was to see and record, notes that she almost didn't see this sign that would lead her to take her most famous photograph. I think the message she is conveying is that to take this picture, she had to do something impulsive and heroic. Indeed, she drives on some twenty miles and then returns, after an inner argument with herself: "Dorothea, how about that camp back there? What is the situation back there? Are you going back? Nobody could ask this of you, now could they? . . . Haven't you plenty of negatives already on the subject? Isn't this just one more of the same?" Referring to the area earlier as "the field" and the people as simply part of a "subject," she lets us know that reiteration of photographs of poor people will be "more of the same."

Here is Lange's account of the actual encounter:

I saw and approached the hungry and desperate mother, as if drawn by a magnet. I do not remember how I explained my presence or my camera to her, but I do remember she asked me no questions. I made five exposures, working closer and closer from the same direction. I did not ask her name or her history. She told me her age, that she was thirty-two. She said that they had been living on frozen vegetables from the surrounding fields, and birds that the children killed. She had just sold the tires from her car

to buy food. There she sat in that lean-to tent with her children huddled around her, and seemed to know that my pictures might help her, and so she helped me. There was a sort of equality about it.

Having taken the picture, she leaves the camp. She adds, "The pea crop at Nipomo had frozen and there was no work for anybody. But I did not approach the tents and shelters of other stranded pea-pickers. It was not necessary. I knew I had recorded the essence of my assignment." Again, we have a confident retrospective that no further information was needed. Reality had been caught in a moment, an instinctive moment of creativity, and the reality was an obvious comment on an obvious plight.

As for her role in this iconic photograph, at first she denies any agency: "I did not create it, but I was behind that big, old Graflex, using it as an instrument for recording something of importance." But immediately afterward she emphasizes her role: "What I am trying to tell other photographers is that had I not been deeply involved in my undertaking on that field trip, I would not have had to turn back. What I am trying to say is that I believe this inner compulsion to be the vital ingredient in our work; that if our work is to carry force and meaning to our view we must be willing to go all-out." Initially, it is the Graflex, referred to almost as a person—"big, old"—an avuncular friend, that is the agent of reception. But quickly the hero of the story is Lange's own motivation—her inner compulsion to go all-out. At this point we have lost any regard for the subject, and the heroism falls on the shoulders of the observer.

But the haunting part of her description comes when she describes the encounter by saying, "There was a sort of equality about it." One wonders about this assertion—where exactly was the equality? A poor, rain-soaked woman with three children and another, wealthier woman with a Graflex? How could there be an equality between the "well dressed" woman, as Thompson's children later described Lange, and their impoverished mother?

A small footnote here: Some may know that Dorothea Lange was a polio survivor whose leg was affected for the rest of her life. She took a famous photograph of her own foot (figure 6.6). When she said, "There was a sort of equality between us," did she refer to her own disability and the poor woman's disadvantage in life?

We can understand this moment better if we take it by stages, almost as the two women encountered it. Lange tells us that she was in the camp for "only ten minutes." Let us imagine her driving in with her nice car to

6.6 Untitled (1957) showing Dorothea Lange's foot. Photograph. LOC Prints & Photographs Division, FSA OWI Collection.

the location where there were old, beat-up cars. That would take all of two or three minutes. Let us say that she saw Florence Owens Thompson and her children and took out her camera. The Graflex Series D came in a large box, which she would have had to open. She would have had to open the camera itself, which involved opening the front and turning a knob that would expand the accordion sides that connected the lens to the body. If she had a tripod, she would have had to set that up. She would have had to set the manual focus, lens opening, and shutter speed. Usually that would involve using a separate light meter to assess the available light. But perhaps she would intuitively know the proper settings after years of being a photographer. Then she would, for each shot, insert a preloaded film cartridge into the back. If she did not have any preloaded film cartridges because she had already finished her job, she would have had to sit in the car and load the cartridges with film in total darkness, achieved by using a black fabric bag. For each shot she would have to pull out a protective cover, shoot the picture, replace the protective cover, and then pull the cartridge out.

I mention all this detail because, strangely in a photography magazine, she doesn't. The world she lives in is not our snap-and-shoot one. We happen to know that she took six photographs. We know this because in the Library of Congress, where *Migrant Mother* rests, there are five other

photographs. But what is clear on full consideration is that this encounter is anything but spontaneous. The impression she gives us later is that she acted as a removed documentarian, really an automatic agent of her Graflex, drawn magnetically to the subject. The reality is richer. The final photograph, as I'll show, was staged for maximum effect and then altered in the darkroom for aesthetic reasons.

It might be worth going through each photograph to get a sense of the encounter. If what Lange says about approaching the family is true, the image in figure 6.7 probably was the first photograph if we imagine her walking toward the tent in which Florence Owens Thompson is sitting.[7] In the photo we see Thompson with her three younger children, but a teenage daughter is sitting on a bentwood rocking chair. The final photo does not include the older girl, who in some sense does not fit into the ideology of the ultimate picture. The teenager is wearing clothing that is not frayed or worn out. Indeed, the pants are identical to those Lange is seen wearing in the photograph of her looking through her camera from the top of her car. The girl's hair is a bit blowsy, but a headband adds some flair. The louche posture of the girl is almost certainly posed, and her direct regard to the camera creates an uncomfortable awareness of the moment. There seems to be some kind of a tool on the chair—possibly a car jack. The chair itself is obviously a precious object—a bent willow piece of furniture, often a handcrafted object from the Ozarks or possibly Oklahoma, where the family was from. Florence Owens Thompson and her three children are almost out of focus and are darkened inside the tent. All are looking at Lange, and the two younger girls are smiling. If this is the initial moment of picture taking, it doesn't conform entirely to the middle-class viewers' expectations about out-of-work pea pickers. (Indeed, it turns out that the family were not such, but that remains to be discovered.) If this were the first photograph, then there already had been some discussion with the family and with the teenage girl in order to pose her in this position.

A second photo (figure 6.8) has the camera moving a few steps closer. We can tell it is the second in the sequence because the rocking chair has been moved into the tent, and the mark of its rocker rails and the girl's footprints seem to be imprinted in the sandy earth.[8] Again, we have to assume that Lange asked that the chair be moved inside the tent. In the previous photo, the car jack on the rocking chair prevented the girl from comfortably sitting on it in the normal manner. Whatever was on the chair has been removed and is no longer visible. One younger girl is still staring at Lange, while the other has gone to the right of the tent, and only her legs

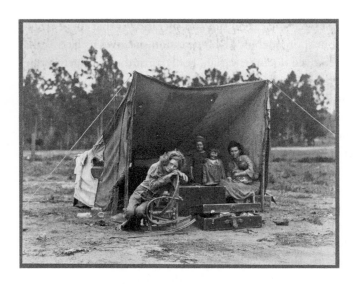

6.7 Dorothea Lange, "Nipomo, Calif. March 1936. Migrant agricultural worker's family. Seven hungry children and their mother, aged 32. The father is a native Californian." Photograph. LOC Prints & Photographs Division, FSA OWI Collection.

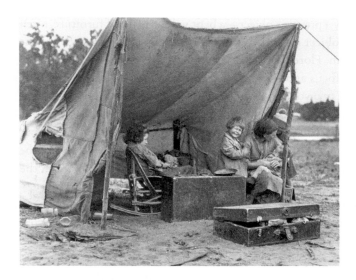

6.8 Dorothea Lange, "Nipomo, Calif. March 1936. Migrant agricultural worker's family. Seven hungry children and their mother, aged 32. The father is a native Californian." Photograph. LOC Prints & Photographs Division, FSA OWI Collection.

and hat are visible. Are the teenage girl and the younger one now attempting to avoid being in the photograph?

Several more photographs were taken closer up to Florence Owens Thompson. One shows us a more frontal and horizontal photograph of her in a Madonna pose with her eyes averted from the camera (figure 6.9). In this one we can see that she is wearing a wedding ring. It is likely that the appearance of legitimacy and normality carried by the wedding ring took away something of the disruption of poverty that might be built into the story of the single mother alone.

Another photograph includes her breastfeeding, revealing a white breast in contrast to the darker skin of the sun-exposed migrant worker (figure 6.10). In this one Florence Owens Thompson's face is suffused with a kind of pleasure and peace associated with the breastfeeding. Again, we see a picture that might have been rejected later for its lack of consonance with expectations of the starkness and hardship of poverty. In terms of Lange's interactions, Thompson might have been asked by Lange to breastfeed the baby. In all the pictures the baby appears to be asleep, so the need to breastfeed was clearly not imperative unless asked for. The supposed quick snaps leading to the iconic photograph had to have extended over a much longer period of time to allow the mother to begin feeding the baby and then to stop for the final picture.

The final and iconic picture (figure 6.11) is the most posed. The two girls now face away from the camera. The woman has put her hand against her chin in a contemplative gesture often used in paintings of thinkers and philosophers. In doing so, she has released her hold on her child, who continues to sleep. Her other hand is holding the branch that is the tent pole. This would mean that enough time has passed for the baby to stop breastfeeding and for the baby to be still enough for the mother to release it completely.

I apologize for this very painstaking reading of the photographs, but I hope I've shown that the easy snap-and-shoot documentarian air that Lange's essay presents conceals a much more complex set of human interactions between the five people in the photograph and the single photographer behind the camera. Adding to what now seems a somewhat false and misleading backstory is the telling detail that later, in the editing process, Lange actually changed the photograph for aesthetic reasons. In the original shot (figure 6.11), we see Thompson's thumb and forefinger in the lower righthand corner, partially obscuring the baby. The thumb was dodged out

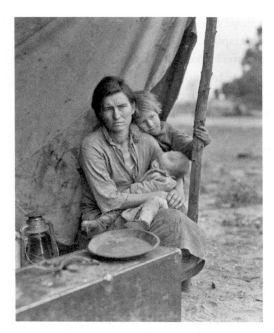

6.9 Dorothea Lange, "Nipomo, Calif. March 1936. Migrant agricultural worker's family. Seven hungry children and their mother, aged 32. The father is a native Californian." Photograph. LOC Prints & Photographs Division, FSA OWI Collection.

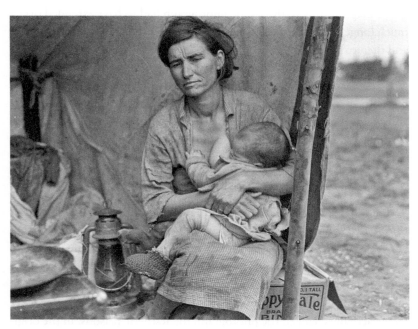

6.10 Dorothea Lange, "Nipomo, Calif. March 1936. Migrant agricultural worker's family. Seven hungry children and their mother, aged 32. The father is a native Californian." Photograph. LOC Prints & Photographs Division, FSA OWI Collection.

of the "official" photograph. In essence, the idea of a purely documentary slice of reality is again belied.[9]

Unlike the majority of Depression-era photographs, whose subjects are anonymous and silent, this one has a subsequent history that allows us to see things from the other side of the lens. In fact, Florence Owens Thompson some forty-two years later spoke about the photograph. Having seen it in a number of places, she wrote a letter to *U.S. Camera* magazine. Her letter said in part:

> This photo since has been displayed In the Palace of Fine Arts San Francisco, also two Years ago it was called to my attention that it appeared in Look Magazine . . . [and] in U. S. Camera. . . . Since I have not been consulted . . . I request you recall all the un-Sold Magazines. . . . You would do Dorothea Lange a great favor by Sending me her address that I may inform her that should the picture appear in any magazine again I and my three daughters shall be forced to protect our rights. Trusting that it will not be necessary to use drastic means to force you to remove the magazine from circulation without due permission to use my picture in your publication I remain
>
> Respectfully
> Florence Thompson

Whether the letter was indeed written by Thompson or by some members of her family, we can get a sense of both the outrage over the encounter and concomitantly the accompanying desire to make some money from a bad situation. In a later *Los Angeles Times* interview on November 18, 1978, Thompson said clearly, "I didn't get anything out of it. I wished she hadn't taken my picture." She added, "She didn't ask my name. . . . She said she wouldn't sell the picture. She said she'd send me a copy. She never did." In another interview Thompson complained, "I'm tired of symbolizing human poverty when my living conditions have improved."[10]

.

Because the object talked back, and the magazine did forward the letter to Lange, we learn indirectly from an interview with a friend that Lange was "shaken—frightened and miserable that her photograph had caused grief."[11]

We might want to compare Thompson's statement, which implies a kind of theft of her image, with a statement made by Lange earlier in

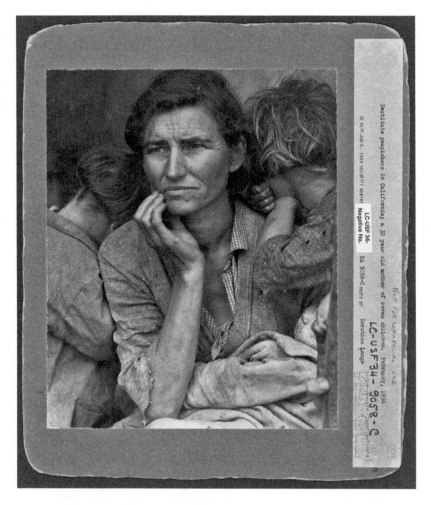

6.11 Dorothea Lange, "Nipomo, Calif. March 1936. Migrant agricultural worker's family. Seven hungry children and their mother, aged 32. The father is a native Californian." Photograph. LOC Prints & Photographs Division, FSA OWI Collection.

talking about her plunge into documentary street photography of home-
less men in San Francisco: "Sometimes you have an inner sense that you
have encompassed the thing. . . . You know then that you are not taking
anything away from anyone, their privacy, their dignity, their wholeness."[12]
This assumption on Lange's part seems consonant with her account of the
encounter in Nipomo. Her notion of "a kind of equality" between her and
Thompson seems to be part of a kind of self-justification for the entire
practice of photographing poor people with or without their permission.

I want to spend a little more time describing how Lange thought about
such encounters. It is not that she was insensitive to the awkwardness of
her position. A photograph shows her in what for her is one of thousands
of such encounters (figure 6.12). We see Lange in her working outfit with
beret, scarf, pants, and camera looking directly at the person taking the
picture of her. She is smiling confidently. Her own Graflex camera domi-
nates the scene with three young farm children surrounding her. A young
boy is standing stiffly, almost at attention, with his fixed smile staring at
Lange's camera. The two other children are looking at the person and cam-
era taking the picture of the group.

One can sense the awkwardness of the encounter and how out of
place Lange seems. In talking about such encounters, Lange describes her
general method: "You know, so often it's just sticking around and being
there, remaining there, not swooping in and swooping out in a cloud of
dust; sitting down on the ground with people, letting the children look
at your camera with their dirty, grimy little hands, and putting their fin-
gers on the lens, and you let them. . . . I have told everything about myself
long before I asked a question. 'What are you doing here?' they'd say. . . . I've
taken a long time, patiently, to explain, and as truthfully as I could." The in-
terviewer then asks, "And people generally would accept that you were trying
somehow to help?" Lange responds, "They know that you are telling the
truth. Not that you could ever promise them anything, but at that time
it very often meant a lot that the government in Washington was aware
enough even to send you out . . . so that you could truthfully say that
there were some channels whereby it could be told. Not about them, but
about people like them."[13]

We can see that by the time that Lange encounters Thompson, she's
developed a technique for winning over the subjects. But in Nipomo she
clearly did not take the time to have that conversation, except briefly. She
did "swoop in and swoop out in a cloud of dust," although she clearly said
that her photographs would "help." She also indicated that the photograph

6.12 Dorothea Lange with three children (c. 1930s). Photograph. Rondal Partridge Collection.

wasn't personally about Thompson but about the situation. These had, no doubt, become mantras she used in her trade. Her approach might have been different from that of another photographer, Russell Lee, who also worked for the FSA. His approach was more direct and perhaps more honest: "I want to show the rest of the country how you live."[14]

It is also worth remembering that Lange's boss was Roy Stryker, who, from Washington, gave his photographers specific instructions on the kind of photographs he wanted. For example, he told another female photographer, Marion Post Wallcott, that he wanted her to "search for ideas to give the sense of loneliness experienced by the women folks who helped settle this country. The idea might be developed around an abandoned dwelling on a plains homestead. Look for interiors where the wallpaper still hangs to wall or ceiling. . . . A shot of a barn or other buildings in state of near ruins. . . . Remember that the windmill is a symbol of the struggle for water. One in ruins is also a symbol." This poornographic script could easily fit into the image of the migrant mother, as would Stryker's request for "spare, bronzed and wrinkled-faced" people."[15]

We have learned something about Lange, but there are two people in this encounter. It is now time to fill in the details of the woman who is the

subject of Lange's photograph. Had she not come forward publicly, she would just be what the iconic picture suggests—white, a poor American woman thrown into desperate situations by social, economic, and political turmoil.

The first thing to note is that Thompson was not white. Florence Owens Thompson was a member of the Cherokee nation. She was born Florence Leona Christie in Indian Territory in 1903, four years before the Indian Territory was obliterated by its "consolidation" with the newly founded state of Oklahoma. Her parents were both Cherokee, and her mother's second husband was as well. Much has been written about this telling detail.[16] It seems clear that because Lange asked no questions, she got no answers; therefore, she was unaware of Thompson's indigenous heritage. This seems to be true as well for Stryker. In fact, he probably would have rejected the photograph if he knew of Thompson's origins. In response to a proposal by another photographer to document indigenous people, he wrote, "The Indian pictures are fine, but I doubt if we ought to get too far involved. There are so many other things to be done. You know I just don't get too excited about the Indians. I know it is their country and we took it away from them—to hell with it!"[17] Had Lange talked to Thompson, she would have discovered that this encounter was not Thompson's first with the well-to-do middle class. In fact, after her first husband, Cleo, died of tuberculosis, she had an affair with a rich, white Oroville merchant, who fathered one of her sons. She was afraid the biological father's wealthy family would try to claim the child, so she took him back to Oklahoma to be raised by her parents. Looking at the photograph, you might not get the sense that Thompson could move between classes in this way. Later, when given the opportunity, she recounted more about her life:

> I left Oklahoma in 1925 and went to California. The Depression hit just about the time them girls [her daughters'] dad died. I was twenty-eight years old, and I had five kids and one on the way. You couldn't *get* no work and what you could, it was very hard and cheap. I'd leave home before daylight and come home after dark—grapes, 'tater, peas, whatever I was doing. Barely made enough each day to buy groceries that night. I'd pick four or five hundred pounds of cotton every day. I didn't even weigh a hundred pounds. We just existed—we survived, let's put it that way.

This account doesn't belie the photograph, but it gives it resonance and nuance. More surprisingly, Thompson follows up what she just said with a literary reference. "When Steinbeck wrote *The Grapes of Wrath* about

those people living under the bridge at Bakersfield—at one time we lived under that bridge. It was the same story. Didn't even have a tent then, just a ratty old quilt. I walked from what they'd call Hoover camp at the bridge to way down on First Street to work in a restaurant for 50 cents a day and leftovers. They'd give me what was left over to take home, sometimes two water buckets full. I had six children to feed at that time." [18] Would the viewer suspect that the haggard woman in the photograph would be aware of Steinbeck's work? A self-awareness of her position and its place in the larger culture is clearly one of the things on her mind, but the photograph can't show us that.

.

Further, crucial details in Lange's account are incorrect, according to Thompson and her family. These differences may seem minor, but they indicate that two very different consciousnesses were at play. Lange identified the family as pea pickers camping in Nipomo. But, in fact, they were not encamped there but merely passing through on their way to Watsonville. Despite being depicted as Dust Bowl refugees newly arrived from Oklahoma, the family had been in California for a decade. [19] Lange says they sold their tires to buy food. But Thompson's son Troy Owens disputes this: "There's no way we sold our tires, because we didn't have any to sell," he told this writer. "The only ones we had were on the Hudson and we drove off in them. I don't believe Dorothea Lange was lying, I just think she had one story mixed up with another. Or she was borrowing to fill in what she didn't have." In fact, the car had trouble with the timing belt. In trying to repair that, the radiator was damaged. To repair the latter, Thompson's husband, Jim Hill, and her two sons went to a nearby town and so were not present for the photograph. The absence of men implied by the photograph's depiction of a solitary woman with children gave the picture a resonance, but the men were in fact very much a part of the family grouping. After the encounter, the husband and sons returned and fixed the car, and the family made it to Watsonville. Obviously, a photograph with those men in it would have detracted from the iconic aura of the lone woman in the picture.

Thompson also claimed that Lange promised the photo would never be published and felt betrayed when it appeared in newspapers a day or so later. [20] Katherine McIntosh, Thompson's daughter who appears in the *Migrant Mother* photo with her head turned away behind her mother's right shoulder, confirmed that Lange "told mother the negatives would never

be published—that she was only going to use the photos to help out the people in the camp."[21]

By the time Lange's photograph about the impoverished and starving pea pickers of Nipomo appeared in the newspapers, sparking a government effort to bring food into the camp, Thompson and family had moved on. In fact, Thompson's son found work as a newspaper boy and was shocked to see the photo of his mother in the paper. "I screamed out, 'Mama's been shot, Mama's been shot,'" Owens recalled. "There was her picture, and it had an ink spot right in the middle of her forehead, and it looked like someone had put a bullet through her. We both ran back to camp, and, of course, she was OK. We showed her the picture, and she just looked at it. She didn't say nothin'."[22] In truth, Thompson had been shot but not in the manner her son imagined. But the "shoot" that did occur placed Thompson in a kind of existential jeopardy.

Lawrence Levine, in writing about Lange's photographs and those of other photographers for the FSA, comments, "The urge, whether conscious or not, to deprive those without any power of determination over their destiny, of any pleasure in their lives, of any dignity in their existence, knows no single part of the political spectrum. . . . The only culture the poor are supposed to have is the culture of poverty; worn faces and torn clothing; dirty skin and dead eyes, ramshackle shelters and disorganized lives. Any forms of contentment or self-respect, even cleanliness itself, have no place in this totality."[23]

As we have seen with other works, particularly those made by those who are not transclass writers, the nondiegetic, nonsymbolic details are often left out. And when the receivers of the narrative or photograph are an "urban, middle-class clientele," like those who consumed the FSA photographs, we find the standard litany of poverty from the playbook of poornography.[24] James Curtis, who studied the FSA archive, notes that "what is surprising is the degree to which they [Stryker and his staff] manipulated individual images and entire photographic series to conform to the dominant cultural values of the urban middle class . . . [by] conscious arrangement of subject matter, posing of people, and construction of assignments to follow predetermined points of view."[25]

Yet when poor or transclass people are directing the narrative, things change. If we listen to one of Thompson's children, Norma Rydlewski, we hear a different version: "Mother was a woman who loved to enjoy life, who loved her children. She loved music and she loved to dance. When I look at that photo of mother, it saddens me. That's not how I like to

remember her." She adds, "Mama and Daddy would take us to the movies a lot. We'd go to the carnival whenever it was in town, little things like that. We listened to the radio. If they had any money at all, they'd get us ice cream. In Shafter, we had friends and relatives visiting. We also had our fun." Troy Owens recalls, "They were tough, tough times, but they were the best times we ever had."[26]

..............

The photograph hardly shows this side of their lives. Rather, it emphasizes the abject and forlorn aspect of poverty. The lack of agency on the part of Florence Owens Thompson and her family is emphasized by a statement made by her daughter Katherine about the iconic picture: "We were ashamed of it. We didn't want no one to know who we were."[27] She added, "The pictures didn't make better kids out of us. Mother did." Trying to fill out the symbolic cipher left by Lange, Katherine noted about her mother, "She worked hard, brought us up and kept us together. We all have good jobs, and we all own our own homes. And none of us have ever been in trouble."[28] For Katherine, there was the issue of someone taking a broken mirror shard of one's life and having the world see it become the whole reflection. Who controls others' view of the objectified poor?

It is not unusual for overstudied and observed groups to resent being documented. Stories of indigenous people not wanting to be photographed abound. Ricardo Moraes, in a story for Reuters (May 12, 2011) about photographing the indigenous people of Brazil, noted, "The Kayapos hate to be photographed after having seen so many strangers arrive, take pictures of them and their children, and then disappear without leaving any photos behind. In these terms, their anger is understandable. Even in the hospital waiting room many of the Kayapos reacted aggressively to my presence, many pointing to their palms in search of compensation for my photos."[29] And as Ariella Azoulay points out, "Weak populations remain more exposed to photography, especially of the journalistic kind, which coerces and confines them to a passive, unprotected position."[30]

Some people, Lange included, make the argument that the photographs, while somewhat invasive, served to improve the lot of the displaced people being photographed. Indeed, the photograph first appeared in the newspaper with a story about the starving pea pickers of Nipomo. Action resulted, with the government bringing food to that area. But in reality, the *Migrant Mother* photograph only appeared in later editions of the news story, after the aid had been sent. The photograph wasn't the inciting

image that launched a thousand baskets of food. The fact is that middle-class people want to believe that photographs like these both capture a reality and can affect that reality. But as we have seen, the actual reality can be quite different from the desired reality.

There is an almost magical belief that socially committed art, in this case what I'm calling *poornography*, has a politically redeeming side to it. Rather than acknowledging the voyeuristic frisson of seeing the life of the poor as the middle class imagines it, a higher moral value is placed on such productions. In the catalog accompanying a Lange exhibit at the San Francisco Museum of Modern Art, exhibit curator Sandra Phillips argued that Florence Thompson's "life [was] most likely saved by Lange's photo."[31] Given what we know now, this statement is unfeelingly and deludedly false. To confirm our perspective, a contemporary news article cites the Thompson family's reaction to that claim: "Phillips' assertion brought out groans of agony from Thompson's children. 'We were already long gone from Nipomo by the time any food was sent there,' said Owens. 'That photo may well have saved some peoples' lives, but I can tell you for certain, it didn't save ours.' 'Our life was hard long after that photograph was taken,' added McIntosh emphatically. 'That photo never gave mother or us kids any relief.'"[32]

In effect, there is in this instance of the object talking back a really complex discussion about the rights of the observed in a situation where journalists or writers use the image or story of impoverished people without permission. Ariella Azoulay spends a good deal of time discussing this complexity in regard to photography. Her main point is that photography implies what she calls a "contract" among at least three stakeholders—the photographer, the person being photographed, and the observer(s) of the photo. Her assertion isn't only that there is an exploitative nature to the encounter but that there can be a positive outcome if the observed have a stake in the dialectic about citizenship that is being played out.

Then there is the very real issue of financial gain. None of the FSA photographers owned their own photographs, although Lange seems to have been one of the few allowed to develop her own pictures in her personal darkroom and keep copies of the work. Nevertheless, she did not directly profit from the *Migrant Mother* photograph financially, although she did so indirectly by accruing the cultural capital that resulted from the publication and exhibition of the work—widely considered to be one of the top hundred photographs of the twentieth century. Sales of the photograph were handled by the Library of Congress, which sold each reprint

for $150. Lange acknowledged this lack of ownership in a 2000 interview but then rather disingenuously claimed that Thompson was in effect the true owner: "The negative now belongs to the Library of Congress which supervises and prints it . . . until now it is her [Thompson's] picture, not mine."[33] Azoulay argues against a claim that anyone can own a photograph and sees the issue of property rights and photography as part of a complex intersection of power, ownership, and citizenship. She has a more Deleuzian sense that there are a multiplicity of gazes, photographs, and observers in dynamic play with each other that are not "synchronized or controlled by a sovereign power."[34]

Yet the reality is that this kind of photography seems to contain an inherent violence and appropriation. As Azoulay points out, "Photography traps one in a paradox. To give expression to the fact that a photographed person's citizen status is flawed or even nonexistent (as in the case of . . . the poor . . .), whoever seeks to use photography must exploit the photographed individual's vulnerability. In such situations, photography entails a particular kind of violence. The photograph is liable to exploit the photographed individual, aggravate his or her injury, publicly expose it, and rob the individual of intimacy. This threat of violation always hangs over the photographic act, and this is the precise moment in which the contract between photographer, photographed, and spectator is put to the test."[35]

While Florence Owens Thompson's story is an example of the object talking back, there are some few others that do so as well. One is provided by the poet Maggie Anderson. Her grandparents lived in rural West Virginia when Walker Evans came through and took photographs for the FSA. Anderson wrote a series of poems that respond to those photographs. Anderson's parents conveyed the transclass consciousness to her. As she notes, "They had worked some ways of carrying the mountain culture with them. . . . It was important to my parents that I know the world they had come from."[36] Having been born in New York City, Anderson at thirteen, on her mother's death, moved back to the ancestral mountain town and lived between the two worlds until she was forty. Experiencing a transclass consciousness both at a generational remove and also directly, Anderson describes living "what W. E. B. Du Bois, speaking of race, calls a life of 'two-ness.'"[37] She adds, "It has taken me many years to realize that to tell our story clearly from my point of view, I must acknowledge fully *both* my worlds."[38]

For Anderson to "speak back" requires a complex algorithm of identities. As Chantal Jaquet describes the complex dialectic of being transclass,

Anderson herself acknowledges the intertwined strands that go into writing about the poor.[39] She notes that hers is "a privileged struggle. I have never worked in a factory or a mill, but I have seen the marks of that labor, and the domestic labor of my aunts, on bodies and faces and imaginations. Yet, as a writer who is two generations away from the working class, I find it impossible not to write of those lives, even though my own relationship to them is painful, ambiguous, and complex."[40] For Anderson, who is a poet and a professor, the fit into academia is, as Pierre Bourdieu describes, rough.[41] "No matter how much middle-class credibility I may have achieved for myself as a tenured academic and as a writer, I always feel only limited, temporary, conditional inclusion."[42] This double task—to describe the world of the poor while living uneasily in another class—is the transclass writer's job.

Anderson's poetry tries to modulate between her two consciousnesses but is always mindful of her not actually being one or the other. She didn't have the term *transclass* to identify her, but she grasps the essence of the concept. In one of her poems, "Long Story," she describes her own life in a small town in West Virginia. In it, we do not see the usual poornographic tropes of violence, ignorance, lust, or laziness, nor is there sentimentalizing of the rural poor. Instead, we see details:

> The dog and I trail the creek bank with the kids,
> past clapboard row houses with Christmas seals
> pasted to the windows as a decoration.
> Inside, television glows around the vinyl chairs
> and curled linoleum, and we watch someone old
> perambulating to the kitchen on a shiny walker.[43]

The language of this telling is cloven into two consciousnesses.

> History is one long story of what happened to us,
> and its rhythms are local dialect and anecdote.
> In West Virginia a good story takes awhile
> and if it has people in it, you have to swear
> that it is true. . . . [44]

When Anderson comes to a group of poems that use as their subject matter the photographs Walker Evans took for the FSA, she speaks with this double consciousness. "What happens when one looks at photos from another

time? I know the place. I know the people. But I try to put some distance between myself and the writing."[45]

In the poem "Independence Day Terra Alta, West Virginia, 1935," she focuses on one photograph by Evans (figure 6.13):

> Another girl, in a middy blouse with a party hat
> tilted on her head, snarls at Walker Evans.
> She doesn't want her picture made beside her mother
> who is wearing a cloth coat with a fur collar
> in early July, with the heat washing the fairgrounds
> and everyone she knows standing around. She knows
> what Evans doesn't: the talk behind the chance booth,
> the way every gesture falls on her in a long shadow
> of judgment and kin, her small mother in her stupid
> cloth coat, clutching her purse to her bosom.[46]

While Anderson has no more right to impose her thoughts on the girl than Evans had to take the picture, there is a kind of justice to the ventriloquizing. Anderson is from Terra Alta and knows the environment and the people. Evans, like Lange, was passing through.

And like Lange, and all the FSA photographers, he comes from an entirely different background. In terms of class, Evans grew up wealthy and affluent. He went to an elite private school and college. He moved with the literati and artists in urban chic New York. What was he looking for in these photographs? Anderson asks this question in another poem about an Evans photograph (figure 6.14), "Among Elms and Maples Morgantown, West Virginia, August 1935":

> . . . In this shot, Evans
> only wanted the rough surfaces of clapboard
> houses, their meshed roofs and slanted gables.
> He didn't want my mother peeling the thin skin
> from tomatoes with a sharp knife, my clumsy
> Aunt Grace chasing the ones she'd dropped
> around the linoleum floor.[47]

With the transclass vision, Anderson is aware that the photographer doesn't really want the daily story of the mundane but precious life lived by the subjects. This kind of life is known and treasured only by those who

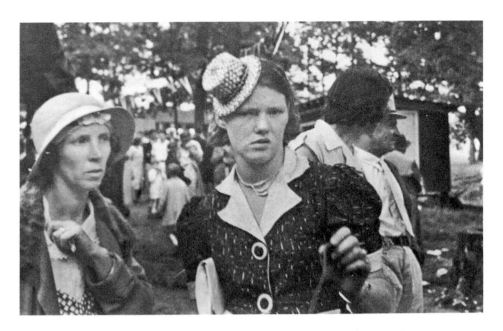

6.13 Walker Evans, *Independence Day Terra Alta, West Virginia, 1935*. Photograph. LOC Prints & Photographs Division, FSA OWI Collection.

live it. And it is not without the consciousness that Anderson herself is at a remove from the original as well.

> . . . I look back from the future,
> Past the undulating, unremitting line of hills
> Evans framed my family in, through the shaggy fronds
> of summer ferns he used to foreground and as a border.[48]

While it is true that she is at a remove, it is Evans who is "framing" the family and the photograph and is both outside the "border" but also the one creating that frame and border.

Likewise, in two other photographs by Evans (figures 6.15 and 6.16), Anderson picks up the tension in being the object of the photographer's gaze and the blank aggression of the camera.

> They had to seize something in the face of the camera.
> The woman's hand touches her throat as if feeling
> for a necklace that isn't there. . . .

6.14 Walker Evans, *Among Elms and Maples Morgantown, West Virginia, August 1935.* Photograph. LOC Prints & Photographs Division, FSA OWI Collection.

> . . . Maybe Evans asked them to stand
> In that little group in the doorway, a perfect triangle
> of people in the morning sun. Perhaps he asked them
> to hold their arms that way, or bend their heads. It was
> his composition after all. And they did what he said.[49]

Anderson speculates on Evans's posing of his subjects. In doing so, she highlights the power dynamics in representational inequality. The camera, the photographer, and the viewer all exert a shared power over the people in the picture. "It was his composition after all," she writes. And the power of the camera makes the woman "have to seize something" in her nervousness at being observed. The simple statement "they did what he said" is the most succinct statement of submission to power that could be laid out here. While Anderson speaks back to Evans, she has to ventriloquize for the actual people in the photographs. This is a response, albeit at a remove.

A more direct response confronts the book made up of James Agee's writings and Walker Evans's photographs of tenant-farmer families in the

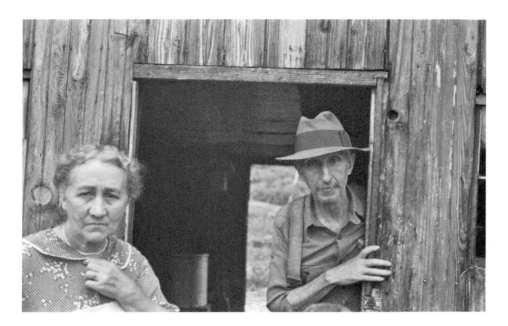

6.15 Walker Evans, Untitled (c. 1940s). Photograph. LOC Prints & Photographs Division, FSA OWI Collection.

South. *Let Us Now Praise Famous Men* (1939, 1941) was originally commissioned as an article for *Fortune* magazine, where Agee was a writer. Tellingly, the original name Henry Luce, the publisher, chose for his magazine was *Power. Fortune*, with a high purchase price, clearly aimed for the "unabashedly wealthy audience of Luce's peers."[50] Luce reminded his stable of writers, including Agee, many of whom were leftists, to "cheerfully remember that [millionaires] happen to be the audience to which they were invited to lecture."[51] The incongruity of reporting on the meager lives of extremely poor people for the delectation of the very wealthy struck Agee as problematic.

Earlier in 1935 Agee wrote an article about the effect of drought on midwestern farmers. The article was published, to Agee's dismay, with photos by Margaret Bourke-White. As Laurence Bergreen wrote:

> Agee perceived strong affinities between his own highly descriptive, impressionistic manner of writing and the art of photography; both were impersonal, immediate, and suggestive. At the same time, he harbored doubts about the propriety of popularizing the plight of the poor. It seemed downright unethical for the Margaret Bourke-Whites of the world to dip into the lives of the poor only long enough to capture a fleeting impression

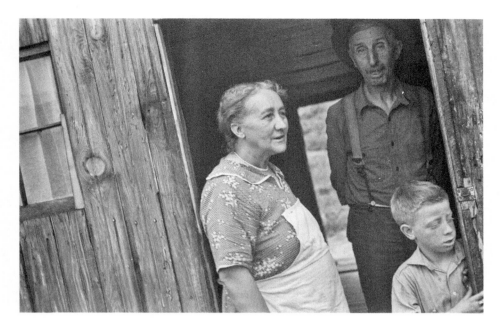

6.16 Walker Evans, Untitled (c. 1940s). Photograph. LOC Prints & Photographs Division, FSA OWI Collection.

of their misery on film. Surely her photographs represented the height of liberal folly. . . . He yearned to put aside conventional journalistic objectivity in favor of becoming at one with the poor and oppressed, to live as they did, eat their food, and sleep in their beds. Empathy was all.[52]

To try to avoid the problems of this kind of poornographic writing, Agee, hyperaware of all the pitfalls we have been noting in this book, made a bold decision. He would compose a work not only about the people he was going to live with but about the very problem of writing about poverty.

To his mentor, Father James Harold Flye, he wrote, "My trouble is . . . such a subject cannot be seriously looked at without intensifying itself toward a centre which is beyond what I, or anyone else, is capable of writing of: the whole problem and nature of existence. Trying to write it in terms of moral problems alone is more than I can possibly do. . . . If I could make it what it ought to be made I would not be human."[53]

Conceptualizing the book, Agee would "write frankly as he dared" about the families, as Bergreen notes, but "on a higher plane, he proposed to delve into the difficulty of writing honestly about a complex reality. If

the principal theme of the book was the nobility of the sharecroppers' humble lives, the secondary theme, taking up nearly as much space, was his struggle to get that phenomenon on paper, to be worthy of it as a writer and a man."[54] The book itself is filled with self-reflection, self-doubt, and an overflowing love and erotic energy toward the poor families with whom he lived. There was never before a book written about poverty that was like this, and for good and bad reasons there probably never will be again. He wrote in the opening of the work, in one of the longest sentences in literary history:

> It seems to me curious, not to say obscene and thoroughly terrifying, that it could occur to an association of human beings drawn together through need and chance and for profit into a company, an organ of journalism, to pry intimately into the lives of an undefended and appallingly damaged group of human beings, in the name of science, of "honest journalism" (whatever that paradox may mean), of humanity, of social fearlessness, for money, and for a reputation for crusading and for unbias which, when skillfully enough qualified, is exchangeable at any bank for money (and in politics, for votes, job patronage, abelincolnism, etc.)[55]

Elsewhere, he describes Evans and himself as spies. And there are moments when he literally spies on the people he is living with, examining their possessions and house in scrupulous detail when they are out in the fields picking cotton. But he does so with awareness, regret, shame, and humility. His act of writing is, according to his aim, nothing short of writing about human existence itself in a beautiful but consistently hostile and challenging world. What results is a challenging book to read, full of poetic and often dizzying language piled on itself, with a self-conscious narrator self-consciously exploring his own self-consciousness. As with Marcel Proust or James Joyce, it is a book that cannot be summarized and barely can be read continuously.

As a commercial venture it was a failure. The original article was never published by *Fortune*.[56] The book sold six hundred copies and plunged into obscurity. Agee died at forty-five in 1955. Agee's *A Death in the Family*, published posthumously, won the Pulitzer Prize and National Book Award. *Let Us Now Praise Famous Men* received new notice in the 1960s when it became a runaway success during the civil rights movement and on college campuses. It sold an additional sixty thousand copies, and it moved from obscurity to be considered a touchstone piece of writing in the twentieth century.

Agee and Evans's assignment from *Fortune* was to live with poor white people. But obviously, to write a book about poverty in the South, you have to perform a major act of erasure in leaving out poor African American tenant farmers, who probably formed a plurality of the population in the area.[57] In the original unpublished *Fortune* article, Agee directly addresses this issue: "No serious study of any aspect of cotton tenancy would be complete without mention at least of . . . the Negro: one tenant in three is a Negro. But this is not their story. Any honest consideration of the Negro would crosslight and distort the issue with the problems not of a tenant but of a race."[58] This was clearly a dodge, and in *Let Us Now Praise Famous Men*, Agee decided to include two chapters that dealt with African Americans directly. In the first, Agee describes being invited by a landowner to hear "negro music." Agee uses indirect discourse to describe the landlord's racism, using the *N*-word freely. In that incident Agee is deeply embarrassed to be trespassing on what is a weekend family gathering for the sole purpose of getting reluctant Black tenant farmers to perform for white folks. He is also interested in a deep and detailed description of the music, as well as the power dynamics inherent in the responses of the Black tenants. In a second incident, Agee describes stopping at a deserted spot to observe and photograph an African American church. A Black couple walks by, and Agee asks them if they know how he can enter the locked church that he and Evans were in the process of breaking into. The couple, aware of all the dangers involved in dealing with white people, avoid Agee. But he is so embarrassed about putting them in a dangerous situation that he makes things worse by pursuing them to apologize. The two chapters amount a kind of apologia but also a testament to the problematics of middle-class whites writing about poor Black people.

We have no account of how these Black citizens responded to Agee and Evans, but there is quite a bit on how the poor white tenant farmers responded years later. Because the Black people were left nameless, reporters later had only the white families to talk with. Dale Maharidge and Michael Williamson went back to find the Burroughs and Tingle families. The book *And Their Children after Them* was an attempt to write about and photograph the same people in the same place years later. [59] Here we get some of the responses we normally do not find in poornographic works.

Ruth Tingle, for example, said, "I don't want to be splashed all over the newspapers. We tried to sue when some stories came out. The judge said we're historical figures and have no right to sue. I don't have no rights, because I'm famous. If I'm famous, why ain't I rich?"[60] Tingle's response

contains some of the sensitive points about exploitation of poor people by the writers who write about them, even when they do so self-consciously and with love. There is a representational and structural inequality that rankles the observed.

In a 1988 PBS video, "*Let Us Now Praise Famous Men*: Revisited," a more complex picture emerges. Allie Mae Burroughs, literally lying on her deathbed, was ambivalent—both critical and accepting. "Didn't none of us know that they were doing that. . . . [W]e didn't know that till we read the book. But I didn't think that was nice. When I first got the book, I didn't care about it. But I finally got one and I read it through. And I could tell what they wrote in the book was true. It was like I told you, honey, a lot of them [her family] said they'd be ashamed. But I wasn't ashamed because that was what I had to do."[61]

In the video a theme emerges that the family was upset because Agee didn't inform the families that he was writing a book about them. He hid his notebooks and mainly wrote at night when they were asleep. This duplicity rankled Charles Burroughs: "The thing I didn't like about it is they didn't tell us the truth about it. If they told us the truth about it why they were there. What they were doing. What they were asked to do. We were taken advantage of by everyone not just them but the landlords and the people that owned the land and people we had to work for. We were been took advantage period."[62]

It is important to see that when the object responds, as we have seen, it is the issue of representational inequality that hurts. The unequal power dynamic between the writer and the people being written about, between the camera and the people being photographed, is painful because it reflects and multiplies the other aspects of being exploited, as Charles Burroughs notes, by landlords, banks, and anyone else with the power to do harm.

And of course, money is an issue. One of the other children says, "I was surprised, and you feel shock toward it. . . . [I]t wasn't right to do it. I don't think they should have done it. We're not asking to get rich off it, but I think they should give us some of it for publishing."[63] Charles Burroughs went so far as to approach lawyers. "I carried the book to a law firm in town. I've carried it to two here in Tuscaloosa, and they told me the statute of limitations had run out on it, and, you know, I couldn't do anything about it. And if I could do anything about it, the book was published in New York or somewhere, and I would be butting heads with people up there." Ruth Tingle adds to this, "We never got anything out of it. They never gave us money, never sent us anything." Floyd Burroughs Jr. echoes this issue when

he refused to speak with Maharidge. His anger and fears do not seem entirely misplaced given the amount of money people made selling photographs of his parents. "Everyone gits rich offn us. I ain't talking."[64] We can see in Floyd Burroughs's refusal to engage a lesson learned. Don't talk to journalists. There's nothing in it for you. That "you" isn't the reader or the writer. It is the object of the poornographic vision, the one who never gets to speak or to be remunerated.

It is worth noting that the responses to Agee's writing was not all negative. Agee describes his erotic attraction to Emma Woods (in real life Mary McCray), who was visiting her sister, Allie Mae Burroughs. Mary was living in a loveless marriage with a man her father's age. Agee wrote of their parting, "What's the use of trying to say what I felt . . . ? [T]here she stood looking straight into my eyes, and I straight into hers, longer than you'd think it would be possible to stand it. I would have done anything in the world for her (that is always characteristic, I guess, of the seizure of the strongest love you can feel: pity, and the wish to die for a person because there isn't anything you can do for them that is at all measurable to your love)."[65] Whether the authorial recollection of love is genuine or hyperbolic, readers do not know. But there is no question of an erotic charge toward the women and men in the families Agee lived with. Is this simply a variation on the poornographic gaze, or is it something more elemental—or both? What we do have is Mary's subsequent recounting to journalists who followed up on her later in life. At first, she comments, "He must have been drunk. I bet he was drunk. Now I can say that, and I know I'm telling the truth. Because that was wrong. And he shouldn't have done that, no matter how cute I thought he was." But then she added, "If I'd been there another week, who knows what would have happened."[66] In another interview she clarifies her feelings while laughing with girlish humor. "I never did read this book. I read my story and that was all. . . . Well, it tickled me. . . . I'd a wished I'd a known he felt like that. And me and him would have had more fun than what we did."[67] In contrast to Agee's reverential and polite middle-class demeanor, Mary reveals a more open attitude toward sexuality that only emphasizes the gap between the exo-writer and the endo-worldview.

It is worth noticing, as we have elsewhere, that the photographs, while purporting to have documentary objectivity, are, of course, highly curated, selected, and posed. Some of the iconic photographs, like *Migrant Mother*, became so because they reflected and were constructed to reflect the genre

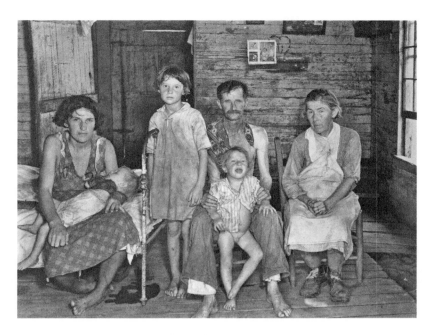

6.17 Walker Evans, *Tingle Family* (1941). Photograph. LOC Prints & Photographs Division, FSA OWI Collection.

requirements of such works. Evans's photographs, many of them stunningly beautiful in their starkness and appreciation of the details of the housing, the texture of clothing, skin quality, and human proportion, are nevertheless designed for a purpose. As with Agee's writing, Evans wants to find the aesthetic aspect to poverty. He is less interested in grime and filth, and more in weathered wooden boards and weathered faces. But we know, from looking through the archive of his pictures, that he chose photos that emphasized the debasement of the poor people. If we compare two photographs—of the Tingle family (figure 6.17) and the Burroughs family (figure 6.18)—we can see that when the Burroughs family dressed up and spruced up for a family portrait, they ceased to be the poor family Evans needed to go with Agee's story. And so the more cleaned-up family portrait was left out of the book because it did not provide the needed poornographic element.

If anything, these three rare examples of the objects talking back to the poornographer offer us a roadmap to understand the problematics of representational inequality. Florence Owens Thompson and the Burroughs seem

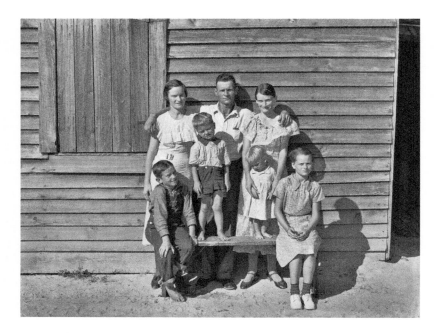

6.18 Walker Evans, *Burroughs Family* (1941). Photograph. LOC Prints & Photographs Division, FSA OWI Collection.

to express the same feelings: a hurt at being deceived by the process of recording their lives, a disappointment at being left out of the distribution of the work, a shame about having to be the permanent symbol of poverty when poverty itself did not define who they were, and an anger about being left out of the remunerative structures that reward turning people into art.

They Got It Right Now?

A lot of this book has been about the past. While I have included con-
temporary works, the well of the study has been the mid- to late nineteenth
century and the first half of the twentieth century, mainly in the United
Kingdom, the United States, and western Europe. It is a fair question to
ask—haven't things gotten better? Aren't there writers now coming from a
diversity of backgrounds who are writing more realistically about poverty?
What about bestsellers that appeal to a more enlightened public than we
had seen in the past? Instead of doing an extensive reading of all recent
books that depict poverty, I am going to take four representative works and
provide a brief analysis of each.

It would be rewarding to say that yes, there has been progress, but de-
spite some enlightened points of view, the hegemony of the poornographic
impulse seems to be as strong as ever, though refracted through various
lenses—leftist feminist, right-wing conservative, racialized, and gender
based. To demonstrate that, I briefly discuss four books from the past
thirty years.

I want to start with an easy one—J. D. Vance's *Hillbilly Elegy: A Mem-
oir of a Family and a Culture in Crisis*, published in 2016. The book topped
the *New York Times* bestseller list and was made into a major motion pic-
ture directed by Ron Howard, starring Amy Adams and Glenn Close. Sell-
ing poverty to middle-class America, the copy on the back cover of the
book announces, "As the family saga of *Hillbilly Elegy* plays out, we learn
that J. D.'s grandparents, aunt, uncle, sister, and, most of all, his mother
struggled profoundly with the demands of their new middle-class life,
never fully escaping the legacy of abuse, alcoholism, poverty, and trauma so
characteristic of their part of America." So characteristic, as we have been
saying. The writer of that blurb acknowledges that Vance was not poor but
middle class. Even so, the book claims that the family's previous poverty

carried with it an inheritance of "abuse, alcoholism, poverty, and trauma." As we have seen throughout this study, this kind of characterization of poor people is poornographic and demeaning. Vance himself did come from a troubled family. His mother was, like so many Americans rich and poor, addicted to painkillers that she became hooked on after a bout of bodily pain. In searching for an explanation for his childhood trauma with his mother, Vance hits on the perfect explanation—his mother's addiction was a consequence of the fact that her parents were "hillbillies." The reality is, and Vance mentions this several times, that he is not poor, nor is he a hillbilly. He grew up middle class in Ohio. His family never had to worry about money; he mentions "their financial success," and his uncle says that they were "just a happy, normal middle-class family" with "new material comforts."[1] His grandfather, grandmother, and mother all had houses in a suburban neighborhood in Middletown, Ohio. Papaw, his grandfather, "owned stock in Armco [the steel company he worked for his entire life] and had a lucrative pension."[2] His uncle Jimmy worked for Johnson and Johnson and lived comfortably in Napa, California, where the average home price in 2023 according to Zillow is a little under $1 million. Vance lets us know that he never lived in Appalachia and only visited with his grandparents during the summer when his great-grandparents were alive. Even his Appalachian great-grandparents owned their own four-bedroom house and had a fair amount of land that went with it. And Vance points out that the visits to Appalachia decreased with time as his grandparents aged. So, what is this about being poor and writing with authority about poverty? To justify his memoir as something more than a tale of a drug-addicted mother and a son who went to Yale, he fashions a notion that being a hillbilly does not have to be related to social class (or even living in Appalachia). Hillbilly-ness is tied to a family history and identity. Over the course of the book, he confuses himself and us by saying that he is variously middle class, working class, and poor. He falsely introduces himself when he is at Yale as "a conservative hillbilly from Appalachia."[3] As he says, "Mamaw [his grandmother] had thought she escaped the poverty of the hills, but the poverty—emotional, if not financial—had followed her."[4] What exactly is "emotional" poverty? Mamaw, a central character in the story, was in Appalachia for only thirteen of her seventy-plus years. What exactly is this legacy of poverty? Vance takes us very close to the now-debunked theories of a culture of poverty. He doesn't seem to care about that because the book turns out to be a screed against liberalism and a call for a new right-wing conservatism that supports the white working

class. This approach is at the same time anticorporate and anticapitalist. How this works is that Vance, like so many of his colleagues, sees liberal politics as leading to a society dependent on welfare. He pines with an unexamined nostalgia for the imagined past of white America. His neighbors in Middletown had lost (because of American liberalism) "the tie that bound them to their neighbors, that inspired them in the way my patriotism had always inspired me."[5] White people have lost faith in the system, and so they live in a culture where not working is seen as better than being gainfully employed. He's caught on the horns of a dilemma— are these people simply lazy, or are they the victims of the Democratic Kool-Aid that drags them to the couch to watch TV and eat bad food as they collect welfare or disability checks? He "solves" the problem with the age-old critique of poor people—they got there because of "bad choices." He mentions a friend who had a job that provided a steady income but nevertheless quit it because he didn't like getting up early. "His status in life is directly attributable to the choices he's made, and his life will improve only through better decisions."[6] Several times he refers to individuals who live on welfare as "never [having] worked a paying job in [their] life."[7] One was a neighbor who complained about the lack of hardworking people "despite never having worked in her life."[8] Aside from it being impossible to prove this specific assertion, he is buying into, although he doesn't want to, the notion that people are poor because they are lazy freeloaders. But his way out is to say that the white working class has been shunted from a central place in a thriving economy (in the nostalgic past), becoming a marginalized and ostracized group who now no longer have faith in the American dream and therefore have withdrawn their support by refusing to work and by engaging in substance abuse, destructive nutritional habits, and domestic violence.

The film, directed by Ron Howard, begins with a reference that is not in the book. Young J. D. is riding his bike to the swimming hole when he sees a turtle crossing the road whose shell has been cracked and is bleeding. He carefully picks up the turtle and brings it to the swimming hole. One of the local boys suggests a variety of cruel things to do to the reptile, but J. D. demurs, saying that the turtle will heal, as he puts it back into the river. The screenwriter, Vanessa Taylor, obviously referencing the opening of both the novel and the film of *The Grapes of Wrath*, wants us to see this movie as a kind of updated and more kindhearted version of the Dust Bowl tale.[9] But Taylor, who had previously written *The Shape of Water* and two seasons of *Game of Thrones*, decided to strip Vance's account of any

political references and to focus on the family drama and his tale of upward mobility. Taylor, seemingly an exo-writer born in Boulder, Colorado, who worked in an investment bank and had applied to law schools, does a smash-up job of furthering the misleading vision of Vance's life as steeped in poverty. The locales and interiors shown in the film are dingy, peeling-paint classics from the catalog of poornography's greatest hits. And the arc of the film is an inspirational up-from-poverty transclass tale. It begins with the turtle in Appalachia and ends at Yale in a successful job interview with a classy law firm. Job well done!

That the film strips the book of its compassionate-conservative, right-wing message shows us that the heart of the book is basically a domestic story about a son, an addicted mother, and a supportive, if foul-mouthed, grandmother. For all its talk of gun-toting hillbillies, writer Vance and director Howard lean into the drama of personal emotions set against the genre background of poverty. The one thing that Vance, and the film, portrays well is Vance's transclass experience of the awkwardness of being at elite Yale University. Vance's confusion about choosing wines at a school cocktail party, his lack of knowledge about which fork to use at a fancy dinner, and his cluelessness about networking and family connections in gaining status and cultural capital coincide with other moments we have seen in various novels and films. But in the end, this is a book with a grudge. The author's inner pain is about his mother's addiction. His ambivalence toward her and his grandmother is transmuted into some half-baked and superficially researched argument about the fall of the American white working class during a period of economic distress. We really don't get the kind of picture of the life of the poor that an endo-writer would give us. Rather, we get the broad and all-too-familiar impasto strokes of the poornographic artist who has the required limited palette and only one crude paint knife.

In contrast to Vance, much more nuanced and delicate descriptions are provided by Dorothy Allison in her 1992 novel *Bastard out of Carolina*. Also a bestseller made into a major motion picture, directed by Anjelica Huston and starring Jennifer Jason Leigh, this book was written by an endo-writer who genuinely grew up poor. As such, it exhibits the qualities of books like it, in which the author finds beauty in impoverished surroundings and focuses on love, relationships, and domestic ties. By her own account, Allison wanted to tell "tragic awful stories full of powerful broken people."[10] Nostalgia, where it occurs, is directed toward the author's childhood past, not some imagined halcyon moment in American history. Descriptions

like this one abound: "Greenville, South Carolina, in 1955 was the most beautiful place in the world. Black walnut trees dropped their green-black fuzzy bulbs on Aunt Ruth's matted lawn, past where their knotty roots rose up out of the ground like the elbows and knees of dirty children suntanned dark and covered with scars. Weeping willows marched across the yard, following every wandering stream and ditch, their long whiplike fronds making tents that sheltered sweet-smelling beds of clover."[11]

Allison writes about not only the romantic side of familiar things but also the darker shadows cast by personalities and situations that fit in with a tonal landscape of Southern Gothic. Allison as author tells us of her fascination with books that "heightened the sense of life's wonders without denying the complexity and horror that sometimes accompanied those wonders."[12] Unlike the exo-writer, she doesn't focus on the usual negatives, but the book ultimately deals with physical and sexual abuse—which is not, of course, confined to poor people only. Allison elaborates on the very concept of poornography without using that term. She talks about "the mythology" that dogs poor people: "People from families like mine—southern working poor with high rates of illegitimacy and all too many relatives who have spent time in jail—we are the people who are seen as the class that does not care for their children, for whom rape and abuse and violence are the norm. That such assumptions are false, that the rich are just as likely to abuse their children as the poor, and that southerners do not have a monopoly on either violence or illegitimacy are realities that are difficult to get people to recognize."[13]

What is unique to poverty, and something that endo-writers often recall with a vividness that escapes exo-writers, is hunger. Allison describes, "Hunger makes you restless. You dream about food, magical meals, famous and awe-inspiring, the one piece of meat, the exact taste of buttery corn, tomatoes so ripe they split and sweeten the air, beans so crisp they snap between the teeth, gravy like mother's milk singing to your bloodstream."[14] But unlike the dour vision of hunger that the poornographer would present to well-fed middle-class readers, Allison gives us certainly a concerned view but one also laced with humor. She describes a scene in which Mama cajoles the hungry narrator and protagonist Bone and her sister, Reese, saying they were "making so much noise over so little." The mother recounts how when she was a child, there was "real hunger, hunger of days with no expectation that there would ever be biscuits again." And during those times she and her siblings would make "up stories about what we'd cook if we could. Earle liked the idea of parboiled puppies. Your aunt Ruth al-

ways talked about frogs' tongues with dew berries. . . . But Raylene won the prize with her recipe for sugar-glazed turtle meat with poison greens and hot piss dressing."[15] The humor continues with the mother "laughing and teasing and tickling our shoulders." But humor is a coping mechanism that helps the girls through marginal nutrition and covers the mother's distress that her children are going hungry. After she yells at her husband for not working, she dresses up and goes out, the implication being that she will pick up some money for the family through sex work. Allison doesn't justify either the humor or the seriousness—they are all wrapped up in a life lived. Yes, there is violence of all kinds—verbal, physical, and sexual— but unlike Vance, she doesn't revel in the activity as a sign of hillbilly-ness. Rather, as Bone recalls her mother saying flatly, "Nothing to be proud of in shooting at people for looking at you wrong."[16]

While Vance uses the hillbilly elegy to account for his success in life (as well as some difficulties), Allison's protagonist tells the story of how the sexual and physical abuse led to her becoming a storyteller. Bone recounts how she transformed the abuse into masturbatory reenacting reveries and how it also provided the grist for grisly stories she would tell her playmates. These in turn led to her becoming an avid devourer of novels like *Not as a Stranger* and *The Naked and the Dead*, where she "read the sexy parts."[17] When she reads *Gone with the Wind*, she internalizes that exo-writer's perspective, and while longing to be Scarlett, she realizes that she is more like the poor character Emma Slattery. "I was part of the trash down in the mud-stained cabins . . . stupid, coarse, born to shame and death."[18] Her reaction: "I shook with fear and indignation."[19] Those combined emotions of terror and outrage encompass how an endo-reader might affectively react to realizing that they were being both condemned and stereotyped in such a literary work. Allison, as author, talks about herself having the same realization. "I am always running into people for whom that family [Slattery] is a part of how they see people like me."[20]

Allison's narrative is also more conscious of the nature of storytelling linked to strategies used by the poor to resist the actions of those with money. Bone's aunt Raylene recounts to Bone's mother how their sister Alma fought back against a sheriff who had come to repossess her furniture. "Wade always said she threw her housedress at him, and then just stood there in her underwear." Mama's response was, "That's just what people tell. She didn't do that. She just threatened to do that." Raylene comments, "It's a better story if she had done it, which is probably why they say she stripped down to her panties."[21] While Vance simply takes at face

value some of the probably exaggerated stories of his family to ramp up the stereotypes about hillbillies, Allison gives us the deeper, more nuanced background of how those stories came to be.

Vance's story is an aspirational one that laments the plight of white hillbillies but revels uncomfortably in attaining the American dream. Allison, on the other hand, has a suspicious view of the "good life." In a crucial scene, Bone and her cousin break into the local Woolworth to pay back the store manager for humiliating her for stealing a Tootsie Roll. Rather than reveling in the bounty of goods, as does her cousin, Bone sees the dime-store cornucopia as a tawdry illusion of plenty. Previously, she had longingly eyed a seemingly brimming glass case of nuts, but now, on shattering the display case, she "saw that the case was a sham. There hadn't been more than two inches of nuts pressed against the glass front, propped up with cardboard." Her reaction: "Cheap sons of bitches."[22] Rather than being aspirational, Allison as an endo-writer is more engaged in class consciousness, detecting the false allure of cheap commodities. "I looked . . . at all the *things* on display. Junk everywhere: shoes that went to pieces in the rain, clothes that separated at the seams, stale candy, makeup that made your skin break out." In contrast, she thinks of the value of the home-canned goods made by her aunt. "That was worth something. All this stuff seemed tawdry and useless."[23] While Vance ultimately adapts to the life of the wealthy, Bone resents the rich. In a conversation with her aunt Raylene, Bone says she "hates" them. Her aunt provides the poor person's counterpoint to hate. "You think because they wear different clothes than you . . . they're rich and cruel and think terrible things about you. Could be they're looking at you sitting up here eating blackberries . . . could be they're jealous of you for what you got, afraid of what you would do if they stepped in the yard."[24] Allison gives us simultaneously the class resentment and the poornographer's vision of fascinated envy and fear toward the poor.

The film of Allison's novel is mostly true to the novel's emotions and the consequences of child abuse. The film in fact was dropped from the TNT network because of the graphic depiction of child sexual abuse. The screenwriter, Anne Meredith, along with director Anjelica Huston miss the mark a bit when it comes to the depiction of poverty. Meredith was the child of a newspaper magnate and philanthropist, coming from a long line of white Protestant privilege. Huston was the daughter of acclaimed director and actor John Huston and ballerina Enrica Soma. Neither obviously had the experience to design a visual world that corresponded to the reality of poverty. The costumes are pristinely clean and stylish, more befitting a

middle-class period piece than a work of this type. The cars and trucks are worn and rust-eaten, but the houses and actors seem more like they belong in *Leave It to Beaver* than in a depiction of the poor people of the South. Caryn James's December 14, 1996, review in the *New York Times* noted the bad tuning of its depiction of poverty: "'Bastard Out of Carolina' sometimes goes astray, especially when it tumbles into redneck cliches. As Granny Boatwright, Grace Zabriskie sits on the porch of her shack spittin' and rockin', and Bone's uncles drink moonshine from glass jars."[25]

The most recent book that I consider here, from 2023, is Joseph Earl Thomas's *Sink: A Memoir*. Set in the 1990s in the Frankford area of Philadelphia, the work focuses on the life of Joey, a poor Black boy living in a family composed of his mother, Keisha, an addict and sex worker; her crack-using, trick-turning mother, Ganny; and her mother's partner, Popop, as well as his daughter, Tia. This is far from a socialist realist work. The author, who grew up poor, evokes a postmodern flattened tone when matter-of-factly describing violent or difficult situations. Thomas comments, "I was trying to capture the way that people talk . . . especially concerning violence. Like how we talked about things. Not through a college education and a series of norming institutions. . . . Not fully actualized and not factually understood."[26] In essence, the hallmark poornographic approach was insufficient to understand how life looks within the family and the community.

The author's narrative voice, however, is erudite, reflecting seemingly literary (although Thomas was not a reader as a child), pop culture, and digital influences, while some of his characters, like the "grandfather" Popop, use black working-class language and inflection. Part of the success of the work is the interesting combination of high and low language thrown into a stream-of-consciousness style. For example, when Popop discovers Joey naked and engaging in sex play at eight years old with his older "aunt" Tia, the narrator describes him as "digivolving back down into Agumon from Greymon, deflating in spirit as much as body." The "high" linguistic tone here is actually borrowed from a Japanese digital monster franchise, Digimon; those games, along with others, are the "great books" equivalent in this work. This description continues during Popop's exclamation, "Whatever, lil bitch ass nigga. Ain't nobody tryna hear that punk ass little faggot shit."[27] The mixture of registers in language might seem odd for an eight-year-old narrator, but Thomas notes in an interview that because of the failure of public schools, he had to learn complex language from role-playing games and sophisticated video games.[28] As Bryan Washington noted in his February 21, 2023, review of the book in the *New York*

Times, "In the library of this memoir's mind, the video game series 'Final Fantasy' occupies currency equivalent to 'Moby-Dick.'"[29]

As with almost all endo-writers, the violence and the cramped living conditions inform the narrative but play a secondary role to the human relations, being, in some sense, like background radiation. There is the same nostalgia for the way things were, even if to a middle-class person that way was tainted with the hallmark signs of poverty. Joey's relationship to his little sister, Mika, is touching: "Mika had all these butterfly barrettes in her hair, so whenever she climbed or slid or nodded it sounded like a whole bag of plastic toys dancing to life. The siblings would bang their head on the concrete and giggle. . . . Joey loved his sister most in those moments—not just her cuteness which he saw as being overvalued, but because she was his companion."[30]

Because Thomas is a waxing transclass author, he had a choice to make. Should the book be a redemptive story of upward mobility, like that of Vance, since Thomas ultimately becomes a PhD student at the University of Pennsylvania, or should the story present the world as it is without a bromide or remedy? In an interview Thomas acknowledges the difficulty of being a black transclass writer who has to make this choice: "Changing class positions is slippery for black folks, especially if you come from six generations of folks who never graduated high school and college. . . . The truth is most of the people in my life have much more difficult lives than this or are still dealing with this like three generations later or they didn't survive."[31]

In an interchapter in the book, Thomas addresses the reader directly with these concerns: "Things aren't exactly looking up for our heroes, folks. . . . What will they do? . . . Will he [Joey] develop gumption and introspection . . . ? Will he articulate a nuanced critique of structural injustices centering on the violence of cis-white heteropatriarchy and publish said study through a professional press, therefore saving not only himself but the world from such dangers? [Or will he] . . . pen a more insightful story about the many nuances of Black joy . . . lifting every voice to singing?"[32] The stark contrast is set between an academic approach that will solve structural problems and a literary approach to racism that, too often, must eschew negativity in favor of the uplift story. Thomas in effect gives us an answer—his own novel deftly sidesteps these questions in favor of a coming-of-age story about a "black nerd"—an asthmatic bedwetter bullied by family and friends who finds his actual world of satisfaction and education in video and role-playing games as well as rearing a string of outré

pets brought home from the local pet shop, all of whom usually die sooner rather than later. While Dorothy Allison's protagonist escapes through reading, Joey finds solace in an imaginative world far from books. Rather than the writer-to-be that many transclass narratives present us with, Joey is a gamer-that-was. His literary future at the University of Pennsylvania is never hinted at; rather, his in-the-hood apartment is filled with intelligence and senses derived from anime, manga, and games like Castlevania, Star Ocean, and Pokémon Red.

Yet for all the hip and cool references, Thomas falls back on some repeated ideologemes of poverty. The book is sprinkled liberally with cockroaches and dirty sinks as indicators of low-income life. But in the end, these are decorative motifs, while the core of the book is a fairly standard coming-of-age novel set against rather than in the backdrop of poverty. We have the insecure young boy, the mean girls, the bullies, and a Philly version of a trans Mrs. Robinson. Despite the authorial design, little truths become clear. Popop, while a former gangbanger who served prison time, seems to hold down a steady job throughout the book, always coming up with money when Joey needs it and bringing home bags of food and toys seemingly every day. As the novel progresses, the messy and privacy-free apartment changes to a private house in which everyone has a separate bedroom and cleanliness reigns, coinciding with a change in Popop's female companion. Dotty, this old flame rekindled, tells the children, "Just because you are poor doesn't mean you have to be dirty, too." And she sees her cleanliness as more than godliness: "Look how fuckin clean my kitchen is. Ain't that shit beautiful? That shit sexy, ain't it?"[33] This shows us that in fact the characteristics that litter the earlier part of the narrative are not necessary to a poorscape but rather based more on the personality of the people involved and the requirements of the genre. Also, the friendship between Jeremy, a white boy, and Joey plays around with the genre requirements of a novel about black people. The poverty theme branches out across race because of the cozy fact that "the most comforting part of their friendship was that their mothers smoked crack together."[34]

Novels like Thomas's are noteworthy for their clear-eyed view of the life of a poor person, but these contemporary works lack what might be called an overtly political perspective (aside from the universal claim that the personal is the political). These authors offer no solution to the problem of poverty and no overt critique of capitalism. More telling, perhaps, is that the sensibility of the main character, as the author tells us frequently, is derived not from transgressive or nonconformist novels

written by perspective-driven single authors but from corporate enterprises' broad-based video games that maximize appeal and thereby profit. It would be consistent with such products to create a kind of teenage angsty rebellion combined with an overall capitalist accumulation scenario in which main characters go through the world killing enemies and acquiring spells, loot, booty, and weapons. This inherent message about individualism and triumph in a struggle for life is far from the call to proletarian revolution at the end of Michael Gold's *Jews without Money*. Of course, as Thomas has pointed out, it is not the job of a novel to provide "a critique of structural injustices." On the other hand, this wonderful and heartbreaking novel cannot do more than tell an individual story that might have resonances beyond itself.

Justin Torres's *We the Animals* is another relatively recent book, published in 2011. It was a *New York Times* bestseller, as well as topping the charts in all the well-known US newspapers. It, too, was made into an independent film in 2018, which opened at the Sundance Festival. Having gone to New York University (where he dropped out after the first year), the Iowa Writers' Workshop, and Stanford, Torres, now a professor at the University of California, Los Angeles (UCLA), also was mentored by Dorothy Allison. According to Torres, she cautioned him that his work's anger was important but that he should try to find the "grace and beauty" of his narrative.[35] The book has been described as a novel about poverty, but the more you look into it, the more you realize that it is not really that. The unnamed narrator, a seven-year-old boy, and his older siblings, Joel and Manny, are growing up in a small town north of Syracuse, New York, with a father who is of Puerto Rican descent and a mother who has Italian and Irish origins. The parents grew up in New York City, with the father supposedly living in poverty but not the mother. In fact, although the novel never mentions it, Torres's actual father had become a state trooper in Baldwinsville, New York, and his mother worked for years in the Anheuser-Busch factory. Both were union members who eventually got associate degrees.[36] This isn't the standard poverty scenario. And Torres, in an interview with me on July 18, 2023, indicated that the family rose and fell through layers of comfort and desperation, being more a part of the precariat than the abject poor.[37] So, in contrast to the gritty setting of Thomas's work, Torres's kids are in a lily-white, pristine, all-American small town living in a private house, at least for a while. Where there are tensions with the community, those are more about the fact that the boys are of mixed race and the narrator is queer. In one scene in the book, which is less a novel and

more a collection of short vignettes, the narrator's father has the kids try to imitate his Latinx dancing. The kids try, but to each attempt he tells them they aren't what he is. "'This is your heritage,' he said, as if from this dance we could know about his own childhood, about the flavor and grit of the tenement buildings . . . and dance halls and city parks, and about his own Paps, how he beat him, how he taught him to dance, as if we could hear Spanish in his movements, as if Puerto Rico was a man in a bathrobe, grabbing another beer from the fridge and raising it to drink, his head back, still dancing, still stepping and snapping perfectly in time."[38] The father, who displays the required expected violence of the poverty tale, here transmutes that patrimony into a form of ritually passing along his heritage. As with the other endo-writers, humor is present to counter the domestic abuse and place it in a register that is quite different from the exo-writers' vision of violence associated with poverty. Torres is aware that "there is a lot of poverty porn out there; a lot of Lifetime movies about domestic violence, cliched representations." And he wishes to transmute it into something more "mythic."[39] But in the end, as with all four of these books, the story is an emotional coming-of-age tale that captures the feelings of children as they face sexuality. Vance's story, ironically, is the most political of them all, a conservative revenge story on the liberal, middle-class reader. Allison, Thomas, and Torres all focus on the domestic without a directly political element. While in the past it was the middle-class writer who focused on the poornographic details, ironically now it is these contemporary writers whose books contain but downplay the poornographic elements to create some kind of emotional reward for the reader, who can, as usual, use the poverty setting to sightsee and emote.

These novels make us take into consideration the needs of publishers, who may consider a book about poverty worth taking on only if it meets the expectations of middle-class readers. For example, Torres's work is by his admission a fabricated one in which the bare bones of the setting are accurate but the specific things that happen are invented. He notes in an interview that he was a bit distressed when the publisher marketed the work as "semi-autobiographical" since it was not. But as he says, "it was a very shrewd marketing decision."[40] Indeed, it was, since it allowed the book to fly into the readersphere as a work about poverty, race, and queerness with the trappings of a poverty story trailing behind the main thrust of the family drama. The filmic tie-ins of Allison's and Torres' books (and presumably there will be one for *Sink* as well) usually tighten up the emotional ligature with middle-class audiences and of course exponentially monetize

the whole process of writing about poverty. It's worth mentioning that sexuality plays a big role in such stories. Of course, sex sells, and, of necessity, an entrance into adult sexuality is a crucial part of being a teenager. But sexuality in these works can verge on the abusive and in some sense bring the abusive into a kind of narration of liberation. For Allison, sexual abuse at home is both naturalized and punished at the same time. For Thomas, it is a routine feature of the household, while at the same time part of a cautionary tale about insecurity and danger. For Torres, the end of the book looks a lot like child sexual abuse but is crafted into a scene about an entrance into a recrafted gay manhood, echoing with the triumphant cry "I am made!" as the ending salvo of a story about wanting to achieve manhood but fearing to be a man.

Notably absent from all these works is any radical critique of sexuality that might be derived from a Foucauldian perspective, which would change the demand for sexuality into something more complexly related to power structures. After all, the general goal of coming-of-age stories, as a Freudian exhortation would demand, is to have a "normal" sexual life. That life, the ne plus ultra of bourgeois society, can now be a seen through an LGBTQ+ lens but nevertheless still holds the possibility of a utopian existence that defies class restrictions and ignores economic realities. All you need is love, as the Beatles sang, can be the modern version of Christian faith or other ethical imperatives. But things conspire to turn "all you need is love" into "love is all you need to ignore everything else."

In keeping with the idea of poornography, these four works seem to agree that violence, sexual abuse, and drug and alcohol use are inherent in the poorscape. But as we have seen in earlier chapters, these features of life are not dramatically more prevalent in the life of the poor than in the life of the middle class or rich. For example, drug and alcohol use are more dependent on available money than on any particular class identity. Rich kids start using drugs earlier and may continue using drugs, particularly expensive ones, into adulthood.[41] Violence of course needs to be carefully defined, and factors like unemployment and financial hardship can cause stress on families that results in domestic violence. Theft is always a remedy for immediate economic demands, although the form might shift: robbery for the poor and cheating on income taxes for the middle class. One is obviously more interesting from a narrative perspective than the other. Sexual abuse of children may be found at a higher rate in poorer families, but that could be because this is an overstudied group who are more likely to enter intrusive and data-collecting social services than middle- and upper-class

people. Nevertheless, it is obvious that the reading public and publishing houses are drawn to these features in the lives of poor people. Endo-writers can try to subvert the prurient desires that may bring in more readers, even though these writers may also follow along with the stereotypes. However, that compromise may not be enough to end up with a successful and moneymaking publication. In the end, the best that endo-writers can do is provide a gritty coating for a tale of, as Allison recommended to Thomas, grace and beauty.

Conclusion
What Is to Be Done? Endings and Beginnings

When I was in my first year of college at Columbia, we were required to take two courses, Humanities and Contemporary Civilization, as part of the core curriculum. Many a Columbia undergrad will remember these courses, which spanned antiquity to modernity. While seeming to be a well-meaning Cook's Tour of Western civilization, they were originally developed to, in fact, civilize the young, poor Jewish immigrant children who were flooding the Ivy Leagues with their intelligence and lack of politesse in the early twentieth century. These students from the impoverished Lower East Side and Williamsburg, along with others simultaneously invading places like Harvard, Yale, and Stanford, were a rather disconcerting intrusion into the solidly upper-class WASP establishment, which used these schools as grooming areas and launching pads for their own offspring.[1] What was to be done with these uncultured and uncouth others who happened to be smart enough to break through the iron barriers erected by the power elite? Teach them the classics![2]

My breakthrough moment in the Contemporary Civilization course came when I read Karl Marx. Sure, I grew up poor and went to public schools. I had even marched in civil rights demonstrations and sang songs of labor and revolt in my settlement-house summer camp. In other words, I had an inherent but inchoate understanding of my class position, but I didn't have any way to fully articulate or understand it. In a kind of cultural, and no doubt misguided, mental shorthand, I saw my situation as allied with the front-page struggles of African Americans during this period. I lived in Mitchell-Lama Program housing, whose residents were in

large part black and brown people, so civil rights seemed to me to be about my friends' rights and, in some illogical but felt way, my rights.

Reading Marx, I realized there was an analysis of poverty that was different from the inherent ideological message conveyed to me by my parents. To them, being poor was an existential condition—not a thing to be overcome. Like being Deaf, being poor was something that you lived with and that you found acceptable and beneficial because it was your life. My parents did not rail against the ruling class, nor did they hate their bosses. They had imbibed the working-class ethic that is a precondition of survival under capitalism. And they had internalized the hidden injuries of class, quietly acceding to the notion that they were in their place in society because they deserved to be there. Far from resenting their location on the social scale, they accepted that they were uneducated and lacked the skills to make it out of their economic situation. My father, a seasonal worker who was laid off for half the year, praised both his unemployment insurance and the compound interest that micro-incrementally added to his slim savings. He didn't realize that banks were businesses made to increase the wealth of rich people. To him they were sacred places "made of marble," as Les Rice's song puts it, and he accepted the paltry interest he got as manna from heaven.[3] It was reading Marx that helped me to understand that we weren't poor because we had lost the Darwinian race but because an unjust system extracted the labor of workers while alienating that labor in the process. Marx made sense of our poverty for me. He gave clarity to a fog of feelings and misinformation that had previously made seeing impossible. He gave me a solution to a problem I didn't know I had.

I read Marx when I was seventeen. Now I am seventy-five, but I am still wrestling with both the problem and the solution. This book has been a working-through, if not a working-out, of that same issue of class and its place in telling the story of people enmeshed in this battle between labor and capital. Marx's answer of revolution has receded as a realizable reality, whereas in the mid-1960s, violent overthrow seemed, at least to some, an imminent possibility. Now we have people like Thomas Piketty advocating a greater redistribution of wealth through "participatory socialism."[4] But solutions do not abound. In considering the way that literature and media portray poverty, I am coming to a greater clarification about the role of literature and culture in this dilemma.

But as with my intellectual struggle, the works I am describing themselves have struggled with that same divide between labor and capital. Works like the novel have those contradictions built into their

very structure. As forms, the novel and memoir are generally about an individual—their dreams, aspirations, disappointments, loves, struggles, and psychology. Because they reproduce individual identity, it is difficult for these literary forms to come up with collective solutions. Indeed, it is even difficult for them to represent groups of people without turning them into metaphors—tidal waves, flocks of birds, stampeding animals. Given the technology of the novel, once a narrator introduces more than two or three people in conversation around a dinner table, say, it becomes increasingly difficult for readers to follow who is saying what. The same scene in a film would not present the same problem. In one scene in Ken Loach's film *Land and Freedom* (1995) about the Spanish Civil War, there is a thirteen-minute dialogue in which the townspeople debate whether the land won by the partisans from Francisco Franco should be collectivized. Such a scene in a novel, with something like fifty people arguing, would be impossible to depict. But according to Loach, the scene was the most important one in the film.[5] Or take the four-hour Argentinian documentary *The Hour of the Furnaces* (1968), written and directed by Octavio Gettino and Fernando Solanas, which focuses on the Peronist poor people's struggle against the rich. The film is designed to be stopped periodically so that the audience can debate the ideas presented. The words "Space Open for Dialogue" appear on the screen. The filmmakers added, "The film is a pretext for dialogue, for the search and the meeting of wills. This is a report we place before you for your consideration to be debated after the screening. What counts is the conclusions you can draw as the real authors and protagonists of this story. . . . Above all, what counts is the action that might spring from these conclusions. . . . That's why the film stops here and opens up for you to continue it."[6]

This kind of Brechtian moment would be virtually impossible in the novel form with its individual reader dwelling in the inner world of the central character. In other words, an ideological and formal problem is built into the novel that permits it to tackle the problem of labor versus capital but does not allow it to resolve that problem because the solution is a group solution and groups don't represent well in the novel. Nor is it the job of the novel to organize groups or outcomes. Even the proletarian writers of the first part of the twentieth century saw it as the job of agitprop to agitate readers to take action, without specifying what that action might be.

This isn't to say that novels can't and don't try to deal with larger groups. *Germinal*, by Émile Zola, might be a case in point. We have a group of miners who launch a strike against the mine owners. We focus on a particular

family, the Maheus, and some of their neighbors, friends, and coworkers, as well as two rich families. All well and good, although it does get a little difficult to keep everyone in place. But when there is a communal dance, an organizing rally, or the strike that eventually happens, the authorial eye either moves back for the panorama or zeroes in on a particular character. It cannot give us the totality of the action. As Georg Lukács notes in *The Historical Novel*, the best way for a novel to present a large historical happening is to focus on a representative character, like Fabrizio wandering confusedly through the Battle of Waterloo at the opening of Stendhal's *Charterhouse of Parma*.

If we think of various endings to the canonical works of poornography, we can get a better sense of the dilemma. Elizabeth Gaskell ends *Mary Barton* with a sentimental reconciliation of laborer John Barton with mill owner John Carson as the former dies in the arms of the latter, who forgives him for killing his son. Her other industrial novel, *North and South*, ends with a marriage between John Thornton, mill owner, and Margaret Hale, who is sympathetic to the plight of the workers while far from being a laborer herself. Thornton loses his money, and Hale replaces it with her own while creating a more benevolent factory situation. In Zola's *Germinal*, a strike fails, and the central character goes off to organize unions in Paris. Charles Dickens's *Hard Times* ends with a failed strike and a nonstriking protagonist who is ostracized and dies. In George Gissing's *Demos*, the socialistic worker who inherits money and tries to transform a factory ends up corrupt and is killed by a crowd of angry workers. Agnes Smedley's *Daughter of Earth* ends with the protagonist leaving the country for life abroad. Michael Gold's *Jews without Money* ends with the protagonist listening to a soapbox communist harangue and deciding to follow the cause. Henry Roth's *Call It Sleep* opts for a quasi-religious illumination stemming from the main character being electrocuted by the third rail of a railroad track. John Steinbeck's *The Grapes of Wrath* ends with Tom Joad disappearing into a future where he will in some mystical way fight against injustice as his sister breastfeeds a starving old man. Richard Wright's *Black Boy* ends with the main character disillusioned with his role as an author-worker in the Communist Party and seeking some kind of one-on-one communication that might be found in writing novels. None of these endings provides what we might call a solution to the labor and capital problem.

While film does have the ability to represent crowds, it has more often been mired in the same problematic, caught between the individual story and the societal resolution. In a film like Vittorio De Sica's *The Bicycle*

Thieves, the defeated and crying father and son walk off into a crowd. In Luchino Visconti's *The Earth Trembles*, one poor fishing family is completely ruined after trying to subvert the economic system that penalizes the fishermen. More often than not, films about poverty revolve around a love plot. Antinomies are resolved by marriage, separation, or death—not by anything resembling politics. *Moonlight* takes place in Liberty City, Florida, an African American neighborhood in which director Barry Jenkins and writer Tarell Alvin McCraney grew up. But the film barely interacts with poverty, except for the inclusion of drugs as a signaling device. A few design details also signal poverty, but the crux of the story is a coming-of-age plot combined with a love story, which ends ambiguously but essentially optimistically. A film like Robert Wise and Jerome Robbins's *West Side Story* is ostensibly about poverty, but again it is framed through a love story ending in death. Both versions of the film indicate poverty by shots of graffiti-covered tenement buildings with action taking place in liminal spaces like fire escapes, roofs, alleys, and industrial storage areas. Steven Spielberg's version liberally displays the hanging laundry that haunted Friedrich Engels and so many other poornographers. The fact that four middle-class Jewish men, all of whom were either gay or bisexual, wrote and directed the work about poor, heterosexual masculinity only emphasizes the exo-writer origin of the work. Lin Manuel Miranda's stage musical and film *In the Heights* brings in elements of a critique of racism and economic oppression but also ends with one character going off to college and another remaining in the hood to continue running his small grocery. The confused solution is both to stay and to go—which expresses a typical kind of transclass ambivalence about the value of the original culture while keeping open an aspirational future.

This brings me to a more delicate issue about the dilemma of transclass writers and the overall problem of writing about the poor. It has been a relatively unexamined, at least until recently, tenet within academia and elsewhere that anyone can be a leftist intellectual. You don't need credentials; you only need convictions. Both in fact and in theory leftist intellectuals can be drawn from any class. Upper-class people can be as passionate about supporting the working classes as a working-class intellectual can be. In this leftist class-free zone, there are only ideas and arguments; pedigrees don't come into play.

Of course, the problem of the role of intellectuals was well hashed out in the earlier days of Marxism. Marx and Engels themselves were from the bourgeois class, as were many other Marxist theorists. It was a generally

accepted fact that "declassed" intellectuals were often in the forefront of working-class movements, so much so that the first Council of People's Commissars elected the day after the October Revolution had eleven intellectuals and only four workers.[7] And writers like Cornel West have noted the ambiguous relationship of Black intellectuals to the community they are supposed to represent.[8]

But most identity groups would now say that the best critics are those who are in the group. The phrase "Nothing about us without us!" is the rallying cry of the disability activist movement. Yet that criterion seems to be null and void when it comes to talking about class. Perhaps not caring about the origin of the critic makes sense if you are considering class from a purely structural and economic perspective. Who cares if a mathematician or a physicist is working class or not? But if you are thinking about the lived experience of class, does it make a difference or add a nuance when we consider who speaks? This was, of course, one of the issues raised by Gayatri Spivak about the subaltern studies group in India, which comprised bourgeois and wealthy intellectuals who were trying to speak for the subaltern.[9] While it makes little sense to limit who should be on the left and who should make decisions about the poor and working class, it is at least worth raising the issue of the value of certain kinds of judgments about that group. If we acknowledge, at least provisionally, the argument that only transclass writers can give us representations of the poor that would resonate with the poor, then might it make sense to make the same argument about intellectuals and critics? If, as Jack Conroy has suggested, it is the role of the proletarian writer to "vivify the contemporary social fact," then that vivification must fight stereotyping and universalizing, as must the reader and critic who read such works.[10] If, as the editor of an issue of *New Challenge* (most probably Richard Wright) proposed, writers engage in "the realistic description of life through the sharp focus of social consciousness," then what would that realism look like if it were truly socially conscious?[11]

I have tried to show in this book that it might make some difference if we parsed books about poverty by whether they were written by endo-writers or exo-writers. I have been part of a group who has investigated this question through the lens of digital humanities.[12] The result is the Endo/Exo Writers Project website, which has compiled a large corpus of books about poverty and divided them by the two types of writers.[13] The website is open to all, and people are beginning to mine it to analyze what kinds of differences one can find between endo- and exo-writers. A very preliminary word search has shown, for example, that the most common words

found among endo-writers but not exo-writers are *I* and *my*.[14] While this is not yet a critical point, it does indicate that the personal is more important to endo-writers, while, as we have noted throughout, the exo-writers tend to emphasize the poorscape and certain stereotypical features of poornography. Much more research will come out of the project as it develops.

It is easy to write a book that critiques but much harder to write one that recommends. What would a just representational equality for the poor look like at the present moment? I have written what I call a *minifesto* of what poverty studies might look like. I will break that down in what follows and will do so, according to the tradition of the manifesto, in somewhat more inflammatory language than I used in writing this book thus far.

— *It matters who represents the poor.*

In this I am reiterating the point that I have been maintaining throughout this work: that not just anyone can or should depict the poor. The poor should represent themselves in an ideal world, but the ideal world is not the current real world. Until such an ideal is realized, the best writer to represent the poor is the transclass writer.

— *The poor are not the poor. Disaggregate the poor;*
find granularity and alternative categories.

The poor are a kind of cabinet of curiosities for the rich and well-off. If nothing else, this book has shown that the fascination and titillation that are the concomitant obsessions of the poornography genre are almost required for a certain kind of complacency and complicity of middle-class life. But an antipoornographic stance would not see a knowable set of stereotypes through which to create simulations of poverty but rather would present the rich complexity of life lived in the intersections and byways created under capitalistic oppression.

— *Acknowledge the value of local knowledges.*

While there are advantages to a global or Olympian view, the knowledge of the person who lives the life and inhabits the environment is as significant. Reformers and poornographers tend to be those who view from afar with the aim of correcting the ills of poverty or portraying them to others who lack local knowledge. The problem is that this kind of writing ultimately fails to grasp the local view and can only, like the old-time anthropologist, create works that speak to the reader rather than the observed, often misunderstanding the local by making it global.

— *Nothing about us without us.*

As with other oppressed groups, poor people should be involved in any depictions of themselves, if not through direct action, then through reactive critical processes.

— *Be suspicious of purely structural explanations.*

Many engaged and vociferous leftists are wealthy and privileged people, often scions of wealthy families. No admission fees and no merit badges are needed to belong to this community of outrage, which often focuses on structural explanations of capitalism rather than on the actual demographic of the people directly involved. While it would be crass and insane to limit the critique of capitalism to only poor people, there should be a special recognition of the role of poor people. A certain kind of humility should prevent blanket declarations by wealthy or middle-class leftists about the "horrors" of poverty or the view of the lived experience of the poor as merely the equivalent of a spider caught in a structural web of capitalism.

— *Study up on poverty in the real world.*
 How much do you actually know?

It is easy to act as if a critique of capitalism and a knowledge of poverty are the same. They are not. Instead of just talking in a general sense about the poor, do the deep dive to research poverty. If you want to be an ally, find ways to do that without being a do-gooder or a false friend.

— *Be suspicious of eliminate-poverty rhetoric (not of the goal).*

Obviously, redistributing wealth should be the goal of any social justice movement, including means such as a universal guaranteed income, reparations, "baby bonds," anticipatory cash, and the like, but if that rhetoric involves a denigration of the lives of poor people and the existence they experience and value, then that rhetoric is simply a smokescreen for saying that those who grew up in poverty should not have. In that case, one might just as easily say that well-off and middle-class people should be eliminated since they are the implicated subjects and beneficiaries of an unjust system. We should look at their lives in horror, as we would at anyone who profited from the oppression of others.

— *Be suspicious of unnuanced and untheorized working-class studies.*

There were two bad periods in the study of the poor. One was in the 1950s and 1960s, when academics and politicians came up with the idea of a

"culture of poverty," which ended up blaming people of color and poor people for their own condition. Authors like Oscar Lewis and Michael Harrington, along with academic politicians like Daniel Patrick Moynihan, proposed that structural issues in society created a culture of poverty that reproduced itself through the attitudes and family structure of poor people.[15] Another moment followed in the 1970s and 1980s, which was simply a celebration of working-class literature without much theoretical underpinning. Since then, working-class studies has become more nuanced and theorized, which does not mean it is automatically better but possibly means it can know and analyze the way that dominant cultures work to disenfranchise poor people. Rather than asserting that there is a culture of poverty, I am suggesting that we parse the culture that has arisen within the dominant classes about poverty.

— *Poverty is not an academic subject; poverty should be an academic study.*

Of course, poverty is not an academic subject. It is a real, lived experience for a good portion of the world. To simply take it on in a detached way as a subject of study is to already disrespect poor people. On the other hand, as with so many other forms of oppression, the academic study of that negative force producing poverty can be at least part of a step toward undoing that force.

— *End povertyism.*

While we talk about racism, sexism, ableism, and the like, we do not generally think of poverty as having an *ism*. But prejudice against poor people can result in social harms and denial of rights. A 2022 United Nations official inveighed against "povertyism," noting that "poverty will never be eradicated while povertyism is allowed to fester, restricting access to education, housing, employment and social benefits to those who need them the most."[16] We need to end discrimination against poor people simply for being poor, living in a "poor" zip code, having gone to a "poor" school, and the like.

It makes sense to end this book with a look at the popularity of poornography. Of novels written about the poor, the ones that have sold the best are those most characteristic of the genre. Of all the proletarian novels, John Steinbeck's *The Grapes of Wrath* has sold the most copies—400,000 copies in the year it was published and by now over 14 million.[17] The two books that did extremely well in the 1940s were Richard Wright's *Native*

Son, which sold 215,000 copies in the first three weeks, and Ann Petry's *The Street*, which was the first novel by a Black woman to sell over a million copies.[18] If we look at what constitutes the attraction of these works, we can see in the latter two a fascination by middle-class audiences with the grittiness and violence of the life of poor Black people. In the case of Steinbeck's work, we get a paean to the American family, particularly the desire of Ma to keep everyone together, a kind of ode to America itself, with a somewhat mild critique of capitalism. The violence seen in the African American novels is shifted in Steinbeck's work from the family and the neighborhood toward the poor, carried out by corporate farmers and the police.

It might be fitting to understand that Steinbeck's novel was a classic case of reportorial work done mainly with research materials and was initially based around a series of articles called "The Harvest Gypsies" that Steinbeck was commissioned to write for the *San Francisco News*, accompanied by photographs by Dorothea Lange. He published them separately under the rather eugenic title "Their Blood Is Strong," made more telling by his disparagement of Chinese, Mexican, Filipino, and Japanese workers, who were deported when they started to organize and were replaced by white people like the Joads. But the core of Steinbeck's observation about the Joads came from material he gathered, according to his own words, from Tom Collins, who ran the "Weedpatch" migratory labor camp near Bakersville, California, and provided weekly reports about conditions there.[19] Steinbeck said, " "Letter from Tom. . . . He is so good. I need this stuff. It is exact."[20] What Steinbeck doesn't tell us is that all that written material on which he based his information concerning the Okies was written by Sanora Babb, who was, at the time, Collins's assistant and had grown up living the dust bowl life that Steinbeck only researched. Babb had decided to write her own novel about the Okies and their trek across the country by telling her own endo-writer story. In fact, she secured a contract for a first novel from Bennett Cerf of Random House. It was scheduled for publication in the same year that Steinbeck was to publish his novel. But Steinbeck's work came out first, and Babb's contract was canceled. Her own novel, *Whose Names Are Unknown*, lay in obscurity until it was published in 2004 when she was ninety-seven.

I tell this story to show how the exo-writer often has a leg up on the endo-writer. Add to that patriarchy and cultural capital, and you get a formula by which someone like Steinbeck gets published and someone like Babb doesn't—or at least not until a new consciousness about female

writers and class begins to arise. This is not to say that Steinbeck's work is not worthy of the attention it received, but we do have to point out that the fascination it holds is one that fits nicely, like a lock and key, into the preformed imaginary that is poornography. In the end, genre will win over experience, imagined lives will triumph over lived experience, and clichés will seem more real than innovative insights. The visitor will always be convinced that they know more about the landscape than the denizen does, and when proven wrong, they will fall back on truisms. This is not to say that we cannot learn to undo the harm done by representational inequality, but to do so will take a lot of work.

Some of that work will be in the cultural realm. What will that look like? We have become more adept at seeing contradictions in literary and visual forms around race, gender, sexuality, and disability, and we will have to extend that to issues around poverty. This isn't to say that we abandon our attacks on the abuses of capitalism and our attempts to transform it, but these strategies are intricately intertwined with our cultural understandings of those ills. The more familiar middle-class readers become with the reality and perspective of the poor, the less likely they will produce remedies that are misguided or misplaced.

A recent study has shown us that when poor people and wealthy people are able to be in close contact, poor people actually are able to increase their earning capacity over a lifetime.[21] While, as with all studies, the conclusions and methods of this one could be questioned, it is clear that the segregation and isolation of people in poor neighborhoods, a result of povertyism, ultimately benefits no one. And what we have in the realm of poornography is a kind of segregation and isolation in a cultural sense. Regarding academia, there is a separation between poor people and the campus—both physically and psychologically. Elite and noncommuter campuses create rifts between town and gown but more specifically between poor people and those who study and write about poverty.[22] I am not suggesting a kumbaya moment in which we all live happily together in well-wrought villages, but I am suggesting that the current situation in which the rich and the poor live two different lives and have very different access to education and the means of representation can only further the economic and cultural divide.

Marx and Engels talked about a time when there would be a dictatorship of the proletariat as a transitory phase, and then after that the structures of the state would wither away into a classless society. This was in effect a romantic vision of life applied to a much more complex situation.

But if we are talking about how poor people can represent themselves, we are envisioning a series of transitional steps. One of those is that the transclass writer will be part of a temporary phase in transitioning to a point when social class will not determine who gets to represent whom.

It might be fitting to end by returning to Edward Said, who in some ways is one of the foremost theoreticians, or at least advocates, of engaged and politically active scholarship. In his essay "Opponents, Audiences, Constituencies, and Communities," he writes, "We need to think about breaking out of the disciplinary ghettos in which as intellectuals we have been confined, to reopen the blocked social processes ceding objective representation (hence power) of the world to a small coterie of experts and their clients, to consider that the audience for literacy is not a closed circle of three thousand professional critics but the community of human beings living in society."[23] I have focused in this book on his notion that there is a contention between those who have the power of "objective representation" and those who have ceded it to this "closed circle" of experts. The reference here is to Antonio Gramsci's notion of hegemony and particularly the idea that power is something that is ceded and therefore can be withdrawn by those who ceded it.

To some extent this opening suggested by Said in 1982 can be said to have been accomplished. His lament that literary criticism had removed itself from politics has been refuted in the work of scholars who have written about and protested social and political abuses concerning race, gender, sexuality, and disability. Said could not have imagined the intensifying effect of social media for writers and proponents in academia and beyond. Yet it remains the case that power is concentrated in few hands and elites still control to a great extent the ability to represent. In updating Said's call, I can reiterate the desire to open the "closed circle" he decries but also point out that the closed circle includes the very academics who seek to open it. Where a kind of clarity has emerged around how to combat racism, homophobia, transphobia, sexism, disability, and the like, much more work needs to be done to create the same clarifying vision around the lived experience of poverty and its representation. In the end, our job as readers and writers is to understand better the subject matter at hand. If we do not, we risk not simply continuing numbing repetitions of poornography as a genre but also enduring the cultural consequences of representational inequality and political actions that follow from those imbalances.

Notes

PREFACE

1. Táíwò, *Elite Capture*, 14–17.
2. Lévi-Strauss, *Structural Anthropology*, 211.

INTRODUCTION

1. Their letters and stories are published in a book I edited called *Shall I Say a Kiss?*
2. H. L. Mencken, in an attack on proletarian literature that contains an anti-Semitic sideswipe, describes such work as "pornography of the lowly." Mencken, "Illuminators of the Abyss," 156.
3. Jones, *American Hungers*, 4.
4. Tompkins, "Extreme Poverty."
5. Sanchez-Paramo et al., "COVID-19 Leaves a Legacy."
6. Lynch, "Casualties from War."
7. Kristof, "Why 2018."
8. T. Hitchcock and Shoemaker, *London Lives*, 5.
9. Confronting Poverty, "Poverty Facts and Myths."
10. Sauter, "Faces of Poverty."
11. Bremner, *From the Depths*, 68.
12. Frangi and Morandotti, "Giacomo Ceruti," 7.
13. Bayer, *Painters of Reality*, 219.
14. Advertisement, *Morning Post*, December 15, 1883, quoted in Jakobs, *Pictures of Poverty*, 132.
15. Jakobs, *Pictures of Poverty*, 45.
16. Jakobs, *Pictures of Poverty*, 56.
17. Jakobs, *Pictures of Poverty*, 63.
18. Bednarz, "Slum Tourism."
19. The link between sexuality and disgust was carefully detailed by Sigmund Freud, but recent work with brain mapping has also made that connection apparent. See, for example, Bourg, De Jong, and Georgiadis, "Subcortical Bold Responses."

20. Children's Hunger Fund, "Poverty Encounter," https://childrenshungerfund.org/poverty-encounter/.

21. Schocket, "Undercover Explorations," 121.

22. Gandal, *Virtues of the Vicious*, 21.

23. Braddon, *Trail of the Serpent*, 228.

24. Rabinowitz, *They Must Be Represented*, 4.

25. Trilling, "Greatness with One Fault," 99.

26. Marshall, *Slum*, 20–21.

27. Quoted in Abbott, "Charles Booth," 197–98.

28. Tennant, *London Street Arabs*, 5.

29. Tennant, *London Street Arabs*, 4.

30. Tennant, *London Street Arabs*, 4.

31. Roberts, "Jacob Riis Photographs."

32. Riis, "Flashes from the Slums."

33. Bertellini, *Italy*, 156.

34. Riis, *How the Other Half*, 29, 43.

35. Jakobs, *Pictures of Poverty*, 53.

36. Quoted in Davin, *Growing Up Poor*, 64.

37. Gold, *Jews without Money*, 46.

38. Gold, *Jews without Money*, 158.

39. Torres, *We the Animals*, 3.

40. Smedley, *Daughter of Earth*, 41.

41. Wright, *Black Boy*, 60.

42. Hartman, *Wayward Lives, Beautiful Experiments*, 5–6.

43. Zangwill, *Children of the Ghetto*, ix.

44. P. Thomas, *Down These Mean Streets*, 14.

45. P. Hitchcock, "They Must Be Represented?," 26.

46. Das, *Affliction*, 12, 16.

47. One might see a relationship between the idea of exo-writers and Mikhail Bakhtin's early formulation of "exotropy," which posits a more philosophical idea that a writer must identify with the subject being written about but then pull back to an inner self that is outside of the subject in order to "form and consummate the material." That viewpoint is more about the dialectic between subject and object, while the concept of the exo-writer is vastly simpler, pertaining to the social class of the author in relationship to the subject of the writing. See Bakhtin, *Art and Answerability*, 26.

48. Geertz, *Local Knowledge*, 6.

49. Geertz, *Local Knowledge*, 181–82.

50. The term I use in this book for that phenomenon—*transclass*—is taken from Chantal Jaquet's work *Les transclasses ou la non-reproduction* (*Transclasses: A Theory of Social Non-reproduction*).

51. Obviously, this was true for all oppressed groups, from women to people of color, LGBTQ+ people, and the like. Various struggles have permitted

many of these groups to represent themselves by now. The poor are still challenged in many areas of publishing and distribution.

52. Lyons, *Sex among the Rabble*, 281.
53. Agee and Evans, *Let Us Now Praise*.

INTERCHAPTER I. WHY ME?

1. Dickens, *Hard Times*.
2. Arner, "Degrees of Separation."

CHAPTER I. HOW TO READ THIS BOOK AND HOW THE LIVES OF THE POOR HAVE BEEN READ, OR, WHY YOU?

1. I do recognize that adjuncts who work in academia occupy a liminal status in this pecking order. If they are unionized, their lot may be somewhat better than nonunionized non-tenure track faculty. Overall, their labor is exploited and they may see themselves as allies or even part of the working poor. Their precarious position may be offset by future job security but that is by no means certain. Nevertheless, if they come from middle-class or upper-class backgrounds, their perspective will be most certainly be different from the multigenerational poor I am discussing in this book.
2. Nord, *Walking the Victorian Streets*, 51.
3. Baldwin, "Creative Process," n.p.
4. Harris and Fiske, "Dehumanized Perception"; and Fiske, "Look Twice."
5. Kraus, Park, and Tan, "Signs of Social Class."
6. Kraus, Park, and Tan, "Signs of Social Class," 427.
7. Cuddy, "Psychology of Antisemitism."
8. See my *Obsession: A History* for a more detailed explanation of the limits of brain science.
9. There is also some neuroimaging work that shows that poverty affects the brains of poor people. Mathewson, "How Poverty Changes the Brain."
10. Cohen, "Southerners, Facing Big Odds."
11. Cohen, "Southerners, Facing Big Odds."
12. N. Smith, "Stop Blaming America's Poor."
13. Davis and Morris, "Biocultures Manifesto."
14. Davis, *Obsession*.
15. P. Hitchcock, "They Must Be Represented?," 21.
16. Oldfield and Johnson, "Introduction." 1.
17. Rothberg, *Implicated Subject*, 11.
18. Berlant, "Without Exception"; and Nixon, *Slow Violence*.
19. Arner, "Working-Class Women."

20. Strauss, "Education as a Meritocracy?"; and Bourdieu and Passeron, *Les héritiers.*
21. Chetty et al., "Mobility Report Cards."
22. Glynn, *Opening Doors.*
23. Chetty et al., "Mobility Report Cards."
24. Kahlenberg, "Harvard's Class Gap."
25. Cahallan and Perna, *Indicators,* 11.
26. Helm, "Homeless High-School Valedictorian."
27. Cahallan and Perna, *Indicators,* 15.
28. Ashkenas, Park, and Pearce, "Even with Affirmative Action."
29. Bowen and Bok, *Shape of the River,* cited in Jack, *Privileged Poor,* 3.
30. Jack, *Privileged Poor,* 10.
31. Jack, *Privileged Poor,* 11.
32. Hamilton and Nielsen, *Broke,* 1–26.
33. Hallett, Crutchfield, and McGuire, "'Addressing Homelessness.'"
34. Laterman, "Tuition or Dinner."
35. Barron, "A Food Pantry."
36. Arner, "Working-Class Women."
37. Arner, "Working-Class Women."
38. Arner, "Working-Class Women."
39. Connell, *Good University,* 85–89.
40. Mullen, *Degrees of Inequality,* 157.
41. Colander, "Where Do PhDs," 140–44.
42. Wu, "Where Do Faculty Receive," 53–54.
43. Arner, "Degrees of Separation," 102.
44. Connell, *Good University,* 95–98.
45. As Aijaz Ahmad noted, in the early days of postcolonial studies, the scholars in this field who secured positions in elite US universities speaking about the subaltern were "intellectual émigrés, largely male . . . often members of ruling classes in their respective countries— even of classes that had flourished during colonial rule." Ahmad, paraphrased in Mishra, "Reorientations of Edward Said."
46. Jack, *Privileged Poor,* 21.
47. I am aware that the right wing has tried to defuse race-based affirmative action by calling for class-based alternatives. While I see the destructiveness of such an approach, it seems that rather than setting race against class, we should think more synchronistically. We don't have to jettison class when we seek justice for race. See, for example, Kahlenberg, *Remedy*; Oldfield and Conant, "Professors, Social Class"; Oldfield, "Humble and Hopeful"; Taylor, "Class-Based Affirmative Action"; and Alon and Malamud, "Israel's Class-Based Affirmative Action."
48. Reihl, Hurley, and Taber, "Neurobiology."
49. Quoted in Langer, "Virginia Walcott Beauchamp."

50. Rothberg, *Implicated Subject*, 14; see also Hirsch, *Generation of Postmemory*.
51. Binfield and Christmas, *Laboring-Class British Literature*, 3.
52. Kuppens et al., "Educationism."
53. Connell, *Good University*, 110.
54. Board of Governors of the Federal Reserve Board, *Survey of Consumer Finances*.
55. Acevedo-Garcia, Dolores et al., *Geography of Child Opportunity*, 3.
56. KFF, "State Health Facts."
57. Winship et al., "Long Shadows."
58. Newman, "Retirement."
59. Iacurci, "Are U.S. seniors among the developed world's poorest?"
60. Fazio, Launius, and Strangleman, *Working-Class Studies*.
61. Lindquist, "Class Affects, Classroom Affectations," 190.
62. Joan Scott, "Gender," 1055, 1067.
63. Jones, *American Hungers*, 8.
64. Reeves, "Dangerous Separation."
65. Reeves, "Dangerous Separation."
66. Rothberg, *Implicated Subject*, 12.
67. Sakar et al., *Souls of Poor Folks*, 9.
68. Pande, McIntyre, and Page, "Extreme Poverty Has Plummeted."
69. Pande, McIntyre, and Page, "Extreme Poverty Has Plummeted."
70. Confronting Poverty, "Poverty Facts and Myths: Fact 4: America's Poor Are Worse Off than Elsewhere," https://confrontingpoverty .org/poverty-facts-and-myths/americas-poor-are-worse-off-than -elsewhere/. Accessed March 3, 2024.
71. Bremner, *From the Depths*, 3–15; and Ehrenreich, *Fear of Falling*, 17–48.
72. Greeley, "Tenement Houses."
73. *Oxford English Dictionary*, s.v. "horde," accessed 02/11/2024, https:// www.oed.com/dictionary/horde_n?tab=meaning_and_use#1262683.
74. *New York Times*, July 30, 1893, quoted in Brodkin, *How Jews Became White*, 29.
75. Bremner, *From the Depths*, 19.
76. Jakobs, *Pictures of Poverty*, 5.

CHAPTER 2. THE PROBLEM OF REPRESENTING THE POOR

1. Adichie, "Danger."
2. See, for example, Carretta, *Unchained Voices*.
3. McCaulley, "Meaning of a Song."
4. Quoted in M. Cooper, "Complex History."
5. Quoted in Kennicott, "*Porgy and Bess*," 28.
6. Quoted in M. Cooper, "Complex History."

7. Quoted in Kennicott, "*Porgy and Bess*," 28.

8. Cruse, *Crisis*, 103–4.

9. M. Scott, "'Django Unchained.'"

10. Fox Fisher, "Fox Fisher on Trans Representation in Literature."

11. Derrida, *Writing and Difference*, 234.

12. Hall, *Representation*, 4.

13. Gombrich, *Art and Illusion*, 345.

14. Lukács, *Essays on Realism*, 45–71.

15. Althusser and Balibar, *Reading Capital*, 36.

16. Jameson, *Marxism and Form*, 195.

17. Howard, *Form and History*, 28.

18. Dyer, *Matter of Images*, 3.

19. Hale, *Social Formalism*, 221.

20. Hale, *Social Formalism*, 221.

21. Nancy Ruttenburg claims that the contradiction between represented and representer is resolved to some degree in the person and persona of Walt Whitman, who she claims "annulled the gap between being and representation, self and other," by combining in himself the "genuine American author and exemplary American character." While the claim seems valid, it is unlikely that a single author can change in one fell swoop the complicated problematic I am discussing. See Ruttenburg, *Democratic Personality*, 295.

22. Bourdieu and Passeron, *Reproduction*, 34.

23. Bendix, *In Search of Authenticity*, 27–44.

24. Johann Gottfried Herder, *Stimmen der Völker in Liedern*, edited by V. Muller, quoted in Bendix, *In Search of Authenticity*, 40.

25. Ruttenburg, *Democratic Personality*, 312–14.

26. Bendix, *In Search of Authenticity*, 73.

27. Dvořák, "Antonin Dvorak"; and Dvořák, "Real Value," 28.

28. Morgan, *Frankie and Johnny*, 18–19.

29. Poor Magazine. http://www.poormagazine.org. Accessed February 26, 2024.

30. The Class Work Project, https://www.theclassworkproject.com. Accessed: February 26, 2024.

31. *Oxford English Dictionary*, "identity politics (n)."

32. Bakhtin, "Art and Answerability," 2. Michael Holquist tries more fully to develop the idea of answering in his "Answering as Authoring."

33. Wimsatt and Beardsley, "The Intentional Fallacy," 468–88.

34. Dyer, *Matter of Images*, 3.

35. Lylo, "Ideologeme."

36. Dyer, *Matter of Images*, 2.

37. This emphasis on lack can be seen as parallel to a deficit model described by Eve Tuck, who sees a problem in education around immigrants and other marginalized groups. Tuck, "Suspending Damage."

38. Jones, *American Hungers*, 3.

39. Price, *Essays on the Picturesque*, 272–75.

40. Armstrong, *Fiction*, 95.

41. Michaels, *Beauty of a Social Problem*, 65.

42. Min Joo Kim, "Gangnam style vs. Squalor."

43. Zola, *Ladies Paradise*, 390ff.

44. Marx, *Capital*, 35.

45. Lukács, *Essays on Realism*, 48.

46. There is a complex history of the rise and use of this phrase. See J. Bell, "No Taxation without Representation." For our purposes it is enough to stress that there was a tandem coevolution of the notion of representation in its political and aesthetic sense.

47. Mitchell, "Representation."

48. Spivak, "'Can the Subaltern Speak?," 34.

49. NPR, "StoryCorps," accessed February 26, 2024, https://www.npr.org /series/4516989/storycorps.

50. Daniel Defoe, *Robinson Crusoe*.

51. Hamilton, Madison, and Jay, *The Federalist Papers*, 303–4.

52. Robbins, *Servant's Hand*, 8.

53. Woods, "Doré's London," 341.

54. *Reynold's Newspaper*, May 18, 1851, 14, quoted in Mayhew, *London Labour*, 315–16.

55. *Reynold's Newspaper*, June 15, 1851, 14, quoted by Mayhew.

56. Humpherys, *Travels*, 10.

57. Habermas, "Public Sphere."

58. Kurtzelben, "Fact Check."

59. Lauter, "Under Construction," 74–75.

60. L. Hunt, *Inventing Human Rights*, 68.

61. Pinker, *Better Angels*, 177.

62. E. Gaskell, *Mary Barton*, 241.

63. E. Gaskell, *Mary Barton*, 241.

64. E. Gaskell, *Mary Barton*, 29–30.

65. E. Gaskell, *Mary Barton*, 243.

66. Shakespeare, *Henry IV, Part One*, 4.2.36–69.

67. E. Gaskell, *Mary Barton*, 243.

68. E. Gaskell, *Mary Barton*, 244.

69. E. Gaskell, *Mary Barton*, 247.

70. E. Gaskell, *Mary Barton*, 247.

71. E. Gaskell, *Mary Barton*, 247.

72. E. Gaskell, *Mary Barton*, 247.

73. E. Gaskell, *Mary Barton*, 247.

74. E. Gaskell, *Mary Barton*, 248.

75. *English Charter Circular* 1 (1841): 162, quoted in Vicinus, *Industrial Muse*, 2, quoted in Uglow, *E. Gaskell*, 103–4.

1. Zandy, *Liberating Memory*.
2. Davis, "Voyage Out," 159.
3. Davis, "Voyage Out," 161.
4. Davis, "Voyage Out," 164.
5. Tokarczyk and Fay, "Introduction," 5.
6. Jensen, *Reading Classes*, 10, 25.
7. Rubin, *Worlds of Pain*, 13.
8. McGarvey, *Poverty Safari*, 13.
9. Miner, "Writing and Teaching Class," 73.
10. Tapper, "Huge Decline."
11. For more on this, see Pittenger, *Class Unknown*.
12. Joseph Entin, reformulating E. P. Thompson's statement that class is "a relationship not a thing," has argued that "working class is not now and never has been a stable, singular, organic entity, identity or formation." Thompson, *Making*, 11; and Entin, "Reconceiving Class," 34. So we do have to use some caution when thinking of class as a stable identity. I think the notion of transclass can help us produce what Entin suggests: "new and more nuanced understandings of the way that class comes into being, operates, and intersects with other axes of identification, collectivity and conflict." Entin, "Reconceiving Class," 34.
13. Jaquet, *Transclasses*, 82.
14. Ryan and Sackrey, *Strangers in Paradise*; Dews and Law, *This Fine Place*; and Tokarczyk and Fay, *Working-Class Women*.
15. Oldfield and Johnson, Introduction, 4.
16. Smedley, *Daughter of Earth*, 211.
17. M. Blair, *Madeleine*, 14.
18. Cisneros, *House on Mango Street*, 91.
19. Olsen, *Yonnondio*, 142–43.
20. Smedley, *Daughter of Earth*, 55–56.
21. Jensen, *Reading Classes*, 19.
22. Jack, *Privileged Poor*, 1–24.
23. Said, "Edward Said and Palestine (1988)."
24. Du Bois, *Souls of Black Folk*, 38.
25. Bruce, *How to Go Mad*, 22.
26. Zandy, *Hands*, 86.
27. Bourdieu, *Sketch for a Self-Analysis*, 41.
28. Jack, *Privileged Poor*, 182.
29. Jaquet, *Transclasses*, 73.
30. Quoted in Eaton, "Poverty Line."
31. Bourdieu, *Sketch for a Self-Analysis*, 89.
32. Bourdieu, *Sketch for a Self-Analysis*, 100.

33. Sharpe, *In the Wake*, 5.

34. Sharpe, *In the Wake*, 5.

35. Sharpe, *In the Wake*, 5.

36. Jensen, *Reading Classes*, 22.

37. Linkon, "Class Analysis," 23. Kindle.

38. Hamsun, *Hunger*, xiii.

39. Rubin, *Worlds of Pain*, 13.

40. Rubin, *Worlds of Pain*, 9.

41. Petry, *Street*, 3.

42. Petry, *Street*, 23.

43. Schocket, "Undercover Explorations," 110.

44. Schocket, "Undercover Explorations," 111.

45. London, *People of the Abyss*, 12–13.

46. London, *People of the Abyss*, 13.

47. P. Hitchcock, "Passing," 5.

48. Quoted in Jellinek, "How Eric Blair," 7.

49. Roosevelt, *Life and Reminiscences*, 368–69.

50. Ackroyd, *London*, xix; and *Morning Post*, November 30, 1872, 6.

51. Bly, "Biggest New York Tenement," 21.

52. Quoted in Delany, *George Gissing*, 51.

53. Conroy, *Disinherited*, 28.

54. Dickens, *Hard Times*, 192.

55. Sancho, *Letters*.

56. T. Cooper, "'Merrie England.'"

57. S. Smith, *Other Nation*, 36.

58. T. Cooper, "'Merrie England.'"

59. Gramsci, *Selections from the Prison Notebooks*, 144.

60. T. Cooper, "'Merrie England.'"

61. T. Cooper, "'Merrie England.'"

62. Dickens, *Hard Times*, 192.

63. T. Cooper, "'Merrie England.'"

64. T. Cooper, "'Merrie England.'"

65. T. Cooper, "'Merrie England.'"

66. Whitfield, *Frederick Engels in Manchester*, 29.

67. Alternate speculations are that she was a factory worker in Engels's mill or that she and her sister were domestics.

68. Engels, *Condition*, 10.

69. Engels, *Condition*, 9.

70. T. Hunt, "Feminist Friend or Foe?"

71. Quoted in Whitfield, *Frederick Engels in Manchester*, 19.

72. Quoted in Dash, "Friedrich Engels' Radical Lover."

73. Herbert, "Frederick Engels."

74. Engels, *Condition*, 39.

75. Engels, *Condition*, 13.

76. Engels, *Condition*, 13.

77. Engels, *Condition*, 13.

78. Engels, *Condition*, 39.

79. P. Thomas, *Down These Mean Streets*, 106.

80. Eisner, *Contract with God*, n.p.

81. Engels, *Condition*, 40.

82. Engels, *Condition*, 40.

83. "Dwellings of the Poor," 336.

84. "Dwellings of the Poor," 336.

85. "Dwellings of the Poor," 337.

86. "Dwellings of the Poor," 337.

87. "Dwellings of the Poor," 337.

88. Allbut, *Rambles in Dickens' Land*, 39. Kindle.

89. Humpherys, *Travels*, 16.

90. A. E. Johnson, *Clarence and Corinne*, 5–6.

91. S. Gaskell, *Slums*, 3.

92. Huk, *Ben Brierly*, 6–7.

93. Brierly, *Chronicles of Waverlow*, 9–10.

94. Quoted in Whitfield, *Frederick Engels in Manchester*, 22.

95. Jekyll, introduction to Sancho, *Letters*, 52.

96. Gissing, *Workers in the Dawn*, 141.

97. Gissing, *Workers in the Dawn*, 142.

98. Fern, *Ruth Hall*, 73.

99. Fern, *Ruth Hall*, 81.

100. Fern, *Ruth Hall*, 90.

101. Lingeman, *Theodore Dreiser*, 24.

102. Lingeman, *Theodore Dreiser*, 26.

103. Blair, *Madeleine.*

104. Blair, *Madeleine*, 6.

105. Blair, *Madeleine*, 4.

106. Blair, *Madeleine*, 11.

107. Blair, *Madeleine*, 13.

108. Wright, *Black Boy*, 60.

109. Wright, *Black Boy*, 19.

110. Wright, *Black Boy*, 137.

111. Wright, *Black Boy*, 288.

112. Wright, *Black Boy*, 151.

113. Wright, *Black Boy*, 253.

114. Morgan, *Rethinking Social Realism*, 5.

115. Thurman, *Blacker the Berry*, 5.

116. Thurman, *Blacker the Berry*, 10.

117. Kogan, "Forgotten Writer Willard Motley."

118. Morgan, *Rethinking Social Realism*, 254; and Fleming, *Willard Motley*, 16.
119. Wald, *American Night*, 205–6.
120. Wald, *American Night*, 206.
121. Fleming, *Willard Motley*, 28.
122. Motley, *Knock on Any Door*, 83–84.
123. Quoted in Fleming, *Willard Motley*, 18–19.
124. Motley, "Pavement Portraits," 2.
125. Motley, *Let Noon Be Fair*, 414.
126. Motley, *Let No Man*, 10.
127. Quoted in Morgan, *Rethinking Social Realism*, 261.
128. Motley, *Diaries of Willard Motley*, xix.
129. Fleming, *Willard Motley*, 24–25.

CHAPTER 4. BIOCULTURAL MYTHS OF THE POOR BODY

1. Foster, *New York by Gas-Light*, 69.
2. Ehrenreich, *Fear of Falling*, 51.
3. Cited in Ehrenreich, *Fear of Falling*, 53.
4. Davis and Morris, "Biocultures Manifesto."
5. Buchele, "Poor Neighborhoods Feel Brunt."
6. Meg Anderson, "Racist Housing Practices"; Hoffman, Shandas, and Pendleton, "Historical Housing Policies"; and Root, "Heat and Smog."
7. Closson, "Disparity in Access."
8. Leahy and Serkez, "Since When Have Trees."
9. Rabin, "Poor Americans."
10. *Illustrated Times*, "Gas."
11. Baumgaertner, "Noise Could Take Years."
12. Healy, "Scorching Hot in Phoenix."
13. Ellison, "Sleep Gap."
14. Ellison, "Sleep Gap."
15. Lazo, Jayaraman, and Moriarty, "D.C. Traffic Deaths."
16. Biornsdottir and Rule, "Visibility of Social Class."
17. DeParle, "Cash Aid."
18. Noble, "Children's Brains."
19. Fears and Amer, "To Stop a Scrapyard."
20. McCord and Freeman, "Excess Mortality in Harlem."
21. Akiliah Johnson, "Black Adult Hospitalizations."
22. Fryer, *Staying Power*, 194.
23. Fryer, *Staying Power*, 235.
24. Fryer, *Staying Power*, 230.
25. Fryer, *Staying Power*, 231.
26. Mayhew, *London Labour* (2020), 340.

27. Foster, *New York by Gas-Light*, 125.
28. Collyer, *Lights and Shadows*, 7.
29. Dickens, *American Notes*, 220.
30. London, *People of the Abyss*, 133, 129, 28.
31. A. Bell, *Memoir*.
32. Luczak, *Breeding and Eugenics*, 78.
33. Gissing, *Demos*, 121.
34. Zola, *Germinal*, 490.
35. Paul, "Interests of Civilization," 118–19.
36. Wells, *Time Machine*, 40–41.
37. Wells, *Time Machine*, 63.
38. Wells, *Time Machine*, 63–64.
39. Wells, *Time Machine*, 41–42.
40. Wells, *Time Machine*, 61.
41. Wells, *Time Machine*, 65.
42. Zola, *Germinal*, 116.
43. Zola, *Germinal*, 17.
44. E. Gaskell, *Mary Barton*, 35.
45. E. Gaskell, *Mary Barton*, 36.
46. Carter, "Vampire of the South," cited in Wray, 113.
47. Mackenzie et al., "Childhood Malnutrition."
48. Beddoe, *Races of Britain*.
49. Abernathy, *Jew a Negro*.
50. Sims, *How the Poor Live*, 5.
51. Luczak, *Breeding and Eugenics*, 72.
52. Mayhew, *London Labour*, 1851, 1:3.
53. *Reynolds's Newspaper*, July 20, 1851, 3, quoted in Mayhew, *London Labour* (2020), 318.
54. Mayhew, *London Labour* (1851), 1:6.
55. Stowe, *Key to Uncle Tom's Cabin*, 431.
56. Wray, *Not Quite White*, 60.
57. Wray, *Not Quite White*, 62–63.
58. London, *People of the Abyss*, 127.
59. London, *People of the Abyss*, 179.
60. Quoted in Mayhew, *London Labour* (2020), 311.
61. Engels, *Condition*, 42.
62. Grindrod, *Slaves of the Needle*, extracted in E. Gaskell, *Mary Barton*, 539.
63. Bronte, *Jane Eyre*, 32.
64. Nicholls, *Politics of Alcohol*, 40.
65. E. Gaskell, *Mary Barton*, 241.
66. E. Gaskell, *Mary Barton*, 36.
67. Quoted in Kevles, *Eugenics*, 48.
68. Baynton, "'Silent Exile,'" 29.

69. "William Faulkner," Encyclopedia.com. Cengage. https://www
 .encyclopedia.com/people/literature-and-arts/american-literature
 -biographies/william-faulkner. Last updated May 18, 2018.
70. Baynton, "'Silent Exile,'" 21.
71. London, *People of the Abyss*, 9.
72. London, *People of the Abyss*, 77.
73. Jacobs and Fishberg, "Stature."
74. Moore, *Esther Waters*, 146.
75. Moore, *Esther Waters*, 150.
76. Valentova et al., "Relative Height"; Sorowski et al., "Variable Prefer-
 ences"; and Sorowski et al., "Height Preferences in Humans."
77. Regan, "Partner Preferences."
78. Zimmer, "Agriculture Linked."
79. Phelan and Rose, "Why Dietary Restriction."
80. Gillespie, "Rich Men Drink More."
81. Rampell, "Rich Drink More."
82. Galea et al., "Neighborhood Income."
83. Kumin, "Hard Evidence."
84. Russell, *Renegade History*, 6.
85. Russell, *Renegade History*, 5.
86. Rorabaugh, *Alcoholic Republic*, 8, 9, 15.
87. Nicholls, *Politics of Alcohol*, 6.
88. Nicholls, *Politics of Alcohol*, 11.
89. Quoted in Nicholls, *Politics of Alcohol*, 26.
90. Nicholls, *Politics of Alcohol*, 26.
91. Nicholls, *Politics of Alcohol*, 29.
92. Russell, *Renegade History*, 32–33.
93. Quoted in Bremner, *From the Depths*, 71.
94. Moore, *Esther Waters*, 273.
95. Moore, *Esther Waters*, 273.
96. "Population History of London."
97. Jackson, *Dirty Old London*, 47.
98. https://nautarch.tamu.edu/portroyal/CHAMBER/Dry_land.htm.
99. Jackson, *Dirty Old London*, 156.
100. Cats Meat Shop, "Urine Deflectors."
101. Williams, *Rich Man*, 13.
102. Gilbert, "Medical Mapping," 79.
103. Dickens, *Dombey and Son*, 647–48.
104. Allen, *Cleansing the City*, 13.
105. E. Gaskell, *Mary Barton*, 97.
106. E. Gaskell, *Mary Barton*, 97.
107. E. Gaskell, *Mary Barton*, 97–98.
108. E. Gaskell, *Mary Barton*, 100.

109. Marcus, *Engels, Manchester,* 184.

110. Halliday, "Death and Miasma."

111. Swift, *Complete Poems,* 113.

112. Lonsdale, *Eighteenth Century Verse,* 87–88.

113. Pannell, "Viperous Breathings," 25.

114. This attitude is so much a part of modern life that France recently had to pass a law permitting the smells and sounds of rural life to exist, since in the twenty-first century many residents of the countryside expect to live in scentless and silent bucolic bliss. See Breeden, "French Roosters."

115. Nead, *Victorians,* 158.

116. "Dwellings of the Poor," 336.

117. E. Gaskell, *Mary Barton,* 98.

118. Chadwick, *Inquiry,* 4.

119. Williams, *Rich Man,* 31.

120. Finer, *Life and Times,* 347.

121. S. Gaskell, *Slums,* 3.

122. John Scott, "Sanitary Remonstrance," 5.

123. The letter itself is written in nonstandard English and published with solecisms ("just as it was received"). It is unclear to this researcher whether the letter was published unredacted to amuse the middle-class readers with the errors or to achieve a certain authenticity. It has to also be considered that the letter, although signed by over fifty residents, could have been a forgery sent to the newspaper with some ulterior motive. Since a specific address is listed, it is possible that a rival intended to injure an owner.

124. Jackson, *Dirty Old London,* 161.

125. Eveleigh, *Bogs, Baths and Basins,* xvii.

126. Rochefoucauld, *Frenchman's Year in Suffolk,* 23.

127. Steinbeck, *Grapes of Wrath,* 356–57.

128. Allen, *Cleansing the City,* 43.

129. Allen, *Cleansing the City,* 43.

130. Wray, *Not Quite White,* 125.

131. Brace, *Dangerous Classes,* 194.

132. Ewen, *Immigrant Women,* 137.

133. Pope, *Complete Poetical Works,* 15.

134. Almeroth-Williams, *City of Beasts,* 76–77.

135. McNeur, *Taming Manhattan,* 27.

136. Guilford, "Hogs," quoted in the *New York Times.*

137. Dickens, *American Notes,* 205.

138. McNeur, *Taming Manhattan,* 25.

139. McNeur, *Taming Manhattan,* 23.

140. Collyer, *Lights and Shadows,* 6.

141. Almeroth-Williams, *City of Beasts,* 79.

142. Guilford, "Hogs."

143. Almeroth-Williams, *City of Beasts*, 85.

144. Dyos and Wolff, "Way We Live Now," 898.

145. Bremner, *From the Depths*, 8.

146. A. Thomas, *Cholera*, 62.

147. "Facts Proved by the Health of Towns Commission," *Liverpool Health of Towns Advocate* I (September 1, 1845), quoted in Williams, *Rich Man*, 32.

148. Williams, *Rich Man*, 35, quoted in Allison.

149. World Health Organization, "Preventing Chronic Diseases," 61.

150. Meg Anderson and McMinn, "As Rising Heat Bakes."

151. T. Hitchcock and Shoemaker, *London Lives*, 6.

152. Proudhon, *Property Is Theft*, 87.

153. Gray, *Crime, Prosecution*, 32.

154. Gray, *Crime, Prosecution*, 54.

155. Gray, *Crime, Prosecution*, 38–54.

156. T. Hitchcock and Shoemaker, *London Lives*, 7.

157. Green and Wakefield, "Middle- and Upper-Class Homicide," 175.

158. Godfrey, *Crime in England*, 7.

159. Godfrey, *Crime in England*, 7.

160. Godfrey, *Crime in England*, 31.

161. T. Hitchcock and Shoemaker, *London Lives*, 8.

162. Gray, *Crime, Prosecution*, 2.

163. Dennis, *Robert Koehler's* The Strike, 96.

164. Quoted in Dennis, *Robert Koehler's* The Strike, 98.

165. Riis, *How the Other Half*, 226.

166. Quoted in Riis, *How the Other Half*, 226.

167. Brodkin, *How Jews Became White*, 117–18.

168. Ewen, *Immigrant Women*, 126–27.

169. Ewen, *Immigrant Women*, 176–77.

170. Ewen, *Immigrant Women*, 257.

171. Dacus, *Great Strikes*, iv–v.

172. Quoted in Wray, *Not Quite White*, 21–22.

173. Wray, *Not Quite White*, 106.

174. Quoted in Wray, *Not Quite White*, 108.

175. Cantacessi et al., "Experimental Hookworm Infection."

176. Doucleff, "Could Worms."

177. Cited in T. Hitchcock and Shoemaker, *London Lives*, 23.

178. T. Hitchcock and Shoemaker, *London Lives*, 23.

179. Murray, "Working Poor," 5.

180. Kim, "Are the Working Poor."

181. Ewen, *Immigrant Women*, 243.

182. Mishel, "Vast Majority."

183. Mani et al., "Poverty Impedes Cognitive Function," 976.

184. Bartos et al., "Effects of Poverty."
185. Wadsworth and Rienks, "Stress as a Mechanism."
186. C. Blair and Raver, "Poverty, Stress."
187. Evans, Brooks-Gunn, and Klebanov, "Stressing Out the Poor," 19, 21.
188. Gershwin and Heyward, "I Got Plenty of Nuttin'."
189. Gershwin and Heyward, "I Got Plenty of Nuttin'."
190. Rogers and Hammerstein, "How Can Love Survive?"
191. Rogers and Hammerstein, "How Can Love Survive?"
192. Harburg, "When the Idle."
193. Harburg, "When the Idle."
194. Engels, *Condition*, 41.
195. Engels, *Condition*, 47.
196. Quoted in Engels, *Condition*, 48.
197. Quoted in Engels, *Condition*, 49.
198. Symons, *Arts and Artisans*, 116.
199. Quoted in Nead, *Victorian Babylon*, 150.

CHAPTER 5. FEMALE SEX WORKERS

1. Xavier Hollander, *The Happy Hooker*.
2. Nord, *Walking the Victorian Streets*, 3.
3. There is one type of sex work that I am not going to discuss in this chapter. This is forced sexual work on the part of enslaved women and indentured servants. As Ruth Rosen notes, "The legal and systematic sexual exploitation of female indentured servants and black female slaves constituted one form of forced prostitution. Female slaves and indentured workers encountered not only forced labor but also the sexual exploitation of their owners. Forced to submit to masters' sexual demands, both groups of women gave birth to children sired by their masters. The law underscored their total lack of rights; a pregnant indentured servant earned a lengthened period of servitude, and the slave saw her offspring become the property of the rapist. Such forced prostitution, however, was a form of sexual slavery and differed from the commercial sale of sex." Rosen, *Lost Sisterhood*, 2.
4. There is a question of terminology that needs to be dealt with. As with the recent change from *slave* to *enslaved person* and from *slave master* to *enslaver*, we might want to rethink the language we use with sex work. Terms like *bordello* or *brothel* carry a whiff of superiority on the part of people who use them. If we think of sex work as work like any other form of labor, then might we call such places *sex-work shops*? Workers there might be freelancers, apprentices, or laborers as they would in any trade or industry, depending on their status and how they are paid. *Streetwalkers* might be called *gig workers* or *itinerant peddlers*.

5. Luddy, *Prostitution and Irish Society*, 163.

6. See, for example, Glickman, *Jewish White Slave Trade*; and Hirata, "Free, Indentured, Enslaved."

7. Karras, *Common Women*, 16.

8. Rosen, *Lost Sisterhood*, 1–2.

9. Karras, *Common Women*, 131.

10. Wollstonecraft, *Vindication*, 157.

11. Foster, *New York by Gas-Light*, 229.

12. Humpherys, *Travels*, 17–18.

13. Kristina Straub's comprehensive book *Domestic Affairs* gives plenty of background on the subject but does not expand much on novels beyond the work of Richardson.

14. E. Gaskell, *Mary Barton*.

15. Foster, *New York by Gas-Light*, 93.

16. Foster, *New York by Gas-Light*, 70–71.

17. Lyons, *Sex among the Rabble*, 284.

18. M. Blair, *Madeleine*.

19. We might think of women in the precariat now who are using the internet to do sex work of various types. See, for example, Freedman, "Jobless, Selling Nudes Online."

20. Nead, *Myths of Sexuality*, 5.

21. Laite, *Common Prostitutes*; and Bartley, *Prostitution*, 3–4.

22. Finnegan, *Poverty and Prostitution*, 24.

23. Clayson, *Painted Love*, 117.

24. Russell, *Renegade History*, 103–4.

25. Walkowitz, *Prostitution and Victorian Society*, 38–39. Interestingly, at least in France, it seems that not all prostitutes were from poor families. Alain Corbin notes that in Marseilles among the registered sex workers were the daughters of thirteen teachers, six court ushers or bailiffs, four lawyers, four magistrates, and tellingly one inspector in the vice squad as well as a very large number of retired soldiers and teachers. Corbin, *Women for Hire*, 46.

26. Lyons, *Sex among the Rabble*, 320.

27. Quoted in Nord, *Walking the Victorian Streets*, 5–6.

28. See Laqueur, *Solitary Sex*.

29. Mahood, *Magdalenes*, 42.

30. Lyons, *Sex among the Rabble*, 12.

31. Quoted in Corbin, *Women for Hire*, 248.

32. Quoted in Corbin, *Women for Hire*, 4.

33. Dickens, *Bleak House*.

34. Mac and Smith, *Revolting Prostitutes*, 51.

35. Mac and Smith, *Revolting Prostitutes*, 52.

36. Epstein, "Over 3 Million Women."

37. Higgins, "DC Could Be First."

38. Logan, *Great Social Evil*, 132.

39. Foster, *New York by Gas-Light*, 96.

40. Quoted in Nead, *Myths of Sexuality*, 158.

41. Karras, *Common Women*, 54.

42. Wardlaw, *Lectures on Female Prostitution*, 101.

43. Attwood, *Prostitute's Body*, 33.

44. Quoted in Nead, *Myths of Sexuality*, 154.

45. Charles Dickens, "Appeal to Fallen Women," quoted in Gissing, *Unclassed*, 399–400.

46. Quoted in Nead, *Myths of Sexuality*, 148.

47. Quoted in Corbin, *Women for Hire*, 9.

48. Nield, *Prostitution*, introduction, n.p.

49. Heydt-Stevenson, *Austen's Unbecoming Conjunctions*.

50. Coustillas and Partridge, *Gissing*, 13.

51. Shakespeare, *Hamlet*. 163.

52. Goldsmith, *Vicar of Wakefield*.

53. Gissing *Unclassed*, 128.

54. Gissing, *Unclassed*, 128–29.

55. Gissing, *Unclassed*, 126–27.

56. Gissing, *Unclassed*, 139.

57. Gissing, *Unclassed*, 130.

58. George Bentley to George Gissing, January 4, 1884, quoted in Gissing, *Unclassed*, 394.

59. Reproduced in Review, *Evening News*, June 25, 1884, quoted in Gissing, *Unclassed*, 396.

60. A. R. Barker, *Academy*, June 28, 1884, quoted in Gissing, *Unclassed*, 397.

61. Hollander, *Happy Hooker*, 24–25.

62. Hollander, *Happy Hooker*, 308, 310.

63. Mac and Smith, *Revolting Prostitutes*, 141.

CHAPTER 6. THE ENCOUNTER, OR, THE OBJECT TALKS BACK

1. I am indirectly indebted to James Elkins for the phrase "the object talks back." Elkins discusses this issue in a very different way in his book *The Object Stares Back*. Elkins opens the book with a haunting photograph of a naked eunuch from a nineteenth-century French medical journal. His discussion of the vulnerability of the person in the image is, though, very much in line with the discussion in this chapter.

2. Gordon, *Dorothea Lange*, 45–46.

3. Denning, *Cultural Front*.

4. Lange, "Assignment I'll Never Forget," 42.

5. Rabinowitz, *They Must Be Represented*, 12.

6. Goldfine, "Dorothea Lange."

7. Sally Stein, who has written extensively about Lange, argues that this is not the first photograph. In correspondence with me, she makes a case for the first photograph being the one I am saying is second. Either way, this does not fundamentally change the argument I am making.

8. As mentioned, Sally Stein disagrees. We did go over the photograph during a conversation, and she is dubious about my claim that the mark of the rocker rails are visible and that the arrangement of the sand indicates the girl's presence previously. You'll have to decide. But either way, the chair was moved, probably at Lange's request.

9. Experts on documentary photography like Paula Rabinowitz have written about the effect of the real that is produced by the documentary photograph, which often belies the art and artifice behind the photographs. Rabinowitz notes that often it is the political effect to spur change or to define themselves and their political ideologies that is the primary goal of documentarians, more than an aim of authenticity. Rabinowitz, *They Must Be Represented*.

10. Quoted in Robin, *Photos of the Century*.

11. Quoted in Gordon, *Dorothea Lange*, 141.

12. Quoted in Gordon, *Dorothea Lange*, 116.

13. Lange, oral history interview.

14. Quoted in Ganzel, *Dust Bowl Descent*, 108.

15. Quoted in Ganzel, *Dust Bowl Descent*, 8.

16. The most complete is Stein's essay "Passing Likeness."

17. Quoted in Stein, "Passing Likeness," 352.

18. Quoted in Ganzel, *Dust Bowl Descent*, 31.

19. Dunn, "Photographic License."

20. Jardine, "Dustbowl Part IV."

21. Quoted in Dunn, "Photographic License."

22. Quoted in Dunn, "Photographic License."

23. Levine, *Unpredictable Past*, 268–69.

24. Curtis, *Mind's Eye, Mind's Truth*, viii.

25. Curtis, *Mind's Eye, Mind's Truth*, ix.

26. Quoted in Dunn, "Photographic License."

27. Quoted in Gutierrez and Drash, "Girl."

28. Quoted in Ganzel, *Dust Bowl Descent*, 31.

29. Moraes, "Photographing the Kayapo," 12.

30. Azoulay, *Civil Contract of Photography*, 117.

31. Dunn, "Photographic License."

32. Quoted in Dunn, "Photographic License."

33. Quoted in Azoulay, *Civil Contract of Photography*, 101.

34. Azoulay, *Civil Contract of Photography*, 113.

35. Azoulay, *Civil Contract of Photography*, 118–19.

36. Maggie Anderson, "Two Rivers," 144.

37. Maggie Anderson, "Two Rivers," 144.

38. Maggie Anderson, "Two Rivers," 148.

39. Jaquet, *Transclasses*.

40. Maggie Anderson, "Two Rivers," 148–49.

41. Bourdieu, *Sketch*.

42. Maggie Anderson, "Two Rivers," 149.

43. Maggie Anderson, *Greatest Hits*, 17.

44. Maggie Anderson, *Greatest Hits*, 17–18.

45. Maggie Anderson, interview by Lennard Davis, November 2019.

46. Maggie Anderson, *Cold Comfort*, 19.

47. Maggie Anderson, *Cold Comfort*, 20.

48. Maggie Anderson, *Cold Comfort*, 20.

49. Maggie Anderson, *Cold Comfort*, 21.

50. Bergreen, *James Agee*, 117.

51. Bergreen, *James Agee*, 149.

52. Bergreen, *James Agee*, 145.

53. Quoted in Bergreen, *James Agee*, 219.

54. Bergreen, *James Agee*, 214.

55. Agee and Evans, *Let Us Now Praise*, 5.

56. The original manuscript, much shorter than the book, was only discovered recently and published as a book by James Agee and Walker Evans, entitled *Cotton Tenants: Three Families*.

57. Whitford, "Most Famous Story."

58. Agee and Evans, *Cotton Tenants*, 31.

59. Maharidge and Williamson, *And Their Children After Them*.

60. Matthews, "Protesting," 56.

61. Agee and Evans, "*Let Us Now Praise Famous Men*: Revisited."

62. Agee and Evans, "*Let Us Now Praise Famous Men*: Revisited."

63. Agee and Evans, "*Let Us Now Praise Famous Men*: Revisited."

64. Matthews, "Protesting," 58.

65. Agee and Evans, *Let Us Now Praise*, 58.

66. Maharidge and Williamson, "When Emma Met James Agee."

67. Agee and Evans, "*Let Us Now Praise Famous Men*: Revisited."

INTERCHAPTER 2. THEY GOT IT RIGHT NOW?

1. Vance, *Hillbilly Elegy*, 36, 39, 32.

2. Vance, *Hillbilly Elegy*, 54.

3. Vance, *Hillbilly Elegy*, 200.

4. Vance, *Hillbilly Elegy*, 142.

5. Vance, *Hillbilly Elegy*, 190.

6. Vance, *Hillbilly Elegy*, 193.

7. Vance, *Hillbilly Elegy*, 58.

8. Vance, *Hillbilly Elegy*, 57.

9. Steinbeck, *Grapes of Wrath*.

10. Allison, *Bastard out of Carolina*, 315.

11. Allison, *Bastard out of Carolina*, 17.

12. Allison, *Bastard out of Carolina*, 315.

13. Allison, *Bastard out of Carolina*, 317.

14. Allison, *Bastard out of Carolina*, 71.

15. Allison, *Bastard out of Carolina*, 73.

16. Allison, *Bastard out of Carolina*, 110.

17. Thompson, *Not as a Stranger*; Mailer, *The Naked and the Dead*; and Allison, *Bastard out of Carolina*, 119.

18. Mitchell, *Gone with the Wind*.

19. Allison, *Bastard out of Carolina*, 206.

20. Allison, *Bastard out of Carolina*, 317.

21. Allison, *Bastard out of Carolina*, 188–89.

22. Allison, *Bastard out of Carolina*, 224.

23. Allison, *Bastard out of Carolina*, 224.

24. Allison, *Bastard out of Carolina*, 262.

25. James, "A Child Abused."

26. J. Thomas, "*Sink.*"

27. J. Thomas, *Sink*, 19, 20.

28. J. Thomas, *Sink*.

29. Washington, "An Extraordinary Memoir."

30. J. Thomas, *Sink*, 7.

31. J. Thomas, "Sinking."

32. J. Thomas, *Sink*, 90.

33. J. Thomas, *Sink*, 192–93.

34. J. Thomas, *Sink*, 159.

35. Torres, "Justin Torres on *We the Animals*."

36. Torres, "My Story."

37. Justin Torres, phone interview by the author, July 18, 2023.

38. Torres, *We the Animals*, 10–11.

39. Torres, "An Interview."

40. Torres. "Justin Torres on *We the Animals*."

41. Patrick et al., "Socioeconomic Status."

CONCLUSION

1. Weissman, "Reckoning with the Past."

2. Leggas, "Columbia's Insistent Problem."

3. Les Rice, "The Banks Are Made of Marble." http://www
.protestsonglyrics.net/Anti_Capitalism_Songs/Banks-Are-Made-Of
-Marble.phtml.

4. Piketty, *Brief History of Inequality*.

5. Wikipedia, s.v. "*Land and Freedom* (Film)," last updated December 23, 2023, 15:24 (UTC), https://en.wikipedia.org/wiki/Land_and
_Freedom.

6. Quoted in Mestman, "*Hour of the Furnaces*."

7. Novack, "Marxism and the Intellectuals."

8. West, "Dilemma."

9. Spivak, "Can the Subaltern Speak?"

10. Quoted in Morgan, *Rethinking Social Realism*, 244.

11. Quoted in Morgan, *Rethinking Social Realism*, 248.

12. The cocreators of this group are Carla Barger, Alex Dunst, Hannah Huber, Katie Brandt, Travis Mandell, and Justin Allen.

13. The Endo/Exo Writers Project, https://endoexo.digital.uic.edu.
Hosted by the University of Illinois at Chicago. Accessed March 2,
2024.

14. Research undertaken by Alexander Joseph Sherman, a PhD student in the Department of English, Stanford University.

15. Lewis, *Children of Sanchez*; Harrington, *The Other America*; and Moynahan, *Moynahan Report*.

16. Quoted in Davies, "Make Poverty Discrimination Illegal."

17. Bancroft, "Steinbeck's *Grapes of Wrath*."

18. Menand, "Hammer and the Nail."

19. Benson, "'To Tom.'"

20. Steinbeck, *Grapes of Wrath*, xxv.

21. Miller et al., "Vast New Study."

22. Burns, "Elite Universities."

23. Said, "Opponents, Audiences," 24.

Bibliography

Abernathy, Arthur T. *Jew A Negro: Being a Study of Jewish Ancestry from an Impartial Perspective.* Moravia Falls, NC: Dixie Publishing Company, 1910.

Abbott, Edith. "Charles Booth: 1840–1916." *Journal of Political Economy* 25, no. 2 (February 1917): 195–200.

Acevedo-Garcia, Dolores, Clemens Noelke, Nancy McArdle, et al. Diversitydatakids.org, Brandeis University Heller School for Social Policy and Management, https://www.diversitydatakids.org/sites/default /files/file/ddk_the-geography-of-child-opportunity_2020v2_0.pdf (accessed February 23, 2024).

Ackroyd, Peter. *London: A Pilgrimage.* New York: Anthem, 2005.

Adichie, Chimanda Ngozi. "The Danger of a Single Story." TED Talk, July 2009. https://www.ted.com/talks/chimamanda_ngozi_adichie _the_danger_of_a_single_story.

Agee, James. *A Death in the Family.* New York: Library of America, 2005.

Agee, James, and Walker Evans. *American Experience.* Season 1, episode 9, "*Let Us Now Praise Famous Men*: Revisited." Directed by Carol Bell. Aired November 29, 1988. PBS, video.

Agee, James, and Walker Evans. *Cotton Tenants: Three Families.* New York: Melville House, 2013.

Agee, James, and Walker Evans. *Let Us Now Praise Famous Men.* Boston: Houghton Mifflin, 2001.

Allbut, Robert. *Rambles in Dickens' Land.* New York: Truslove, Hanson and Comba, 1899.

Allen, Michelle. *Cleansing the City: Sanitary Geographies in Victorian London.* Athens: Ohio University Press, 2008.

Allison, Dorothy. *Bastard out of Carolina.* New York: Penguin, 1992.

Almeroth-Williams, Thomas. *City of Beasts: How Animals Shaped Georgian London.* Manchester: Manchester University Press, 2019.

Alon, Sigal, and Ofer Malamud. "The Impact of Israel's Class-Based Affirmative Action Policy on Admission and Academic Outcomes." *Economics of Education Review* 40 (2014): 123–39.

Althusser, Louis, Étienne Balibar, Pierre Macherey, and Jacques Rancière. *Reading Capital.* London: New Left Books, 1970.

Anderson, Benedict. *Imagined Communities: Reflections on the Origins and Spread of Nationalism.* London: Verso, 1983.

Anderson, Maggie. *Cold Comfort*. Pittsburgh, PA: University of Pittsburgh Press, 1986.

Anderson, Maggie. *Greatest Hits 1984–2004*. Columbus, Ohio: Pudding House Publications, 2004.

Anderson, Maggie. "Two Rivers." In Zandy, *Liberating Memory*, 144–51.

Anderson, Meg. "Racist Housing Practices from the 1930s Linked to Hotter Neighborhoods Today." NPR, January 14, 2020. https://www.npr.org/2020/01/14/795961381/racist-housing-practices-from-the-1930s-linked-to-hotter-neighborhoods-today.

Anderson, Meg, and Shawn McMinn. "As Rising Heat Bakes US Cities, the Poor Often Feel It Most." NPR, September 3, 2019. https://www.npr.org/2019/09/03/754044732/as-rising-heat-bakes-u-s-cities-the-poor-often-feel-it-most.

Arner, Lynn. "Degrees of Separation: Hiring Patterns and First Generation University Students with English Doctorates in Canada." *minnesota review* (2021) 96, 101–34.

Arner, Lynn. "Working-Class Women at the MLA Interview." *Rhizomes*, no. 27 (2014). http://www.rhizomes.net/issue27/arner.html.

Ashkenas, Jeremy, Haeyoun Park, and Adam Pearce. "Even with Affirmative Action, Blacks and Hispanics Are More Underrepresented at Top Colleges Than 35 Years Ago." *New York Times*, August 24, 2017. https://www.nytimes.com/interactive/2017/08/24/us/affirmative-action.html.

Attaway, William. *Blood on the Forge*. New York: NYRB Classics, 2005.

Attwood, Nina. *The Prostitute's Body: Rewriting Prostitution in Victorian Britain*. London: Pickering and Chatto, 2011.

Austen, Jane. *Emma*. New York: Penguin, 2003.

Azoulay, Ariella. *The Civil Contract of Photography*. New York: Zone Books, 2008.

Babb, Sanora. *Whose Names Are Unknown*. Norman: University of Oklahoma Press, 2004.

Bakhtin, Mikhail. *Art and Answerability*. Translated by Vadim Liapunov. Austin: University of Texas Press, 1990.

Baldwin, James. "The Creative Process." In *Creative America*, edited by John F. Kennedy. New York: Ridge, 1962, 17–52.

Bancroft, Colette. "Steinbeck's *Grapes of Wrath* Still Resonates after 75 Years." *Tampa Bay Times*, April 1, 2014.

Barron, James. "A Food Pantry That Keeps Hunger at Bay for Needy College Students." *New York Times*, August 14, 2023. https://www.nytimes.com/2023/08/14/nyregion/newyorktoday/food-pantry-college-students.html.

Bartley, Paula. *Prostitution: Prevention and Reform in England, 1860–1914*. London: Routledge, 2000.

Bartos, Vojtech, Michal Bauer, Julie Chytilová, and Ian Levely. "Effects of Poverty on Impatience: Preferences or Inattention?" CERGE-EI Work-

ing Paper No. 623. SSRN, September 1, 2018. https://ssrn.com/abstract
=3247690. https://doi.org/10.2139/ssrn.3247690.

Baumgaertner, Emily, Jason Kao, Eleanor Lutz, Josephine Sedgwick, Rumsey
Taylor, Noah Throop, and Josh Williams. "Noise Could Take Years off
Your Life: Here's How." *New York Times*, June 9, 2023.

Bayer, Andrea, ed. *Painters of Reality: The Legacy of Leonardo and Caravaggio
in Lombardy*. New York: Metropolitan Museum of Art; New Haven,
CT: Yale University Press, 2004.

Baynton, Douglas. "Disability in History." *Disability Studies Quarterly* 28,
no. 3 (Summer 2008): 108.

Baynton, Douglas. "'A Silent Exile on This Earth: The Metaphorical Con-
struction of Deafness in the Nineteenth Century.'" In *Disability Studies
Reader*, edited by Lennard J. Davis. New York: Routledge, 2018: 216–43.

Bednarz, Christin. "Inside the Controversial World of Slum Tourism."
National Geographic, April 25, 2018. https://www.nationalgeographic
.com/travel/article/history-controversy-debate-slum-tourism.

Bell, Alexander Graham. *Memoir upon the Formation of a Deaf Variety of the
Human Race*. Washington, DC: National Academy of Sciences, 1884.

Bell, J. L. "No Taxation without Representation (Part 2)." *Journal of the
American Revolution*, May 22, 2013. https://allthingsliberty.com/2013
/05/no-taxation-without-representation-part-2/.

Bendix, Regina. *In Search of Authenticity: The Formation of Folklore Studies*.
Madison: University of Wisconsin Press, 1997.

Benson, Jackson J. "'To Tom, Who Lived It': John Steinbeck and the Man
from Weedpatch." *Journal of Modern Literature* 5, no. 2 (1976): 151–210.

Bey, Dawoud. *Night Coming Tenderly, Black*. Photograph. 2017.

Bergreen, Laurence. *James Agee: A Life*. New York: Dutton, 1984.

Berlant, Lauren. "Without Exception: On the Ordinariness of Violence."
Interview by Brad Evans. *Los Angeles Review of Books*, July 30, 2018.
https://lareviewofbooks.org/article/without-exception-on-the
-ordinariness-of-violence/.

Bertellini, Giorgio. *Italy in Early American Cinema: Race, Landscape, and the
Picturesque*. Bloomington: Indiana University Press, 2010.

Binfield, Kevin, and William J. Christmas. *Teaching Laboring-Class British
Literature of the Eighteenth and Nineteenth Centuries*. New York: Mod-
ern Language Association, 2018.

Biornsdottir, R. Thora, and Nicholas O. Rule. "The Visibility of Social Class
from Facial Cues." *Journal of Personality and Social Psychology* 113, no. 4
(2017): 530–46.

Blair, Clancy, and Cybele Raver. "Poverty, Stress, and Brain Development: New
Directions for Prevention and Intervention." *Academic Pediatrics* 16, no. 3
Suppl. (2016): s30–36. https://doi.org/10.1016/j.acap.2016.01.010.

Blair, Madeleine [pseud.]. *Madeleine: An Autobiography*. 1919. New York: Harper and Brothers, 1924.

Bly, Nellie. "The Biggest New York Tenement." *New York World*, August 5, 1894.

Bontemps, Arna. *Black Thunder*. Boston: Beacon Press, 1992.

Booth, Charles, *Life and Labour of the People of London*. London: Macmillan and Co., 1903.

Bourdieu, Pierre. *Sketch for a Self-Analysis*. Translated by Richard Nice. Chicago: University of Chicago Press, 2008.

Bourdieu, Pierre, and Jean-Claude Passeron. *Les héritiers: Les étudiants et la culture*. Paris: Minuit, 1964.

Bourdieu, Pierre, and Jean-Claude Passeron. *Reproduction in Education, Society, and Culture*. 1977. London: Sage, 2000.

Bourg, Charmaine, Peter J. de Jong, and Janniko R. Georgiadis. "Subcortical BOLD Responses during Visual Sexual Stimulation Vary as a Function of Implicit Porn Associations in Women." *Social Cognitive and Affective Neuroscience* 9, no. 2 (February 2014): 158–66.

Bowen, William, and Derek Bok. *The Shape of the River: Long-Term Consequences of Considering Race in College and University Admissions*. Princeton, NJ: Princeton University Press, 1998.

Brace, Charles Loring. *The Dangerous Classes of New York*. New York: Wynkoop and Hallebeck, 1872.

Braddon, Mary Elizabeth. *The Trail of the Serpent*. New York: Modern Library, 2003.

Breeden, Aurelien. "French Roosters Now Crow with the Law behind Them." *New York Times*, January 24, 2021. https://www.nytimes.com/2021/01/24/world/europe/france-countryside-noises-smells-law.html.

Bremner, Robert H. *From the Depths: The Discovery of Poverty in the United States*. New York: New York University Press, 1964.

Brierly, Benjamin. *Chronicles of Waverlow*. London: Simpkin, Marshall, 1884.

Brim, Matt. *Poor Queer Studies: Confronting Elitism in the University*. Durham, NC: Duke University Press, 2020.

Brodkin, Karen. *How Jews Became White Folks and What That Says about Race in America*. New Brunswick, NJ: Rutgers University Press, 2010.

Brontë, Charlotte. *Jane Eyre*. London: Penguin, 1996.

Bruce, La Marr Jurelle. *How to Go Mad without Losing Your Mind: Madness and Black Radical Creativity*. Durham, NC: Duke University Press, 2021.

Buchele, Mose. "Poor Neighborhoods Feel Brunt of Rising Heat. Cities Are Mapping Them to Bring Relief." NPR, August 28, 2020. https://www.npr.org/2020/08/28/905922215/poor-neighborhoods-feel-brunt-of-rising-heat-cities-are-mapping-them-to-bring-re.

Burns, Nick. "Elite Universities Are Out of Touch: Blame the Campus." *New York Times*, August 3, 2022. https://www.nytimes.com/2022/08/02/opinion/elite-universities-campus.html.

Cahallan, Margaret, and Laura Perna. *Indicators of Higher Education Equity in the United States: 45 Year Trend Report*. Washington, DC: Pell Institute for the Study of Opportunity in Higher Education, 2015. https://files.eric.ed.gov/fulltext/ED555865.pdf.

Cantacessi, Cinzia, Paul Giacomin, John Croese, Martha Zakrzewski, Javier Sotillo, Leisa McCann, Matthew J. Nolan, Makedonka Mitreva, Lutz Krause, and Alex Loukas. "Impact of Experimental Hookworm Infection on the Human Gut Microbiota." *Journal of Infectious Diseases* 210, no. 9 (2014): 1431–34. https://doi.org/10.1093/infdis/jiu256.

Carretta, Vincent, ed. *Unchained Voices: An Anthology of Black Authors in the English-Speaking World of the 18th Century*. Lexington: University Press of Kentucky, 2004.

Carter, Marion Hamilton. "The Vampire of the South." *McClure's Magazine* 33, no. 6 (October 1901): 617.

Cat's Meat Shop. "Urine Deflectors in Fleet Street." July 23, 2013. http://catsmeatshop.blogspot.com/2013/07/urine-deflectors-in-fleet-street.html.

Chadwick, Edwin. *An Inquiry into the Sanitary Condition of the Labouring Population of Great Britain*. London: W. Clowes and Sons, 1842.

Children's Hunger Fund. "Poverty Encounter," accessed February 7, 2024. https://childrenshungerfund.org/poverty-encounter/.

Cisneros, Sandra. *The House on Mango Street*. New York: Vintage, 1984.

Clayson, Hollis. *Painted Love: Prostitution in French Art of the Impressionist Era*. Los Angeles: Getty Research, 2003.

Clelland, John. *Fanny Hill: or, Memoirs of a Woman of Pleasure*. New York: Modern Library, 2001.

Closson, Troy. "The Disparity in Access to New York's Parks." *New York Times*, May 27, 2021. https://www.nytimes.com/2021/05/27/nyregion/parks-access-nyc.html.

Cohen, Patricia. "Southerners, Facing Big Odds, Believe in Path Out of Poverty." *New York Times*, July 4, 2019. https://www.nytimes.com/2019/07/04/business/economy/social-mobility-south.html.

Colander, David, with Daisy Zhuo. "Where Do PhDs in English Get Jobs: An Economist's View on the English PhD Market." *Pedagogy: Critical Approaches to Teaching Literature, Language, Composition, and Culture* 15, no. 1 (2014), 139–56.

Collyer, Robert H. *Lights and Shadows*. Boston: Redding, 1843.

Confronting Poverty, "Poverty Facts and Myths: Fact 1: Most Americans Will Experience Poverty," https://confrontingpoverty.org/poverty-facts-and-myths/most-americans-will-experience-poverty/ (accessed February 7, 2024).

Connell, Raewyn. *The Good University: What Universities Actually Do and Why It's Time for Radical Change*. London: Zed Books, 2019.

Conrad, Joseph. *The Secret Agent.* New York: Penguin, 2007.

Conroy, Jack. *The Disinherited: A Novel of the 1930s.* Columbia: University of Missouri Press, 1982.

Cooper, Michael. "The Complex History and Uneasy Present of 'Porgy and Bess.'" *New York Times,* September 19, 2019.

Cooper, Thomas. "'Merrie England'—No More!" In *Old-Fashioned Stories.* London: Hodder and Stoughton, 1875. https://minorvictorianwriters .org.uk/cooper/c_stories_4.htm.

Corbin, Alain. *Women for Hire: Prostitution and Sexuality in France after 1850.* Cambridge, MA: Harvard University Press, 1990.

Coustillas, Pierre, and Colin Partridge. *Gissing: The Critical Heritage.* London: Routledge, 1972.

Cruse, Harold. *The Crisis of the Negro Intellectual: A Historical Analysis of the Failure of Black Leadership.* New York: New York Review of Books, 2005.

Cuddy, Amy. "Psychology of Antisemitism." *New York Times,* November 3, 2018. https://www.nytimes.com/2018/11/03/opinion/sunday /psychology-anti-semitism.html.

Curtis, James. *Mind's Eye, Mind's Truth: FSA Photography Reconsidered.* Philadelphia: Temple University Press, 1989.

Dacus, Joseph. *Annals of the Great Strikes in the United States: A Reliable History and Graphic Descriptions of the Causes and Thrilling Events of the Labor Strikes and Riots of 1877.* Chicago: L. T. Palmer, 1877.

Das, Veena. *Affliction: Health, Disease, Poverty.* New York: Fordham University Press, 2015.

Dash, Mike. "How Friedrich Engels' Radical Lover Helped Him Father Socialism." *Smithsonian Magazine,* August 1, 2013. https://www .smithsonianmag.com/history/how-friedrich-engels-radical-lover -helped-him-father-socialism-21415560/.

Davies, Lizzie. "Make Poverty Discrimination Illegal like Racism or Sexism, Urges UN Official." *Guardian,* October 26, 2022. https://www .theguardian.com/global-development/2022/oct/26/make-poverty -discrimination-like-racism-or-sexism-official-to-tell-un.

Davin, Anna. *Growing Up Poor: Home, School and Street in London, 1870–1914.* London: River Orams, 1996.

Davis, Lennard J. *Obsession: A History.* Chicago: University of Chicago Press, 2009.

Davis, Lennard J. *Resisting Novels: Fiction and Ideology.* London: Routledge, 1987.

Davis, Lennard J., ed. *Shall I Say a Kiss? The Courtship Letters of a Deaf Couple, 1936–1938.* Washington, DC: Gallaudet University Press, 1999.

Davis, Lennard J. "A Voyage Out (or Is It Back?)." In Zandy, *Liberating Memory,* 54–63.



Davis, Lennard J., and David B. Morris. "Biocultures Manifesto." *New Literary History* 38, no. 3 (2007): 411–18.

Defoe, Daniel. *Robinson Crusoe*. Oxford: Oxford University Press, 2009.

Defoe, Daniel, *Roxana: The Fortunate Mistress*. Oxford: Oxford University Press, 2008.

Defoe, Daniel, *Moll Flanders*. New York: Norton, 2003.

Delany, Paul. *George Gissing: A Life*. London: Phoenix, 2008.

Denning, Michael. *The Cultural Front: The Laboring of American Culture in the Twentieth Century*. London: Verso, 1997.

Dennis, James M. *Robert Koehler's* The Strike: *The Improbable Story of an Iconic 1886 Painting of Labor Protest*. Madison: University of Wisconsin Press, 2011.

DeParle, Jason. "Cash Aid to Poor Mothers Increases Brain Activity in Babies, Study Finds." *New York Times*, January 24, 2022. https://www.nytimes.com/2022/01/24/us/politics/child-tax-credit-brain-function.html.

Derrida, Jacques. *Of Grammatology*. Translated by Gayatri Spivak. Baltimore: Johns Hopkins University Press, 1977.

Derrida, Jacques. *Writing and Difference*. Translated by Alan Bass. Chicago: University of Chicago Press, 1978.

De Sica, Vittorio, dir. *The Bicycle Thieves*. Arthur May and Joseph Burstyn, 1948. Film.

Dews, C. L. Barney, and Carolyn Leste Law, eds. *This Fine Place So Far from Home: Voices of Academics from the Working Classes*. Philadelphia: Temple University Press, 1995.

Dickens, Charles. *American Notes*. London: Chapman and Hall, 1842.

Dickens, Charles. "Appeal to Fallen Women." Leaflet. 1849.

Dickens, Charles. *Bleak House*. Oxford: Oxford University Press, 2008.

Dickens, Charles, *David Copperfield*. New York, Viking, 2023.

Dickens, Charles. *Dombey and Son*. Oxford: Oxford University Press, 1991.

Dickens, Charles. *Hard Times*. Edited by Graham Law. Toronto: Broadview, 2003.

Dickens, Charles. *Oliver Twist*. New York: Penguin, 2002.

Doré, Gustav, and Blanchard Jerrold. *London: A Pilgrimage*. London: Grant and Company, 1872.

Doucleff, Michael. "Could Worms in Your Gut Cure Your Allergies?" NPR, August 12, 2016. https://www.npr.org/sections/goatsandsoda/2016/08/12/489619045/could-worms-in-your-gut-cure-your-allergies.

Du Bois, W. E. B. *The Souls of Black Folk*. Edited by David W. Blight and Robert Gooding-Williams. Boston: Bedford Books, 1997.

Dunn, Geoffrey. "Photographic License." *New Times*, June 2, 2002. http://www.newtimes-slo.com/archives/cov_stories_2002/cov_01172002.html.

Dvořák, Antonín. "Antonin Dvorak on Negro Melodies." *New York Herald*, May 28, 1893. https://static.qobuz.com/info/IMG/pdf/NYHerald-1893-May-28-Recentre.pdf.

Dvořák, Antonín. "Real Value of Negro Melodies." *New York Herald*, May 21, 1893.

"Dwellings of the Poor, from the Notebook of an M.D." *Illuminated Magazine* 3 (October 1844).

Dyer, Richard. *The Matter of Images: Essays on Representation*. London: Routledge, 1992.

Dyos, H. J., and M. Wolff. "The Way We Live Now." In *The Victorian City: Images and Realities*, edited by H. J. Dyos and M. Wolff. London: Routledge, 1973, vol. 2: 893–908.

Ehrenreich, Barbara. *Fear of Falling: The Inner Life of the Middle Class*. New York: Pantheon, 1989.

Eisner, Will. *A Contract with God and Other Tenement Stories: A Graphic Novel*. Princeton, WI: Kitchen Sink, 1985.

Elkins, James. *The Object Stares Back*. San Francisco: Harvest Books, 1996.

Ellison, Katherine. "The Sleep Gap: If You Are Wealthy You Probably Get Plenty. If You're Poor or a Minority You Might Not, Research Finds." *Washington Post*, August 31, 2021. https://www.washingtonpost.com /health/sleep-deficits-minorities-poor/2021/07/30/f5cb91e8-df51 -11eb-b507-697762d090dd_story.html.

Engels, Friedrich. *The Condition of the Working Class in England*. Translated by Florence Kelley Wischnewetzsky. Oxford: Oxford University Press, 2009.

Entin, Joseph. "Reconceiving class in contemporary working-class studies." In *Routledge International Handbook of Working-Class Studies*, edited by Michelle Fazio, Christie Launius, and Tim Strangleman. London: Routledge, 2020, 32–44.

Epstein, Kayla. "Over 3 Million Women in the United States Say Their First Sexual Experience Was Rape." *Washington Post*, September 19, 2019. https://www.washingtonpost.com/dc-md-va/2019/09/19/over -million-women-us-say-their-first-sexual-experience-was-rape/.

Equiano, Olaudah. *The Interesting Narrative of the Life of Olaudah Equiano*. New York: Penguin, 2003.

Evans, Gary W., Jeanne Brooks-Gunn, and Pamela Kato Klebanov. "Stressing Out the Poor: Chronic Physiological Stress and Income-Achievement Gap." *Pathways*, Winter 2011, 16–21. https://inequality.stanford.edu /sites/default/files/PathwaysWinter11_Evans.pdf.

Eveleigh, David J. *Bogs, Baths and Basins: The Story of Domestic Sanitation*. Stroud, Gloucestershire, UK: Sutton, 2002.

Ewen, Elizabeth. *Immigrant Women in the Land of Dollars: Life and Culture on the Lower East Side, 1890–1925*. New York: Monthly Review Press, 1985.

Fears, Daryl, and Robin Amer. "To Stop a Scrapyard, Some Members of a Latino Community Risked Everything." *Washington Post*, October 22,

2021. https://www.washingtonpost.com/climate-environment
/interactive/2021/south-side-chicago-scrapyard.

Fern, Fanny. *Ruth Hall*. New Brunswick, NJ: Rutgers University Press, 1986.

Finer, S. E. *The Life and Times of Sir Edwin Chadwick*. London: Methuen, 1952.

Finnegan, Frances. *Poverty and Prostitution: A Study of Victorian Prostitutes in York*. Cambridge: Cambridge University Press, 1979.

Fisher, Fox. "Fox Fisher on Trans Representation in Literature." Penguin, January 21, 2019. https://www.penguin.co.uk/articles/company -article/fox-fisher-on-trans-representation-in-literature.

Fiske, Susan. "Look Twice." *Greater Good Magazine*, June 1, 2008. https:// greatergood.berkeley.edu/article/item/look_twice.

Flaubert, Gustav. *Madame Bovary*. New York: Vintage, 1991.

Fleming, Robert E. *Willard Motley*. Boston: Twayne, 1978.

Ford, John, dir. *Grapes of Wrath*. 20th Century Fox, 1940. Video. Film.

Foucault, Michel. *The Order of Things: An Archeology of the Human Sciences*. Translated by Alan Sheridan. New York: Vintage, 1994.

Foster, George G. *New York by Gas-Light and Other Urban Sketches*. 1850. Berkeley: University of California Press, 1990.

Frangi, Francesco. "Giacomo Ceruti: A Profile." In *Giacomo Ceruti: A Compassionate Eye*, edited by Davide Gasparotto. Los Angeles: J. Paul Getty Museum, 2023, 1–2.

Freedman, Gillian. "Jobless, Selling Nudes Online and Still Struggling." *New York Times*, January 13, 2021.

Fryer, Peter. *Staying Power: The History of Black People in Britain*. London: Pluto, 1984.

Galea, Sandro, Jennifer Ahem, Melissa Tracy, and David Vlahov. "Neighborhood Income and Income Distribution and the Use of Cigarettes, Alcohol, and Marijuana." *American Journal of Preventative Medicine* 32, suppl. 6 (2008): S195–202.

Gandal, Keith. *The Virtues of the Vicious: Jacob Riis, Stephen Crane, and the Spectacle of the Slum*. Oxford: Oxford University Press, 1997.

Ganzel, Bill. *Dust Bowl Descent*. Lincoln: University of Nebraska Press, 1984.

Gaskell, Elizabeth. *Mary Barton*. 1848. Toronto: Broadview, 2000.

Gaskell, Elizabeth. *North and South*. 1855. New York: Norton, 2004.

Gaskell, S. Martin, ed. *Slums*. Leicester: Leicester University Press, 1990.

Geertz, Clifford. *Local Knowledge*. London: Fontana, 1993.

Gershwin, George and DuBose Heyward, "I Got Plenty of Nuttin'." 1935, accessed February 1, 2024. https://www.lyrics.com/lyric/8855921 /George+Gershwin/I+Got+Plenty+O%27+Nuttin%27+%5BFrom +Porgy+and+Bess%5D.

Getino, Octavio, and Fernando Solanas. *[The] Hour of the Furnaces*. Solanas Productions, 1968. Film.

Gilbert, Pamela. "Medical Mapping: The Thames, the Body, and *Our Mutual Friend*." In *Filth, Dirt, Disgust, and Modern Life*, edited by William Cohen and Ryan. Minneapolis: University of Minnesota Press, 2005: 78–102.

Gillespie, Patrick. "Rich Men Drink More Than Anyone Else, Study Finds." CNN Business, May 12, 2015. https://money.cnn.com/2015/05/12/news/economy/alcohol-consumption-economy-oecd/index.html.

Gissing, George. *Demos: A Story of English Socialism*. Brighton, UK: Victorian Secrets, 2011.

Gissing, George. *The Unclassed: The 1884 Text*. Victoria, Canada: ELS Press, 2010.

Gissing, George. *Workers in the Dawn*. 1880. London: Dodo, 2008.

Glickman, Nora. *The Jewish White Slave Trade and the Untold Story of Raquel Liberman*. New York: Garland, 2000.

Glynn, Jennifer. *Opening Doors: How Selective Colleges and Universities Are Expanding Access for High-Achieving, Low-Income Students*. Jack Kent Cooke Foundation, September 2017. https://files.eric.ed.gov/fulltext/ED589028.pdf.

Godfrey, Barry. *Crime in England, 1880–1945: The Rough and the Criminal, the Policed and the Incarcerated*. London: Routledge, 2014.

Gold, Michael. *Jews without Money*. 1930. New York: Public Affairs, 1996.

Goldfine, Gil Stern. "Dorothea Lange: Photographer of the people." *Jerusalem Post*, April 6, 2006. https://www.jpost.com/travel/around-israel/dorothea-lange-photographer-of-the-people.

Goldsmith, Oliver. *The Vicar of Wakefield*. New York: Penguin, 2015.

Gombrich, E. H. *Art and Illusion: A Study in the Psychology of Pictorial Representation*. Rev. ed. Princeton, NJ: Princeton University Press, 1969.

Gordon, Linda. *Dorothea Lange: A Life beyond Limits*. New York: Norton, 2009.

Gramsci, Antonio. *Selections from the Prison Notebooks of Antonio Gramsci*. Translated by Quentin Hoare and Geoffrey Nowell Smith. London: Lawrence and Wishart, 1971.

Gray, Drew D. *Crime, Prosecution and Social Relations: The Summary Courts of the City of London in the Late Eighteenth Century*. London: Palgrave, 2009.

Greeley, Horace. "Tenement Houses: Their Wrongs." *New York Daily Tribune*, November 23, 1864, 4.

Green, Edward, and Russell Wakefield. "Patterns of Middle- and Upper-Class Homicide." *Journal of Criminal Law and Criminology* 70, no. 2 (1979), 172–81.

Grindrod, Ralph Barnes. *Slaves of the Needle: An Exposure of the Distressed Condition, Moral and Physical, of Dress-makers, Milliners, Embroiderers, Slop-workers, &c*. London: William Brittain and Charles Gilpin, 1845.

Guilford, Gwynn. "The Hogs That Created America's First Working Class." *Quartz*, July 16, 2017. https://qz.com/1025640/hogs/.

Gutierrez, Thelma, and Wayne Drash. "Girl from Iconic Great Depression Photo: 'We Were Ashamed.'" CNN, December 2, 2008.

Habermas, Jürgen. "The Public Sphere: An Encyclopedia Article (1964)." Translated by Sara Lennox and Frank Lennox. *New German Critique*, no. 3 (Autumn 1974): 49–55. https://doi.org/10.2307/487737.

Hale, Dorothy J. *Social Formalism: The Novel in Theory from Henry James to the Present.* Stanford, CA: Stanford University Press, 1998.

Hall, Stuart, ed. *Representation: Cultural Representations and Signifying Practices.* London: Sage, 1997.

Hallett, Ronald E., Rashida M. Crutchfield, and Jennifer J. McGuire. "'Addressing Homelessness and Housing Insecurity in Higher Education.'" Interview by Scott Jaschik. *Inside Higher Education*, July 26, 2019. https://www.insidehighered.com/news/2019/07/26/authors-discuss -new-book-homelessness-higher-ed.

Halliday, Stephen. "Death and Miasma in London: An Obstinate Belief." *British Medical Journal* 323, no. 7327 (December 2001): 1469–71.

Hamilton, Alexander, James Madison, and John Jay. *The Federalist Papers.* Mineola, NY: Dover, 2014.

Hamilton, Laura T., and Kelly Nielsen. *Broke: The Racial Consequences of Underfunding Public Universities.* Chicago: University of Chicago Press, 2021.

Hamsun, Knut. *Hunger.* New York: Penguin, 1998.

Harburg, E. Y. and Burton Lane. "When the Idle Poor Become the Idle Rich." 1947, accessed March 1, 2024. http://www.songlyrics.com /finian-s-rainbow/when-the-idle-poor-become-the-idle-rich-lyrics/.

Harrington, Michael. *The Other America: Poverty in the United States.* New York: Scribner, 1997.

Harris, Lasana T., and Susan T. Fiske. "Dehumanized Perception: A Psychological Means to Facilitate Atrocities, Torture, and Genocide?" https:// www.ncbi.nlm.nih.gov/pmc/articles/PMC3915417/.

Hartman, Saidiya. *Wayward Lives, Beautiful Experiments: Intimate Histories of Riotous Black Girls, Troublesome Women, and Queer Radicals.* New York: Norton, 2019.

Healy, Jack. "Scorching Hot in Phoenix: What It Is Like to Work in 115 Degrees." *New York Times*, June 21, 2021. https://www.nytimes.com/2021 /06/20/us/100-degree-weather.html.

Helm, Joe. "Five Years Ago, She Was a Homeless High-School Valedictorian. Saturday, She Got a Degree from Georgetown." *Washington Post*, May 18, 2019. https://www.washingtonpost.com/local/education/five -years-ago-she-was-a-homeless-high-school-valedictorian-saturday -she-got-a-degree-from-georgetowni-want-people-to-look-at-me-and

-say-she-did-it-i-can-do-it-/2019/05/18/4d2af82e-766e-11e9-b3f5
-5673edf2d127_story.html.

Herbert, Michael. "Frederick Engels and Mary and Lizzie Burns." *Manchester's Radical History*. March 15, 2010. https://radicalmanchester.wordpress
.com/2010/03/15/frederick-engels-and-mary-and-lizzy-burns/.

Herder, Johann Gottfried. *Stimmen der Völker in Liedern*, edited by
V. Muller. Berlin: K. Gräffer und Härter, 1813.

Heydt-Stevenson, Jillian. *Austen's Unbecoming Conjunctions: Subversive Laughter, Embodied History*. London: Palgrave Macmillan, 2005.

Higgins, Abigail. "DC Could Be First US City to Decriminalize Sex Work."
Washington Post, October 27, 2019. https://www.washingtonpost.com
/gender-identity/dc-could-be-the-first-us-city-to-decriminalize-sex
-work-here-are-arguments-from-both-sides-of-the-debate/.

Hirata, Lucie Cheng. "Free, Indentured, Enslaved: Chinese Prostitutes in Nineteenth-Century America." *Signs* 5, no. 1 (Autumn 1979): 3–29.

Hirsch, Marianne. *The Generation of Postmemory: Writing and Visual Culture after the Holocaust*. New York: Columbia University Press, 2012.

Hitchcock, Peter. "Passing: Henry Green and Working-Class Identity." *Modern Fiction Studies* 40, no. 1 (Spring 1994): 1–31.

Hitchcock, Peter. "They Must Be Represented? Problems in Theories of Working-Class Representation." *PMLA* 115, no. 26 (January 2000): 20–32.

Hitchcock, Tim, and Robert Shoemaker. *London Lives: Poverty, Crime, and the Making of a Modern City, 1690–1800*. Cambridge: Cambridge University Press, 2015.

Ho, Bong Joon, dir. *Parasite*. Neon Films, 2019. Film.

Hoffman, Jeremy S., Vivek Shandas, and Nicholas Pendleton. "The Effects of Historical Housing Policies on Resident Exposure to Intra-urban Heat: A Study of 108 US Urban Areas." *Climate* 8, no. 1 (2020): 12. https://
doi.org/10.3390/cli8010012.

Hollander, Xaviera, with Robin Moore and Yvonne Dunleavy. *The Happy Hooker: My Own Story*. New York: Dell, 1972.

Holquist, Michael. "Answering as Authoring: Mikhail Bakhtin's Trans-Linguistics." *Critical Inquiry* 10, no. 2 (December 1983): 307–19.

Howard, June. *Form and History in American Literary Naturalism*. Chapel Hill: University of North Carolina Press, 1985.

Hugo, Victor. *Les Miserables*. New York: Signet, 2013.

Huk, David. *Ben Brierly*. Manchester: Richardson, 1995.

Humpherys, Anne. *Travels into Poor Man's Country: The Work of Henry Mayhew*. Athens: University of Georgia Press, 1977.

Hunt, Lynn. *Inventing Human Rights: A History*. New York: Norton, 2007.

Hunt, Tristram. "Feminist Friend or Foe?" *Guardian*, April 28, 2009. https://
www.theguardian.com/lifeandstyle/2009/apr/29/friedrich-engels
-prostitution-suffrage.

Iacurci, Greg. "Are U. S. seniors among the developed world's poorest? It depends on your point of view." CNBC. August 5, 2023. https://www .cnbc.com/2023/08/05/whether-us-seniors-among-developed-worlds -poorest-depends-on-data-used.html.

Jack, Anthony Abraham. *The Privileged Poor: How Elite Colleges Are Failing Disadvantaged Students*. Cambridge, MA: Harvard University Press, 2019.

Jackson, Lee. *Dirty Old London: The Victorian Fight against Filth*. New Haven, CT: Yale University Press, 2014.

Jacobs, Joseph, and Maurice Fishberg. "Stature." In *Jewish Encyclope-dia*. New York: Funk and Wagnalls, 1906, 536–39. http://www .jewishencyclopedia.com/articles/13993-stature.

Jakobs, Lydia. *Pictures of Poverty: The Works of George R. Sims and Their Screen Adaptations*. New Barnett, UK: John Libbey, 2021.

James, Caryn. "A Child Abused, Body and Soul." *New York Times*. Decem-ber 14, 1996.

Jameson, Fredric. *Marxism and Form: Twentieth-Century Dialectical Theories of Literature*. Princeton, NJ: Princeton University Press, 1971.

Jaquet, Chantal. *Transclasses: A Theory of Social Non-reproduction*. Translated by Gregory Elliott. London: Verso, 2023.

Jardine, Jeff. "Dustbowl Part IV: Symbol of an Era." *Modesto Bee*, Septem-ber 17, 2008. https://www.modbee.com/latest-news/article3114135 .html.

Jellinek, Roger. "How Eric Blair Became George Orwell." *New York Times Book Review*, November 12, 1972.

Jensen, Barbara. *Reading Classes: On Culture and Classism in America*. Ithaca, NY: Cornell University Press, 2012.

Johnson, A. E. *Clarence and Corinne; or, God's Way*. Oxford: Oxford Univer-sity Press, 1989.

Johnson, Akiliah. "Black Adult Hospitalizations Reached a Pandemic High during the Omicron Wave, CDC Study Finds." *Washington Post*, March 18, 2022. https://www.washingtonpost.com/health/2022/03 /18/black-hospitalizations-omicron-cdc/.

Jones, Gavin. *American Hungers: The Problem of Poverty in American Litera-ture, 1840–1945*. Princeton, NJ: Princeton University Press, 2007.

Kahlenberg, Richard D. "Harvard's Class Gap: Can the Academy Under-stand Donald Trump's 'Forgotten' Americans?" *Harvard Magazine*, May–June 2017. https://www.harvardmagazine.com/2017/05 /harvards-class-gap.

Kahlenberg, Richard D. *The Remedy: Class, Race, and Affirmative Action*. New York: Basic Books, 1996.

Karras, Ruth Mazo. *Common Women: Prostitution and Sexuality in Medieval England*. New York: Oxford University Press, 1996.

Keating, Peter, ed. *Into Unknown England, 1866–1913: Selections from the Social Explorers*. Manchester: Manchester University Press, 1976.

Kennicott, Phillip. "Despite Its Political Incorrectness *Porgy and Bess* Remains an Important Work—and a Vital One." *Opera News*, January 2020, 28.

Kevles, Daniel J. *In the Name of Eugenics: Genetics and the Uses of Human Heredity*. Cambridge, MA: Harvard University Press, 1998.

Kim, Marlene. "Are the Working Poor Lazy?" *Challenge* 41, no. 3 (May–June 1998). 85–99.

Kingsley, Charles. *Alton Locke*. Oxford: Oxford University Press, 1984.

Kogan, Rick. "Remembering Forgotten Writer Willard Motley." *Chicago Tribune*, April 3, 2015. https://www.chicagotribune.com/entertainment /ct-remembering-willard-motley-20150402-story.html.

Kraus, Michael W., Jun Won Park, and Jacinth J. X. Tan. "Signs of Social Class: The Experience of Economic Inequality in Everyday Life." *Perspectives on Psychological Science* 12, no. 3 (2017): 422–35.

Kristof, Nicholas. "Why 2018 Was the Best Year in Human History." *New York Times*, January 5, 2019. https://www.nytimes.com/2019/01/05 /opinion/sunday/2018-progress-poverty-health.html.

Kumin, Beat. "Hard Evidence: How Much Did Our Ancestors Drink, and Are We Drinking More?" Conversation, October 22, 2014. http:// theconversation.com/hard-evidence-how-much-did-our-ancestors -drink-and-are-we-drinking-more-32842.

Kuppens, Toon, Russel Spears, Anthony S. R. Manstead, Bram Spruyt, and Matthew J. Easterbrook. "Educationism and the Irony of Meritocracy: Negative Attitudes of Higher Educated People towards the Less Educated." *Journal of Experimental Social Psychology* 76, no. 1 (November 2017): 429–47. https://www.researchgate.net/publication /321250845_Educationism_and_the_irony_of_meritocracy_Negative _attitudes_of_higher_educated_people_towards_the_less_educated.

Kurtzelben, Danielle. "Fact Check: Bernie Sanders and Whether Poor Americans Vote." NPR, April 25, 2016. https://www.npr.org/2016/04/25/475613276 /fact-check-bernie-sanders-and-whether-poor-americans-vote.

Laite, Julia. *Common Prostitutes and Ordinary Citizens: Commercial Sex in London, 1885–1960*. London: Palgrave, 2012.

Lange, Dorothea. Oral history interview. May 22, 1964. Smithsonian Archives of American Art. https://www.aaa.si.edu/download_pdf _transcript/ajax?record_id=edanmdm-AAADCD_oh_213615.

Lange, Dorothea. "The Assignment I'll Never Forget." *Popular Photography* 46, no. 2 (June 1960): 42–43, 128.

Langer, Emily. "Virginia Walcott Beauchamp, Pioneer of Women's Studies, Dies at 98." *Washington Post*, March 7, 2019. https://www .washingtonpost.com/local/obituaries/virginia-walcott-beauchamp

-pioneer-of-womens-studies-dies-at-98/2019/03/07/40918472-408e
-11e9-922c-64d6b7840b82_story.html.

Laqueur, Thomas. *Solitary Sex: A Cultural History of Masturbation*. New York: Zone Books, 2004.

Laterman, Kaya. "Tuition or Dinner, Nearly Half of College Students Surveyed in a New Report Are Going Hungry." *New York Times*, May 2, 2019. https://www.nytimes.com/2019/05/02/nyregion/hunger -college-food-insecurity.html/.

Larsen, Nell. *Passing*. New York: Signet, 2021.

Lauter, Paul. "Under Construction: Working-Class Writing." In *New Working-Class Studies*, edited by John Russo and Sherry Lee Linkon. Ithaca, NY: Cornell University Press, 2005: 63–77.

Lazo, Luz, Sahana Jayaraman, and Dylan Moriarty. "D.C. Traffic Deaths at 14-Year High with Low-Income Areas Hardest Hit." *Washington Post*, February 23, 2022. https://www.washingtonpost.com/transportation /2022/02/23/dc-traffic-deaths-highest-record/.

Leahy, Ian, and Yaryna Serkez. "Since When Have Trees Existed Only for Rich Americans?" *New York Times*, June 30, 2021. https://www .nytimes.com/interactive/2021/06/30/opinion/environmental -inequity-trees-critical-infrastructure.html.

Leggas, Dimitri. "Columbia's Insistent Problem: Protestant Ethics, World War I, and Contemporary Civilization." Research paper for Columbia University and Slavery Seminar, 2017. https://columbiaandslavery .columbia.edu/content/dam/cuandslavery/seminars/hist-3518/2017 -projects/Leggas%202017%20-%20Columbia%E2%80%99s%20Insis- tent%20Problem.pdf.

Leonhardt, David. "The College Access Index Returns." *New York Times*, September 8, 2023. https://www.nytimes.com/2023/09/08/briefing /college-access-low-income.html.

Levine, Lawrence W. *The Unpredictable Past: Explorations in American Cultural History*. Oxford: Oxford University Press, 1993.

Lewis, Oscar. *Children of Sanchez: Autobiography of a Mexican Family*. New York: Vintage, 2011.

Lévi-Strauss, Claude. *Structural Anthropology*. Translated by Claire Jacobson and Brooke Grundfest Schoepf. New York: Basic Books, 1963.

Li, Zhe, and Joseph Dalaker. *Poverty among the Population 65 and Older*. Congressional Research Service, December 6, 2022. https://sgp.fas.org /crs/misc/R45791.pdf.

Lindquist, Julie. "Class Affects, Classroom Affectations: Working through the Paradoxes of Strategic Empathy." *College English* 67, no. 2 (November 2004): 187–209.

Lingeman, Richard. *Theodore Dreiser*. Vol. 1, *At the Gates of the City, 1871– 1907*. New York: G. P. Putnam's Sons, 1986.

Linkon, Sherry Lee. "Class Analysis from the Inside: Scholarly Personal Narrative as a Signature Genre of Working-Class Studies." In *The Routledge International Handbook of Working-Class Studies*, edited by Michele Fazio, Christie Launius, and Tim Strangleman. New York: Routledge, 2021: 20–31.

Loach, Ken, dir. *Land and Freedom*. Columbia TriStar Films, 1995. Film.

Logan, William. *The Great Social Evil: Its Causes, Extents, Results, and Remedies*. London: Hodder and Stoughton, 1871.

London, Jack. *The People of the Abyss*. In *Jack London: Novels and Social Writings*, edited by Donald Pizer. New York: Library of America, 1982. 1–184.

Lonsdale, Roger, ed. *The New Oxford Book of Eighteenth Century Verse*. Oxford: Oxford University Press, 1984.

Luczak, Ewa Barbara. *Breeding and Eugenics in the American Literary Imagination: Hereditary Rules in the Twentieth Century*. New York: Palgrave Macmillan, 2015.

Luddy, M. *Prostitution and Irish Society*. Cambridge: Cambridge University Press, 2007.

Lukács, Georg. *Essays on Realism*. Translated by David Fernbach. Cambridge, MA: MIT Press, 1981.

Lukács, Georg. *The Historical Novel*. Translated by Hannah Mitchell and Stanley Mitchell. Lincoln: University of Nebraska Press, 1983.

Lylo, Taras. "Ideologeme as a Representative of the Basic Concepts of Ideology in the Media Discourse." *Social Communication* 3, no. 1 (August 2017): 14–20.

Lynch, David. "Casualties from War in Ukraine Include Millions of the World's Poor." *Washington Post*, July 7, 2022. https://www.washingtonpost.com/business/2022/07/07/ukraine-war-poverty-undp/.

Lyons, Clare. *Sex among the Rabble: An Intimate History of Gender and Power in the Age of Revolution, 1730–1830*. Chapel Hill: University of North Carolina Press, 2006.

Mac, Juno, and Molly Smith. *Revolting Prostitutes: The Fight for Sex Workers' Rights*. London: Verso, 2018.

Mackenzie, Colin A., Kazumasa Wakamatsu, Neil A. Hanchard, Terrence Forrester, and Shosuke Ito. "Childhood Malnutrition Is Associated with a Reduction in the Total Melanin Content in Scalp Hair." *British Journal of Nutrition* 98, no. 1 (August 2007): 159–64. https://www.researchgate.net/publication/6425393_Childhood_malnutrition_is_associated_with_a_reduction_in_the_total_melanin_content_of_scalp_hair.

Mailer, Norman. *The Naked and the Dead*. New York: Picador, 2000.

Maharidge, Dale, and Michael S. Williamson. *And Their Children After Them: The Legacy of* Let Us Now Praise Famous Men: *James Agee,*

Walker Evans, and the Rise and Fall of Cotton in the South. New York: Seven Stories Press, 2008.

Maharidge, Dale, and Michael S. Williamson. "When Emma Met James Agee." YouTube, September 2015. https://www.youtube.com/watch?v=Qw5oBeKyb1c&t=129s.

Mahood, Linda. *The Magdalenes: Prostitution in the Nineteenth Century.* London: Routledge, 1990.

Mani, Anandi, Sendil Mullainathan, Eldar Shafir, and Jiaying Zhao. "Poverty Impedes Cognitive Function." *Science,* August 20, 2013, 976–80.

Marcus, Steven. *Engels, Manchester, and the Working Classes.* New York: Random House, 1974.

Marshall, Howard. *Slum.* In collaboration with Miss Avice Trevelyan. London: William Heinemann, 1933.

Marx, Karl. *Capital.* Translated by Samuel Moore and Edward Aveling. New York: International Publishers, 1974.

Marx, Karl, and Frederick Engels.*Marx and Engels Collected Works. Letters 189–92.* Vol. 49. London: Lawrence and Wishart, 2010.

Matthews, Scott L. "Protesting the Privilege of Perception: Resistance to Documentary Work in Hale County, Alabama, 1900–2010." *Southern Cultures* 22, no. 1 (Spring 2016): 31–65.

Mathewson, Tara Garcia. "How Poverty Changes the Brain." *Atlantic,* April 19, 2017. https://www.theatlantic.com/education/archive/2017/04/can-brain-science-pull-families-out-of-poverty/523479/.

Mayhew, Henry. *London Labour and the London Poor.* London: George Woodfall and Son, 1851.

Mayew, Henry. *London Labour and the London Poor: Selections.* Edited by Janice Schroeder and Barbara Leckie. Peterborough, Ont.: Broadview, 2020.

McCaulley, Essau. "Does the Meaning of a Song Change Depending on Who Wrote It?" *New York Times,* December 23, 2022. https://www.nytimes.com/2022/12/23/opinion/cultural-appropriation-black-music.html.

McCord, Collin, and Harold Freeman. "Excess Mortality in Harlem." *New England Journal of Medicine* 322 (January 18, 1990): 173–77.

McGarvey, Darren. *Poverty Safari: Understanding the Anger of Britain's Underclass.* Edinburgh: Luath, 2017.

McNeur, Katherine. *Taming Manhattan: Environmental Battles in the Antebellum City.* Cambridge, MA: Harvard University Press, 2014.

Menand, Louis. "The Hammer and the Nail: Richard Wright's Modern Condition." *New Yorker,* July 13, 1992. https://www.newyorker.com/magazine/1992/07/20/the-hammer-and-the-nail.

Mencken, H. L. "Illuminators of the Abyss." *Saturday Review of Literature,* October 6, 1934.

Mestman, Mariano. "*The Hour of the Furnaces*: Crafting a Revolutionary Cinema." *Vertigo*. https://www.closeupfilmcentre.com/index.php ?cID=1623&bID=808&arHandle=New+Leter&ccm_token=1525637 101:894a2c90e327c7a5e30845e5e5a8a59c&btask=passthru&method =mailchimp_subscribe.

Michaels, Walter Benn. *The Beauty of a Social Problem: Photography, Autonomy, Economy*. Chicago: University of Chicago Press, 2015.

Miller, Claire Caine, Josh Katz, Francesca Paris, and Aatish Bhatia. "Vast New Study Shows a Key to Reducing Poverty: More Friendships between Rich and Poor." *New York Times*, August 1, 2022. https://www .nytimes.com/interactive/2022/08/01/upshot/rich-poor-friendships .html.

Miner, Valerie. "Writing and Teaching Class." In Tokarczyk and Fay, *Working-Class Women*, 73–86.

Min Joo Kim. "Gangnam style vs. squalor: Inequality in South Korea's most famous area." *Washington Post*, July 6, 2023. https://www .washingtonpost.com/world/2023/07/06/gangnam-seoul-south -korea-rich-inequality/.

Miranda, Lin Manuel, dir. *In the Heights*. 5000 Broadway Productions, 2021. Film.

Mishel, Lawrence. "Vast Majority of Wage Earners Are Working Harder, and Not for Much More: Trends in US Work Hours and Wages, 1979–2007." Economic Policy Institute Issue Brief 348, January 30, 2013. https://www.epi.org/publication/ib348-trends-us-work-hours-wages -1979-2007/.

Mishra, Pankaj. "The Reorientations of Edward Said." *New Yorker*, April 19, 2021. https://www.newyorker.com/magazine/2021/04/26/the -reorientations-of-edward-said.

Mitchell, Margaret. *Gone with the Wind*. New York: Scribners, 1996.

Mitchell, W. J. T. "Representation." In *Critical Terms for Literary Study*, edited by Frank Lentricchia and Thomas McLaughlin, 11–22. Chicago: University of Chicago Press, 1995.

Mogador, Celeste. *Memoirs of a Courtesan in Nineteenth-Century Paris*. Lincoln, NE: Bison Books, 2001.

Jenkins, Barry, dir. *Moonlight*. A24, 2016. Film.

Moore, George. *Esther Waters*. Oxford: Oxford University Press, 2012.

Moreas, Ricardo. "Photographing the Kayapo." Reuters (May 12, 2011).

Morgan, Stacy I. *Frankie and Johnny: Race, Gender, and the Work of African American Folklore in 1930s America*. Austin: University of Texas Press, 2017.

Morgan, Stacy I. *Rethinking Social Realism: African American Art and Literature, 1930–1953*. Athens: University of Georgia Press, 2004.

Motley, Willard. *The Diaries of Willard Motley.* Edited by Jerome Kinkowitz. Ames: Iowa State University Press, 1979.

Motley, Willard. *Knock on Any Door.* New York: D. Appleton-Century, 1947.

Motley, Willard. *Let No Man Write My Epitaph.* New York: Signet, 1958.

Motley, Willard. *Let Noon Be Fair.* New York: Putnam, 1966.

Motley, Willard. "Pavement Portraits." *Hull House Magazine* 1, no. 2 (December 1939): 2–6.

Moynihan, Daniel Patrick. *The Moynihan Report: The Negro Family—The Case for National Action.* New York: Cosimo Books, 2018.

Mullen, Ann L. *Degrees of Inequality: Culture, Class, and Gender in American Higher Education.* Baltimore: Johns Hopkins University Press, 2010.

Murray, Charles. "In Search of the Working Poor." *National Affairs* 59 (Spring 2024): 3–19.

My Secret Life: An Erotic Diary of Victorian London. New York: Signet, 2007.

Nead, Lynda. *Myths of Sexuality: Representations of Women in Victorian Britain.* Oxford: Blackwell, 1988.

Nead, Lynda. *Victorian Babylon: People, Streets and Images in Nineteenth-Century London.* New Haven, CT: Yale University Press, 2000.

Nead, Lynda. *The Victorians and the Visual Imagination.* Cambridge: Cambridge University Press, 2000.

Newman, Katherine. "Retirement Should Not Mean Hardship—but Many Older Americans Live in Poverty." *Guardian*, May 26, 2019. https://www.theguardian.com/us-news/2019/may/24/elder-poverty-america-hardship-retirement-economics.

Nicholls, James. *The Politics of Alcohol: A History of the Drink Question in England.* Manchester: Manchester University Press, 2011.

Nield, Keith. *Prostitution in the Victorian Age: Debates on the Issue from 19th Century Critical Journals.* Westmead, UK: Gregg International Publishers, 1973.

Nixon, Rob. *Slow Violence and the Environmentalism of the Poor.* Cambridge, MA: Harvard University Press, 2013.

Noble, Kimberly. "By Age Five, Children's Brains Can Look Very Different—and Family Income Is a Factor." *TED Radio Hour*, NPR, November 11, 2022. https://www.npr.org/transcripts/973794361.

Nord, Deborah Epstein. *Walking the Victorian Streets: Women, Representation, and the City.* Ithaca, NY: Cornell University Press, 1995.

Novack, George. "Marxism and the Intellectuals." *New International* 2, no. 7 (December 1935): 227–32.

Oldfield, Kenneth. "Humble and Hopeful: Welcoming First-Generation Poor and Working-Class Students to College." *About Campus* 11, no. 6 (2007): 2–12.

Oldfield, Kenneth, and Richard F. Conant. "Professors, Social Class, and Affirmative Action." *Journal of Public Affairs Education* 7, no. 3 (2001): 171–85.

Oldfield, Kenneth, and Richard Greggory Johnson III. "Introduction." In *Resilience: Queer Professors from the Working Class*, edited by Keith Oldfield and Richard Greggory Johnson III, 1–6. Albany: State University of New York Press, 2008.

Olsen, Tillie. *Yonnondio: From the Thirties*. Lincoln, NE: Bison Books, 2004.

Pande, Rohini, Vestal McIntyre, and Lucy Page. "Extreme Poverty Has Plummeted: But Not in Middle-Income Countries." *New York Times*, January 28, 2019. https://www.nytimes.com/2019/01/28/opinion/inequality-poverty-global-aid.html.

Pannell, Lindsay. "Viperous Breathings: The Miasma Theory in Early Modern England." Master's thesis. West Texas A&M, 2016.

Patrick, M. E., P. Wightman, R. F. Schoeni, and J. E. Schulenberg. "Socioeconomic Status and Substance Use among Young Adults: A Comparison across Constructs and Drugs." *Journal of Studies on Alcohol and Drugs* 73, no. 5 (September 2012): 772–82. https://doi.org/10.15288/jsad.2012.73.772.

Paul, Diane. "In the Interests of Civilization: Marxist Views of Race and Culture in the Nineteenth Century." *Journal of the History of Ideas* 42, no. 1 (January–March 1981): 118–19.

Petry, Ann. *The Street*. 1946. New York: Houghton Mifflin, 2020.

Phelan, John P., and Michael R. Rose. "Why Dietary Restriction Substantially Increases Longevity in Animal Models but Won't in Humans." *Ageing Research Reviews* 4, no. 3 (2005): 339–50.

Piketty, Thomas. *A Brief History of Inequality*. Cambridge, MA: Harvard University Press, 2022.

Pinker, Steven. *The Better Angels of Our Nature: Why Violence Has Declined*. New York: Penguin, 2011.

Pittenger, Mark. *Class Unknown: Undercover Investigations of American Work and Poverty from the Progressive Era to the Present*. New York: New York University Press, 2012.

Pope, Alexander. *The Complete Poetical Works of Pope*. Boston: Houghton Mifflin, 1903.

"Population History of London." The Proceedings of the Old Bailey, accessed March 1, 2024. https://www.oldbaileyonline.org/static/Population-history-of-london.jsp.

Proudhon, Pierre-Joseph. *Property Is Theft! A Pierre-Joseph Proudhon Anthology*. Chico, CA: AK Press, 2011.

Rabin, Roni Caryn. "Poor Americans More Likely to Have Respiratory Problems, Study Finds." *New York Times*, May 31, 2021. https://www

.nytimes.com/2021/05/28/health/tobacco-smoking-poor-americans
.html.

Rabinowitz, Paula. *They Must Be Represented: The Politics of Documentary.*
London: Verso, 1994.

Rampell, Catherine. "The Rich Drink More." *New York Times,* July 30, 2010.
https://economix.blogs.nytimes.com/2010/07/30/the-rich-drink
-more.

Reeves, Richard V. "The Dangerous Separation of the Upper Middle Class."
Brookings, September 3, 2015. https://www.brookings.edu/research
/the-dangerous-separation-of-the-american-upper-middle-class/.

Regan, Pamela, Roberta Medina, and Anuparna Joshi. "Partner Preferences
among Homosexual Men and Women: What Is Desirable in a Sex
Partner Is Not Necessarily Desirable in Romantic Partner." *Social Behav-
ior and Personality: An International Journal* 29, no. 7 (January 2001):
625–33.

Reihl, Kristina M., Robin A. Hurley, and Katherine H. Taber. "Neurobiology
of Implicit and Explicit Bias: Implications for Clinicians." *Journal of
Neuropsychiatry Clinical Neuroscience* 27, no. 4 (Fall 2015): 248–53.
https://neuro.psychiatryonline.org/doi/pdf/10.1176/appi.neuropsych
.15080212.

Richardson, Samuel. *Pamela: Or, Virtue Rewarded.* New York: Penguin,
1981.

Riis, Jacob. "Flashes from the Slums." *New York Sun,* February 12, 1888.

Riis, Jacob. *How the Other Half Lives.* New York: Scribner's, 1914.

Robbins, Bruce. *The Servant's Hand: English Fiction from Below.* New York:
Columbia University Press, 1986.

Roberts, Sam. "Jacob Riis Photographs Still Revealing New York's Other
Half." *New York Times,* October 22, 2015.

Robin, Marie-Monique. *The Photos of the Century: 100 Historic Moments.*
Cologne, Germany: Taschen, 1999.

Rochefoucauld, François de la. *A Frenchman's Year in Suffolk.* Translated by
Norman Scarfe. Martlesham, Suffolk: Boydell, 1988.

Rogers, Richard, and Oscar Hammerstein. "How Can Love Survive?" 1959.
https://rodgersandhammerstein.com/song/the-sound-of-music/how
-can-love-survive/. Accessed March 1, 2024.

Roosevelt, Blanche. *Life and Reminiscences of Gustave Doré.* London: Cassell,
1885.

Root, Tik. "Heat and Smog Hit Low-Income Communities and People of
Color Hardest, Scientists Say." *Washington Post,* May 26, 2021. https://
www.washingtonpost.com/climate-environment/2021/05/25/heat
-inequality-climate-change/.

Rorabaugh, W. J. *The Alcoholic Republic: An American Tradition.* Oxford:
Oxford University Press, 1979.

Rosen, Ruth. *The Lost Sisterhood: Prostitution in America, 1900–1918*. Baltimore: Johns Hopkins University Press, 1982.

Roth, Henry. *Call It Sleep*. New York: Farrar, Straus and Giroux, 1991.

Rothberg, Michael. *The Implicated Subject: Beyond Victims and Perpetrators*. Palo Alto, CA: Stanford University Press, 2019.

Rubin, Lillian Breslow. *Worlds of Pain: Life in the Working-Class Family*. New York: Basic Books, 1976.

Russell, Thaddeus. *A Renegade History of the United States*. London: Simon and Schuster, 2010.

Ruttenburg, Nancy. *Democratic Personality: Popular Voice and the Trial of American Authorship*. Palo Alto, CA: Stanford University Press, 1998.

Ryan, Jake, and Charles Sackrey, eds. *Strangers in Paradise: Academics from the Working Class*. Boston: South End, 1984.

Said, Edward. "Edward Said and Palestine (1988)," interviewed on *Exiles*, BBC2, 1986. YouTube, uploaded April 5, 2013. https://youtu.be/7g100TNkMQ4.

Said, Edward W. "Opponents, Audiences, Constituencies, and Communities." *Critical Inquiry* 9, no. 1 (September 1982). 1–26.

Said, Edward W. *Orientalism*. New York: Pantheon, 1978.

Said, Edward W. *Out of Place*. New York: Vintage, 2000.

Sakar, Saurav, Shally Gupta Barnes, and Aaron Noffke. *The Souls of Poor Folk: Auditing America 50 Years after the Poor People's Campaign*. Washington, DC: Institute for Policy Studies, 2020.

Sanchez-Paramo, Carolina, Ruth Hill, Daniel Gerszon, Ambar Narayan, and Nishant Yonzan. "COVID-19 Leaves a Legacy of Rising Poverty and Widening Inequality." World Bank, October 7, 2021. https://blogs.worldbank.org/developmenttalk/covid-19-leaves-legacy-rising-poverty-and-widening-inequality.

Sancho, Ignatius. *Letters of the Late Ignatius Sancho, an African*. Edited by Vincent Carretta. Toronto: Broadview, 2015.

Sauter, Michael B. "Faces of Poverty: What Racial, Social Groups Are More Likely to Experience It." *USA Today*, October 10, 2018. https://www.usatoday.com/story/money/economy/2018/10/10/faces-poverty-social-racial-factors/37977173/.

Schocket, Eric. "Undercover Explorations of the 'Other Half,' or the Writer as Class Transvestite." *Representations*, no. 64 (Autumn 1998): 109–33.

Scott, John, Emen Scott, Joseph Crosbie, Hanna Crosbie, Edward Copeman, Richard Harmer, and John Barnes. "A Sanitary Remonstrance." *Times*, July 5, 1845, 5.

Scott, Mike. "'Django Unchained': Abomination or Entertainment?" NOLA.com, January 3, 2013. https://www.nola.com/entertainment_life/movies_tv/article_a18905c4-53b0-5e4a-8cff-343d18804481.html.

Shakespeare, William. *Hamlet*. In *The Norton Shakespeare*, vol. 2, edited by Stephen Greenblatt, 1402–1488. New York: Norton, 2016.

Shakespeare, William. *King Henry IV*. In *King Henry IV, Part One*, edited by Barbara Hodgdon, Boston: Bedford/St. Martin, 1997.

Sharpe, Christina. *In the Wake: On Blackness and Being*. Durham, NC: Duke University Press, 2016.

Sims, George Robert. *How the Poor Live, and Horrible London*. London: Chatto and Windus, 1889.

Sims, George Robert. *Living London: Its Work and Its Play, Its Humour and Its Pathos, Its Sights and Its Scenes*. London: Cassel and Company, 1902.

Smedley, Agnes. *Daughter of Earth*. Mineola, NY: Dover, 2011.

Smith, Noah. "Stop Blaming America's Poor for Their Poverty." Bloomberg News, July 30, 2019. https://www.bloomberg.com/opinion/articles/2019 -07-30/u-s-economy-personal-bad-behavior-isn-t-what-causes-poverty.

Smith, Sheila. *The Other Nation: The Poor in English Novels of the 1840s and 1850s*. Oxford: Oxford University Press, 1980.

Sorowski, Piotr, and Marina Butovskaya. "Height Preferences in Humans May Not Be Universal: Evidence from the Datoga People of Tanzania." *Body Image* 9, no. 4 (September 2012): 510–16.

Sorowski, Piotr, Agnieszka Sorokowska, Bernhard Fink, and Mara Mberira. "Variable Preferences for Sexual Dimorphism in Stature (SDS) Might Not Be Universal: Data from a Semi-nomad Population (Himba) in Namibia." *Journal of Cross Cultural Psychology* 43, no. 1 (January 2012): 32–37.

Spivak, Gayatri Chakravorty. "'Can the Subaltern Speak?'" In *Can the Subaltern Speak? Reflections on the History of an Idea*, edited by Rosalind C. Morris, 21–80. New York: Columbia University Press, 2010.

"State Health Facts." KFF.org. https://www.kff.org/other/state-indicator /poverty-rate-by-raceethnicity/. Accessed: February 23, 2024.

Stein, Sally. "Passing Likeness: Dorothea Lange's 'Migrant Mother' and the Paradox of Iconicity." In *Only Skin Deep: Changing Visions of the American Self*, edited by Coco Fusco and Brian Wallis, 345–55. New York: International Center of Photography in association with Abrams, 2003.

Steinbeck, John. *The Grapes of Wrath*. New York: Penguin, 1992.

Steinbeck, John. *Their Blood is Strong*. San Francisco: Simon J. Lubin Society, 1938.

Stendhal. *The Charterhouse of Parma*. Oxford: Oxford University Press, 2009.

Stowe, Harriet Beecher. *A Key to Uncle Tom's Cabin*. Boston: Houghton Mifflin, 1896.

Straub, Kristina. *Domestic Affairs: Intimacy, Eroticism, and Violence between Servants and Masters in Eighteenth-Century Britain*. Baltimore: Johns Hopkins University Press, 2009.

Strauss, Valerie. "Education as a Meritocracy? Report Finds It Is Still Better to Be Born Rich than Smart in U.S." *Washington Post*, June 19, 2019. https://www.washingtonpost.com/education/2019/06/18/education -meritocracy-report-finds-it-is-still-better-be-born-rich-than-smart-us.

Swift, Jonathan. *The Complete Poems.* New Haven, CT: Yale University Press, 1983.

Symons, J. C. *Arts and Artisans at Home and Abroad.* Edinburgh: William Tait, 1889.

Táíwò, Olúfẹ́mi O. *Elite Capture: How the Powerful Took Over Identity Politics (and Everything Else).* New York: Haymarket Books, 2022.

Tapper, James. "Huge Decline of Working-Class People in the Arts Reflects Fall in Wider Society." *Guardian,* December 10, 2022. https://www .theguardian.com/culture/2022/dec/10/huge-decline-working-class -people-arts-reflects-society.

Tarantino, Quentin, dir. *Django Unchained.* Weinstein Company and Columbia Pictures, 2012. Film.

Taylor, Stuart. "A Case for Class-Based Affirmative Action." *Connecticut Law Tribune,* September 30, 1991, 18.

Tennant, Dorothy [Mrs. H. M. Stanley]. *London Street Arabs.* London: Cassell, 1890.

Thomas, Amanda J. *Cholera: The Victorian Plague.* Barnsley, South Yorkshire, UK: Pen and Sword, 2015.

Thomas, Jon, and Adolphe Smith. *Street Life in London.* London: Sampson Low, Marston and Company, 1877.

Thomas, Joseph Earl. *Sink: A Memoir.* New York: Grand Central, 2023.

Thomas, Joseph Earl. "Joseph Earl Thomas: *Sink*: A Coming-of-Age Memoir." Family Action Network, YouTube, uploaded February 24, 2023. https://youtu.be/2mCIej6YwxM.

Thomas, Joseph Earl. "Sinking with Joseph Earl Thomas." *Mighty Writers* (podcast), with Maureen Boland, episode 3, May 18, 2023. https:// mightywriters.org/episode-3-sinking-with-joseph-earl-thomas/.

Thomas, Piri. *Down These Mean Streets.* 1967. New York: Vintage, 1997.

Thompson, E. P. *Making of the English Working Class.* New York: Vintage, 1963.

Thompson, Morton. *Not as a Stranger.* New York: Scribners, 1954.

Thurman, Wallace. *The Blacker the Berry.* Mineola, NY: Dover, 2008.

Tokarczyk, Michelle M., and Elizabeth A. Fay. "Introduction." In *Working-Class Women in the Academy: Laborers in the Knowledge Factory,* edited by Michelle M. Tokarczyk and Elizabeth A. Fay, 1–10. Amherst: University of Massachusetts Press, 1993.

Tompkins, Lucy. "Extreme Poverty Has Been Sharply Cut. What Has Changed?" *New York Times,* December 2, 2021. https://www.nytimes .com/2021/12/02/world/global-poverty-united-nations.html.

Torres, Justin. "An Interview with Justin Torres." Bruin Film Society. YouTube, uploaded September 12, 2018. https://youtu.be/BJ8_yJtMgFc.

Torres, Justin. "Justin Torres on *We the Animals.*" Chicago Humanities Festival, YouTube, uploaded November 26, 2013. https://www .chicagohumanities.org/media/justin-torres-we-animals/.

Torres, Justin. "My Story, and *We the Animals*: Justin Torres at TEDx-Stanford." YouTube, uploaded August 3, 2012. https://youtu.be/ST4JS67JoY4.

Torres, Justin. *We the Animals*. Boston: Mariner Books, 2011.

Trilling, Lionel. "Greatness with One Fault in It." *Kenyon Review* 4, no. 1 (Winter 1942). 99–102.

Tuck, Eve. "Suspending Damage: A Letter to Communities." *Harvard Educational Review* 79, no. 3 (Fall 2009): 409–28.

Uglow, Jenny. *Elizabeth Gaskell*. London: Faber and Faber, 1993.

US Department of Education. "College Affordability and Completion: Ensuring a Pathway to Opportunity," accessed 2/12/2024. https://www.ed.gov/sites/default/files/college-affordability-overview.pdf.

Valentova, Jaroslava Verella, Gert Stulp, Vit Trebicky, and Jan Havlicek. "Preferred and Actual Relative Height among Homosexual Male Partners Vary with Preferred Dominance and Sex Role." *PLoS One* 9, no. 1 (2014): e86534.

Vance, J. D. *Hillbilly Elegy: A Memoir of a Family and a Culture in Crisis*. New York: Harper, 2016.

Vicinus, Martha. *The Industrial Muse: A Study in Nineteenth-Century Working-Class Literature*. New York: Barnes and Noble, 1974.

Visconti, Luchino, dir. *The Earth Trembles*. FIT Films, 1948. Film.

Wadsworth, Martha E., and Shauna L. Rienks. "Stress as a Mechanism of Poverty's Ill Effects on Children." *CYF News* (American Psychological Association), July 2012. https://www.apa.org/pi/families/resources/newsletter/2012/07/stress-mechanism (accessed February 3, 2021).

Wald, Alan M. *American Night: The Literary Left in the Era of the Cold War*. Chapel Hill: University of North Carolina Press, 2012.

Walkowitz, Judith R. *Prostitution and Victorian Society: Women, Class, and the State*. Cambridge: Cambridge University Press, 1982.

Wardlaw, Ralph. *Lectures on Female Prostitution: Its Nature, Extent, Effects, Guilt, Causes and Remedy*. Glasgow: J. Maclehose, 1842.

Washington, Bryan. "An Extraordinary Memoir of a Black American Boyhood." *New York Times*, February 21, 2023. https://www.nytimes.com/2023/02/21/books/review/sink-joseph-earl-thomas.html.

Weissman, Sara. "Reckoning with the Past, Looking toward the Future: Stanford University Uncovered a History of the Institution Limiting Jewish Student Enrollments." *Inside Higher Education*, October 27, 2022. https://www.insidehighered.com/news/2022/10/27/stanford-uncovers-limits-put-jewish-admissions.

Wells, H. G. *The Time Machine/The War of the Worlds*. New York: Fawcett, 1968.

West, Cornel. "The Dilemma of the Black Intellectual." *Journal of Blacks in Higher Education*, no. 2 (Winter 1993–94): 59–67.

Wimsatt, W. K. and M. C. Beardsley, "The Intentional Fallacy." *Sewanee Review* 54, no. 3 (July–September 1946): 468–88.

Winship, Scott, Christopher Pulliem, Ariel Gelrud Shiro, Richard V. Reeves, and Santiago Deambrosi. "Long Shadows: The Black-white gap in multigenerational poverty." https://www.brookings.edu/articles/long-shadows-the-black-white-gap-in-multigenerational-poverty/.

Whitfield, R. *Frederick Engels in Manchester: The Search for a Shadow*. Manchester: Working Class Movement Library, 1988.

Whitford, David. "The Most Famous Story We Never Told." *Fortune*, September, 19, 2005. https://archive.fortune.com/magazines/fortune/fortune_archive/2005/09/19/8272885/index.htm.

Williams, A. Susan. *The Rich Man and the Diseased Poor in Early Victorian Literature*. London: Macmillan, 1987.

Wise, Robert, and Jerome Robbins, dirs. *West Side Story*. United Artists, 1961. Film.

Wollstonecraft, Mary. *A Vindication of the Rights of Women*. New York: Norton, 2009.

Woods, Alan. "Doré's London: Art and Evidence." *Art History* 1, no. 3 (1978): 341–59.

World Health Organization [WHO]. *Preventing Chronic Disease. A vital investment*. Geneva: WHO, 2005.

Wray, Matt. *Not Quite White: White Trash and the Boundaries of Whiteness*. Durham, NC: Duke University Press, 2006.

Wright, Richard. *Black Boy*. New York: Harper, 1993.

Wright, Richard. *Native Son*. New York: Perennial, 2023.

Wu, Stephen. "Where Do Faculty Receive Their PhDs?" *Academe* 91, no. 4 (July/August 2005): 53–54.

Zandy, Janet. *Hands: Physical Labor, Class, and Cultural Work*. New Brunswick, NJ: Rutgers University Press, 2004.

Zandy, Janet, ed. *Liberating Memory: Our Work and Our Working-Class Consciousness*. New Brunswick, NJ: Rutgers University Press, 1995.

Zangwill, Israel. *Children of the Ghetto: A Study of a Peculiar People*. New York: Grosset and Dunlop, 1895.

Zimmer, Carl. "Agriculture Linked to DNA Changes in Ancient Europe." *New York Times*, November 23, 2015. http://www.nytimes.com/2015/11/24/science/agriculture-linked-to-dna-changes-in-ancient-europe.html.

Zola, Émile. *Germinal*. Translated by Peter Collier. Oxford: Oxford University Press, 1993.

Zola, Émile. *The Ladies Paradise*. Translated by Brian Nelson. Oxford: Oxford University Press, 2008.

Zola, Émile. *Nana: A Novel*. Translated by Brian Nelson. Oxford: Oxford University Press, 2020.

Index

Abernathy, Arthur, 116–17

abortions, 162

abuse, 216; physical, 158, 209–10; sexual, 40, 154, 160, 209–11, 217–18

Die Abwesenheit der Antragsteller (*The Absence of Applicants*), 53–54

academia, 25, 28–32, 77–82, 229–30, 233n1, 234n45; intellectuals and, 223–24; working-class studies in, 226–27

accountability, 49, 64–65, 69

accuracy, 7, 45, 59–60

Acton, William, 164–65

addiction, 205–6, 208, 212

Adichie, Chimamanda Ngozi, 42–43

affirmative action, 30, 234n47

African Americans, Black people and, 12, 30, 47, 73, 119, 200, 219–20, 223; life expectancy of, 112–13; in London, 113–14; median wealth of, 33–34; poornography by, 100; racialization of, 116–17; representations of poor, 227–28; in *Sink*, 212–15; as transclass writers, 82, 88–89, 105–9, 212–15

Agee, James, 19, 196–203, 250n56

agency, 147, 177–92

Ahmad, Aijaz, 234n45

air quality, 112

alcohol, alcoholism and, 27, 104, 154, 163, 168, 121–26, 217

Alger, Horatio, 147

alienation, 81, 220

Alison, William Pulteney, 138

Allbut, Robert, 99

Allen, Michelle, 134

"The Alley" (Pope), 130

allies, 17–18, 92–93, 226

Allison, Dorothy, 208–11, 214–17

Althusser, Louis, 44–45

Alton Locke (Kingsley), 89

ambivalence, 25–26, 59, 201; transclass, 71, 106, 208, 223

American dream, 207, 211

American Notes (Dickens), 114, 136

Among Elms and Maples Morgantown, West Virginia, August 1935, 194–96

"Among Elms and Maples Morgantown, West Virginia, August 1935" (Anderson, M.), 194–96

Anderson, Benedict, 7

Anderson, Maggie, 19, 192–96

And Their Children after Them (Maharidge, Williamson), 200

anger, 145, 190, 201–2, 204, 215

answerability, 49, 236n32

anti-Semitism, 231n2

Appalachia, 205–8

Armstrong, Nancy, 53

Arner, Lynn, 31

arranged marriages, 156

Artaud, Antonin, 44

Attaway, William, 144

Austen, Jane, 133, 165

authenticity, x, 244n123, 249n9; representation and, 44–50, 60–61, 63, 65–69

Azoulay, Ariella, 190–92

Babb, Sanora, 228–29

Bacon, Francis, 176

Baker, Houston, 47

Bakhtin, Mikhail, 49, 232n47

Baldwin, James, 26, 43, 75

Balibar, Étienne, 44–45

Bamford, Samuel, 68

Barron, James, 30

Barthelemy, Toussaint, 162

Barthes, Roland, 50

Bastard out of Carolina (Allison), 208–12

Baudelaire, Charles, 161

Beardley, Monroe, 50

Beauchamp, Virginia Walcott, 32

Beddoe, John, 116

beer, 123, 125–26

Beer Street, 123, 125

beggars, 51–52, 113

Belafonte, Harry, 43

Bell, Alexander Graham, 115

Bendix, Regina, 46

Bentley, George, 167

Bergreen, Laurence, 197–99

Berlant, Lauren, 29

Bey, Dawoud, 53

biases, 5, 32–33, 84, 140

The Bicycle Thieves (film), 222–23

Binfield, Kevin, 33

Binschtok, Viktoria, 53

biocultural, 28, 111–12; myths, 113, 118–26,
 135–36, 142, 146–49, 152–53, 165

birth control, 156

Black Boy (Wright), 12, 105–6, 222

The Blacker the Berry (Thurman), 106–7

Black intellectuals, 224

Black Thunder (Bontemps), 144

Blood on the Forge (Attaway), 144

Bly, Nellie, 85–86

bodies, poor, 18, 40, 148, 156

Bong Joon Ho, 55–56

Bontemps, Arna, 144

Booth, Charles, 7, 126

Bourdieu, Pierre, 16–17, 46, 74, 81–82, 193

Bourke-White, Margaret, 197–98

boycotts, 145

Brace, Charles Loring, 135

brains, 26–27, 112, 148, 213n19, 233n9

Brandeis University, 24

Brazil, 190

breastfeeding, 180–82

Bremner, Robert, 40

Brierly, Ben, 100–101

Brontë, Charlotte, 118, 158

Bronx, New York City, 2–3, 21

bubonic plague, 138

Burke, Edmund, 59

Burney, Frances, 58

Burns, Mary, 92–93

Burroughs, Allie Mae, 201–2

Burroughs, Charles, 201

Burroughs Family, 203–4

Byrd, William, II, 146

California, 6, 174–92, 228

Call It Sleep (Roth), 222

Callot, Jacques, 52

Campbell, John, 152

capitalism, 13, 32, 56–57, 111, 152, 161,
 214–15, 229; class analysis and, 34–35;
 labor and, 158, 220–21; in the *North and
 South*, 91; sex works and, 165; structural-
 ism and, 226–27

Catholic Worker, 79

Cerf, Bennett, 228

Chadwick, Edwin, 130–31

The Charity of a Beggar at Ornans, 52

Cherokee nation, 187

Chicago, Illinois, 107–9, 112–13, 145, 154

childbirth, 121, 156, 246n3

children, poor, 11–13, 33–34, 37, 135, 149,
 210, 216, 219; brain development and, 112,
 148; illegitimacy and, 208–9; malnutri-
 tion of, 116, 119; photographs depicting,
 8–10, 171–72, 176–92, 194, 203–4; sexual
 abuse of, 211, 217–18

China, 37

cholera, 132, 137

Christmas, William, 33

chronic diseases, 138–39

City University of New York, 30

civil rights movement, 199, 219–20

Clarence and Corinne; or, God's Way
 (Johnson, A.), 100

Clarissa (Richardson), 64

Clark, Aaron, 137

class, social, 135, 159, 194, 219–20, 232n47, 247n25; academia and, 28–32; accents and, 76–77; analysis, 22, 34–36; consciousness, 77, 211; criminality and, 139–41; diseases and, 137; identity and, 160, 206–7, 217, 238n12; neurobiology and, 26–27; nonreproduction, 74, 81; prejudices, 106, 140, 168; race and, 107–8, 115–19, 234n47; resentment, 56, 211; traitors, 70, 94. *See also specific classes*

class-transvestite narratives, 85–86

Class Work Project, 48

Cleland, John, 153–54

coal miners, 84, 116

Cochrane, Charles, 132–33

coffee, 126

cognitive function, 27, 148

Collins, Tom, 228

Collyer, Robert, 136

Columbia University, 21–24, 71, 80, 206

Columbine Mine Massacres, 145

coming-of-age stories, 213–14, 216–17, 223

communism, 143, 222

The Condition of the Working Class in England (Engels), 91–92

Connell, Raewyn, 33

Conroy, Jack, 88, 224

Cooper, Thomas, 89–91

Cooper Union, 146

Corbin, Alain, 162, 247n25

Cornel West, 224

Courbet, Gustave, 52

COVID-19 pandemic, 4, 113

crime, criminality and, 18, 27, 40–41, 110–11, 119, 126, 217; class and, 139–41; licensing act and, 122–23; prostitution and, 159

Cuarón, Alfonso, 53, 55–56

Cuddy, Amy, 27

cultural: capital, 16–17, 79, 105, 170, 191–92, 208, 228–29; production, 46–47, 50, 111

"culture of poverty," 110–11, 189, 206, 226–27

Curtis, James, 189

Das, Veena, 13

Daughter of Earth (Smedley), 77–78, 222

Davenport, Charles, 119

David Copperfield (Dickens), 167

Davis, Eva, 21

Davis, Moishe (Morris), 1–3, 14–15, 21

Deaf people, Deafness and, 1–2, 14, 21, 42, 76, 115

A Death in the Family (Agee), 199

deaths, 103, 112, 123–24, 146, 165, 187, 192, 199; childbirth related, 121, 156; disease and, 131–32; in novels, 68, 143, 167, 222; of prostitutes, 163; by starvation, 157

degeneration, racial, 116–18, 121

Delaney, Beauford, 75

democracy, representative, 17, 57–58

Democratic Personality (Ruttenburg), 58

Demos (Gissing), 102–3, 115, 222

Denning, Michael, 172

Depression era, 171–74, 183, 187

Derrida, Jacques, 44, 46

"A Description of a City Shower" (Swift), 130

dialectical relationships, 44–45

Dickens, Charles, 4, 98–99, 114, 128–29, 136, 164, 167, 222; as a exo-writer, 85, 90; transclass characters by, 88; on working-class people, 101. *See also specific works*

dignity, 185, 189

direct democracy, 58

disabilities, 18, 28, 115, 141, 143, 177–78, 224

discrimination, 21, 33, 114, 227

diseases, 18, 38–39, 130–34, 136–39, 147, 156, 177; sexually transmitted, 161–62, 164

Django Unchained (film), 44

documentary photography, 7, 181, 183, 185, 202–3, 249n9

Dombey and Son (Dickens), 128–29

domestic: labor, 70, 156–58, 160; violence, 207, 216–17

Doré, Gustave, 6, 86–87

Dorothea Lange on the Job, 175

double consciousness, two-ness and, 80–81, 102, 192–94

Douglass, Norman, 10–11

downward mobility, 86, 154

Dreiser, Theodore, 104
dressmakers, 157
drugs, 27, 121–22, 205–6, 208, 214, 217, 223
drunkenness, drinking and, 18, 110, 121–22, 159
Du Bois, W. E. B., 81, 192
Dunleavy, Yvonne, 168
Dvořák, Antonín, 47
Dyer, Richard, 45, 50–51

The Earth Trembles (film), 223
education, 1–2, 65, 119, 215, 223, 234n47; Ivy Leagues, 23, 29–30, 80, 82, 219–20; transclass people and, 21–24, 75–82, 213–14. *See also* academia
Ehrenreich, Barbara, 110
Eisner, Will, 96
Elizabeth I (Queen), 127
Elkins, James, 248n1
Ellington, Duke, 43
Emerson, Ralph Waldo, 46–47
Emma (Austen), 165
encounters, photographic, 171–73, 176–92
Endo/Exo Writers Project, 224–25
endo-writers, endo-artists and, 13, 17, 53, 73, 81–83, 216, 218, 224–25; Allison as an, 208–11; Babb as an, 228–29; Brierly as a, 100–101; Cooper as, 89–91; exo-writers compared to, 65–66, 209, 228–29; Wright as a, 105–6
Engels, Friedrich, 2, 18, 101, 115, 151, 223–24, 229; as an exo-writer, 91–99
England, 22, 37–38, 91–99, 102, 121–33, 140–41, 145. *See also* London
English Charter Circular, 68
enslaved people, 16–17, 53, 82, 113, 155; illustrations of, 14–15; sexual exploitation of, 246nn3–4; as transclass writers, 88–89
Entin, Joseph, 238n12
Equiano, Olaudah, 88–89
erasure, 28–29, 32, 114–15, 200
erotic desire, eroticism and, 7, 16–17, 199, 202
Essays on the Picturesque (Price), 53
Esther Waters (Moore, G.), 119–20, 126

eugenics, 18, 40, 65, 111, 115, 117–21, 135, 164, 169
Evans, Walker, 19, 192–200, 203, 250n56
excrement, 26–27, 127–34, 147
exiles, political, 80
exo-observers, exo-readers and, 19, 99, 102
exo-writers, 13, 57, 82–87, 88, 101–2, 224–25, 232n47; endo-writers compared to, 65–66, 209, 228–29; Engels as a, 91–99; on female sex workers, 153–54; Gaskell as a, 65–68, 91; stereotypes invoked by, 81, 118–22, 126–32
exploitation, 8, 16–17, 33, 35, 152; labor, 157, 161, 233n1; photography and, 191–92, 200–201; publishing and, 201–2; sexual, 158, 246nn3–4

factory workers, 19, 65–67, 116, 160; women as, 93, 157–58
"fallen women," 18, 158, 161, 163–64, 167–68
families, poor, 33–34, 53, 55–56, 217–18, 228; in *Bastard out of Carolina*, 208–11; "culture of poverty" and, 226–27; in *Hillbilly Elegy*, 205–6; photography depicting, 19, 171–74, 176–200, 203–4; in *We the Animals*, 215–16
Fanny Hill (Cleland), 153–54
Farm Security Administration (FSA): photography by Evans for, 192–98; photography by Lange for, 172–74, 176–92
Faulkner, William, 119
The Federalist Papers, 59–60
Fern, Fanny (Sarah Payson Willis Parton), 103–4
films, 109, 205, 207–8, 211–12, 215, 221–23; middle-class audiences for, 216–17; representation in, 43–44, 53, 55–56. *See also specific films*
filth, 10–13, 18, 38–39, 55–56, 95–98, 103–4, 135–36, 214; human excrement, 26–27, 127–34, 147
first-person accounts, 16, 153–54, 168
Fisher, Fox, 44
Fiske, Susan, 26

Flaubert, Gustave, 164

Flye, James Harold, 198

Fortune magazine, 197–200

Foster, George, 110, 114, 157, 159

Foucault, Michel, 94

France, 35, 84, 96–97, 123, 146, 160, 162,
 165, 244n114

From the Depths, 144

FSA. *See* Farm Security Administration

"fugitive slaves," 113

gambling, 126–27

Gandal, Keith, 6

Gaskell, Elizabeth, 116, 118–19, 143, 222; as
 an exo-writer, 65–69, 91. *See also specific
 works*

gatekeeping, cultural, 25

Gates, Henry Louis, 47

gazes, 78, 192, 195–96, 202

Geertz, Clifford, 13

gender, 5, 34–35, 46, 83–84, 107, 118,
 151–52; "fallen women" and, 18, 158, 161,
 163–64, 167–68; labor and, 92, 145–46,
 148, 174; photography and, 19, 171–92;
 publishing and, 105, 228–29; sex work
 and, 16–18, 104–5, 153–63

Germinal (Zola), 84, 115–16, 143, 221–22

germ theory, 130, 134

Gershwin, George, 43

Gettino, Octavio, 221

Gilbert, Pamela, 128

gin, 123–24, 126

Gin Lane, 123–24

Gissing, George, 17–18, 86–87, 115, 165–68,
 222; as an exo-writer, 86, 88

Glasgow, Scotland, 132, 161–62

Godfrey, Barry, 141

Gold, Michael, 11, 215, 222

Gombrich, E. H., 44

Goodrich Sport Shoes, 174–75

Gramsci, Antonio, 89, 230

The Grapes of Wrath (Steinbeck), 133–34,
 187–88, 207, 222, 227

The Great Social Evil (Logan), 163

Greeley, Horace, 38–40

Grindrod, Ralph Barnes, 118

guilt, societal, 7, 26, 68, 155

Habermas, Jürgen, 63

Hale, Dorothy, 45

Hall, Stuart, 44

Hamilton, Alexander, 126

Hamilton, Laura, 30

Hammerstein, Oscar, 150

Hamsum, Knut, 75, 83

The Happy Hooker (Hollander), 168

Harburg, Yip, 150–51

Hard Times (Dickens), 88, 90, 143–44, 222

Hardy, Thomas, 101, 121

Harlem, New York City, 12–13, 73, 84–85,
 96, 113

Harper's Weekly, 143

Harrington, Michael, 110, 227

Hartman, Saidiya, 12

Harvard University, 29

"The Harvest Gypsies" (Steinbeck), 228

health, health standards and, 18, 111–13

heat levels, 111–12, 139

hegemony, 205, 230

hepatitis, 138

Herder, Johann Gottfried, 46

Hill, Jim, 188

Hillbilly Elegy (Vance), 205–8, 210–11

Hirsch, Marianne, 32

The Historical Novel (Lukács), 222

Hitchcock, Peter, 13, 28, 86

Hitchcock, Tim, 147

Hogarth, William, 123–25

Hollander, Xaviera, 168

Holquist, Michael, 236n32

homeless people, homelessness and, 26, 30,
 154, 183, 185

homicides, 140

homosexuality, 120

hookworm parasites, 134, 147

horses, horseracing and, 126–27

The Hour of the Furnaces (documentary), 221

Howard, June, 45

Howard, Ron, 207–8

How the Other Half Lives (Riis), 145

Hughes, Langston, 47
Hugo, Victor, 139–40
Humanitarian Revolution, 64
human rights, 64
humor, 209–10, 216
hunger, 83, 90, 157, 176–77, 209–10
Hunger (Hamsun), 83
Hunt, Lynn, 64
Hurston, Zora Neale, 47
Huston, Anjelica, 208, 211
hygiene, personal, 18, 132–33

identity, 21–22, 28, 45, 61, 74, 83–84, 107,
 192–93, 221; class and, 160, 206–7, 217,
 238n12
identity politics, 34, 48–49
Illinois, 107–9, 112–13, 145, 154
Illuminated Magazine, 98–99
illustrations, 6, 8–9, 14–15, 123–25
immigration, immigrants and, 38–39, 76,
 119, 137, 162; German, 104, 107; Jewish,
 1–2, 11, 21–22, 219
implicated subjects, 29, 32, 36–37, 226
implicit bias, 32
incarceration, 18, 89, 140–41, 143, 146, 209
income, wages and, 4, 207; inequality,
 35–36, 122; for poor women, 154, 157
Independence Day Terra Alta, West Virginia,
 1935, 194–95
"Independence Day Terra Alta, West
 Virginia, 1935" (Anderson, M.), 194
"Index of Negrescence" (Beddoe), 116
India, 37, 224
Indigenous people, 46, 187, 190
individuality, individualism and, 215,
 221–23
industrialization, 37–40, 100
Industrial Revolution, 100
infant mortality, 121, 135
infectious diseases, 138
"In Imitation of Spenser" (Pope), 135
In Search of Authenticity (Bendix), 46
intellectuals, 21, 64, 75, 89, 90–91, 223–24,
 229–30
intention, intentional fallacy and, 50

The Interesting Narrative of the Life of
 Olaudah Equiano (Equiano), 88–89
intersectionality, 33–34, 80
In the Heights (musical, film), 223
In the Wake (Sharpe), 82
Into Unknown England (Keating), 117
Inuits, 118
Inventing Human Rights (Hunt), 64
Irish people, 116, 136
Ivy League colleges and universities, 23,
 29–30, 80, 82, 219–20

Jack, Anthony Abraham, 32, 80
Jakobs, Lydia, 40
James, Caryn, 212
James, Henry, 45
Jameson, Fredric, 45
Jane Eyre (Brontë), 118, 158
Japan, 27
Jaquet, Chantal, 17, 71, 74, 81–83, 192–93,
 232n50
Jekyll, Joseph, 101–2
Jenkins, Barry, 73, 223
Jensen, Barbara, 72, 78, 82
Jerrold, Blanchard, 6, 86
The Jew a Negro (Abernathy), 116–17
Jewish people, 114–17, 135, 145–46, 155, 223;
 as immigrants, 1–2, 11, 21–22, 219
Jews without Money (Gold), 11, 215, 222
Johnson, Amelia Etta Hall, 100
Johnson, Joseph, 113
Johnson, Richard Greggory, III, 74–75
Jones, Gavin, 3, 35, 52–53
Julie, Or the New Heloise (Rousseau), 64
Juvenile Fine Art Exhibition (London), 5

Kant, Immanuel, 58
Karras, Ruth Mazo, 155
Kayapos people, 190
Keating, Peter, 117
Keats, John, 120–21
Ker, William Balfour, 144
Kim, Marlene, 147
Kingsley, Charles, 89
Knock on Any Door (Motley), 107–9

Koehler, Robert, 142–43
Kuppens, Toon, 33

labor, 215; capitalism and, 158, 220–21; domestic, 70, 156–58, 160; exploitation of, 157, 161, 233n1; gender and, 92, 145–46, 148, 174; migrant, 174, 176–92, 228; sexual, 154–56, 159, 246nn3–4; strikes, 91, 142–45, 221–22; wage, 19, 35, 159–61
lack, 52–53, 55, 69, 236n37
Ladies Paradise (Zola), 56–57
Land and Freedom (film), 221
Lange, Dorothea, 19, 171–92, 228, 249nn7–8
language, 46–47, 70–71, 76–77, 88, 112, 155–56, 199, 212; of disability, 115; in poornography, 38, 51, 94–96, 102–4; representation and, 44, 51
Larsen, Nell, 83
Latinx people, 30, 215–16
Lattimer Massacres, 145
Lauter, Paul, 64
laziness, 18, 26–27, 146–51, 207
Lee, John, 151
Lee, Russell, 186
Leiserson and Triangle Shirtwaist shops, 146
leisure classes, 93
Leonhardt, David, 30
Let No Man Write My Epitaph (Motley), 108
Let Noon Be Fair (Motley), 108
Let Us Now Praise Famous Men (Agee), 19, 196–99
"Let Us Now Praise Famous Men" (PBS video), 201
Levine, Lawrence, 189
Levy, Sydney Nathan, 76
Lewis, Oscar, 110, 227
liberalism, 27, 206–7, 216
Liberating Memory (Zandy), 71
Library of Congress, 191–92
Life and Labour of the People of London (Booth), 7
life expectancy, 112–13
Lindquist, Julie, 34

Lindsay, John, 168
Lindsey, Ben, 105
Lingeman, Richard, 104
liquor, 123–24
literacy, 4, 154
lived experience of poor people, 2–3, 227; representation and, 48–49, 53, 57, 61–62
livestock, living with, 18, 135–37
Living London (Sims), 6
Loach, Ken, 221
"local knowledge," 13, 225
Logan, William, 163
London (Jerrold, Doré), 6, 86
London, England, 1–2, 112–13, 126–28, 131–32, 138, 165–66; animals in, 135–37; crime in, 139–40; domestic labor in, 157–58; East End of, 14, 114–15, 119; poverty in, 4–11, 85–86, 117–18; the Rookery, 96, 132
London, Jack, 85–87, 115, 117–19
London Labour and the London Poor (Mayhew), 10, 41, 61, 99
London Street Arabs (Tennant), 8
"Long Story" (Anderson, M.), 193
Los Angeles Times, 183
lotteries, 127
Lowell, James Russel, 145
lower-class, 6, 85–86, 121–23; sex work and, 18–19, 152–63, 169
Lower East Side, New York City, 8, 11, 38–39, 85, 135, 145, 148
Lubbock, Percy, 45
Luce, Henry, 197
Luczak, Ewa Barbara, 115
Lukács, Georg, 44, 57, 222
Lumpen (publication), 48
Lyons, Clare, 19, 159–61

Mac, Juno, 162–63, 169
Madame Bovary (Flaubert), 164
Madeleine (anonymous), 19, 104–5, 154, 160, 168
Maharidge, Dale, 200–201
Male Beggar Dressed in Rags, 52
malnutrition, 116, 119, 148
Mandler, Peter, 147

Marcus, Steven, 80, 129

marriages, 18–19, 115, 156, 167, 172, 222, 292; sex outside of, 19, 155, 158–62

Married Women's Property Act (1882), 156

Marshall, Howard, 7

Martin, George, 62, 117

Martin, John, 141, 143

Marx, Karl, 21, 56–57, 93–94, 115, 219–20, 223–24, 229

Marxism, 28, 45, 74, 223–24

Mary Barton (Gaskell), 65–69, 91, 116, 118–19, 129, 158, 163, 222

masturbation, 108, 161

materialism, 44

Mayhew, Henry, 10, 41, 61–62, 99, 113–14, 117–18

McClure's Magazine, 116

McCraney, Tarell Alvin, 223

McCray, Mary, 202

McGarvey, Darren, 72

McIntosh, Katherine, 188–89, 191

Melandovitz, Shlomo (Solomon), 1

Memoirs of a Courtesan (Mogador), 154

Mencken, H. L., 231n2

meningitis, spinal, 2

mental, 158; illness, 110–11

Meredith, Anne, 211

"'Merrie England'—No More!" (Cooper), 89

Mexico, 53–54

miasma theory, 130–31, 136–37

Michaels, Walter Benn, 53

middle-class, 4–5, 40, 133, 158, 163, 200, 205, 213, 223, 225–26; academia and, 27–36; African Americans, 106–8; class identity of, 160; fears of the, 137–38, 145; Lange as, 174; transclass people and the, 70, 193; values, 189; women, 161

middle-class readers and observers, 4–6, 19, 61–62, 81–83, 170; photography and, 179, 189–91; poornography and, 13, 41, 129–30, 205, 216–17, 227–29

middle-class writers, 4–7, 11, 18, 64–65, 97–99, 117, 205–6; stereotypes invoked by, 118–22, 126–30

migrant labor, 174, 176–92, 228

Migrant Mother, 19, 171–74, 176–79, 188–91, 202–3

Miner, Valerie, 72–73

minimum wage, 35

Miranda, Lin Manuel, 223

miscegenation, 114, 134

Les Misérables (Hugo), 139–40

Mississippi, 34

Mitchell, W. J. T., 57–58

modernism, 63

Mogador, Celeste, 154

Moonlight (film), 73, 223

Moore, George, 119–20, 126

Moore, Robin, 168

Moraes, Ricardo, 190

Morning Chronicle (newspaper), 41

Morris, David, 111

mortality rates, 111–12

Moskovich, Bella Esther, 1

mothers, 11, 78, 205–6; poor, 5, 171–73, 176–92; as sex workers, 156–57

Motley, Willard, 107–9

Moynihan, Daniel Patrick, 227

Muggeridge, Malcolm, 86

multigenerational poverty, 33–34, 233n1

murders, murder rate and, 139–41, 145

Murray, Charles, 147

My Secret Life (anonymous), 158

mythemes, 50, 81, 152

Nana (Zola), 164

narratives, 18, 50–51; coming-of-age, 213–14, 216–17, 223; transclass, 84–86, 154

Native Americans, 46, 187, 190

Native Son (Wright), 227–28

Nead, Lynda, 160–61

neoliberalism, 32, 111

neuroscience, 26–27, 32, 213n19, 233n9

New Challenge (publication), 224

New Republic (publication), 110–11

New York by Gas-Light and Other Urban Sketches (Foster), 110

New York City, 1–3, 111, 114, 122, 136, 192, 215; Bronx, 2–3, 21; Harlem, 12–13, 73,

84–85, 96, 113; Lower East Side, 8, 11, 38–39, 85, 135, 145, 148; sex work in, 159, 163, 168

New York Times, 30, 39, 136, 143, 147, 212–13

Nicholls, James, 122

Nield, Keith, 165

Nielsen, Kelly, 30

Night Coming Tenderly, Black, 53

Nightingale, Florence, 131

Nipomo, California, 174–92

noise levels, 112

nonmarital sex, 19, 155, 158–62

nonreproduction, class, 74, 81

Nord, Deborah, 26, 153

North and South (Gaskell), 91, 143, 222

Northern Star (newspaper), 68

nostalgia, 53, 55, 207–9, 213

"No Taxation without Representation," 57–59, 237n46

nouveau riche, 70–71, 88

novels, 50, 58–59, 64, 221–22; poornographic, 227–28; sex workers in, 153–54. *See also specific novels*

objectification, 170–72, 190

objectivity, objective observers and, 6, 176, 198–99, 202–3, 230

The Object Stares Back (Elkins), 248n1

Occupy protests, 35

odor, smell and, 38–39, 97–99, 103–4, 128–34, 136–37; representations of, 52, 55

Of Grammatology (Derrida), 46

Ohio, 206–7

Oklahoma, 187

Oldfield, Kenneth, 74–75

Oliver Twist (Dickens), 99, 115, 167

Olsen, Tillie, 71–72, 77–78

"Opponents, Audiences, Constituencies, and Communities" (Said), 230

orality, 46

The Order of Things (Foucault), 94

organic intellectuals, 21, 64, 75, 89

Orientalism (Said), 7

Orshansky, Mollie, 81–82

Orwell, George, 85–86

Out of Place (Said), 81

Owens, Troy, 188–91

ownership, 139–40, 191–92

paintings, 5, 51–53, 142

Pamela (Richardson), 64, 158

Parasite (film), 55–56

Parent-Duchâtelet, Alexandre, 165

Paris, France, 96–97, 146

parish housing, 141, 157

"participatory socialism," 220

Parton, Sarah Payson Willis (Fanny Fern), 103–4

Passing (Larsen), 83

patriarchy, 156, 228–29

people of color, 30; poor, 16, 111, 226–27; representations and, 43–44, 63. *See also* African Americans, Black people and

People of the Abyss (London), 115

Petry, Ann, 73, 84–85, 227–28

Philadelphia, Pennsylvania, 19, 122, 159, 161–62, 212

Phillips, John, 123

Phillips, Sandra, 191

photography, 248n1, 249nn7–8, 250n56; by Binschtok, 53–54; by Bourke-White, 197–98; depicting poor children, 8–10, 171–72, 176–92, 194, 203–4; documentary, 7, 181, 183, 185, 202–3, 249n9; by Evans, 19, 192–200, 203–4; exploitation and, 191–92, 200–201; by Lange, 19, 171–92, 228; of poor families, 19, 171–74, 176–200, 203–4; representational inequality and, 196, 201, 203–4; staging of, 10, 180–82, 195–96; street, 9–10, 172, 183, 185

physical, abuse, 158, 209–10

pigs, hogs and, 135–37

Piketty, Thomas, 220

Pinker, Steven, 64

Plato, 44, 49

play, pleasure and, 10–13

Poland, 2

police, 56, 98–99, 130

polio, 177–78

political representation, 57–60
pollution, 112, 137–38
Poor Laws, 131–32
POOR Magazine, 47–48
poornography (genre), 3–7, 91, 109, 145, 191, 222; advent of, 37–41; contemporary, 205–16; on diseases, 138; endo-writers and, 100–101; by Engels, 94–99; exo-writers and, 13; fallen-woman narratives in, 167; language and, 38, 51, 94–96, 102–4; middle-class and, 158–59, 205–6, 225; middle-class readership of, 13, 41, 129–30, 205, 216–17, 227–29; sex workers and, 16–17, 158. *See also* stereotypes, clichés and
poor people. *See specific topics*
poorscape, 12–13, 96, 100, 105, 107–9, 214, 217, 225
Pope, Alexander, 130, 135
Popular Photography (magazine), 172–74, 176–77
Porgy and Bess (musical), 43, 149–50
pornography, 5, 152
postmemory, 32
postmodernism, 50, 63, 212
poverty, 3–5, 30, 95–96, 137, 148, 233n9; "bad choices" causing, 26–27, 207; "culture of," 110–11, 189, 206, 226–27. *See also* representations; *specific topics*
poverty index, US, 81–82
povertyism, 227, 229
poverty porn, 3, 216
Poverty Safari (McGarvey), 72
poverty studies, 225, 227
poverty tourism ("poorism"), 6
Povinelli, Elizabeth, 13
power dynamics, 19, 159, 170, 176–96, 200–201, 217, 230
precarity, the precariat and, 33, 36, 82, 233n1, 247n19
pregnancies, 104, 154, 156–58
prejudices, 18, 32, 151, 227; class, 106, 140, 168; racial, 116–17
Price, Uvedale, 53
Princeton University, 79–80

proletarian writers and literature, 47, 88, 221, 224, 227–28, 231n2
property and ownership rights, 139–40, 191–92
prostitution, 16–19, 26, 40, 93, 153, 169, 246nn3–4, 247n25; Acton on, 164–65; decriminalization of, 163; Engels on, 97; in New York City, 110, 159; sex panic and, 154–55; sexually transmitted diseases and, 161–62, 164. *See also* sex work, sex workers and
Proudhon, Pierre-Joseph, 139
psychopaths, 110–11
public: health, 18, 130–38, 165; schools, 21, 30, 212, 219; transportation, 2–3
publishing, distribution and, 16, 47, 167–68, 196–99, 228, 232n51; asymmetrical power dynamics in, 170, 201–2; photography and, 183, 185–89; representation and, 62–63; transclass writers and, 72–73, 105
Puerto Rican Americans, 215–16
Pullman strike, 145
Punch magazine, 62

queer people, 107, 215–16

Rabinowitz, Paula, 7, 173, 249n9
race, 33–34, 106–7, 111–13, 187, 192, 214, 216; class and, 107–8, 115–19, 234n47; erasure and, 114–15, 200
racial: degeneration, 116–18, 121; prejudices, 116–17
racialization, 43, 83, 116, 135
racism, 23, 43, 97, 114, 200, 213, 223
railroad strikes, 145
Rambles in Dickens' Land (Allbut), 99
rape, 143, 156, 158, 160
Ray, Nicholas, 109
reader-response theory, 63
realism (genre), 7, 10, 45, 61, 63, 211–12
Renaissance, 157
rent strikes, 146
representational inequality, 16, 17, 25, 61, 152, 153, 170, 229; photography and, 196, 201, 203–4

representations of poverty and the poor, 4–8, 17, 58–59, 236n21, 237n46; authenticity and, 44–50, 60–61, 63, 65–69, 109; erasure and, 114–15; exo-writers and, 65–67; in films, 43–44, 53, 55–56; intellectuals and, 223–24; lived experience and, 48–49, 53, 57, 61–62; paradox of, 42–44; in photography, 171–92; self-representation and, 225–26, 230; sex workers and, 18, 153

representative democracy, 17

The Republic (Socrates), 49–50

Resilience (Johnson, R.; Oldfield), 74–75

respectability, 5, 107, 155, 160

Revolutionary War, 57–59, 122, 126

Richardson, Samuel, 58, 64, 158

rights, 64, 183, 194, 200–201, 227, 246n3; ownership, 191–92; of women, 156

Riis, Jacob, 8–10, 145

Robbins, Bruce, 61

Robbins, Jerome, 223

Rodgers, Richard, 150

Roma (film), 53, 55

Rosen, Ruth, 246n3

Roth, Henry, 222

Rothberg, Michael, 29, 32, 36

Rubin, Lillian Breslow, 72, 83

rural poor, 53, 106, 147, 156–57, 172, 193

Rush, Benjamin, 126

Russell, Thaddeus, 126

Ruth Hall (Fern), 103–4

Ruttenburg, Nancy, 58, 236n21

Rydlewski, Norma, 189–90

Said, Edward, 7, 80–81, 230

Sancho, Ignatius, 88, 101–2

San Francisco, California, 172, 183, 185

San Francisco Chronicle, 172

San Francisco News, 228

Schocket, Eric, 6, 85

Scotland, Scottish people and, 129, 161–62

Scott, Joan, 35

Scripture Reader in a Night Refuge, 87

seasonal employment, 2, 21, 220

segregation, 30, 152, 229

sewer systems, 96, 128, 132–34

sex panic, white slavery and, 154–55

sexual: abuse, 40, 154, 160, 209–11, 217–18; labor, 154–56, 159, 246nn3–4; revolution, 153, 168

sexuality, 18, 39–40, 108, 151–52, 210, 212, 215–17, 231n19; exo-writers and, 202; sex work and, 155–56

sexually transmitted diseases, 161–62, 164

sex work, sex workers and, 210, 212, 246nn3–4, 247n19; domestic servants and, 158; gender and, 16–18, 104–5, 153–63; Gissing on, 165–68; lower class women as, 18–19, 152–63, 169; in *Madeleine*, 104, 154, 160; in New York City, 159, 163, 168; syphilis and, 161–62. *See also* prostitution

Shakespeare, William, 67–68, 131

shame, 77–78, 203–4

sharecroppers, 19, 106

Sharpe, Christina, 82

Shoemaker, Robert, 147

shortness, height and, 18, 118–21

Sica, Vittorio De, 222–23

Sims, George, 6, 117

Sink (Thomas, J.), 73, 212–15

Slaves of the Needle (Grindrod), 118

Slaves on the Eve of Freedom, 15

sleep, sleeping arrangements and, 112, 151–52

slumming, 5, 98

slums, 5–9, 10–13, 100, 131–32, 162

Smedley, Agnes, 11, 77–78, 222

Smith, Adolphe, 6

Smith, Molly, 162–63, 179

social Darwinism, 147

socialism, 57, 143

The Socialist, 142–43

social services, 134–35, 217–18

Socrates, 49–50

Solanas, Fernando, 221

The Sound of Music (musical), 150

South Carolina, 208–11

southern whites, poor, 116–17, 142–43

Spanish Civil War, 221

Spanish Harlem, New York City, 12–13, 96

Spielberg, Steven, 223

Spivak, Gayatri, 58, 224

Stanley, Henry Morton, 8

starvation, 4, 83, 157

Steinbeck, John, 133–34, 187–88, 222, 227–29

stereotypes, clichés and, 3, 48, 51–53, 55, 193, 210–11, 217–18; biocultural, 113, 118–21, 140–41; exo-writers and, 65–68, 224–25; neurological activity and, 26–27; transclass, 83–84, 88, 102

Stowe, Harriet Beecher, 117

The Street (Petry), 73, 84–85, 227–28

Street Arabs in Sleeping Quarters, 9

Street Life in London (Thomson, Smith), 6

street photography, 9–10, 172, 183, 185

stress, 148–49

The Strike, 142–43

strikes, labor, 91, 142–45, 221–22

structural inequality, 25, 201

structural injustices, 29, 213, 215

structuralism, 50, 213, 224, 226–27

Stryker, Roy, 172, 186–87, 189

subaltern, 224, 234n45

subconsciousness, class, 27

subsistence living, 148, 160–61

suicide, 79

sweatshops, 1–2, 21, 79

Swift, Jonathan, 130

symbols, symbolism and, 121, 169, 186

Symons, J. C., 152

syphilis, 161–62

Syracuse, New York, 215

Tarantino, Quentin, 44

Taylor, Paul, 172

Taylor, Vanessa, 207–8

tenant farmers, 192–202

Tennant, Dorothy, 8–9

Terre Haute, Indiana, 104

theater of cruelty, 44

theft, 40, 97, 139–41, 159, 183, 185, 217

"Their Blood Is Strong" (Steinbeck), 228

They Leave Danger Behind, 15

Thomas, Joseph Earl, 73, 212–15, 217

Thomas, Piri, 12–13, 96

Thompson, E. P., 238

Thompson, Florence Owens, 171–73, 176–92, 203–4

Thomson, John, 6

Thurman, Wallace, 106–7

The Time Machine (Wells), 115–16

Times (newspaper), 132

Tingle, Ruth, 200–201

Tingle Family, 203

Torres, Justin, 11, 73, 215–16

trafficking, sex, 162–63

Transclasses (Jaquet), 71

Les transclasses ou la non-reproduction (Jaquet), 232n50

transclass people, 16–18, 70–72, 74, 189–90; ambivalence of, 71, 106, 208, 223; education and, 21–24, 75–82, 213–14; transclass consciousness of, 106, 192–95

transclass writers, 17–18, 168, 223, 230, 232n50, 238n12; academia and, 77–82; African American, 82, 88–89, 105–9, 212–15; Cooper as, 89–91; double-consciousness of, 81, 102; Gissing as a, 102–3; publishing and, 72–73, 105; on sex work, 153–54; Thomas, J., as a, 212–15; Vance as a, 206–8, 210–11; waning, 86, 88, 102–5, 108–9; waxing, 105–6, 109

transgender people, 44, 49, 83–84

trauma, 32, 205–6

Triangle Shirtwaist shops, 146

Trilling, Lionel, 7

Trinity College, 22–23

tuberculosis, 187

Tuck, Eve, 236n37

two-ness, 80–81, 102, 192–94

Uganda, 148

Ukraine, 4

The Unclassed (Gissing), 88, 165–67

underrepresented groups, 30, 42–44

unemployment, 2, 21, 40, 126, 217, 220

unionization, unionized labor, 160–61, 215, 233n1

United Kingdom, 127, 138, 156, 160; murder rate in, 140; Scotland, 161–62; sex panic, 154–55

United Nations, 37, 79, 163, 227

United States (US), 36–40, 46–47, 122, 140, 145–46; civil rights movement, 199, 219–20; Depression era, 171–74, 183, 187; Eugenics Record Office, 119; life expectancy in, 112–13; sex panic, 154–55; social workers, 134–35. *See also specific states*

University of Pennsylvania, 214–15

unwanted pregnancies, 158, 160, 162

upper-class, 14–15, 22, 30, 102–3, 126–27, 133, 137–40, 194; marriages, 156, 158

upward mobility, 207–8, 213

urban farmers, 135–37

urban poor, 18, 46, 85, 100, 114, 134, 156–57; African American, 106; British, 37–38, 102, 118; Petry on, 85

US. *See* United States

U.S. Camera (magazine), 183

Vagabondiana (compendium), 113

vagrancy act, 140

Vance, J. D., 205–8, 210–11, 216

venereal diseases, 161–62

ventriloquy, 16, 170, 194, 196

Victorian period, 40–41, 130, 157–58, 168

Vietnam War, 79

A Vindication of the Rights of Women (Wollstonecraft), 156

violence, 27, 29, 85, 110, 143–46, 162, 192, 209–10, 212, 228; criminality and, 40–41; domestic, 207, 216–17

Virginia, 146–47

Visconti, Luchino, 223

wage labor, 19, 35, 159–61

Wald, Alan, 107

Walkowitz, Judith, 161

Wallcott, Marion Post, 186

Wardlaw, Ralph, 163

Washington, Bryan, 212–13

Waters, Billy, 113

wealth redistribution, 220, 226

"Weedpatch" migratory labor camp, 133–34, 228

Weintrobe, Eli, 2

Wells, H. G., 115–16

West Nile, 138

West Side Story (film), 223

West Virginia, 192–93

We the Animals (Torres), 73, 215–16

"When the Idle Poor Become the Idle Rich" (song), 150–51

white, 207–8; beggars, 113–14; men, 16, 19, 43–44, 187; poor white people, 116–18, 146–47, 192–202; slavery, 154–55, 162–63

Whitman, Walt, 236n21

Whose Names Are Unknown (Babb), 228

Williamson, Michael, 200

Wimsatt, W. K., 50

wine, 123

Wise, Robert, 223

Wollstonecraft, Mary, 156

women, 42, 120, 124–25, 145–46, 148, 154–55; Black, 227–28; poor, 18–19, 171–72

Wood, Anthony, 127

Workers in the Dawn (Gissing), 102

working-class, 13, 16, 18, 21, 122, 129, 133, 143–45, 176, 206–8; African American, 73; Anderson, M., on, 193; Black, 212; Engels and the, 91–99, 101; exo-writer representation of, 65–69; female sex workers, 153–54; Gissing portraying, 102–3; intellectuals, 223–24; transclass people and, 70–72, 89; writers, 47, 65, 82

working conditions, 112, 146, 152, 154

working poor, 21, 116, 209, 233n1

World Health Organization, 138–39, 163

World War II, 33

Wright, Richard, 12, 105–6, 222, 227–28

Yale University, 206, 208

Zahl, Erasmus, 75

Zandy, Janet, 71, 81

Zangwill, Israel, 12

Zola, Émile, 4, 85, 115, 116, 164, 221–22